Theatre for Lifelong Learning

Theatre for Lifelong Learning

A Handbook for Instructors, Older Adults, Communities, and Artists

Linda Lau and Rae Mansfield

Bristol, UK / Chicago, USA

First published in the UK in 2022 by
Intellect, The Mill, Parnall Road, Fishponds, Bristol, BS16 3JG, UK

First published in the USA in 2022 by
Intellect, The University of Chicago Press, 1427 E. 60th Street,
Chicago, IL 60637, USA

Copyright © 2022 Intellect Ltd
Paperback © 2024 Intellect Ltd

All rights reserved. No part of this publication may be reproduced, stored in a retrieval system, or transmitted, in any form or by any means, electronic, mechanical, photocopying, recording, or otherwise, without written permission.
A catalogue record for this book is available from the British Library.

Copy editor: Newgen KnowledgeWorks
Cover image: *Senior woman raising her hands*. Photo by Rawpixel on iStock.
Cover designer: Tanya Montefusco
Production editor: Debora Nicosia
Typesetting: Newgen KnowledgeWorks

Hardback ISBN: 978-1-78938-492-5
Paperback ISBN: 978-1-78938-877-0
ePDF ISBN: 978-1-78938-493-2
ePUB ISBN: 978-1-78938-494-9

To find out about all our publications, please visit
www.intellectbooks.com
There you can subscribe to our e-newsletter, browse or download our current catalogue, and buy any titles that are in print.

This is a peer-reviewed publication.

Contents

List of Figures	vii
Preface: Why Older Adult Theatre?	ix
Older Adults Pursuing the Now	ix
The Three D's in Popular Culture	xi
Changing Perceptions of Older Adults through Theatre	xiii
Benefits of Older Adult Theatre Courses	xiv
Introduction	1
How to Use This Book	1
The Lifelong Learning Theatre Instructor	7
Our Approach to Theatre for Lifelong Learning	10
Inclusivity and Play for Older Adult Theatre	13
Where Do I Begin?	16
1. Collaborating with Older Adults	19
What Are the Challenges?	20
Suggested Best Practices	20
Theatre for the Virtual Classroom	29
How to Help Your Students Learn Online	32
Course Evaluations	34
Things to Remember	36
Our Learning Philosophy	37
2. Theatre Appreciation	40
What Is Theatre Appreciation?	40
How Do I Put Together a Course?	41
How Do I Select and Organize Topics?	43
What Activities and Discussions Can I Do?	50
How Do I Run the Course?	64
What Do I Include on the Syllabus?	69
Sample Syllabi	72
Additional Resources	93
3. Theatre History, Theory, and Criticism	95
What Are Theatre History, Theory, and Criticism?	96

How Do I Put Together a Course?	97
How Do I Select and Organize Topics?	104
What Activities and Discussions Can I Do?	110
How Do I Run the Course?	124
What Do I Include on the Syllabus?	128
Sample Syllabi	128
Additional Resources	154
4. Playwriting, Play Development, and Storytelling	162
What Are Playwriting, Play Development, and Storytelling?	163
How Do I Put Together a Course?	164
How Do I Select and Organize Topics?	166
What Activities and Discussions Can I Do?	170
Playwriting Exercises	172
Storytelling Exercises	180
How Do I Run the Course?	192
What Do I Include on the Syllabus?	200
Sample Syllabi	200
Additional Resources	215
5. Performance	218
What Is Performance?	218
How Do I Put Together a Course?	220
How Do I Select and Organize Topics?	222
What Activities and Discussions Can I Do?	231
Performance Exercises	231
How Do I Run the Course?	267
What Do I Include on the Syllabus?	276
Sample Syllabi	277
Additional Resources	293
Conclusion: Theatre for All	296
Intergenerational Theatre	298
Autobiographical and Documentary Theatre	298
Theatre and Dementia	299
Musical Theatre	300
Theatre Repertories	300
What Other Opportunities Are Out There?	301
Why We Wrote This Book	302
Notes	305
Bibliography	312

Figures

I.1	Course Development Process	2
4.1	Feedback	194
5.1	You Must Pay the Rent	253
5.2	An Interrupted Wedding	254
5.3	Melodramatic Gestures	254
5.4	Performance	266
C.1	Theatre	297

Preface: Why Older Adult Theatre?

I pursue nowness. That's what I do.
—Wang Deshun, model and actor[1]

What is something you have always wanted to do but were afraid to try? Many people dream of performing on stage, writing a book, taking up painting, learning how to dance, or doing "something" for themselves that they enjoy and can share with others. They often abandon these dreams due to responsibilities and wonder how to revisit them later in life. At any stage, becoming involved with the arts opens up possibilities that spark creativity and engagement with the world. The opportunities that the arts provide enable us to do what many of us endeavor to do each day, to live in the now. We strive to pursue nowness and any time is the right time to do that, regardless of age, background, or experience.

Theatre instantly puts us in the now, no matter which role we play. If you have picked up this book, you are off to an excellent start! You have chosen to be an instructor or facilitator and you will play an important role in using theatre to help people connect, learn, and have fun. *Theatre for Lifelong Learning* will be your partner on this journey, providing a one-stop shop for designing and teaching theatre for older adults.

So how can teaching and learning about theatre help us live in the moment? When we are not engaged, it is easy to forget that we are capable, curious, creative people who have the ability to expand our knowledge and experiences every day. Theatre encourages us to find meaning in small things, chance encounters, and the tapestry of life. All of the material provided for you in *Theatre for Lifelong Learning* is here to motivate instructors and students to get involved and pursue the now.

Older Adults Pursuing the Now

Age does not have to stop us from pursuing the now. There are many older adults who continue to learn and seek new avenues of exploring the world.

Some have even made new careers and gained international acclaim out of their interests.

Wang Deshun started modeling in his eighties. He was inspired to begin bodybuilding at 57 when he saw a Rodin sculpture. Since 2015, his story has gone viral and media outlets have dubbed him, "Hot Grandpa."[2] Wang modeled for world-recognized brands including athletic clothing company Reebok, where he was the face of their "Be More Human" campaign, and luxury brand Ermenegildo Zegna, whose other models include Robert De Niro.[3] He can be spotted all over the world, strutting the runways of Fashion Week in Beijing and Milan, and inspiring others with his long white locks and toned 80-year-old abs.

Maggie Kuhn was a program director for the Young Women's Christian Association-United Service Organizations (YWCA-USO) and spent the majority of her career working for the Presbyterian Church. When she turned 65, she was forced out of her job due to mandatory retirement laws. Inspired by the Black Panthers, she mobilized with other older adults, as well as high school and college-age people, and formed the Gray Panthers in 1970. The Gray Panthers focuses on older adult advocacy and activism, as well as economic inequality, civil liberties, election reform, and environmental issues.

Anna Mary Robertson, better known as Grandma Moses, began a career in folk art painting in the 1930s when she was in her late seventies. Before devoting herself to painting, she spent much of her life working on a farm and raising children. Robertson turned to painting when she developed arthritis and could no longer dedicate her time to embroidery. In her three decades of painting, she created over 1,500 pieces and successfully sold paintings during her lifetime.

The rule breakers mentioned here are just some of the few who have achieved great success and fame in their retirement years. There are many other examples. After working as a high school teacher in New York for over 30 years, Frank McCourt published *Angela's Ashes*, which became an international bestseller and won a Pulitzer Prize. Estelle Getty took time away from acting to raise a family. She was cast in her first major Broadway show in her late fifties, and as a result secured her first major television role as Sophia on *The Golden Girls*. Catherine Walter, Pauline Horn, Shirley Webb, and Willie Murphy all turned to powerlifting in their seventies and eighties. Murphy's weightlifting story hit the headlines when she defended herself against a home invasion in 2019.[4]

What can we learn from Wang, Kuhn, Robertson, and countless others? There are many older adults who continue learning, creating, and being active members of their communities. Older adults are just as capable as anyone else to start something new, develop talents, and make an impact in the world. Theatre is one of the ways that people can get involved and confront negative portrayals of older adults in popular media.

PREFACE: WHY OLDER ADULT THEATRE?

The Three D's in Popular Culture

People encounter negative media portrayals of older adults, often without recognizing that the portrayals are negative. Images of older adults on-screen tend to be associated with the Three D's: death, dying, and dementia. The Three D's are frequently employed as plot devices to bring about an emotional response in audiences or are used to sell products. From advertisements and films to plays, novels, and TV shows, the Three D's are ubiquitous. On television commercials, older adults are either planning to die or trying to avoid death. They are seen creating wills and estate planning, purchasing in-home and long-term care insurance, and making funeral preparations, or trying the latest heart drug, hormone replacement therapy, and erectile dysfunction medication. The public is saturated with these negative images and, in turn, more likely to see older adults as either in denial about aging or unable to participate in everyday activities or be independent, as a burden or isolated from society.

Death

In film and television, funerals and death are popular in genres such as comedies, dramas, and murder mysteries involving battles over estates. A common trope involves the mysterious death of an older relative, a dramatic reading of the will, and a room full of strangers who have never met before or family who have not seen each other in a very long time. The only "benefit" of having an older adult relative is monetary. Their "purpose" is to die and pass wealth onto the younger generations. Examples of this trope are *Knives Out* and *Lady on a Train*.

Comedies in the "death" category often involve the death of an older adult and the bonding of sometimes prodigal family members over their dead relatives. *The Funeral* and both versions of *Death at a Funeral* are examples of this. Other less conventional comedies use death as a vehicle for farce. In *Don't Tell Mom the Babysitter's Dead*, the older adult babysitter unexpectedly dies and the children must take care of themselves. *Mad Men* secretary Miss Blankenship dies at her desk and two characters attempt to sneak her body from the building unnoticed. In these comedies, deaths of older adults function as a punchline, rather than as a central part of the story. Their deaths are often not mourned, no one misses them, and the story continues without them.

Death of a quirky older adult also occurs as a plot device to make another character "better," like Grandpa's heroin overdose before the beauty pageant in *Little Miss Sunshine*, Oliver's reflection on the late-life coming out of his deceased father Hal in *Beginners*, and Phil's multiple attempts to save Les Podewell in *Groundhog Day*. Again, older adults are used to bring about change in other characters rather

than being in the role of the protagonist who gets to undergo a journey and life transformation.

And, of course, in *Arsenic and Old Lace*, the Brewster sisters murder men who come to stay at their rooming house. They have their nephew Teddy bury the bodies in the cellar. While this seems to be an exception rather than the rule where the audience sees the older adults being "active" by murdering men, the sisters end up committed to the Happy Dale Sanatorium. Their multiple transgressions are allowed to a certain extent as they are prevented from future murders but are not punished for the murders already committed. While *Arsenic and Old Lace* may seem like a positive take on older adults being active, ultimately, the Brewster sisters have to be separated from society. It leaves audiences with a message that when older adults are left to their own devices, they make poor decisions and do not understand what they are doing, however well-intentioned.

Dying

The process of dying, surprisingly, is a whole other category in itself in film. Dying is seen in "bucket list" movies in which characters go on experience missions or strive to set things right after receiving terminal diagnoses. Some bucket list films include *The Bucket List* (obviously), *Wild Strawberries*, and *Venus*. These films show older adults having lived a mostly uneventful life, finally doing something about it right before they die. For example, *The Bucket List* features the adventures of two men, Carter and Cole, following their lung cancer diagnoses. They travel the world, go skydiving, and attempt to mend relationships with family, before Carter receives news that the cancer has spread to his brain and he sends Cole to finish the list, though their list is not completed until both characters die. The missions that the characters go through help them rebalance the scales of the world so that their lives and deaths have meaning. These "dying" narratives suggest that in order to have a meaningful life, people need to do something grand for a big finish.

Caregiving and elder abuse is another theme in films about dying. *Marvin's Room*, *Crimes of the Heart*, *Out of Season*, and *A Patch of Blue* feature older adults depicted as unable to take care of themselves and at the mercy of younger, more capable adults who may or may not take advantage of them. They are characters to be either exploited or pitied as older adults exist in a space of what film reviewer Peter Bradshaw describes as "very-old-ness and not-yet-dead-ness."[5] Their value as people is wholly left for others to determine and older adults have no agency in carving out meaning for themselves. Many of these narratives are focused on the struggles faced by a caregiver, who had to give up other relationships or sacrifice their goals to take care of a dying relative. Others explore those affected by the caregiver's relationship with the older adult, such as neglected

children or partners, rather than telling the story from the perspective of the older adult. These stories suggest the older adults are limiting the lives and societal value of their caregivers. Only the caregivers' lives matter because the older adults are dying and they do not matter.

Dementia

According to the World Health Organization, dementia affects 5–8 per cent of the population over 60.[6] Although many older adults will not get dementia, popular media has perpetuated the myth that *everyone* will get dementia, supported by a growing genre in film and theatre. Examples include: *Sundowning, Aurora Borealis, Away from Her, The Father, Iris, The Outgoing Tide, The Heath, The Savages*, and *What They Had*. In these films, the characters' lives are being destroyed by dementia and they have no way to stop it. Frequently presented as tragedies, films and plays about dementia often pivot into horror movie territory. Partnering dementia with horror creates uneasiness and fear among both younger and older adults about aging, and the fear of caregivers watching their loved ones disappear. This fear is so real that a 2019 study sponsored by the American Association of Retired Persons (AARP) and the National Institute on Aging found a majority of adults in their fifties and sixties overestimate their risk of developing dementia, undertaking measures to prevent dementia while neglecting efforts to prevent diabetes and heart disease.[7] A 2011 study found that more adults responded they were more afraid of dementia than any other medical condition, including cancer.[8] These narratives support the idea of dementia as an ever-lurking silent enemy waiting to steal away loved ones and their memories. They encourage people to live in fear or worry about dementia. However, worrying about dementia does nothing to prevent it and takes focus away from living life.

Changing Perceptions of Older Adults through Theatre

Seeing aging as frightening and older adults as burdens who cannot participate in society is culturally and politically damaging. The expression, "children are the future," promotes the idea that younger generations have the greatest potential for societal change and change is up to them. While this can be empowering for younger generations, it shifts responsibility for addressing climate change, social security, healthcare, debt, and other issues onto populations in the distant future. Change does not happen only in the future. Change can happen now. Older adults are still here and they can be change agents in society.

While the majority of the media paints a negative image of older adults, this is slowly shifting. Instagrandmas Moon Lin, Baddie Winkle, and Emiko Mori became viral sensations attracting fans all over their world with their bright colored fashion and political activism. MeUndies commercials feature older adults dancing in matching underpants. The iconic Betty White was a working actor until her death at 99 and, according to the Guinness Book of World Records, had the longest TV career by an entertainer.[9] There are a number of films featuring positive and unconventional portrayals of older adults. In *The Straight Story*, an older adult travels cross-country on his ride-on lawnmower after losing his driver's license. The Pixar film *Up* features a man who avoids being put in a retirement home by flying away in his house with balloons. In *Lucky*, the protagonist takes up yoga in his nineties and achieves enlightenment. Near the conclusion of the film Lucky tells a group of people that all the things that seem to matter so much in life eventually go away and you are left with nothing, and that when you are left with nothing "you smile."[10] All of the milestones younger people perceive as important are not as important as being in the now. Other examples include the great uncles in the coming-of-age film *Secondhand Lions*, the *RED* action comedy film series, featuring "Retired, Extremely Dangerous" agents, outsourced retirement ensemble romantic comedy *The Best Exotic Marigold Hotel*, and the Helen Mirren and Ian McKellen con-artist thriller *The Good Liar*.

A more significant reimagining in images of older adults in popular media still waits to be seen. This will likely come as perceptions around aging shift because of the growing older adult populations. However, we do not have to rely on media alone. As theatre educators and practitioners, we can be proactive in changing the culture by taking an active role. Courses for older adults are part of this movement toward creating positive images and experiences.

Theatre for older adults influences society far beyond those taking courses. Theatre helps people acknowledge that the older adults they know can be independently engaged, live their own lives, are capable of gaining new knowledge and skills, can build friendships, are able to have fun, and aren't always having "senior moments." As older adult theatre expands, there will be more visibility, which may change younger adults' perspectives on their own aging process, helping younger people recognize that isolation and loneliness are not inevitable outcomes of aging.

Benefits of Older Adult Theatre Courses

It may not be a coincidence that Wang, the high fashion runway model mentioned earlier, was an actor before becoming a model. Having theatre experience opened up doors for Wang in radio, film, television, and other creative arts.[11] Like Wang,

many older adults can use what they learn in theatre to make a positive change in their own lives.

Benefits for Students

Learning about theatre through a facilitated course adds value to students' lives in a number of areas:

- Students gain facility with staying in the present, practicing to live in and celebrate the now.
- Students have social opportunities that can help with:
 - Reducing loneliness and depression.
 - Developing new skills and generating new ideas.
 - Practicing how to work as part of a group.
 - Challenging themselves by hearing new perspectives.
 - Embracing the joy of imperfection.
 - Gaining flexibility and tolerance.
- Students gain cognitive and health benefits such as:
 - Improving memory and brain function.
 - Improving and maintaining cognition.
 - Physical movement.
- Students improve their communication skills such as:
 - Listening actively.
 - Reconnecting with writing skills.
 - Speech and public speaking.
 - Thinking creatively, analytically, and critically.
- Students improve well-being and quality of life through play by:
 - Having fun.
 - Decreasing stress and anxiety.
 - Making friends.
 - Improving self-esteem and confidence.

Benefits for Instructors

Instructors also gain a significant amount of experience and benefit from teaching older adult theatre. Some of the benefits are:

- Instructors get to have fun. They can play along with their students in exercises or performances, participate in friendly dialogue, and do other lively activities.

- Instructors acquire skills in addressing accessibility and access. For example, using microphones to help people hear.
- Instructors become more precise and clearer in their communication. Students generally speak up when they do not understand what is being communicated.
- Older adult courses also train teachers to modify their expectations and to be adaptable. When something doesn't work out as planned, which is inevitable no matter how much planning is done, instructors must improvise.
- Older adult instructors get to choose how and what they teach. Perhaps because of this flexibility, these courses are fun, fulfilling experiences in which both students and teachers take part in the learning process.
- Theatre educators gain first-hand experience working with diverse populations, discover interests and backgrounds of the subscriber base for most League of Resident Theatres (LORT) in the United States (and of "everyday" people drawn to theatre who are not regular theatregoers), learn about past performances and historical events from people who experienced them, and have the opportunity to workshop their own creative works.
- Teaching older adults equips instructors with an expanded tool kit for engaging, connecting, and transforming students in any environment.
- Teaching older adults may become part of the instructor's own experience of aging.

Benefits for the Community

Older adult theatre adds to communities both directly and indirectly. The impact of these courses can best be seen in:

- Raising perception and awareness that involvement in theatre is for everyone.
- Increasing the publics' awareness of the arts as a whole.
- Creating an intersectional space for absent narratives.
- Reducing gerascophobia by actively including older adults in the community.
- Supporting local theatre companies by creating new audiences and sustaining existing ones.

The benefits of teaching older adult theatre extend far beyond students. Instructors gain skills and communities are impacted by changing the cultural landscape of how older adults are perceived and act in society. Older adult theatre builds lifelong connections that have a positive influence on and bring about change in society, all the while having a good time.

Introduction

Everyone can act. Everyone can improvise. Anyone who wishes to can play in the theater and learn to become "stageworthy."
—Viola Spolin, founder of Theatre Games[1]

Theatre is inclusive and accessible to any individual with a desire to participate. Teaching theatre is also accessible to anyone with a desire to teach. While it can be beneficial to have a strong background in theatre, it is not necessary to teach theatre. What an instructor or facilitator does not know, they can practice alongside their students. Even professionals in the field do not know everything about theatre and there is something for instructors of any background to gain from *Theatre for Lifelong Learning*. Lifelong learning means learning at all life stages and this applies for instructors as well as students. This book can be a springboard for instructors to expand their areas of expertise in theatre. This approach may appear bold and idealistic to some, but the most important thing about theatre is connecting with people. This book demystifies the curriculum development and teaching process for older adult theatre instructors and provides ideas on how to build a connected and positive classroom. It encourages anyone interested in theatre and working with older adults to get involved in the creation of theatre communities.

Theatre for Lifelong Learning presents guidelines vs. strict rules. The objective is not to privilege any specific type of theatre practice over another or promote the methodologies of specific theatre artists, educators, or theorists. The aim of this book is to support instructors in generating ideas and prepare them to be experts in the field of older adult theatre.

How to Use This Book

Theatre for Lifelong Learning takes you through the course development process (Figure I.1). While you might not perform the steps exactly in the order presented,

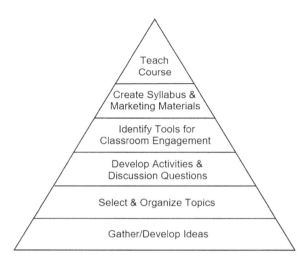

FIGURE I.1: Course Development Process.

you may find it helpful to cover all of these steps throughout your process. Each chapter gives specific examples of how to develop courses based on different subject areas as well as guidance on how to run courses, manage topics, address specific issues, and keep your students engaged. Whenever possible, start at the bottom of the pyramid and ask students for ideas as you develop your courses. Students' interests are essential in course design for older adults and their opinions are just as important as your own. (Do not create courses based on your interests alone!) You may find yourself cycling back and forth between getting feedback and developing ideas throughout a course as you tailor your courses to the interests and needs of your students.

Chapter Overviews

Chapter 1 outlines basic strategies for working with older adults. It addresses how to work with people with different accessibility needs, how to assess learning outcomes, how to moderate discussions, how to manage difficult personalities, and how to create a positive learning environment in any setting.

Chapter 2 explores theatre appreciation, courses that introduce students to the main elements of theatrical production and theatre-going experience by involving students in the creative process, playing games, and going behind the scenes.

Students learn how to be critical and informed audience members. Theatre appreciation also includes learning about theatres of diversity, intersectionality, and canonical dramas.

Chapter 3 on history, theory, and criticism exposes students to theatrical practices from different traditions and perspectives through discussions, games, activities, and site visits. It provides ideas for studying theatre histories through politics, economies, identities, stagecraft, and more. It explores dramatic criticism, the role of the theatre critic, and how to critique theatre. Chapter 3 also offers resources for introducing students to theoretical lenses for analyzing theatre and performance onstage and in everyday life.

Chapter 4 on playwriting, play development (devised theatre), and storytelling welcomes people of all experience levels and backgrounds. It includes writing exercises and improvisational activities that help beginning to advanced writers build confidence, reduce the fears of the inner critic, share their work with others, and provide constructive feedback to their peers. There are individual, partner, and group exercises that challenge students to be present, focus, think creatively, and collaborate on devised theatre pieces. For students and instructors who wish to share their work with an audience, this chapter offers suggestions on how to develop a performance program. If you are looking specifically for writing activities, turn to Playwriting Exercises in Chapter 4.

Chapter 5 focuses on performance. This chapter helps students discover their talents and build upon their individual skills to be part of a communal activity. It includes games, warm-ups, character exercises, and scene work for students of any experience level. Activities come from different performance styles such as improvisation, melodrama, and clowning. There are also tips for instructors to develop their own performance skills as well as suggestions on how they can discover their approach to teaching an acting course. If you are looking specifically for performance activities and warm-ups, jump directly to the Performance Exercises in Chapter 5.

The conclusion discusses the expanding interest in older adult theatre, suggests a call to action by theatre companies, and shares our story.

Using Chapter 2 as a Template

Chapter 2 can be treated as a template for developing and running any theatre course. If you are primarily using Chapters 3, 4, or 5, it is strongly recommended that you also refer to Chapter 2 when you are developing your course. Chapter 2 provides several strategies, such as how to create learning objectives and outcomes, how to write course descriptions, and how to frame discussion questions, which are not included in the other chapters.

Using Sample Syllabi

Sample syllabi are based around a twelve-week structure. They can be expanded or condensed based on available time. Most contain multi-week topical sections that you can extract to use as mini courses. Each syllabus includes a course overview and schedule of topics, activities, and pre- and post-activity discussion questions. The pre- and post-activity discussions establish the "why" behind each activity. The weekly topics are meant to be shared with your students. The detailed discussion questions and suggested activities are for your eyes as the instructor.

Modifying Your Syllabi

Once you begin teaching your class, you may realize what you planned may not be suitable for your students. To keep enrollment up, you may need to change topics and activities, and customize the course for the students. For example, in a theatre history class, students may want three weeks of musical theatre instead of just one. If activities are too difficult for students, they may stop coming to class. Check the activities section of each chapter for ideas on how to modify your syllabi. There are a lot of crossovers within this book and there may be activities in other chapters you can use.

Marketing Your Course

The sample syllabi course descriptions are written as marketing pieces, rather than academic catalogue listings. These course descriptions can be used in part or in whole to (1) propose a course to curriculum committees or activity directors, (2) provide copy for marketing material that may be requested from your institutional partners, and (3) create blurbs for you to market the course on your own on social media and other outlets.

The syllabi descriptions are short and include a general course overview, what topics will be covered, and what activities the students will do in class. These course descriptions are intended to welcome students from a range of experience levels. Students like to know what they are learning and how they will learn it, so be sure to include that in your marketing material.

Gathering Plays and Films

Names of plays and films are provided, but you will need to obtain your own copies. Many of the plays and films we reference are available at the libraries or

online. Build your course based on the plays and/or films available to you. This will save you and your students time and money spent trying to procure obscure materials.

We recommend catering your play and film selections to your audience. If possible, include plays and films that showcase local or regional artists, cultures represented in your classroom, special topics relevant to your students' experiences, and so on. The examples we provide are meant to be a starting point in helping you build your course. The plays and films we have included in this book have been successful with our students across multiple generations and represent a small sample of possible options of material you can include in your theatre courses. We draw from works that are often produced and popular with a range of audiences. Some of the included films, plays, and songs were selected because they are familiar to many of our students. The lists are not meant to be comprehensive. Select plays and films that best suit your course and students.

As you develop your courses, examine recent adaptations and productions. If you are choosing to incorporate plays that are no longer produced or artists who are no longer popular, think about why it is important for you to include them in the course content. Ask yourself, "What value will this material add to your students' understanding of theatre?" Connect the dots for your students and make your reasons for including this material transparent.

It is highly recommended to watch a film or clip in entirety before showing it in class. Students are inquisitive and like knowing the context of plays and films. Be prepared to answer a myriad of questions about the play, production, and/or film or bring notes to which you can refer. Gauge your students' levels of tolerance for profanity, nudity, and violence in course materials.

Selecting Activities

Each chapter provides a range of individual, partner, small group, and full class activities. It is recommended to use a variety of group sizes. Activities also encompass a range of skill and experience levels, from introductory to advanced. Choose activities that suit your students' skill levels and use a mix of easy and advanced activities within a course and throughout the semester. The activities should be difficult enough to challenge them but not to create frustration. The variety of levels prevents learning fatigue and helps sustain interest.

Using Resource Lists

The resource lists include materials that are generally available at public libraries or free online. They include mainstream books written for wide audiences as

well as films and online resources. They are divided into categories of books, play anthologies, television shows, and other media, websites, and in-depth reading.

Each chapter's In-Depth Reading list includes academic resources that may not be readily available at the public library but may be available at colleges and universities. Some college and university libraries offer community borrower library cards. You may contact your local college to find out. Some of these resources may include academic jargon, which may require more dedicated time to read as they are not written for general readership. It is recommended to use this section after you have read a few of the mainstream texts.

Mixing and Matching Topics, and Using Cross-References

Elements from the four broad subject areas of theatre appreciation, theatre history/theory/criticism, playwriting/play development/storytelling, and performance in *Theatre for Lifelong Learning* cross-pollinate as do ideas for designing and running classes. The chapters are organized by the overarching topics, but that does not mean you must teach your courses within siloed categories. When teaching any theatre course, you will find yourself naturally drawing from multiple facets of theatre.

The course topics and activities are meant to be mixed and matched. For example, if you are interested in designing a course that uses improvisation techniques and freewriting activities to devise a new musical based on current events, combine elements from Chapters 3, 4, and 5. Or combine playwriting and dramatic criticism or history and improvisation. Ideas from different courses can be combined and repurposed as needed. Most of the sample syllabi have three- to four-week topical units that can be transformed into new courses to meet your students' interests. Feel free to blend as you see fit. The options are limitless.

Special Features

Theatre for Lifelong Learning includes several features that will help you create and manage a successful course:
- *How Do I Put Together a Course?* helps instructors create a class from the ground up. It provides concrete examples of course material, ways for instructors to brainstorm their own ideas, and how to structure the class to meet the needs of both the instructor/facilitator and student.
- *Key Terms* provides instructors with the language of the field.

- *What Activities and Discussions Can I Do?* provides engaging methods for an instructor to teach the course. It helps instructors deemphasize lecture-based learning and uses a variety of activities to stimulate critical thinking, creativity, and social interaction with students.
- *How to Engage with Students and Create an Active Classroom* (Chapter 1) offers instructors resources to promote active learning from new perspectives and reengagement with course material.
- *How to Manage Different Personalities* (Chapter 1) should always be at instructors' fingertips to keep a course running smoothly, address digressions and controversial topics, and promote a supportive and collaborative classroom environment.
- *Course Evaluations* (Chapter 1) helps instructors gather information to modify curricula and course expectations in direct response to student feedback while a class is running, leading to an improved course experience.

The Lifelong Learning Theatre Instructor

Theatre for Lifelong Learning is for anyone interested in teaching theatre to older adults. Independent theatre instructors, including those directly involved with senior centers and care facilities, health organizations, public and community arts organizations, regional theatres, and nonprofit organizations working with seniors, can use *Theatre for Lifelong Learning* when implementing best practices for working with older adults and developing curricula.

Older adults wishing to organize their own courses and theatrical communities will also be able to use this book. This includes programming hosted by older adult networks and programs, community-based play development groups and theatre/community partnerships, events hosted by advocacy organizations like the Gray Panthers and SAGE (Services & Advocacy for GLBT Elders), informal learning groups (i.e., book clubs, meetups, discussion groups, and writing groups), and enterprising individuals.

Academics, from graduate students to emeriti, involved in higher education settings or lifelong learning programs may find this book helpful. It introduces academics to teaching as a facilitator-centered role vs. a traditional lecture-focused teaching role, emphasizing student interaction, shared experiences, and building friendships among peers.

Artists and theatre professionals, who may be experts in some, but not all, aspects of theatre, can use *Theatre for Lifelong Learning* to integrate what they know to create engaging courses. It also fills in knowledge gaps on historical, theoretical, and other topics with which artists and theatre professionals may be less familiar or actively engaged in their everyday practice.

Interdisciplinary Arts Perspectives

All artists have something to bring to the table should they be inclined to take on the role of older adult theatre instructor. Theatre is an inherently interdisciplinary and collaborative art form that brings together multiple means of expression.

- Instructors with a dance background can easily transition to teaching any movement or physical theatre course (especially non-Western forms and experimental forms), dance choreography, Broadway musical theatre, and even puppetry.
- Visual artists can teach students to explore thematic elements of art through theatre, helping them develop their knowledge of design and interpretation of design, and also explore theatrical movements that connect directly to other arts movements, such as expressionism and surrealism.
- Instructors with a background in English, literature, poetry, creative writing, journalism, or other writing arts can help students learn how to analyze dramatic texts, criticism, dramaturgy, and history. With a strong foundation in writing, these instructors are also equipped to help students learn how to write their own creative or critical analysis of theatre.
- Filmmakers and others with a background in film and digital media may teach courses exploring theatre as film, textual adaptation, theatre history through digital media, and history of theatrical technology as well as theatrical lighting and sound design.
- Musicians can teach courses that touch on the interconnection of theatre and music throughout history and around the world. This may include anything from gamelan for *wayang kulit* puppet theatre to opera to Broadway musicals. Students enjoy performing, and observing performances of, theatre music as well.
- Artists involved in crafts such as woodworking, sewing, and textile arts can use their expertise to teach courses on scenic design, puppetry, costumes, set and prop design, curtains, and masks. Their practical experience can help turn any theatre course into a workshop where students can try their hand at making crafts for theatre.

These are just a handful of examples of how artists with different backgrounds will be able to use their own skill sets to provide fresh perspectives on theatre while expanding their own perspectives. Theatre thrives when other artists join in the creative process, expanding mutual learning across disciplines and strengthening artistic communities.

INTRODUCTION

How to Organize a Group-Led Course

This book can be used by older adults interested in running and enhancing their own theatre programs. If you are new to working as a group, we recommend addressing the following:

1. How well does your group collaborate? What do you have in common? How does your group advocate to make sure needs are being met? What are your strengths and weaknesses? How well can the group work with different ideas? Are there any guidelines that need to be established in order to successfully work together? *We strongly suggest figuring some of this out before starting work on a course. A fun way to do this is by trying some of the beginning warm-ups in Performance Exercises in Chapter 5. You will quickly see how you function together as a group.*
2. How formal do you want this course to be?
3. What level of commitment does the group want from its participants?
4. How often will the group meet?
5. What roles are available and what are the expectations for each role? *For example, will the group form programming committees to manage space usage, teaching resources, funding, marketing, and outreach, or will there be individual roles for these responsibilities?*
6. If programming committees will be developed, how often will the committees meet and how often will they report to each other?
7. How will the course be run? Is this going to be an individually led course or a group-led course?
 - If it is a group-led course, do you need a coordinator? If not, how will you make decisions? By voting? By flipping a coin? Random drawing? By committee?
 - If it is individually led, how much work does the individual do? What are the expectations? Are they the moderator? Or are they expected to do additional work beyond what the other group members do?
8. How often will the course meet?
9. What is the maximum or minimum number of students for the course?
10. How will you discern the needs, wants, and interests of your community? Are people interested in something more history and appreciation-based?
11. How will you solicit feedback from residents or people in your community? By survey? Word of mouth? Meetings?

Our Approach to Theatre for Lifelong Learning

Our approach is to increase the types of theatre courses offered to older adults by preparing instructors on how to teach acting and beyond. Some of the topics covered in the sample courses include Going to the Theatre, Backstage: Elements of Theatrical Production, Theatre as Film, The Art of Playwriting, Theorizing Theatre, Musical Theatre History, Theatre History: A Hands-On Experience, "Serious" Acting: Acting Methods and Games, Theatre Production Workshop, and Theatre Improvisation for Everyone. These courses reflect typical offerings found in college theatre programs across the USA. Providing older adults with courses beyond performance is significant for two main reasons: (1) not everyone likes performing or acting, and (2) other types of theatre courses can be active and engage older adults.

For many people, public speaking and any other type of activity involving being in front of an audience is anxiety-producing. An emphasis on performance can discourage older adults from taking advantage of the benefits of theatre. However, if a student starts with a nonperformance course such as Going to the Theatre, they may enjoy the experience and decide to give improvisational theatre or acting a try. Many students do not realize that "acting" is not all about being a "star" or memorizing dialogue, and performance involves a lot of fun games. Courses on theatre appreciation, history, criticism, and theory emphasize that it is not necessary for someone to ever become an actor or take a performance-based course to become an involved member of a theatre community.

All theatre courses can be active. Instructors can incorporate games, discussions, writing, and other activities to turn courses traditionally seen as lectures into engaging classes, no matter the content. Offering students a wide range of theatre courses may help students discover new opportunities for learning, socializing, and connecting with the present.

Active Learning

A key aspect of older adult education is that courses are focused on developing a space for older adults to engage in discussions and activities. Existing older adult programs at colleges are also structured this way, such as Santa Rosa Junior College which has no lectures and instead offers discussion groups. Within these discussion groups, there are a variety of subjects including LGBTQIA+ history, A Sonoma County Timeline, Ageing Gayfully, and Exploration of World Travel. Older adult courses at other colleges echo this format. Santiago Canyon College offers Creative Cooking for Older Adults, Famous People and Places, and Staying Mentally Sharp. Orange County Continuing Education offers Mature Drivers and Quilting for Older Adults. The University of Massachusetts Lowell's Learning in

Retirement Association (UML LIRA) offers Laughing on the Outside and Crying on the Inside, and How to Read and Understand Shakespeare. All courses are focused on being active versus passive, and *Theatre for Lifelong Learning* helps instructors construct similarly active courses. There are no lecture notes outlined in each chapter for instructors. Instead, there are topical discussion points, hands-on exercises, and other experiential learning activities.

Play Selection

Encouraging students to see productions of plays that they study is an important part of our approach. Throughout *Theatre for Lifelong Learning*, readers will see examples of works that may not be considered "great" theatre in addition to famous works of world theatre and the Western theatrical canon. Some of these works are included because they are frequently produced and students may be able to see them at local theatres. We also include "commercial" plays (which may be seen as "commercial" vs. "artistic" by academics.) For example, sample courses in Chapter 3 explore Broadway hits and community and school theatre staples that aren't critically acclaimed but are very popular. Many of the plays that are part of the canon, such as *Macbeth* and *A Streetcar Named Desire*, are used to illustrate historical and theoretical perspectives as well as performance and staging techniques.

Theatre and Theatre Therapy

Older adults taking theatre courses may find the courses therapeutic, but the purpose of *Theatre for Lifelong Learning* is to learn about theatre and to have fun in the present. This book is not intended to treat or diagnose any psychological condition.

While there are many therapeutic theatre practices such as playback theatre, drama therapy, creative care, psychodrama, bibliotherapy, and so on that medical professionals use to work with older adults, *Theatre for Lifelong Learning* does not cover these techniques. Some of these practices have been used to help older adults navigate personal histories, living with dementia, and improving emotional well-being. We strongly recommend readers complete professional training if they are interested in becoming certified in creative care.[2]

Memory, New Experiences, and Brain Health

Theatre for Lifelong Learning is focused on helping older adults be present, learn new skills, and be involved in activities and discussions that challenge their minds. Reminiscence, or the process of recalling memories, is a common practice in therapeutic theatre and older adult classes in general. For a comprehensive overview

of the field of reminiscence theatre, its practitioners, and information on how to engage reminiscence theatre in practice, see *Reminiscence Theatre: Making Theatre from Memories*. While there may be discussions and exercises that draw from memory, reminiscence is not the goal or purpose of this book. *Theatre for Lifelong Learning* instead uses recollection to create something new, hear new perspectives, and think critically.

Theatre for Lifelong Learning emphasizes new experiences because of the opportunities they create for improving brain health. In a study by psychological researcher Denise Park, founder of the Aging Mind Lab at the University of Texas at Dallas, she found that new activities offer more benefits to brain health than familiar ones. After observing the participants over three months she noted, "It seems it is not enough just to get out and do something—it is important to get out and do something that is unfamiliar and mentally challenging" and speculated, "What if challenging mental activity slows the rate at which the brain ages? Every year that you save could be an added year of high quality life and independence."[3] Doctors Ipsit Vahia at McLean Hospital and Anne Fabiny of Harvard Medical School also tout the benefits of focusing on the "new" to improve brain function. Vahia says, "classes offer a complexity factor that have long-term benefits."[4] Fabiny recommends, "Be open to new experiences that cause you to see the world and do things differently."[5] She suggests four strategies for maintaining brain health as we age: lifelong learning, practice challenging tasks, get uncomfortable and explore the unfamiliar, and be social. *Theatre for Lifelong Learning* promotes all of these practices and encourages participants to be social, be challenged, and explore the unfamiliar.

Prioritizing Friendships

Finally, *Theatre for Lifelong Learning* acknowledges that courses for older adults have a different social aspect to them than "typical" college courses. Older adults may attend courses specifically to make new friends. The structure of courses provides room for students to work together while getting to know one another.

Two longitudinal research studies sponsored by the National Institute on Aging found that for older adults having friends and maintaining close friendships has a more significant impact on health and well-being than ties to family. According to a *Time* article, "Why Friends May Be More Important Than Family," William Chopik's studies emphasize that family relationships involve obligation and caregiving, whereas nonfamilial friendships are more beneficial because they are free of those things.[6] In "Friendship in Later Life: A Research Agenda," the authors cite copious research that points to the benefits of older adult friendships, including "provid[ing] companionship through mutual interests

and shared activities."[7] They also included a study from 2004 examining friendships formed by older adults through common activities like crafting, and one from 2017 that states older adults continue to make new friends when they connect with new people.[8]

Developing courses focused on helping students create friendships may seem like an unconventional approach to teaching, but for older adults these relationships are important in contributing to overall well-being. *Theatre for Lifelong Learning* supports this practice by prioritizing building supportive social environments that encourage connection in a sometimes disconnected period of life.

Inclusivity and Play for Older Adult Theatre

How is working with older adults different than working with other students? In some ways teaching older adults is no different than teaching any student. The objective is the same: for students to learn something new. On the other hand, teaching older adults is completely different than teaching secondary school or higher education. Unlike secondary school, compulsory education, or credited courses in higher education, older adults are taking classes for enjoyment in whatever form it may come. Enjoyment can develop from being social, taking part in discussions, playing improvisational games, sharing stories, and more. That means teaching older adults must first and foremost be engaging to the students. A second important defining feature of teaching older adults is that the students' personal experiences must be taken into account. Older adult students have a wealth of knowledge and are not starting from scratch. Much of an instructor's focus is on helping students make connections between disparate things.

For instructors wishing to apply existing pedagogic models to their teaching, there are a number of frameworks that they can draw from. Most directly related approaches to older adult theatre may be older adult learning, inclusive pedagogy, and play pedagogy. Each instructor's approach is informed by their own background, personality, and goals for the course, as well as their students' backgrounds, personalities, and goals. *Theatre for Lifelong Learning* does not prescribe any one pedagogic model and instead offers these approaches as a starting point for instructors to contemplate when developing their courses and concepts for learning.

Older Adult Learning Models

Lifelong learning and geragogy are two interrelated fields that address older adult education. Geragogy argues that older adult learning is distinct from childhood or

adult learning. As noted by Marvin Formosa, geragogy is not a "comprehensive educational theory for older adults" and is more about "an awareness of and sensitivity towards gerontological issues."[9] Researches from diverse fields, including Psychology, Adult Education, Gerontology, Philosophy, and Sociology, have independently developed their own models of older adult learning and employ different names to describe it.[10] Some strategies and models include empowering older adults, preparing older adults for aging, changing the ageist landscape through political activism, treating learners as unique individuals, setting personal goals, self-actualization, learners as people with experience, learning as a collective activity, social inclusion, peer teaching, expressive learning, reminiscence learning, and online learning.[11] Critics have pointed out that there is a lack of common language and agreed paradigm in geragogy.[12] This ambiguity invites instructors and students interested in older adult education to take part in the development of geragogy.

In contrast to geragogy, the approach that lifelong learning takes widens pedagogy. Lifelong learning's broadest definition includes learning at any stage of life. However, the development of lifelong learning institutes in the USA popularized lifelong learning to be targeted for people in retirement.[13] While many lifelong learning programs are marketed for older adult students, most programs do not have an age minimum and all are welcome to join. Many of the programs are affiliated with colleges and courses can be led by hired instructors, existing college faculty, retired professors, community members, or students. As such, the approaches to lifelong learning are often inclusive of diverse learners.

Many lifelong learning institutes in the USA function independently from one another and adopt different strategies to suit the needs of their demographics. One organization is Road Scholar that creates experiential learning activities. Their mission is "to inspire adults to learn, discover and travel" and "stimulate discourse and friendship among people for whom learning is the journey of a lifetime."[14] At the Osher Lifelong Institute (OLLI) at Tufts University, they "strive to create an environment where both the members and the study group leader learn and explore together."[15] At California State University, Long Beach, their OLLI program "provides educational opportunities, encourages an active lifestyle, and promotes social opportunities for older adults."[16] And at the UML LIRA, the focus is on creating an environment "where everyone feels welcomed, accepted, and able to speak up, share insights, and provide value to our organization regardless of culture, ethnicity, sex, gender identity, color, beliefs, or ability."[17]

While these examples show a variety of approaches to lifelong learning, they all value social interaction. Working together, sharing perspectives, and building friendships are all common parts of lifelong learning institutes.

INTRODUCTION

Inclusive Pedagogy

As noted in the LIRA program above, welcoming everyone regardless of their background is an important part of older adult education. Older adult students are diverse, and it is often difficult for instructors to predict what their classroom demographics will be.[18] Inclusive pedagogy prioritizes these differences and calls for instructors to create classrooms that support every student.

Inclusive education was developed in the 1980s with a focus on disabilities and education, emerging in response to the growing disability rights movement. Today, inclusive pedagogy has expanded to mean inclusive of race, gender, and more. It has been adopted by many educational institutions and will continue to expand in the coming years. As described by Kevin Gannon in "The Case for Inclusive Education," inclusive pedagogy is "a mind-set, a teaching-and-learning worldview, more than a discrete set of techniques."[19] Yale University suggests teachers consider the following questions:

> Why do some types of students seem to participate more frequently and learn more easily than others? How might cultural assumptions influence interaction with students? How might student identities, ideologies, and backgrounds influence their level of engagement? Finally, how might course and teaching redesign encourage full participation and provide accessibility to all types of students?[20]

Inclusive pedagogy necessitates a commitment by instructors to learn about their students and incorporate students' perspectives and experiences in classroom and course design.

While it is up to each instructor to evaluate how they can be inclusive in their approach to education, universal design has helped instructors create more accessible learning environments. Many institutions that use inclusive pedagogy apply universal design to develop accessible classrooms. That means making sure that students get course materials in different formats (such as audio and closed captions, screen reader–compliant text, clear large font copies) and provide a variety of methods for students to engage and express themselves (such as individual writing assignments, talking group discussions, doing a performance, creating artwork). Inclusive pedagogy and universal design do not require everyone to use what is available in the same way, but they do make it possible for everyone to participate fully.[21]

Play Pedagogy

Play, and specifically theatre play, whether through dramatization or interactive games, has proven to be a useful tool in many aspects of learning. One example

is Gunilla Lundqvist's Playworlds, which are the dramatization of literature into immersive learning experiences with children.[22] Another example is the Kalgoorlie Primary School in Western Australia, where students practice collaboration and communication through puppetry, play, and interactive arts projects, while also learning the role of media in culture and interpersonal connection.[23] Finally, the Play Pedagogy Project at Harvard University works with Project Zero and the LEGO Foundation to develop ongoing research in the field. They outline the main components of pedagogy of play (PoP) as creating a space for choice, wonder, and delight.[24]

Without play, theatre could not exist. In the groundbreaking works of Viola Spolin, Augusto Boal, Richard Schechner, and others, artists have used play as an integral part of theatre. Drawing from Neva Boyd's work on children's games, Spolin created theatre games that are now the foundation for many acting training practices in the USA and beyond. Theatre games are used to help actors be present, perform spontaneously, and connect with others. Boal used play to encourage everyday audiences to become participants in theatre and be civically engaged. In Boal's theatre, performers and spectators play together to address social issues. Schechner's work explored play and performance in everyday life as part of developing the field of performance studies. He and others broadened the understanding of theatre in "nontraditional" areas such as work, school, relationships, politics, and so on. Schechner situated play as a natural process that is not only present in many parts of our lives but also provides a means of subverting power structures and is a necessary part of human connection.[25] From theatre stages to public and everyday stages, play helps people have fun, connect, collaborate, develop ideas, make positive changes in society, challenge themselves and each other to broaden their perspectives, and gain new knowledge. Applying play to older adult theatre courses, whether performance-based or not, can enliven the learning experience for students.

No matter what approach an instructor decides to take, the most important practice is to adapt to change. Instructors will likely need to draw from multiple approaches when teaching because the older adult classroom is ever evolving. While instructors cannot predict everything that will happen in their courses, they can heed the improvisational philosophy of "Yes, and …."

Where Do I Begin?

Teaching a new course can be intimidating. Some of you may also be new to teaching older adults. It is not an easy task but is rewarding if you stick with it. If you are feeling overwhelmed and have no idea of where to start, we recommend

looking through the activities and resources first. Check the activities sections and learn new trivia, famous figures in theatre, and popular show tunes. Then pick something you find interesting and see what you can learn about it. Review the course subjects first and leave Chapter 1 to review at the end.

Teaching older adults is unlike teaching any other population. There are constant changes and many ups and downs. Each class will be different from the last. What we have compiled from our book is not necessarily what happens in our typical classes. We would love to boast that we practice what we preach and that we do it well each time, but the reality is that we have made countless mistakes! These mistakes have helped us grow as instructors and as people. This book is an ideal for which we strive and each class brings different challenges and opportunities to practice, learn, and connect. Here are some of the biggest mistakes we have made while teaching older adults:

- *Not checking resources in advance.* For a course on film adaptations of famous novels, I discovered after the class started that there wasn't a practical way to get copies of the novels to the students. I ended up having to spend a significant portion of each week dedicated to summarizing each novel's plot points before screening the adaptation so that we could discuss how they differed.
- *Spending too much time checking for resources in advance.* It is easy to get "lost in the links" and gather hundreds of articles and plays to share with students, check out every single book in the library on a specific topic, meticulously write out lecture notes, and obsess about what to include on the weekly schedule. I did this for my first two classes (not having learned my lesson the first time) and put in many late-night hours for it to all go out the window once class started.
- *Not taking into account the differences in accessibility.* Many of the students needed help hearing, which often meant turning up the volume on media, using microphones, and speaking loudly. However, there were also students who had sensitive hearing and lower volumes were preferred. I learned that when one student came up to me after class and told me that the video hurt her ears.
- *Not realizing that students may have hidden disabilities.* A cofacilitator and I had designed a public history course around site visits and field excursions and spent the first four weeks of classes preparing to make an underground trip. On the day of the trip, one of the students let us know that they needed a wheelchair to travel outside of the retirement community and the site we were visiting was not accessible, lacking ramps and elevators. We adapted the trip on the fly to visit theatres that were accessible, calling them while we were on the road. It was exciting, and in the end, we had a successful trip that the students enjoyed, but it was very *very* stressful.

- *Not spending time managing difficult personalities in the class or spending too much class time managing difficult personalities.* In almost every class, there are difficult personalities. One time, all of the other students dropped the class because there was an unpleasant student. By the time I realized that I should have spoken to the student individually about how to appropriately pivot class discussions, it was too late. The last two weeks of the course ended up being a one-on-one discussion between the two of us.

Perhaps the best advice we can offer is learning how to manage your own expectations for yourself and your students. Show your students that it is okay to make mistakes and we can all learn and grow from them. This will encourage them to participate and try things that are unfamiliar. Find out how you work best without overextending yourself or feeling stressed. Do your homework and know your limits. Remember, if you are having fun, your students are likely having fun. Your students are there because they have at least a passing interest in theatre. They want you to succeed and they want the course to be a valuable use of their time. Students want to have a good time learning with you. That is the core of theatre for lifelong learning.

1

Collaborating with Older Adults[1]

I came into the classroom and I saw a bunch of older adults who were really excited to be there and they were absolutely determined to learn [...] They didn't have to be there. They chose to be there.
 —Irina Yakubovskaya, Theatre Artist and Educator[2]

Older adults may be your least homogeneous student population. They come from a wide variety of backgrounds, have lived in and traveled to different parts of the world, and have experiences that are unique—all of which add value and richness to courses and create a sense of interconnectedness among students. You may have an age range of 30 to 40 years, from students in their 50s to students in their 90s, and you should plan accordingly to accommodate their diverse needs and interests.

How do you adjust your mindset to work with older adults? While you are bringing your own experiences and technical skills to your teaching, your goal is not assessing their competency or mastery of skills. You are there to provide information and exercises, facilitate discussions, and coordinate their experiences. You may be the expert in the room, but your perspectives on the material are no more valid than those of your students. Expect many tangents and enjoy the discussions and possibilities that come out of your digressions. As long as your students are engaged, you are doing your job.

Another helpful way to think about teaching older adults is to see yourself as the group facilitator. Socializing with others may be the highest priority for many students. Students may have different ideas of how they want to socialize with each other and it is your job to manage their expectations and attitudes to create a positive environment.

Teaching older adults carries a unique set of challenges and rewards, from instantaneous feedback to discussions of diversity and accessibility. You will be learning just as much as the students are. This is an opportunity for you to expand your own knowledge and experience by making connections and interacting with people from different generations.

What Are the Challenges?

The biggest challenge you will face is that student attendance may not be consistent. Students may miss sessions or stop showing up altogether for a variety of reasons, often unrelated to your teaching style. Some of the reasons could include: transportation difficulties, social obligations, caring for others, and health reasons (being injured, illness, or, in some circumstances, having passed away). Courses are often competing against time with family, friends, vacations, and other activities. Inconsistent attendance will affect your course structure, especially for performance or play development topics where skills are built upon each week. You may need to incorporate more recaps and revisit exercises to give students who miss class an opportunity to learn the material, while keeping the course interesting for students who have attended every session.

If teaching at a library or other public venue vs. a senior facility, instructors may be responsible for addressing medical emergencies and may have to help a student with a health issue. While you may not be a medical professional, at a minimum, you will need to be ready to assist students in a way that is sensitive to their situations. Some students are uncomfortable with realities of aging and do not want their health issues on display. They may be discouraged from returning to your course after a health issue if they do not feel emotionally safe to do so.

Moreover, space and accessibility are not consistent. Instructors may use a multiuse room that is not specifically designed as a classroom; the space may not be equipped with a technology for learning or include desks. Instructors may need to arrange tables and chairs at the beginning of class for students.

You cannot control the venue and you cannot control your students' obligations outside of your course, but you can create a lively classroom atmosphere in which students enjoy taking part. Students immediately stop attending if they are not engaged. Students are vocal in expressing their opinions and will let instructors know when there is something they do not like about the course. The best way to use your energy is to focus on interacting with students as much as possible so that they will participate in the course in a positive way.

Suggested Best Practices

How to Engage with Students and Create an Active Classroom

A classroom centered on active learning is key to success in any older adult classroom. The diverse demographics require instructors to create an inclusive classroom environment. At the beginning of the course:

1. *Tell students that you are interested in helping them learn.* Yes, say it out loud! It sets the tone for a positive learning experience.
2. *Find out why students are taking the class.* The theatre history and practice course Burlesque in Boston had a population of eleven women and one man, a retired engineer who had frequented Boston's Old Howard Casino Theatre and informed the class on the first day that he was only there to see what kind of women would sign up for a class about strippers. (**Answer:** two sex therapists, two psychiatric social workers, an English professor, three teachers, a reference librarian, a poet, and an expert on Anthony Comstock.)
3. *Assess what students already know and have experience with.* You may have students who are retired professors or professionals in your field. In Playwriting, a student had written and produced an award-winning documentary, another was adapting a novella into a play, and a third was writing political skits for video production. The remaining students had no experience writing plays and learned both from the instructor and their peers.
4. *Assess student interest.* Poll the students to learn which gaps in curriculum they would like filled, and design courses based around student wants. Create something that will be entertaining, elucidating, and engaging that address topics your student population is receptive to such as gender identity, ethnicity, politics, substance abuse, or equality. At Tufts OLLI, students noticed a dearth of courses that appealed to women and requested a course shaped around close readings of the *Femmes Fatales: Women Write Pulp* novel reissues and screenings of the films adapted from these texts.
5. *Revise your course content based on 2, 3, and 4 above.* Create syllabi with specific readings and assignments. After doing 2, 3, and 4, rearrange the course content, create new assignments, and add or change readings to meet these needs. You do not have to start from scratch. Often your syllabus only requires minor reframing and reorganizing to incorporate students' needs.
6. *Be prepared to revise your content on the fly.* Sometimes you will have no technology in your classroom and you will not find out until the last minute. Always have a couple of analog options (hard copies of scripts, casting activities, etc.) if you end up needing to "teach naked."

Throughout the course,

1. *Encourage participation.* In Theatre Improvisation, I tell students, "We will all make mistakes," and "It is part of the learning experience." To help students feel okay about failing, I have them "celebrate" their mistakes by taking a bow or cheering. If students do not want to participate, do not force them.

2. *Assess student learning and solicit feedback several times throughout the course (both formally and informally.)* Check in with your students often. Find out if they want to start, stop, or keep going on a topic or an activity. This is especially important if you think students are having trouble following a topic or an activity. Using start, stop, or keep going questions helps you decide as a class whether to pivot to a new topic/activity or go more in depth.

 After completing a reading or writing exercise in Playwriting, I ask students how difficult the assignment was, what they learned, and how much enjoyment they got from it. At the end of the course, I ask students for teaching evaluations even though it is not required by my program. It is important to get verbal *and* written feedback because students may not feel comfortable doing one or the other.
3. *Do fewer lectures and more discussions.* One of the most important things that theatre students learn is "Show, don't tell." This applies to teaching as well. Students read and discuss *An Inspector Calls* and *Still Stands the House* to learn about well-made plays and problem plays, rather than reading *about* the genres.

 If you are sharing a slideshow, use slides for key points and visuals only. Do not include your entire lecture and read the notes directly off of your slides. Slides are most effective when used to *support* your talks and discussions, not when they are used as teleprompters.
4. *Ask questions, instead of giving answers.* Students are asked to recount and reflect on what happened in improvisational exercises. For one mirror exercise, participants are asked, "Were you able to follow the leader? If not, why was it difficult? And what did the leader do to help their partner?"
5. *When students ask you a question, let other students try to answer first. Most of the time they will figure it out. Sometimes there is no "right" answer anyway.* A student once asked, "How do we get good at these improv exercises?" After a short discussion, one student declared, "Practice!"
6. *Include variety—within a class, provide students different activities/discussions, not just one.* In a public history course on urban renewal in Boston, we toured remnants of Scollay Square and the Combat Zone and visited photo morgues to view pictures of police raids and infrared camera footage. Students also shared their own, sometimes quite painful, stories of the destruction of Boston's West End, desegregation busing riots, the Cocoanut Grove Nightclub Fire, and being pushed from their homes due to gentrification.
7. *Practice experiential learning when possible.* Burlesque in Boston was held in a glass-walled aerobics studio, which was especially enjoyable during the weeks when Vanessa "Sugar Dish" White came to class. Students in the other courses on the same floor would crowd around the windows—a woman

stripping out of a Raggedy Ann costume and twirling tassels is evidently much more interesting than talking about the transcendentalist movement at 10:30 in the morning.

8. *Incorporate multiple art forms.* Draw from different arts to enrich your theatre course and get maximum benefits of activities. Multitasking challenges the brain and helps students with brain and body connection. For example, puppetry requires physically manipulating the puppet while vocalizing its character. It also helps students explore character, voice, movement, and work as an ensemble, all of which helps improve cognitive function.

9. *Encourage students to think critically.* Whenever we read a play, I ask students to share their general reactions. Following that, I give them specific questions to discuss. For example, after reading *Orphan of Chao* and *The Sound of a Voice*, I ask them to compare the two plays and consider how women were portrayed in the works. I ask, "Is it significant that both plays have female characters who die by suicide?"

10. *Help students make connections between disparate things.* Students already have a strong foundation of knowledge in many different areas. Reframing ideas in ways that connect to your students' experiences can help them see the same thing in a new way and deepen their appreciation of their own knowledge and experience. In other words, help them find relatable content in the course material.

 In History of Theatre, students shared their own Depression Era experiences, such as having to relocate from New Jersey to New York to find jobs, attending Yiddish Theatre shows, and seeing bread lines. We discussed the statistics of unemployment and the reasons why that was not representative of their own recollection of the period. (Students felt that much more poverty and unemployment during that era than what the numbers stated.)

 In a discussion of wartime musical theatre and popular entertainment, ranging from the First World War music hall to Vietnam, one Second World War veteran shared the memory of watching Marlene Dietrich play a musical saw the night before he and his best friend left for the Battle of the Bulge. His best friend had been killed and that discussion was the first time he told anyone about that experience.

11. *Admit when you do not know something.* If you do not know something, offer to research the subject and get back to them with information. However, if the inquiry is entirely outside the realm of your class, say that it is beyond the scope.

12. *Remind students that everyone is learning.* Everyone makes mistakes, everyone has something to share, and everyone has something to learn, no matter their education or experience. Encourage students to come to class

with a beginner's mindset throughout the course, not just on the first day. This is beneficial for you, too!

13. *Do most, if not all, assignments or readings in class.* I gave short homework assignments such as viewing a two-minute video clip. Even though the assignments were very short, not everyone completed the homework. To ensure that everyone participates, all activities should be done in class. That way, no student will feel excluded or behind because they did not do the homework.

14. *Have students work together as a whole, in groups, and in partners.* Students think differently when they interact in groups and in partners. This also helps people who do not normally speak up in class discussion to share their ideas with others. In History of Theatre, I divided the class into groups to discuss the following: "Should the government directly support the arts? What are the advantages and disadvantages of different types of patronage models?" After their group discussions, each group shared their findings with the entire class. They were all able to have in-depth conversations that opened up new ways for students to think about the topic.

 Whether your students are working on discussions or activities, be sure to support your students by checking in with each group to make sure they understand what they need to discuss or what they need to do for an activity. If there is confusion about what the discussion or activity is, do not be afraid of using a time-out to clarify instructions.

15. *Have patience.* Students may not understand the purpose of a discussion or activity the first time you explain it to them. If students do not understand what you are asking of them, rephrase the question. If they do not understand an activity, reframe it by breaking it down further into smaller steps.

16. *Provide many examples and provide demonstrations.* Examples for discussion help students brainstorm while maintaining focus and staying on track. Many performance activities will be easier to understand and do if you give your students an example. Show vs. telling them what to do. Relying solely on verbal instructions can be confusing for performance activities and even some discussions. For example, it is easier to show students that Balancing Circle involves walking around a chair mirroring a partner than to explain.

17. *Have fun.* We cannot emphasize this enough. Students can tell if you aren't enjoying yourself so it is essential that you are having fun. Be aware of your tone, body language, facial expressions, and the mood you are striking in the classroom. Students intuit a lot and will react in kind. When you are excited about a topic, students will be more inclined to participate. Sometimes I will screen adaptations that I think are terrible that spark discussions and encourage low-stakes debate, which can generate a sense of fun. Occasionally

students are in unanimous agreement and will ask me, "Why did you make us watch that?" This usually turns into a lively discussion of why they disliked a particular interpretation of a play (i.e., performers using an overwrought "Shakespearean voices" because they're a*cting*).

How to Manage Different Personalities

Students like to know what to expect and understand how they will be participating.

1. *Set clear expectations for both the course and classroom interactions on the first day of class and throughout the term.*
 - Review the course content in detail including weekly topics. They may choose to attend some and not all of the classes depending on the week's topic.
 - Review class etiquette:
 - Describe guidelines on who gets to talk and when.
 - Discuss what respect means, what that might mean for each person, and how to show respect to each other and maintain a supportive environment for everyone while sharing a diversity of opinions.
2. *Remind the students during the course to share the space and be respectful to others.* You may have to do this over and over again even though you have already explained this on the first day. Sometimes, despite good intentions, a course will fail. I began one term with 30 students and ended with five because several outspoken residents landed together in the same course and none had wanted to surrender the floor.
3. *Let students talk.* In Women Write Pulp, one student brought up her postcollege experiences living in Greenwich Village's lesbian community. Over the course of the semester we discussed single parenting, Helen Gurley Brown's *Sex and the Single Girl* (dating married men came up frequently), being forced by societal pressures to give children up for adoption, living alone, and creating communities. Students expressed that this was the first time they were able to share these experiences with others.
4. *For students who talk a lot, pick on someone else before getting back to them.*
 - Always try to link students' comments back to class discussion to regain focus of discussion, or
 - Ask students who talk a lot to link their interjections back to the class discussion.

 After reading *Los Vendidos*, a play about Latinx stereotypes, a student recalled that he once dated a Latina many years ago in Colorado. I asked,

"How did that influence your opinion about Latinx?" He responded that he noticed that Latinx were seen differently in California and that it probably had to do with the fact that there were more migrant workers in California than in Colorado. We went on to discuss the problems with stereotypes and racism in the USA.

Sometimes an interjection will be completely unrelated and cannot be linked to the class discussion. For example, in the middle of a discussion of *Fences*, a student raised his hand and said, "There's a snapping turtle that lives in the lake by my house. I call him 'Big Butch'." Everyone in the class turned and stared. I asked, "How does that relate to the Maxson family?" He shrugged and then we went back to discussing the play.

5. *Allow students to monitor each other*. As long as they are on task, let them help their classmates regain focus. In Film Noir a student began responding to *The Killing* by saying that it was very similar to his past career experiences. A fellow student told him to stop talking because "We're not supposed to tell anyone about that. Talk about the movie." They never shared any more details, but for the rest of the term they were far and away the most enthusiastic film noir students in the course.

6. *Understand that opinionated students want to be heard*. Acknowledge their opinion and connect their ideas back to the discussion. After reading *Trifles*, one student commented that she would "not pay to go see this show." I pried further and she explained that she thought that the characters were not engaging because they were talking about insignificant things like jamming and sewing. Insightfully, she pointed out what the other students did not notice, that the playwright intentionally wrote about these trifles as a way to show the misery and isolation of the offstage female character's life.

Incorporating students' ideas shows that their perspectives are valuable. If you do not know something, offer to research the subject and get back to them with information. However, if the inquiry is outside the realm of your class, say that it is beyond the scope.

7. *Ask students who are not sharing if they have something to contribute (but do not force people to talk.)* Some students are more assertive than others. If students are not speaking, it does not mean that they do not have anything to share. Some may be quick to react and speak up while others need more time to formulate their thoughts.

8. *Solicit course feedback from students who are not sharing*. If students know that you are willing to work with them, they will be more likely to attend class. Some students are better at conversing one-on-one and do not enjoy speaking in front of groups. You may also give them a written questionnaire and include things like "What do you like best? What do you like least? What

do you want to see more of?" See more examples of evaluation questions at the end of the chapter.
9. *Create a sense of community*. The more comfortable students are with each other, the more willing they will be to participate. At the beginning of each writing session for Playwriting, the entire group participates in a storytelling exercise. The class tells a story together one word at a time. Going around in circles, each student contributes one word until the story is complete.

Another way to encourage students to participate immediately is to ask students ice breaker questions such as "What is your favorite or least favorite show that you have attended?" This is an easy and quick way to have students share their opinions and get used to talking in class.

How to Create a Respectful Environment

In a classroom of older adults you are going to have a wide range of viewpoints and experiences. Conversations can often get contentious. Strive to establish and maintain connection-focused respect culture for your students where they value each other as equals and learn together.

1. *Avoid centering discussions around your political viewpoint*. (Inter)national politics is a topic students like to discuss no matter what the course content. Said one student, "You walk into the voting booth and look at your options and you just feel *dirty*." While day-to-day politics may not be on topic (you will find yourself needing to table some discussions), let students share their opinions as long as they relate to the course content.
2. *Be flexible*. If there is a topic/assignment/reading that students are not enthusiastic about, find another way to address the subject. Students did not enjoy reading *The Lesson* as an example of experimental theatre in Playwriting. To reengage the students the following week, I chose a shorter play, *Philip Glass Buys a Loaf of Bread*, which got them excited to discuss nontraditional play structures. For every topic, I prepare several alternatives in case something doesn't work out.
3. *Discuss potentially problematic opinions*. When neo-burlesque strippers visited the Banned in Boston class students praised their entrepreneurial spirit and would happily discuss feminism and grappled with whether stripping can be empowering: "What does your husband/boyfriend/father think about what you do?" was a common question. As a result, we were able to have an in-depth conversation about sex work as work, societal perceptions of performers, and women in economic history. While this discussion was highly politicized, the conversation was necessary because it helped students unpack how burlesque is consumed and interpreted by the public.

4. *Provide content warnings.* If there are difficult topics you think students should be aware of, offer them the option of stepping out of the class, no questions asked. Some students did not wish to discuss *The Outgoing Tide* because the play is about Alzheimer's disease and suicide, though other students wanted to discuss the play in the context of dealing with family, aging parents, and right to die. For more information on including content warnings, see Alison Kafer's "Un/safe disclosures scenes of disability and trauma."[3]
5. *When problematic opinions do arise, try to rephrase it in a new way.* There are many generational differences between older adults and terms that may once have been acceptable to use may no longer be appropriate today. Race, gender, and sexual orientation are subjects on which older adults may use vastly different terminology and express conflicting views from what is acceptable. To help them interact with the current generation, provide new vocabulary to use when possible. For example, if a student says "Orientals," respond with, "Let's use the term Asian/Asian American."

 Another way to help manage problematic opinions is to have students talk about their own experiences of discrimination. For example, ask them, "How are you discriminated against as an older adult? How do you feel when somebody tells you to 'get over it' or 'stop complaining'?" A student once shared that she was told the wrong date for an event by her son. She did not correct her son and ended up rescheduling her entire weekend to accommodate her son's mistake. The student did this to avoid having her son think she was having a "senior moment," that she forgot the date. Reminding older adults what it is like to be discriminated against may help build awareness of how they react to and talk about others' experiences.

 If you wish to take it a step further, have the students practice empathy through role-playing or imagination. Ask them what they think the particular character or person might feel and experience. Some exercises include:
 - *Writing*: Have students write from the perspective of another person. Give them a specific scenario and details of the character. Have them think about a challenging moment for their character and how they might deal with it. Choose a broad situation that could apply to anyone. The purpose is to show them that we're all human, no matter who we are. Example: You are someone who has just lost their home. You have been relocated to a new city to start over. You do not know where your family and friends are and are all alone in a strange place. What do you need first and what will you do next?
 - *Stars Exercise*: Help students who are not LGBTQIA2S+ understand the experience of coming out to friends, family, coworkers, and community.[4] Each student is given a paper star of a different color and writes the name of friends, family, community, career, and hopes and dreams on each point

of the star. You guide the students through the reactions of their friends and family to their coming out, whether they are accepted or rejected.
- *Role-Playing*: Have students act out characters they view as vastly different from themselves. Give students the traits of their characters including age, gender, profession, fears, personality, and quirks. Ask them how their traits influence their actions. Draw from existing characters in plays such as Cynthia in *Sweat* or Nora from *A Doll's House*. Take care to select characters that are not caricatures or stereotypes.

Most higher education institutions have diversity offices with resources that can help you. They are trained professionals and have experience assisting instructors in creating more inclusive classroom environments. Many higher education institutions have recommended Ibram X. Kendi's *How to Be an Antiracist*, Robin DiAngelo's *White Fragility*, and Ijeoma Oluo's *So You Want to Talk About Race*.[5] There are countless other resources available with varied approaches and targeted for different audiences, environments, and backgrounds. Choose one that resonates with you.

6. *Define words and discuss the meaning of what students are actually trying to say*. Sometimes people use the same words and have different meanings. When this happens, make sure to clarify with each student what they are trying to express and, if appropriate, offer another word to use for discussion that is more precise and better encapsulates their intention. For example, a student used the word "inauthentic" to describe Madge in *Picnic* because the character was not saying what they were meaning. Other students disagreed because they did not think the character was deceiving themselves or others.

I suggested the word "subtext" to represent this idea. There are also vague terms that students may intentionally use to talk around topics, mask opinions, or avoid going into detail. Often a student will refer to a dramatic situation, staging choice, or character as "problematic" and not explain how or why the example is problematic. *How* is Stanley and Stella's relationship problematic in *A Streetcar Named Desire*? Or a student will say a character or situation is "relatable" when they mean "believable" vs. that they identify with the character.

Theatre for the Virtual Classroom[6]

Offering theatre courses through virtual platforms can bring courses to older adults who may be unable to attend in-person or otherwise be involved in theatre. Performance-based and nonperformance activities can be used in any type of theatre

course you teach, including virtual courses. While it may be challenging at first, the virtual classroom can be just as engaging for students by making a few adjustments.

- *Plan for accessibility matters*. Provide modifications and offer them to everyone. For example, adapt written word association games so that they can also be played by speaking and vice versa. Enable automatic closed captioning if available and provide clear step-by-step descriptions for all activities.
- *Share videos and other media with your students*. There are many documentaries, interviews, music, productions, readings, lectures, exercises, history, and introductory lessons available online for free. Take time to vet videos for quality, accessibility (check for closed captions and subtitles), and credibility.

Many theatre companies have their own video channels, which are geared toward educating a wide audience. Be creative in your selection. You do not have to *only* use theatre-specific sources. Some of the most fun that we've had in class involve following Jack Lalane, Richard Simmons, and Jane Fonda for physical warm-ups. Tongue twisters with music, cheerleading exercises, vocal warm-ups, and singalongs/lyric videos were also popular and got students engaged right away.

There are many other ways to use media in activities. For example, create a short slideshow and have students improvise a presentation, show a video on mute and have students narrate the video, share a script and have students do a cold reading, or share an image/song and have students write a play inspired by it.

Practice sharing your videos with a friend before class to make sure any AV lags are minimal. Keep in mind that some virtual platforms may have difficulty playing videos due to copyright protections.

- *Modify physical exercises*. Many exercises will not need to be modified (such as pretending to walk through different spaces), and others will need to be. Exercises such as Popcorn and Street Fight can be adapted to the use of hands or the use of gestures only. If it is important for others to be able to see each other, adapt the game so that it only requires the use of upper body parts that can be seen on screen.
- *Mute vocal exercises*. Audio will rarely be perfectly in sync in a virtual classroom. With singing and vocal warm-ups students will need to mute themselves in order to follow the instructor. Being muted can help students feel more comfortable in fully trying out exercises without the fear of having other students hear them.
- *Recreate classroom sharing circles by establishing an order at the beginning of class*. If you are using large group activities, develop an order that students remember for the duration of the class. Once the order is set, students can follow it for each activity. For example, when telling a story one sentence at a

time, students add a sentence when it is their turn. This helps minimize confusion and establishes a better flow for activities.
- *Minimize "hot potato" games.* Games that require students to accept and quickly pass on a task such as Zip Zap Zop or pass the facial expression should be decreased. When translated into a virtual setting, these activities require students to do the task and call out a name, which can become too challenging and break the flow of the game.
- *Increase mirror activities.* Mirroring, ping-pong, and follow the leader-style games encourage students to collaborate with each other and practice a simple-yet-complicated low-stakes activity. There may be a slight audiovisual lag depending on internet connectivity, but mirroring games are beneficial for group cohesion. Ping-pong games work best with partners in breakout rooms. Mirroring and follow the leader can be played in pairs, small groups, or as an entire class.
- *Incorporate readings and narrative storytelling.* If students do not have preferences in terms of roles to read, use the speaking order established at the beginning of class to assign characters. When reading scripts with your students, any actor can play any character. (This is of course within reason. Do not use the guise of nontraditional casting as an excuse for racism, ableism, sexism, ageism, etc.) Narrative storytelling is a great way to get students participating right away. Do group storytelling activities and use suggestions to help students branch out of their normal perspectives.
- *Set the stage.* Like you would do for a standard production, establish ground rules of the virtual stage. Help students brainstorm ways to design a production using available resources in their homes.
 - The "audience" or anyone not performing a scene should be asked to turn off their video and sound so that the performers get the spotlight. The audience should be muted to minimize disruptions. If you would like for your audience to participate in the production, you can encourage them to use the chat function.
 - Experiment with using different backgrounds to reflect their characters or setting. Virtual backgrounds are fun but not necessary.
 - Have students develop their own costumes using everyday items and clothes. Even if the costumes they come up with may not accurately portray a time period/character, being in any costume will help students get into character. Students can also take an abstract approach and create costumes based on their character's story/personality, rather than trying to be realistic.
 - Have students use everyday objects for props. They do not need to be the exact items called for in a script and students have freedom to creatively interpret their props. You may also find plays that involve entertaining props. For example, the toilet brush in *Ubu Roi* or the peas in *Woyzeck*.

- o Rehearse your production before presenting it to an audience. Doing a run-through will help you identify any technical issues that may arise and allow you time to fix them before the opening.
- *Create games and show-tell moments.* Have students apply what they learn by using objects in their own home. For example, in a theatre history course, they can find items that can be used for sound effects and practice being Foley artists.
- *Use partner or small group activities.* Having all students engage as an entire group can be difficult for most activities. Whenever possible, break students up into partners or small groups. This will help them see and hear better. We recommend groups no larger than four.

 Often students who are unwilling to talk in front of the entire class are more likely to share ideas in a small group. Randomly assigning students to small groups and switching the groups up each time helps students interact with new people.
- *Collect student opinions on chat to get instant feedback.* If students are comfortable using the chat option, invite them to use it for brainstorms, discussions, and other activities. Keep in mind that chat will be most successful when people are using devices with keyboards.
- *Use shared documents or whiteboards.* If students are comfortable using shared documents or whiteboards, create and share them with your students. They can be used for collaborative storytelling, brainstorming, ice breakers, and so on. Have students contribute with drawings or text. Keep in mind this requires quick typing and drawing skills and will depend on the type of equipment students are using. Whiteboards are most successful with people using touchscreens and shared documents are most successful with people using devices with keyboards.

How to Help Your Students Learn Online[7]

Just like an in-person course, you will get a variety of students who have different experiences participating in virtual courses. To help your students be comfortable with the course and technology, we recommend doing the following at the beginning of your course:

1. *Welcome students to the course.* Humanize online learning by showing your own face even if you do not require students to show theirs. Show enthusiasm and let your students know that you want to be there. If you do not want to be there, they will not want to be there. Emphasize that an online course is a (virtual) community.

2. *Have students set up their equipment.* Ask students to check their audio, lighting, and camera position. If possible, do a sound check with each student and help them adjust their volume. Recommend to students to use a well-lit location to help others see them and to use headphones to decrease background noise. You may also show students how to update their username to the name they would like to be called and have them set a profile picture or icon to use when their cameras are off. These are not necessary but is a fun way to give them an opportunity to choose how they represent themselves.
3. *Practice using functions of the virtual classroom with students.* Start by having students practice using tools that you will regularly use in your course such as audio, screen and video shares, and breakout rooms. If students are comfortable, have them try out more advanced features such as surveys, whiteboarding, and chats and messaging.
4. *Have students create a focused space.* If possible, ask students to find a space that they can designate as a learning space. This will help train their minds to be ready for class.
5. *Remind students that they can be seen.* While they do not need to be "camera-ready," they need to be camera ready. Tell them that there will be moments that they will be seen and it is important to be fully dressed (in case they need to stand up). To make this fun, you can make getting dressed a game by establishing different themes for each class. Have students suggest themes as well. For example, 80s costume, favorite character or historical figure, or supervillain, creating costumes using things they find around their homes.
6. *Set clear communication expectations.* It can be difficult to hear when more than one person speaks at a time or if there is background noise. Ask students to use the mute button if there are noises at their location. Ask students to refrain from speaking when you are giving instructions so everyone can hear you clearly. When there are discussions, ask students to raise their hand before speaking and not interrupt other students when they are speaking. Any interruption will disrupt *everyone's* ability to hear. If students are comfortable with the technology, they can also use the "raise hands" function or chat.
7. *Address accessibility matters and how to self-advocate.* Invite students to tell you of any accessibility needs before class or as soon as possible. Some students may not be able to hear or see well, which will require you to describe images or provide captions.
8. *If using virtual breakout rooms, explain what they are and how to navigate them.* Discuss how you will use breakout rooms in class and give students

instructions on how to join them. Give students lots of opportunities to practice interacting in small groups. You may also mix up the small groups throughout a class by reassigning the breakout rooms. There are many activities you can do using breakout rooms such as trivia games, ice breaker questions, collaborative storytelling, and so on. We recommend that you check in with your students when they are in breakout rooms by joining them. Do let your students know that you may suddenly appear in their room so they are not surprised.

9. *Establish that you can learn from anywhere.* Discuss strategies for adapting any environment to a learning environment. Students may have multiple members of their households attempting to access Wi-Fi at the same time, which can affect bandwidth. It is ok if their cameras have to be off in order to access the course as long as they are able to engage in other ways.
10. *Establish that everyone is always learning.* Let them know that you are learning the technology as well and expect that it may take a few classes for the course to run smoothly. There may be new things that students will come up with to aid online learning. If someone has a good suggestion for an improvement, show the rest of your students. Encourage students to learn from each other.

Course Evaluations

Collect evaluations so that you can gather information on how to modify and improve your courses going forward and to get feedback on what aspects of your course are most successful and engaging. Evaluations should be concise, easy to read, and no longer than a page. You do not want to overwhelm the students with too much or they may be discouraged from filling out the form. If students have more to say, they can write on the back of the sheet.

Create Rating Statements

Statements should be as specific as possible so that you can gather concrete information to improve your course. Avoid providing a "true neutral" option in your rating so that students must voice an opinion. Depending on what you want to focus on, the sample statements below can be tailored to be made more detailed, such as course materials that can have separate lines for each type. Samples:

Rate the statements from 1 to 4 (1 = strongly disagree, 4 = strongly agree).

- The instructor was enthusiastic.
- The instructor respected student opinions.

- Students respected classmates' opinions.
- The course stimulated student thinking.
- The activities furthered my understanding of the course topic.
- The discussions related to the course topic.
- The course materials (handouts, films, scripts) were useful.
- The course technology (videos and sound recordings) enhanced my experience in the course.
- The instructor created a student atmosphere that encouraged students to participate.
- This course gave me deeper insight into the topic.
- My accessibility needs were met.

Include Qualitative Evaluation Questions

Do your best to use open-ended questions that do not have definitive right or wrong answers. If you do use closed-ended questions, such as yes or no, follow up with a request for more details. Examples:

- Which topic or activity did you like most? Why?
- Which topic or activity did you like least? Why?
- What would you like to learn more about? Why?
- What was the most challenging? Why?
- Is there an activity that we have not done that you would like to do with the class? If yes, please describe.
- Is there a topic you would like to present on or share with the class? If yes, please describe.
- Based on your experience, what would you say to another student who is considering taking a course with this instructor?
- How can the instructor make the course more enjoyable for you?
- What can the instructor improve?
- Would you recommend this instructor or course to others? Why?
- What is a future course you would like to take?

You may also want to provide examples and format these questions in an easy way so students do not have to write very much. Some students may have physical difficulties that make writing challenging.

Sample Evaluation

COURSE EVALUATION

Instructor Name:
Course Title:
Semester and Year:
Instructions: read each statement and circle the number that represents your experience.

Assessment Item	Strongly Disagree	Disagree	Agree	Strongly Agree
	1	2	3	4
1. The instructor was enthusiastic.	1	2	3	4
2. The instructor respected student opinions.	1	2	3	4
3. The course stimulated student thinking.	1	2	3	4
4. The instructor created an atmosphere that encouraged students to participate.	1	2	3	4
5. This course gave me deeper insight into the topic.	1	2	3	4

Which activities did you enjoy the least? Why?
Which activities did you enjoy most? Why?
Is there an activity we did not do that you would like to do with the class?
Would you recommend this instructor or course to others? Why?

Things to Remember

Older adults have a lot of extenuating circumstances going on in their lives that are beyond your control. If a student stops coming to class, do not take it personally. Some may not tell you in advance and can disappear without warning.

In classes, students may express opinions that are vastly different than your own. Again, do not take it personally. The important thing is for your students to be heard, no matter what their perspective (N.B. this does not include hate speech,

refer to section on How to Create a Respectful Environment.) Remember that older adult classes are small communities and each voice is part of that community.

The students are learning, but you are learning as well. If you are new to teaching older adults, it may be difficult at first and it is important to keep in mind that you may not get it right the first time. Part of the teaching experience is that you will be learning about the students. From their personalities, likes and dislikes, political beliefs, and personal histories, you will learn a great deal about every student and encounter a variety of strongly held opinions. This is a significant component to teaching older adults. The more you learn about the students, the more successful you will be. There will also be times when students know more than you and have first-hand experience in something that you have not encountered before. You will be challenged to accept that you do not know everything. Even as an expert you are always learning. That's what makes teaching older adults more interesting than teaching any other group.

Our Learning Philosophy

We have learned a great deal from teaching older adults. We share our philosophy of learning not as a prescription but as an illustration. While we are still learning, we have come to realize that there are several key factors that can play a role in shifting the older adult classroom from a siloed black box to a welcoming community. Supportive communities are created by having fun, making friends, and building trust, which often occurs simultaneously in theatre courses.

Having fun is central to any theatre course. Students are attracted to studying theatre because it is entertainment and it is fun; students have an expectation that they will have fun in theatre courses. Students have fun by playing games, sharing laughter, embracing mistakes, being ridiculous, exploring creativity, and imagining possibilities. Many theatre practices are based on a foundation of play and games (whether they are theatre and performance-based or not, such as word games) can be incorporated into all courses such as theatre history and theory. Games give students opportunities to learn in an active, nonthreatening way. Sharing laughter is often part of the experience of playing games and these collective moments make courses enjoyable for students. Some other ways of inviting students to laugh together are through stories, jokes, singing, and dancing. When students play games and laugh together, they become more comfortable and are more willing to try out new things without fear of failing. Practice making mistakes in a safe setting decreases anxiety that can come from fear of rejection or judgment for not being perfect or doing something wrong. We facilitate a culture of accepting mistakes by having all students practice making mistakes through

exercises that everyone will do wrong the first time (such as tongue twisters) or activities that do not have one "right" way of doing (like interpreting a monologue). Encouraging students to be ridiculous, such as debating bizarre ideas or writing an absurd manifesto for performance, also contributes to alleviating fear of failure. Creativity happens when one lets go of fear and students explore creativity individually and together in exercises such as visual imagery, designing a set or costume for a show, or developing a story to tell. Finally, we create space for students to imagine possibilities, reflect on their own worldviews, and hear how others broaden their perspectives.

The experience of creating and learning about theatre is an opportunity to make friends and strengthen relationships while having fun. Students in a theatre course may have different reasons for being there, but they all made the decision to become involved. Developing friendships is easier when people have something to form common bonds over and they do this by working together to realize a shared goal. Shared goals can be short term or long term, such as collaborating in a small group on a casting activity or writing and rehearsing a scene over many weeks. We work together by saying "Yes" to any group activity and finishing what is started, even when things are difficult. The show must go on!

In the process of making friends, students learn to listen to each other and share the space while offering something about themselves, sometimes for the first time. Often in class, a student will relate past or current experiences as part of improvisation or in course discussion. These provide a point of connection between their classmates, whether about meeting a favorite celebrity; relationships with family; losing a job, partner, or beloved pet; or a strange encounter. It is by celebrating quirks and accepting each other through the process of doing and learning about theatre that friendships are formed.

Building trust between all members of a theatre course is essential if people are to have fun, build friendships, and reap theatre's positive benefits. It is challenging to form bonds within a course without an atmosphere of trust. In a theatre course people are putting themselves on the line, whether by performing a musical monologue for the first time, sharing a new script they've written, or expressing a reaction that differs from the majority about a production. If students do not trust each other, they will be hesitant to fully engage in the experience for fear of judgment. We build trust by having students support each other through providing encouragement, listening to and addressing everyone's needs as they come up, and keeping what happens in the course inside the classroom (obviously there are exceptions depending on your institutional policies). This environment of trust is deepened by students practicing kindness, being respectful by accepting differences of opinion, and being honest with each other.

Our learning philosophy is to create community through theatre practice and education by having fun, making friendships, and building trust. We are social beings, even the most misanthropic among us, and are connected to each other. Our ideal theatre communities are inclusive spaces where we are all present and engaged in the here and now, contributing to the group, saying "Yes," and treating each other with kindness. While we cannot control aging or what will happen in the world tomorrow, through theatre we can create supportive and positive communities that value our differences and celebrate our humanity as we navigate life's possibilities.

2

Theatre Appreciation

I like the ephemeral thing about theatre, every performance is like a ghost—it's there and then it's gone.
—Maggie Smith, actress[1]

An extraordinary thing about theatre is that everyone, whether they are a performer, a technician, or an audience member, is taking part in creating a unique experience and will share memories of an event that will not be repeated ever again. Different audiences bring different energies that change a show for performers even if the text, technology, and venue are the same. For over a decade, the Somerville Theatre in Massachusetts has hosted *The Slutcracker*, a burlesque show that has become a holiday tradition to which thousands of audience members return each year. There have been strange experiences like exploding lights and set pieces crashing from the grid to the stage floor, to an onstage wedding during the closing act (though the couple divorced soon after), as well as subtle night-to-night differences. No two performances are ever identical. That is what connects theatre today with theatre throughout history and is what makes theatre worth watching.

Theatre appreciation is for anyone who enjoys theatre. It is the most approachable of the classes as the subject matter is broad and can include anything from the theatre-going experience to set design. From practitioners and seasoned theatregoers to enthusiastic theatrical amateurs and people with no experience with live theatre, this course is truly for everyone.

What Is Theatre Appreciation?

Theatre appreciation involves learning about all aspects of the form including production, consumption, and cultural impact. From production design, performance techniques, and theatrical genres to the audience experience, students learn how different elements combine to create successful (and unsuccessful) productions, as well as examine the nuances and definitions of "success." Students also

learn historical contexts, dramatic theories, dramatic criticism, what the creative process entails, and have a chance to practice theatre first-hand. An essential part of studying theatre is the collective experience of going to the theatre and understanding plays as works to be performed, versus solely reading plays as literature.

Benefits for Students without a Background in Theatre

Students who have little knowledge and experience seeing live theatre will learn the ins and outs of what goes on in a theatrical production, and how anyone can do and appreciate theatre. They will be exposed to different genres and styles and be encouraged to discover new theatrical experiences of their own.

Benefits for Students with a Background in Theatre

For students with experience attending live theatre, a course in theatre appreciation provides a deeper understanding and broader perspectives of plays and productions. They will learn about production histories and historical contexts that will help frame their own experiences as part of larger cultural movements.

Through theatre appreciation students become reflective, informed critics and audience members. Students' own theatre experiences will be enhanced by studying dramaturgy and criticism, how acting and directing styles have changed and evolved over time, and the role of theatre as a form of entertainment. There continue to be many innovations in theatre and students can be an active part of that creation through their participation.

How Do I Put Together a Course?

Putting together a theatre appreciation course is kind of like compiling a greatest hits album/music anthology. Theatre appreciation instructors can take a variety of approaches to creating a course. When developing a class, here are some areas to explore and think about.

Go See Theatre!

Theatre is meant to be seen, heard, experienced, enjoyed, and discussed (or argued over) collectively. Start gathering ideas about your class by seeing live theatre and becoming engaged in local arts communities. Go see a variety of shows, including commercial/touring companies, black box shows, free shows, or virtual shows. Your local colleges and high schools may also have productions.

Read and Keep Programs

When attending performances, start collecting programs and/or have your students collect them and bring them to class. These articles can be effective in introducing students to theatre history, theatre theory, and script analysis.

Oftentimes, articles in programs are written by dramaturges if a company employs one. A dramaturg may perform research about a play, dramatist, or historical period. They act as script consultants and provide contextualization for productions. Part of a dramaturg's job in writing articles in programs is to help audiences understand the historical, social, and/or cultural significance of the play they are watching.

If the company's dramaturg provides additional materials such as process books or background research for a production, ask for a copy of those as well. For example, Portland Stage Company's community outreach program shared a collection of sketches of Italianate scenery and character design sketches for a production of *The Comedy of Errors*. Tufts University's production of *Hair* compiled newspaper articles and album covers from the 1960s detailing anti-Vietnam War protests.

There may also be dramaturgical lobby displays about the production so make sure to give yourself extra time before or after the show to view and examine them thoroughly. For example, a production of *Red Velvet* at the Boston Center for the Arts had lobby displays providing background information not only for the figures appearing in the production (Ira Aldridge, Ellen Tree, and Charles Kean) but also everything referenced in the dialogue and production design, from the history of clowns to advances in theatre technology.

Read Reviews

Theatre critics and reviewers play an important role in the success of a production. They can make or break a show depending on how favorably or unfavorably they review a show. Critics often attend an early showing of the production and through reviews help audiences understand what the show is about, what is unique about the production, and sometimes provide background about the play, playwright, or production history. This varies depending on the critic and there are individual practices. Some critics write reviews that are primarily made up of a summary of the story while others provide in-depth analysis like the cultural significance of the production, how the performance contributes to addressing particular topics, and what innovations it makes.

For students taking theatre appreciation, they will practice doing the latter. Students will learn how to be critical viewers and analyze theatrical performances as informed audience members by examining technical design (including costume,

scenery, props, lighting, and sound), acting, directing, and musical direction (if any). Students will also learn about theatre history and theory, gaining a basic understanding of different types of theatres and influences.

Collect examples of reviews and have students bring in reviews as well. For teaching purposes, be sure to bring in a variety so you have at least one positive review and a negative review. Having different examples will help students recognize that people experience productions from a variety of perspectives.

Think about Which Topics Interest You or Your Students

The easiest way to develop your course is to select topics that you are interested in. To help you brainstorm, ask yourself the following questions:

- What do you like about seeing theatre? The acting? Special effects? Music?
- What are shows that you have always wanted to see, but haven't?
- What shows would you pay big bucks for?
- What shows would you like to see again?
- What shows have you seen that have been adapted into movies, or what movies have you seen that were adapted into shows? What did you think about them?

Include things completely out of the box as well as familiar and popular theatre that students may already know. Popular topics that we have encountered with our students are:

- Musical theatre.
- Burlesque and vaudeville.
- Cabaret and music hall.
- Physical theatre (clowning, *kabuki*, and circus).
- International theatre.
- Puppetry.
- Anything else with an element of spectacle.
- And there are always a few students who say they love Shakespeare.

How Do I Select and Organize Topics?

Anything goes! Well, almost. A difficult yet advantageous aspect of Theatre appreciation is that it is a broad topic that has a range of material to explore. You can be

specific and have an entire course on Depression Era theatre or do an introduction to theatre production. Ultimately, the content and activities of your classes will largely depend on who is in your class and what appeals to them.

By Student Interest in Topic

If you are able to before the first day of class, poll students on what they are interested in learning about. If you do not know what your students' interests will be on your first day, include a variety of topics on your syllabus. On your weekly schedule, note "tentative" or "schedule subject to change" so students know that topics may change. On the first day of class, make sure to carefully go over your syllabus, especially the weekly schedule. This can be a way to gauge students' interest in the topics. Discuss what sounds interesting or uninteresting to them. You may also collect written responses if students do not want to vocalize their opinions.

By Theatre Season

One of the best ways to develop a new course is to research local theatre companies in your region and find out what shows are playing. Theatre seasons often offer a variety of shows including classics, contemporary plays, world premieres, musicals, and works by local playwrights. You can structure your entire class around theatre shows in your local community or include only one. If there is a production happening before or after your course takes place, that show may also be worthwhile to include. The purpose of discussing local theatrical productions around you is not only to help you find content for your courses but also to encourage students to be active outside the classroom. It is more likely that students will be interested in seeing a show if they have learned about it in class or if they have classmates to attend with them.

Many larger theatre companies have an education division and are looking to include people in their programming. When setting up your courses, reach out to local and regional theatre companies about talkbacks and panels, and coordinate tickets for your class. Negotiate a discounted ticket rate by avoiding weekend performances. Have your students participate in any audience surveys that request information about event and season preferences.

Organize theatre nights for your students by asking local theatre theatres, "On which nights do you usually not sell tickets? How many tickets are you willing to sell us for those nights at a discounted rate?" For one course we were able to bring hundreds of students to shows on Wednesdays because we worked with the theatre. Theatre companies were willing to do this because it is always better to have an audience, even if they are paying a discounted rate, than to play to an

empty house. There may also be virtual performance events and talkbacks you can attend with your students.

By Elements of Theatrical Production

Provide an overview of the roles played by actors, directors, critics, dramaturgs, run crew, the design team, and producers in the realization of a production. Students learn how these disparate parts combine to create a cohesive whole and how these different roles changed over time. For example, the stage manager used to be for all intents and purposes the director, until the director emerged as a distinct role separate from the stage manager. For lighting design, the role of the lighting designer has increased in significance, with lighting design often replacing a physical set in multiuse spaces.

By Region and/or Time Period

Theatre comes in many different forms and each session can explore theatre from a different country or region. You can shape an entire semester on theatre in one country, or travel around the world. This may be especially appealing to students who are well-travelled.

Contrast what was happening in different countries at the same time. For example, discuss how *commedia dell'arte* and Shakespeare rose to popularity in the sixteenth century. Study theatre from around the world during the tumultuous decades between the First World War and the Second World War. After the Second World War, we not only see absurdism and *Butoh* in response to the war but also witness Broadway blockbusters.

By Playwright and/or Playwriting Technique

Spend a full course exploring a single playwright (or group of playwrights) in-depth. These can be well-known playwrights or lesser-known figures. A few popular playwrights with whom your students may not be overly familiar around include August Wilson, Anton Chekhov, Suzan-Lori Parks, Annie Baker, Maria Irene Fornes, Oscar Wilde, Chikamatsu Monzaemon, and Edward Albee.

Even if students know some of the playwrights, it is unlikely that they will have read a majority of their work. Many students may know a playwright's most popular work. For example, people may have heard of Albee's *Who's Afraid of Virginia Woolf?* because it was made into a movie featuring Elizabeth Taylor and Richard Burton, but may not have heard of his three Pulitzer Prize winning plays, *Seascape*, *A Delicate Balance*, or *Three Tall Women*.

By Actors and/or Directors

This course can either look at the work of contemporary artists or delve into history. Some well-known directors include Bertolt Brecht, Julie Taymor, Peter Brook, Ariane Mnouchkine, Orson Welles, Peter Sellars, and Ann Bogart. Many of these artists have directed a wide range of plays and they can be a starting point for in-depth discussion about history, race, cultural appropriation, and so on.

By Genres or Styles

Some of the most popular types of theatre are family dramas, farce, and musicals. Over the course of a semester looking at western theatre you could trace family drama, from Menander's *The Golden Girl*, through Roman comedies, to *The Duchess of Malfi* or *King Lear*, and *Long Day's Journey into Night*, and so on. A course on farce can include Aristophanes's *Lysistrata*, Moliere's *Tartuffe*, Georges Feydeau's *A Flea in Her Ear*, and Michael Frayn's *Noises Off*. A class on the history of musical theatre can take a variety of paths, from looking at the significance of music in classical Indian, Balinese, Javanese, Chinese, and Japanese theatre to the odes in Greek drama to the rise of opera, operetta, and eventually musical theatre. Any combination of styles will work as long as you establish how they relate to each other or set an overall theme.

By Films Available at the Library or Online

Every library carries a different selection of films and you may have access to an assortment of theatre productions on film or plays adapted into films. You may find films about plays and productions, musicals, documentaries, interviews with artists, and more. There may also be theatre depicted in historical films. You will find a variety of online options but will need to curate and ensure all of your students are able to access the materials and that they have closed captions. Below are lists of films, television shows, and web series that you may find helpful:

Film Adaptations

12 Angry Men, directed by Sidney Lumet, 1957
1776, directed by Peter H. Hunt, 1972
Amadeus, directed by Milos Foreman, 1984

Bells Are Ringing, directed by Vincente Minnelli, 1960
Blithe Spirit, directed by David Lean, 1945; directed by Edward Hall, 2020
Blood Wedding, directed by Carlos Saura, 1981
Born Yesterday, directed by George Cukor, 1950
The Boys in the Band, directed by Joe Mantello, 1970
Cabaret, directed by Bob Fosse, 1972
The Caine Mutiny, directed by Edward Dmytryk, 1954 (based on *The Caine Mutiny Court-Martial*)
Carmen Jones, directed by Otto Preminger, 1954
Carousel, directed by Henry King, 1956
Chicago, directed by Rob Marshall, 2002
Chi-Raq, directed by Spike Lee, 2015 (based on *Lysistrata*)
Closer, directed by Mike Nichols, 2004
Damn Yankees, directed by George Abbott and Stanley Donen, 1958
Dial M for Murder, directed by Alfred Hitchcock, 1954
Fences, directed by Denzel Washington, 2016
Gaslight, directed by Thorold Dickinson, 1940; directed by George Cukor, 1944; directed by Keith Allen, 2017
The Girl Can't Help It, directed by Frank Tashlin, 1956 (based on *Born Yesterday*)
The Glass Menagerie, directed by Irving Rapper, 1950
Hedwig and the Angry Inch, directed by John Cameron Mitchell, 2001
Here Without Me, directed by Bahram Tavakoli, 2011 (based on *The Glass Menagerie*)
The History Boys, directed by Nicholas Hytner, 2006
Inherit the Wind, directed by Stanley Kramer, 1960
In the Heights, directed by John M. Chu, 2021
The Importance of Being Earnest, directed by Anthony Asquith, 1952; directed by Olive Parker, 2002
Lion in Winter, directed by Anthony Harvey, 1967
The Little Foxes, directed by William Wyler, 1941
Little Shop of Horrors, directed by Roger Corman, 1960; directed by Frank Oz, 1986
The Long Voyage Home, directed by John Ford, 1940 (based on the *S.S. Glencairn* plays)
The Man Who Came to Dinner, directed by William Keighley, 1942
Maqbool, directed by Vishal Bhardwaj, 2003 (based on *Macbeth*)
"Master Harold" … And the Boys, directed by Lonny Price, 2010
Mister Roberts, directed by John Ford and Mervyn LeRoy, 1955
My Fair Lady, directed by George Cukor, 1964

Noises Off, directed by Peter Bogdonovich, 1992
The Odd Couple, directed by Gene Saks, 1968
Pandora's Box, directed by G. W. Pabst, 1929 (based on *Lulu* and *Earth Spirit*)
Peony Pavilion, directed by Yonfan, 2001
The Producers, directed by Mel Brooks, 1967; directed by Susan Stroman, 2005
Pygmalion, directed by Anthony Asquith and Leslie Howard, 1938
A Raisin in the Sun, directed by Daniel Petrie, 1961; directed by Kenny Leon, 2008
Ran, directed by Kurosawa Akira, 1985 (based on *King Lear*)
Rope, directed by Alfred Hitchcock, 1948
Roxie Hart, directed by William Wellman, 1942 (based on *Chicago*)
The Ruling Class, directed by Peter Medak, 1972
Sita Sings the Blues, directed by Nina Paley, 2008 (based on the *Ramayana*)
Stage Beauty, directed by Richard Eyre, 2004 (based on *Compleat Stage Beauty*)
Stage Door, directed by Gregory La Cava, 1937
A Streetcar Named Desire, directed by Elia Kazan, 1951
Sweet Charity, directed by Bob Fosse, 1969
Throne of Blood, directed by Kurosawa Akira, 1957 (based on *Macbeth*)
West Side Story, directed by Robert Wise and Jerome Robbins, 1962; directed by Steven Spielberg, 2021
Who's Afraid of Virginia Woolf?, directed by Mike Nichols, 1966
The Women, directed by George Cukor, 1939

Notes:
1. Film names are the same as the source play unless otherwise noted.
2. There are only four Shakespeare adaptations listed above, counting *West Side Story*. However, there are hundreds of film and television adaptations of Shakespeare's plays. There are straightforward interpretations, such as Laurence Olivier's *Richard III* and Julie Taymor's *The Tempest*, to radical reworkings, including *My Own Private Idaho* (*Henry IV, Part I*) and *10 Things I Hate About You* (*The Taming of the Shrew*).

Television Shows

Live from Lincoln Center, PBS, 1976–present
The Muppet Show 1976–81
Spotlight, PBS, 1976–present
Working in the Theatre, American Theatre Wing, 1976–present, also streaming on YouTube

Web Series

Homebound
National Theatre
No Pants Theatre Company
Royal Shakespeare Company
Scenesaver

Web Series on YouTube

3Behind the Stratford Festival Curtain
Broadway Backstory
Crash Course
Drama
DramaAlert
DramaChannel
Goodman Theatre
HowlRound
League of Drama
Musical Theatre Mash

By Guest Artists

Students enjoy meeting people in their local community and learning about local art, and local artists usually enjoy talking about their current projects and experiences. Generating interest from community members also helps theatre companies gain audiences and get word-of-mouth support. Have a stage manager, a designer, and a director visit to discuss creating the look of a production and the role of technicians in the creation of a play. Some interview questions you can ask your guest are:

- Why did you go into this profession?
- Would you recommend others to go into this profession?
- What would you do if you did something else for a career?
- Who or what are your biggest influences?
- What do you do in a show?
- What happens in a production beginning to end?
- What is your creative process?
- What is the favorite production you have worked on?
- What is a production you would like to work on that you have not yet?

- What was the least favorite or strangest production you have worked on?
- Who would you like to collaborate with?

By Theatre Company

You may wish to dedicate a course to the work of a few specific theatre companies or collaborative arts organizations. For example, a semester can include Public Theatre that produces new works (some of which have won Tony, Obie, or Drama Desk awards), East West Players that promotes Asian American perspectives, Wow Café Theatre that produces work for women and/or trans artists, and Liars and Believers that creates shows involving puppets, clowns, music, and more. See Online archives and websites in Chapter 3 for links to additional theatre companies and other virtual theatre resources. Questions you can consider about each theatre company include:

- Who are the company founders?
- What were their objectives in founding the company?
- What kinds of performances do/did they produce?
- Are they a resident theatre company?
- Who are their collaborators?
- What community initiatives do they engage in?
- What are they most known for?

What Activities and Discussions Can I Do?

The suggested activities for theatre appreciation serve to help students explore their own learning in reflective and interactive ways. Some of the learning outcomes include students finding renewed interest in learning and opening up to and engaging with new ideas and diverse perspectives that they may have never encountered nor considered before. The encouragement of diverse perspectives enhances critical thinking about art and theatre. These activities also assist students with developing self-awareness and awareness of others. They help students express their feelings, opinions, and experiences in ways that build confidence while experimenting with unfamiliar concepts and ideas.

Because theatre appreciation can cover anything from theatre history to costume design, there are a variety of activities that you can use to engage students. All activities can be framed by discussions. Pre-activity discussions help students understand how the activity relates to the course content and things to consider

while they are performing the activity. Post-activity discussions give students an opportunity to share their experiences, revisit objectives from the pre-discussion, and identify what they learned.

Cast a Play with Famous Actors

Ask students to cast a play and have them explain why each actor should play that role. The actors can be stage, television, or film actors. Do not be surprised if your students start doing impressions! Additional variations are:

- Exquisite Corpse: Each member of the group casts an actor in a role in a given play without seeing the rest of the cast and shares at the end.
- Famous Actor Readers Theatre: Each group draws the names of characters and actors. Then have the group do a reading of the scene of a play where each student plays the actor selected for their character.

Read a Play Out Loud

Select a scene or play, cast students in roles, and have them read the play out loud. You can give them some background information on the play before starting or let them figure out the story and characters as they read it. Some students enjoy the experience of letting the story unfold as they read it and others will want a clearer picture. Even if students already know a play from watching it on stage or on film, reading the text will help them see plays in a new light.

Do a Singalong

Select a musical and find a video online with lyrics for students to singalong with. If the musical or song you want to play is not available, simply put the lyrics on a slide or document and show it while you play the song. Once you begin doing singalongs, you might get many enthusiastic suggestions from your students for future singalongs. If a student wants to sing a song not on the list, help them find the song so that they can share the song with the group. Some popular musicals and songs are listed below:

Cabaret
- "Willkommen"
- "The Money Song"
- "Cabaret"

Carousel
- "If I Loved You"
- "You'll Never Walk Alone"
- "June Is Bustin' Out All Over"

Chicago
- "Cell Block Tango"
- "All That Jazz"
- "When You're Good to Mama"

Company
- "Ladies Who Lunch"
- "Side by Side"
- "You Could Drive a Person Crazy"

Girl Crazy
- "I Got Rhythm"
- "But Not for Me"
- "Embraceable You"

Jesus Christ Superstar
- "I Don't Know How to Love Him"
- "Superstar"
- "Herod's Song"

Little Shop of Horrors
- "Skid Row"
- "Dentist!"
- "Feed Me!"

Man of La Mancha
- "The Impossible Dream"
- "Dulcinea"
- "Man of La Mancha"

Les Miserables
- "Do You Hear the People Sing"
- "On My Own"
- "Master of the House"

- "One More Day"
- "I Dreamed a Dream"

The Sound of Music
- "Do-Re-Mi"
- "My Favorite Things"
- "Climb Every Mountain"

Threepenny Opera
- "Mack the Knife"
- "Cannon Song"
- "Pirate Jenny"

You may also select popular songs that have been included in jukebox musicals. A few popular examples are *Beautiful*, with songs by Carole King, *Mamma Mia!*, the ABBA musical, *Rock of Ages*, featuring classic rock. The musical adaptation of *Priscilla, Queen of the Desert* features pop, dance, and disco music ranging from "I Will Survive" to "Girls Just Wanna Have Fun."

Create a Jukebox Musical

Have students select a time period, background story, and a musician or group and create a jukebox musical. While they are selecting songs, students also develop a general storyline to fit the songs. For example, they can create a jukebox musical based on Gloria Estefan, Taylor Swift, Mariah Carey, or BTS. Students can also create a jukebox musical based on a theme using songs by different artists.

Adapt a Play from a Film, News Event, Real-Life Story, Fairytale, Novel, and So on

Divide the class into small groups or into partners and have them talk about an idea for a play adaptation. They can draw from their own lives, what they see in the news, stories they've heard from others, historical figures and history, existing stories found in film, novel, poems, and more. Ask students to think about:

- What is the genre? Why would that genre work?
- What is the plot of the story?

- What characters will be in the play?
- Who will act and direct the play?
- What does the scene design look like?
- What does the sound and music design look like?
- What kind of stage will be used? Proscenium? Round? Where will the audience sit?

This exercise can be done individually, but it is more fun if there are others involved in the decision-making process.

Adapt a Play Using Different Genres

Pick a well-known play such as *A Christmas Carol*, *Romeo and Juliet*, or *Phantom of the Opera* and have students reimagine the play in a few different ways. Choose three styles, such as comedy, tragedy, science fiction, romance, horror, mystery, parody, musical, historical, and so on.

Act or Direct a Scene Using Different Genres

Once each group of students has adapted their plays into different genre styles, have each group act out the same scene in the play using their chosen genre styles. For example, using *Hamlet*, discuss how the interpretation and performance of scenes between Hamlet and the Ghost vary wildly as perceptions and how attitudes about fatherhood, father and son relationships, and ghosts have changed. Discussion questions may include:

- How did seeing the same scene change your reactions to the play?
- Which style did you think was the most effective for this particular play and why?
- Which was least effective and why?
- What surprised you?

Analyze a Script, Scene, or Line

Take a short scene and ask students:

- What do we learn about each character from the way they speak?
- What do we learn about each character from what they are *not* saying?
- What do we learn about the plot?

- Does the scene want you to keep reading? Why or why not?
- How does the scene start and end?
- How does the playwright show suspense/humor/drama, and so on?

Perform and Direct a Scene in Different Acting or Directing Styles

Select two short scenes (two pages maximum) for two characters. Divide the class into groups of three or four. Have two students perform a scene with the other two students as directors. Instruct the directors to have the actors do three variations of the same scene.[2] When the first scenes are done, give them a second scene. This time the roles will be reversed and the students who were actors will be directors, and directors will be actors. The directors will lead the actors to perform the scene three different ways. When all groups are finished, ask if there are any volunteers who want to show the entire class their scenes.

Do an Improvisational Exercise

There are a variety of improvisational exercises that you can do. From performance to written exercises, pick your exercises that can include all students no matter what their physical abilities. Some improvisational exercises that can be done seated are:

- *Storytelling*: With students seated in a circle, have them tell a story together one sentence at a time. Each student adds a sentence to the story until the story is complete. This should be done in the order students are seated to ensure that everyone contributes equally. If this is too easy, have them tell a story only using one *word* at a time. For advanced students, another variation is to have students speak until another student raises their hand and takes over the story. If no one raises their hand, the student speaking must continue talking until someone "saves" them. If more than one student raises their hand, the speaker chooses who will continue the story. There is no order to who gets to have a turn.[3]
- *Paper Telephone*: Each student gets a pen and a piece of paper and writes a sentence at the top. They pass their paper to the left and the student on their left draws a picture illustrating the sentence. The student that drew the picture folds over the sentence at the top and passes the paper to the left. Continue with sentences and pictures until each paper is returned to the original author. Share the stories at the end.

- *Group Mirror*: One student is the leader and moves their arms as other students try to follow them. Instructor calls out different students to lead.[4]

For more improvisational games, see Performance Exercises in Chapter 5.

Watch a Film

When watching film adaptations of plays, have your students pay close attention to the ways in which the play is staged, interpreted, and changed. Students enjoy pointing this out and will notice that lines are removed if they have just read the scene. Ask students:

- What are your thoughts on the casting and the actors' interpretations of the characters?
- Should film adaptations use the same actors as the stage production? What are the advantages and disadvantages? (For example, Joel Grey's Emcee in *Cabaret* or Rosalind Russell in *Auntie Mame*.)
- How did changes in setting and expanding the production outward enhance or take away from the story? (For example, *Butterflies Are Free* changes the location from New York to San Francisco and adds in an obligatory 1960s psychedelic shopping montage.)
- How did editing enhance the telling of the story?

Make sure that your film screening is accessible. Do a sound check once dialogue starts and turn on the closed captioning and/or audio description if available and requested by your students.

Watch a Live Stage Production

Take the class on a field trip to your local theatre. Pick a popular show that is closest to the classroom location. This will make it easier for students to attend and arrange for transportation. To plan a field trip to the theatre:

1. Research all productions that will be running during the course of your class term and coordinate tickets as soon as you have numbers for your classes.
2. If you are going to have students pay for their own tickets, disclose any fee information in your advertising material and course syllabus.
3. Provide all students with information about transportation, parking, accessibility, restrooms, and concessions.

4. Coordinate with the box office of the theatre to ensure students are able to pick up their tickets without difficulty.
5. If you plan to discuss the show immediately after the production, plan a centralized meeting location.

After the show, have your students collect all available reviews of the production you attend and share and discuss them in class. Possible discussion questions:

- How do your opinions differ from or are similar to the reviewers?
- If this is a new play that you have not seen before, how does it relate to other plays that you do know?
- How was the experience of going to the theatre?
- While watching the play, did the set, costume, and lighting design enhance or distract from the production? Did you not notice these elements?
- What acting and directing choices stood out for you?

Watch a Stage Production on Film

Have students decide whether they would rather read the play before or after watching the filmed stage production. Check if there are any filmed stage productions screening at local movie theatres or streaming online during your course and see if there is student interest in attending or viewing them together.

Watch Multiple Versions of the Same Scene

In addition to the above on watching film adaptations, find several different versions of the same play and have students watch a clip from each one. For example, show Act 1 Scene 1 of *The Glass Menagerie* from four famous adaptations with the following actors playing Amanda Wingfield: Gertrude Lawrence (1950); Shirley Booth (1966); Katharine Hepburn (1973); Joanne Woodward (1987).

Create Production Designs

Have students choose a play and create a scenic or costume design for a show. Students may select a color palette, complete a rough sketch of the set, and find examples of costumes. Students then share their design and provide a justification for how their choices enhance the play. You can also have your students create designs that blend two or more influences. You may end up with some interesting choices such as a steampunk *Twelfth Night* in space or *Pal Joey*

with the actors dressed as spiders. The purpose of this exercise is for students to be able to work with disparate forms and learn how to create a new vision for a classic work.

Put on a Puppet Show

Puppetry is a great way for students to get a full production experience on a smaller scale. Puppet stages can be any size, from a shoebox theatre with finger puppets to a full-size stage. Students can build their own portable sets and stages, write their own scripts, and perform their own characters. If they do not have sewing skills, students can create puppets from any object, for example, socks, paper plates, forks and spoons, and so on. They do not even have to modify objects and can perform found object puppetry.

Play a Game

Games can be incorporated into any class. Include facts and figures that provide context for the day's topic.

Name That Tune/Scene/Actor/Production

Create a game where students identify musical tunes, scenes, actors, or productions. While it is best if these games are played with supporting media, you may also provide narrative descriptions. For example, What song does Eponine sing when she confesses her love for Marius to the audience? **Answer:** "On My Own."

Chronology

Have students arrange a group of plays, people, historical events, trends, theatre forms, musicals, and more in chronological order. For example: *Love Suicides of Sonezaki, Hamilton, Doll's House, Death and the Kings Horseman, Life Is Dream.* **Answer:** *Life Is Dream, Love Suicides of Sonezaki, Doll's House, Death and the King's Horseman, Hamilton.*

Matching

Create a matching game where students match:

- The piece of celebrity gossip with the actors/productions.
- The salary with the actor and the role.

- The actor with the role that made them famous.
- All of the actors who have played the same role.

Matching helps with pattern recognition and can help students remember what they learned. This game may also be easier to play because students are given a list of items to match through process of elimination.

Trivia

Play trivia games. You can ask individual questions as part of class discussion or play a multiple round game in teams. A multiple round game could consist of four rounds of five questions, six rounds of ten, and so on, and you can include visual rounds, where players must identify pictures, or rounds using songs from musicals. You can also embed clues depending on your choice of songs ("Bohemian Rhapsody" for *Faust*, etc.). Unless your students are superfans of the topic, give students multiple choices to select the correct answer. Examples (answers in bold):

1. How many years did Goethe spend working on *Faust*?
 a) 5 years
 b) 10 years
 c) 25 years
 d) 50 years

2. Who coined the term "willing suspension of disbelief"?
 a) William Shakespeare
 b) Oscar Wilde
 c) Samuel Taylor Coleridge
 d) Christopher Marlowe

3. Which pope wrote the play *The Jeweler's Shop* which was played at the Westminster?
 a) Pope John Paul I
 b) Pope John Paul II
 c) Pope Benedict XVI
 d) Pope Francis

4. *The Intimate Review* holds the record for the shortest run in West End history. How long did the show run before closing?
 a) Before the end of its first performance
 b) One day

c) Two days
d) Three days

5. On which day of the week do New York theatres NOT have shows?
 a) Monday
 b) Tuesday
 c) Wednesday
 d) Thursday

6. Who was the first person to win a Tony, Oscar, and Emmy in the same year?
 a) Barbara Streisand
 b) Bob Fosse
 c) Whoopi Goldberg
 d) Gene Kelly

7. What is the longest running play in London?
 a) *The Woman in Black*
 b) *Cats*
 c) *The Mousetrap*
 d) *No Sex Please, We're British*

8. Who inspired Bette Davis to become an actor?
 a) Ethel Barrymore
 b) Peg Entwistle
 c) Helen Hayes
 d) Eleanora Duse

9. Historically, what occupation did most stagehands have prior to working in the theatre?
 a) Teamsters
 b) Rail Workers
 c) Stevedores
 d) Sailors

10. Why is it bad luck to whistle in a theatre?
 a) Stagehands used different whistles as signals to move scenery
 b) Ghosts
 c) It's extremely annoying
 d) It signals the end of a work day and means the show will close early

Bring in a Guest Performer

Guest speakers can be brought into class to share their experience doing theatre. This can be done in an interview format, presentation, or a mix of both. There are a variety of ways to get guest speakers:

- When attending a theatre show, stick around for the talkback or opening reception and see if you can meet some people willing to come to your class.
- If you are not attending shows, try contacting artists via e-mail and see if they are willing to come.
- Contact members of local student and community theatre groups and invite them to visit your class.
- Find out who the theatre instructors are at your college and see if they are interested in guest speaking.
- If you are a practicing artist, you can do a demonstration or talk about your own work. *This might be awkward depending on what you do and how much you want to share your work.*

Do remember that guest speakers may have to be preapproved by your program.

Discussions

When thinking about discussion questions, come up with different types of questions that engage course participants in multiple ways. General questions to ask are:

- Which version of the play/film did you like better? Why?
- Which version stuck closer to play?
- How did the actors portray each character?
- How did each actor's interpretation change the interpretation of the story?
- How did each film make you feel?

Critical

Have students think about what they are seeing and why. Examples: How are gender roles presented by the characters? What do you think the playwright or director is trying to say by making that choice?

Observation

Have students pay close attention to a performance or text. Examples: What did you notice about the women in the play? Did they have many lines? How did the actors embody their characters? How can you see this physically?

Personal

Have students share their own opinions and experiences. Example: What did you like about the play? Did it remind you of any other show? If you have seen this before, is it exactly as you remember it or did you see something new? Do you know anyone in our own life that is like this character? What is a film or show that you love that is generally considered "bad" or reviewed poorly?

Peer

You may also ask students to come up with discussion questions for each other. This is an excellent way to include students' opinions in the class in a structured format. Questions can be collected individually (anonymously on pieces of paper) or in groups. Students can be split up into small groups or partners, and each group comes up with a question for the entire class to discuss or for one group to answer. While all types of questions can be used for any class size, we have found that certain types of questions are more effective for particular groups:

Type of Question	Entire Class	Large Groups (7 or more)	Small Groups (3 to 6)	Partners
Critical	X	X	X	X
Observation	X			X
Personal			X	X
Student	X	X	X	X

The goal when moderating discussions is for positive engagement and discussions should be structured in a way that it helps students reflect on the topic being discussed. For more information on how to manage discussions, see sections in Chapter 1 on How to Manage Different Personalities and How to Create a Respectful Environment.

Writing Exercises

Writing exercises are a great way to help students gather their thoughts, practice communicating in a concise way, try something creative, and think critically.

Write a Scene

Have students choose two different characters. Ask them to describe the character's age, gender, physical description, and personality traits. Next, have them pick a setting, time of day, and come up with a simple plot. For example, boy meets girl. Using all these details, students write a scene for fifteen minutes. For more scene ideas, see Playwriting Exercises in Chapter 4.

Write a Critique

After reading a play or watching a show, have students write about what they saw or read. For performances (this can be seen live or on film), ask them to consider:

- What did you like about the performance? What was effective?
- What special elements did you notice?
- What did you not like about the performance? What was not effective?
- How did the performance expand your worldview? Was there anything new you learned?
- Was this performance entertaining? Why or why not?

For plays that are read, have students think about:

- How was the play constructed? Was it effective it?
- Were the characters nuanced? If not, did they need to be?
- What is the mood of the play?
- What techniques did the writer use? Did it stick to a genre?
- Was the writer effective in telling a story?
- How did the performance expand your worldview? Was there anything new you learned?
- Was the play entertaining? Why or why not?

Write a Response to a Prompt

General discussion questions can help students who prefer not to vocalize their opinions. You can use the same discussion questions that you will ask verbally in the form of writing. Some examples to help students warm up are:

- What do you like most about going to see the theatre?
- What do you think is the purpose and function of theatre in society?
- What is the message of the play?

Write an Artist's, Writer's, or Director's Statement

Have the students imagine that they are an actor, writer, or director. Ask them to write from the perspective of that artist and have them write about:

- What is your perception of theatre?
- What do you want your theatre to achieve?
- What is your relationship to the audience?
- How will you accomplish these goals?

Write an Audience Reflection

Have students write an autobiographical narrative of their experiences attending theatre. Limit the scope and scale by having them think about the top five most memorable performances they remember. Have students write about:

1. When did they see the performance?
2. Where was the performance?
3. Who did they go with? What was the audience like?
4. What was going on at that time period?
5. What issues did the show discuss?
6. How was the show received by critics, audience, or your friends and family?
7. What was most memorable about the show?

How Do I Run the Course?

Strive to keep a theatre appreciation course engaging, respectful, and fun. Because theatre appreciation is an introductory course, maintain an environment that

helps students with different perspectives feel comfortable no matter the activities or discussions you are doing. Throughout the course, incorporate ways for students to create shared experiences and ensure space for students to voice their perspectives.

How Do We Make Theatre Fun?

Go See Theatre Together

In addition to teaching students new information, experiencing live theatre is an excellent learning and social experience. Theatre is inherently a social artistic form and part of the fun of theatre is going to see it together with others. It is highly recommended that instructors encourage students (who are not already going to see theatre) attend local productions. These experiences, even if they are not "good" productions, can lead to productive and interesting conversations for students.

Organize a W(h)ine Night

Check when local theatre companies are hosting opening night receptions, talkbacks, and community events with food, drink, and opportunities to meet performers or vent about the show.

Bring in Props and Other Projects

When possible, bring in props, old photographs, masks, programs, or anything else tactile that students can see and touch. Contact theatre companies, schools, or libraries to borrow materials for your course.

Make Room for Mistakes

Practice making mistakes early on in the course so that everyone realizes that they do not have to be perfect and are in a supportive learning environment. Start with activities where there is no clear "right" or "wrong" way to perform them. Your students can also explore how artists throughout history have worked through their mistakes. Show videos of productions that received a wide range of interpretations from critics from rave reviews to panning. Share stories of actors' first unsuccessful auditions. Read an unsuccessful first play from a very famous playwright or a famous theatre theory that misinterprets information.

Share Gossip

Celebrity gossip has been around for as long as there have been celebrities. It is popular with many people and will help students remember what the topic is about. Gossip may not be accurate but is a good conversation starter to engage your students and discuss how people are portrayed in narratives throughout history.

Tell Strange Stories and Histories

Weird stories, history, and legends are another way to liven up the learning experience. Everyone enjoys a good story and the stranger it is, the more memorable it will be. Stories can be directly related to theatre or connected with a particular time period. These stories help paint a vivid picture of the context in which theatre took place.

A story I have told my students is about working at the Somerville Theatre, which was originally a vaudeville and repertory house. It is haunted by the ghost of a former ticket taker who enjoys flipping empty seats up and down and bouncing the lights when she enjoys a production. One time, we set up a time lapse camera during an overnight load-in. When we reviewed the footage there was a face that popped up on camera. It being 4 a.m. in an empty theatre my crew and I screamed in fear, but usually she is a friendly presence.

How Do I Manage Difficult Topics?

Be sure your students understand that there are ways to address difficult topics that are inclusive and constructive. Discuss the reasons content warnings exist. Content warnings do not shut down discourse. They exist so that students who need to take a step back from an issue are able to. For example, some students may not wish to attend a discussion about plays dealing with Alzheimer's and dementia, but others may still want to have that discussion. Issuing a topical content warning allows both groups of students to have their needs met. See the Chapter 1 sections on How to Manage Different Personalities and How to Create a Respectful Environment for additional ideas.

How Do I Frame Difficult Historical or Social Contexts?

Theatre is a product of and response to the sociocultural contexts in which it was created and the subject matter can get heavy. There are a variety of ways you can lighten the mood when you are exploring a potentially fraught era. For example:

- Show a musical.
- Have students complete casting activities.
- Play a trivia game about the time period.
- Show a comedy from the time period that comments on the historical period or any comedy that comments on societal issues (i.e., *Clouds* or any Aristophanes play).

How Do I Include All Students in Class Field Trips to the Theatre?

When the class goes to see a performance, some students may not be able to attend due to a variety of extenuating circumstances. If possible:

- Get copies of the script for the students unable to attend so that they can read the play.
- Watch a film version of the show in addition to attending the live show.
- Have students read a scene from the play.
- Have students who attended the production explain the design and directing concepts of the production to the students who did not attend the play and discuss how the characters were interpreted.
- Have students who attended the play share their critiques of the play with the students who did not attend.
- Have students who did not attend bring in reviews of the production and have them share these reviews in class.

What Do I Do if Students Do Not Enjoy the Performance?

Even if students do not enjoy the performance, this should not be an issue. Students generally love to discuss bad productions. People always have more to say when they do not like something. A bad production makes a wonderful example for examining *why* something was bad: What did not work? What could have been tweaked to make the production more successful?

What Do I Do on the First Day?

To introduce the class and assess the knowledge of your students, find out what they like about theatre. Discussion questions:

- What is your favorite play?
- Who is your favorite actor or director?
- What kinds of plays do you prefer? Drama or comedy? Musicals or non-musicals?

- How regularly do you attend plays?
- What are the most memorable experiences you have had attending live theatre?
- What made these experiences memorable?
- How often do you see live theatre?

This may lead to lively discussions where students can share their own experiences, and for others to connect through shared memories. It also gives you an idea of what types of theatre your students may be interested in so that you can tailor the class to them.

To include everyone in the class regardless of their experience with theatre, start with an exploration of the audience. This is the easiest way to encourage discussion and show that theatre is subjective and that there are no "wrong" perspectives. Ask students:

- Why do we attend theatre?
- Where have you seen theatre? Have you attended theatre outside of the USA?
- Why have people historically attended theatre in different parts of the world?
- Who supports theatre and how has it been able to survive as an entertainment and art form for millennia?
- What do you wear to a theatre show? What do you do? What do the other audience members look like? What are behavioral expectations, and how do they vary based on time period and location? Where does the audience sit?
- Do you laugh, cry, or applaud during shows?
- How has the theatre-going experience changed during your lifetime? Has it?

How Do I End a Course?

Endings are just as important as beginnings. You want to leave students wanting to return to your next class. It is your last opportunity to impress these students and make them interested in you as an instructor and the course.

Collect Data

Ask students questions that may not be included in their course evaluation forms:

- What were your biggest takeaways from the class?
- What would you like to see next time?
- Are there any topics covered that you would like to take a full course about?
- What were your favorite parts?
- What was the most fun?

- What surprised you the most? Or what did you experience in the course that was unexpected?

Have Students Share Their Work

The last day is a good time for students to share their own works. If they do not have any original writing, they can bring in a favorite scene or short play they want to share with the rest of the class.

Throw a Party

Coordinate a potluck with your students and:

- Show bloopers from shows.
- Share gossip about actors and talk about theatrical myths and stories. Hint: try to find material about topics you want to teach in your next course.
- Do a musical singalong. Have students pick the film beforehand.

Show Your Appreciation

Thank them for their time and let them know that you had a good time teaching the class. It makes a big difference to say this.

What Do I Include on the Syllabus?

Course Descriptions

Course descriptions may be used as marketing material for your class. The course descriptions for older adult classes are different from credit courses at colleges and should have a welcoming tone. Remember, your students must *want* to take your course to sign up. Your course description, and syllabus as a whole, may be the primary way you attract students. Have a friend or family member (or maybe even a complete stranger if you're brave and adventurous) look at your course description and give you feedback. They will be able to tell you if your course sounds interesting and if they would want to take it. Remember to:

- Keep the writing simple and easy to follow.
- Be concise.

- Make the description no longer than one paragraph (about a third of the page).
- Use easy to read font (at least twelve point or higher).

Avoid:

- Using lots of jargon.
- Filling the entire page.
- Writing long sentences.
- Using small point font.

Be sure to include information about the course:

- Contents.
- Structure.
- Activities.

Keep the tone:

- Approachable.
- Fun.
- Engaging.

Learning Objectives and Outcomes

You can choose to include learning objectives and outcomes on your syllabus or not. This depends on whether your program requires them. You may also want to consider whether learning objectives and outcomes will help draw more students to attend your classes or not. Some students might be deterred by the "seriousness" of the class if they see a whole list of objectives and outcomes and others may not. Regardless of whether you include them on the syllabus or not, be sure that you create objectives and outcomes for yourself. Have a clear idea for yourself what your own goals are for teaching the course and what you want your students to get of it. This will help frame your class and keep you on track.

What Are Learning Objectives?

Learning objectives state what students will do in the course. For example:

- Identify main elements of theatre including drama, production, and stagecraft.
- Apply theatre terms in discussions.

- Analyze and critique theatre performances and theatre text.
- Describe current trends in theatre.
- Define the origins of theatre.

What Are Learning Outcomes?

Learning outcomes are what students take away from the activities and discussions in the course. For example:

- Collaboration with arts, peers, and people from different generations and backgrounds.
- Reduced stress and increased confidence through applied creativity.
- Expanded community network.
- Increased appreciation for theatre.
- Increased quality of life.

Class Format

Help students prepare for class by telling them what to expect. Tell them what the format of the class will be. For example:

1. Overview of the day's activities.
2. Introduce topic.
3. Present questions for discussion.
4. Students' discussion.
5. Activities.
6. Summary of class or students share what they've learned.

Weekly Schedule

Provide students with a weekly schedule of topics the course will cover. This will help students get excited about attending class each week. Include a note that the schedule may change so students will not be surprised if you decide to modify the agenda.

Content Warnings

There may be difficult topics that come up when talking about productions. Make a note when your course includes material that may be controversial or distressing. This can be as simple as stating "this film contains brief nudity" or "this play contains violence."

Class Etiquette

Describe the expectations for students clearly. This may seem obvious to you, but students may need best practices reminders for course interactions and sharing the space with others. For example:

- Refrain from talking when the instructor is giving instructions.
- If you arrive late or leave early, please try your best to do so quietly and not disrupt the class.
- Show respect. Give your full attention when others are speaking and provide productive comments in class discussions.
- Be kind. We are in a learning environment and have different perspectives, knowledge, and experiences.
- Share the space with others. Sometimes we may feel passionate about a topic and unintentionally dominate discussions. Be mindful of others in the course and give your classmates a chance to contribute.

Additional Syllabus Items That May Be Required

There may be other important items you may need to include in your syllabus depending on your program, institution, or facility. Find out what guidelines they want you to follow and inform students about them. For example:

- European Accessibility Act, Americans with Disabilities Act (ADA), Disability Discrimination Act (DDA), or other official compliance information.
- Emergency procedures.
- Official catalogue course description (if different from your marketing de scription).

Sample Syllabi

Class activities are highlighted below. Do not include the activity guidelines in the printed syllabus for students. Their version of the weekly schedule should instead list the topics of the day and include dates of any performances or special events. All activities are for entire class unless noted. Instructors may need to introduce topics to set up activities.

THEATRE APPRECIATION

GOING TO THE THEATRE

Course Overview: Find out what it takes to put on a show and why some shows become classics while others flop. Throughout this course, we will read plays, watch films, attend productions, and discuss the ins and outs of producing theatre and the audience experience. Join as we explore theatre by watching professional, amateur, and touring shows in town.

Note: This syllabus is based on a hypothetical season. Please use plays based on your local productions.

Weekly Schedule

Week One: Playwrights

PRE-ACTIVITY DISCUSSION: What playwrights are you familiar with?

ACTIVITY: Watch clips from documentary, *Giving Voice*.

POST-ACTIVITY DISCUSSION: What does it take to be considered "famous" as a playwright?

Week Two: August Wilson

PRE-ACTIVITY DISCUSSION: What inspires you to create art?

ACTIVITY: Introduce August Wilson's inspiration for the play, Romare Bearden's painting *The Piano Lesson*. Read Act I of *The Piano Lesson*.

POST-ACTIVITY DISCUSSION: How would you describe each of the characters? What do we know about their backstories? How do you relate to them?

Week Three: August Wilson Cont'd

PRE-ACTIVITY DISCUSSION: What do you expect from the show?

ACTIVITY: Watch *The Piano Lesson* at the theatre before attending class.

POST-ACTIVITY DISCUSSION: Did the production meet your expectations of the play? Why or why not? What did the performance do differently than the script? Was it effective in conveying the message of the play?

Week Four: New Playwrights; Duncan Macmillan

PRE-ACTIVITY DISCUSSION: What are the most and least elaborate shows that you have seen? What made them successful or not?

ACTIVITY: Read publicity materials of *Lungs* production.

POST-ACTIVITY DISCUSSION: What is the genre and story? For new playwrights that you're unfamiliar with, what would attract you to see a show?

Week Five: New Playwrights; Duncan Macmillan Cont'd

PRE-ACTIVITY DISCUSSION: What are your expectations of the show from reading the publicity materials?

ACTIVITY: Watch *Lungs* at the theatre before attending class.

POST-ACTIVITY DISCUSSION: Did the production meet your expectations of what was advertised? Why or why not? What surprised you about the show?

Week Six: World Classics; William Shakespeare

PRE-ACTIVITY DISCUSSION: What Shakespeare plays have you seen? Should Shakespeare be modernized for today's audience? What do you like/dislike about Shakespeare productions?

ACTIVITY: Watch experimental Shakespeare productions directed by Ariane Mnouchkine, Punchdrunk, and Yukio Ninagawa.

POST-ACTIVITY DISCUSSION: Why is Shakespeare still performed today?

Week Seven: *Romeo and Juliet*

PRE-ACTIVITY DISCUSSION: What makes *Romeo and Juliet* a timeless or universal story? Is it?

ACTIVITY: Watch clips from film adaptations of *Romeo and Juliet* by Baz Luhrmann and Franco Zeffirelli.

POST-ACTIVITY DISCUSSION: How are the different adaptations reflections of the time periods in which they were made?

Week Eight: *Romeo and Juliet* Cont'd

PRE-ACTIVITY DISCUSSION: How would you like to see *Romeo and Juliet* staged today?

ACTIVITY: Read reviews of current and past productions.

POST-ACTIVITY DISCUSSION: What elements are included in the review? What do you learn about the production? What is attractive about the production?

Week Nine: *Romeo and Juliet* Cont'd

PRE-ACTIVITY DISCUSSION: Why do you think this theatre has decided to stage *Romeo and Juliet*?

ACTIVITY: Watch *Romeo and Juliet* at the theatre before attending class.

POST-ACTIVITY DISCUSSION: How did this production modernize the play? What was the vision for the play?

Week Ten: Musicals

PRE-ACTIVITY DISCUSSION: Why are musicals popular?

ACTIVITY: Watch film clips of story-advancing or character-revealing songs from *Gentlemen Prefer Blondes*, *Cabaret*, *Carousel*, and *Hedwig and the Angry Inch*.

POST-ACTIVITY DISCUSSION: How does music help tell the story? What does music do differently than dialogue?

Week Eleven: *The Producers*

PRE-ACTIVITY DISCUSSION: What do you think about the phenomenon of a film being adapted into a musical, then into a stage musical, and then adapted again *from* the stage musical into a film?

ACTIVITY: Watch clips from both the original film and the film of the musical version of *The Producers*.

POST-ACTIVITY DISCUSSION: What do you learn about theatre production from this musical? What comedic elements does the musical employ?

Week Twelve: *The Producers* Cont'd

PRE-ACTIVITY DISCUSSION: What do you like most about attending theatre shows?

ACTIVITY: Watch *The Producers* and stay for talkback at the theatre before attending class.

POST-ACTIVITY DISCUSSION: What did you learn about the production from the talkback? Did it change your experience of the show? How has your perspective of theatre changed?

BACKSTAGE: ELEMENTS OF THEATRE PRODUCTION

Course Overview: What goes on behind the scenes in putting together a theatrical production? What does it take to put on a show to a public audience? Why do people tell actors to "break a leg?" and why should you never whistle in a theatre? This course answers these questions and more. Join us as we explore the theatre-going experience from audience, performer, and production perspectives. Find out what makes a show successful, the role critics play, and how you can better appreciate theatre. We will watch films, read plays, discuss critiques, and share our own experiences.

Weekly Schedule

Week One: What Is Theatre?

PRE-ACTIVITY DISCUSSION: What are your most memorable theatre experiences? What are three things you hope to get out of this course?

ACTIVITY: Play a trivia game about the different elements of theatre.

POST-ACTIVITY DISCUSSION: What are three things you hope to get out of this course?

Week Two: Acting

PRE-ACTIVITY DISCUSSION: What is acting? Who is your favorite actor? Why?

ACTIVITY: Warm-Ups; Tongue Twisters; Balancing Circle; Bodyguard and Assassin; Read a Label. (*See Performance Exercises in Chapter 5 for additional details.*)

POST-ACTIVITY DISCUSSION: What were you thinking about when you were doing these activities? What made the games difficult? What was unexpected?

Week Three: Directing

PRE-ACTIVITY DISCUSSION: What is directing? Who is your favorite director? Why?

ACTIVITY: (Small Groups) Direct a "vague" theatre scene (*Cambodian Rock Band*, *Far Away*, or *The Aliens*) in three different ways. Share with class.

POST-ACTIVITY DISCUSSION: What were you thinking about when you were doing these activities? What new elements did you see in the play with each directing style? Which style did you enjoy the most? Which style was most effective?

Week Four: Production Design and Technicians

PRE-ACTIVITY DISCUSSION: Who do you need to put on a theatre show?

ACTIVITY: (Small Groups) Choose a play. Create a design and directing concept for it and describe the set, costume, and lighting designs. Share with class.

POST-ACTIVITY DISCUSSION: How did your design process go? What did you like about your classmates' designs? What stood out to you?

Week Five: Playwriting

PRE-ACTIVITY DISCUSSION: What makes a great play? How is playwriting different from other types of writing?

ACTIVITY: (Individual) Imagine a character you do not like. Think about all the physical details and personality traits and write down as many as possible in five minutes. *Instructor then provides every other line of dialogue to the entire class and each student uses the character they developed to write their own play with instructor. See Playwriting Exercises in Chapter 4 for full description.*

POST-ACTIVITY DISCUSSION: What did you like about each play? What was unexpected about the exercise? What did you learn about the characters from the way they talked?

Week Six: Theatre Critics

PRE-ACTIVITY DISCUSSION: What plays or films that you love have gotten horrible reviews? What plays and films that you hate have gotten great reviews? Why do you think these works were reviewed the way they were and why do you disagree with the reviews?

ACTIVITY: Watch clips from *The Man Who Came to Dinner*, *All About Eve*, and *Laura*.

POST-ACTIVITY DISCUSSION: How do theatre critics shape popular culture? Why are critics considered by some as the arbiter of good taste? What critics would you consider as cultural icons? Why?

Week Seven: Acting Styles

PRE-ACTIVITY DISCUSSION: How would you describe your favorite actor's acting style? What do you know about their work or life?

ACTIVITY: (Individual) Writing exercise. Answer the following:
1. What is "good" acting?
2. Who or what is important to you in acting? Accuracy? Feeling? Emotion?
Share with class.
POST-ACTIVITY DISCUSSION: Which style did you find most interesting? How does understanding acting styles change your own perspective on theatre?

Week Eight: Production Companies and Producing Models (Economics of Theatre)

PRE-ACTIVITY DISCUSSION: What is community theatre vs. regional theatre vs. Broadway vs. national touring companies? What role do unions play in theatre as a business?
ACTIVITY: (Small Groups) Develop an idea to produce a show. Answer the following:
1. What type of show would you produce?
2. How would you get audiences to see your show?
3. How much would you charge?
4. Are you going to hire professional/union/amateur actors?
5. How are you going to finance the show?
Share with class.
POST-ACTIVITY DISCUSSION: What was most challenging about the production process? What did you learn from other production ideas? What would you do differently next time?

Week Nine: Film Adaptations

PRE-ACTIVITY DISCUSSION: What is your favorite film adaptation of a play?
ACTIVITY: (Small Groups) Choose a play to adapt into film. Think about:
1. What actors would you cast in it?
2. Who will direct it?
3. If the play has already been adapted into a film, why do you want to produce a new adaptation? And what would the new interpretation look like?
POST-ACTIVITY DISCUSSION: Which group's adaptation was your favorite and why? What was your favorite part of that adaptation? How did the adaptation's choices help you see the story in a new way?

Week Ten: Watching Theatre

ACTIVITY: Go see a play. *Work with a local theatre company or school to secure a block of tickets. Make sure the theatre is accessible! Have an alternate activity for students who are unable to attend the production. If there is a film adaptation they can watch, have them view it or read the script.*

POST-ACTIVITY DISCUSSION: What did you experience? What did you enjoy most about the performance? Why? What did you enjoy least about the performance? Why?

Week Eleven: Writing Reviews

PRE-ACTIVITY DISCUSSION: What are the elements of a theatre review?

ACTIVITY: (Individual) Write a review of a play from the previous week. Answer the following:

1. What did you think of the design, directing, acting, and so on?
2. Did all elements come together as a whole?
3. Were there parts that did not come together and distracted you?
4. What was the overall message of the show?

POST-ACTIVITY DISCUSSION: Share reviews with the class.

Week Twelve: Theatre and the Other Performing Arts

PRE-ACTIVITY DISCUSSION: What is theatre? Is performance art theatre? How is theatre related to other art forms?

ACTIVITY: Watch YouTube videos of Karen Finley, Tigger, Diana Oh, and William Pope.L.

POST-ACTIVITY DISCUSSION: Is performance art theatre? What would you do for a performance art piece?

WORLD THEATRE

Course Overview: Join us as we explore theatre from Asia, Europe, and beyond. Theatre is a diverse art form that comes in many different styles. From puppetry to improvisation, theatre is more than just actors talking on a well-lit stage as audiences sit in the dark. Theatre is a communal experience that brings artists and non-artists together. We will watch films, read plays, and discuss the history, influences, and significance of theatre forms around the world.

Weekly Schedule

Week One: Introduction to World Theatre and *Commedia dell'arte*

PRE-ACTIVITY DISCUSSION: What is your favorite type of theatre? What is the most memorable theatre experience you have had? What types of theatre have you seen outside of the USA?

ACTIVITY: Watch documentary on *commedia dell'arte* history in Italy and Europe.

POST-ACTIVITY DISCUSSION: What new things did you learn about theatre from *commedia*?

Week Two: *Commedia dell'arte*

PRE-ACTIVITY DISCUSSION: What are some examples of *commedia* archetypes that you see in contemporary film/plays/television? How are archetypes different from stereotypes?

ACTIVITY: Read and watch scenes from *The Servant of Two Masters*; (Small Groups) Create a different version of *The Servant of Two Masters* set in a new time period and region. For example, 1920s Chicago.

POST-ACTIVITY DISCUSSION: What archetypes does *The Servant of Two Masters* use? How did you adapt your archetypes? Did they become stereotypes? Why?

Week Three: *Commedia dell'arte* Cont'd

PRE-ACTIVITY DISCUSSION: How do theatre artists use *commedia* in their works today? What are some advantages to using these improvisational styles?

ACTIVITY: Watch clips from San Francisco Mime Troupe and The Second City; (Individual) Create a contemporary *commedia* archetype. Share with partners and class.

POST-ACTIVITY DISCUSSION: How do these contemporary *commedia* archetypes look different than stereotypes? How was the story enhanced by the use of these characters?

Week Four: Presentational Forms; *Kabuki, Nō, and Kyōgen*

PRE-ACTIVITY DISCUSSION: Does acting need to be realistic in order for it to be effective?

ACTIVITY: Watch documentary web video "Nippon—The Tradition of Performing Arts in Japan"; (Individual) Line up and do a *mie* (*kabuki* dramatic pose) one at a time; Read *kyōgen* play *Mushrooms*.

POST-ACTIVITY DISCUSSION: Like *commedia*, all of these forms have their own archetypal characters; what connections do you see between all of the forms (masks, stylized movements, costuming, etc.)? How are the acting techniques different?

Week Five: Presentational Forms Cont'd; *Xiqu*

PRE-ACTIVITY DISCUSSION: What is an example of something that was misinterpreted and became a new idea? What is the value of the misinterpretation?

ACTIVITY: Watch documentary video "What It Takes to Be a Chinese Opera Singer" and any clips from a Beijing opera production of *Monkey King*; Read Brecht's "Alienation Effects in Chinese Acting."

POST-ACTIVITY DISCUSSION: What similarities do you see between traditional Chinese theatre and traditional Japanese theatre? How is their training different from what you know about performers today? How does Brecht (mis)interpret *xiqu* (Chinese opera)?

Week Six: Presentational Forms Cont'd; Balinese Dance

PRE-ACTIVITY DISCUSSION: What are some rituals that are based around holidays?

ACTIVITY: Watch documentary video "Three genres of traditional dance in Bali"; Read Antonin Artaud's essay "On the Balinese Theatre."

POST-ACTIVITY DISCUSSION: What is the relationship between theatre and religion? Does theatre need to be merely entertainment? Why or why not? How does Artaud (mis)interpret Balinese dance? Is it okay for audiences to see theatre they know nothing about and make their own (mis)interpretations? Why or why not?

Week Seven: Puppetry; Shadow Puppet Theatre

PRE-ACTIVITY DISCUSSION: How do different cultures use shadow puppetry to tell stories? How are they different from watching live actors?

ACTIVITY: Watch clips from *Angkor Awakens* and *Sita Sings the Blues*.

POST-ACTIVITY DISCUSSION: Why is puppetry more popular with adults in Asia than the USA? Why is puppetry considered a child's activity in the USA?

Week Eight: Puppetry; Japanese *Bunraku*, Marionettes, and Rod Puppetry in Russia and the Americas

PRE-ACTIVITY DISCUSSION: How does Russian puppet theatre combine both traditional western puppets (marionettes and hand puppets) and traditional Asian puppets (rod puppets)?

ACTIVITY: Introduce *bunraku*, marionettes, and rod puppetry and watch clips of each form. (Individual and Small Groups) Make three to five puppets and act out a folktale using the puppets. Share with class.

POST-ACTIVITY DISCUSSION: What was it like performing with a puppet? How did the puppets help tell your folktales?

Week Nine: Puppetry; Punch and Judy, The Muppets, Lunatique Fantastique

PRE-ACTIVITY DISCUSSION: How have the Muppets survived for over 50 years?

ACTIVITY: Watch clips from Punch and Judy, *The Muppet Show*, Lunatique Fantastique, and *Jim Henson's Creature Shop Challenge*.

POST-ACTIVITY DISCUSSION: How has American traditions of puppetry influenced theatre? What is the impact of The Muppets in American culture? How does Lunatique Fantastique's use of objects as puppets help explore difficult topics? How do the Punch and Judy archetypes link back to other archetypes we've discussed this semester?

Week Ten: Musicals

PRE-ACTIVITY DISCUSSION: What musicals do you know that are adaptations of historical events?

ACTIVITY: Watch clips from *1776* and *Hamilton*; (Small Groups) Pick a historical event to transform into a musical. Share with class.

POST-ACTIVITY DISCUSSION: *1776* won the Tony over *Hair* in 1969; how is this reflective of the tumultuous time period in which these plays premiered? What are your thoughts on the incorporation of letters and speeches into songs? How does *1776* connect to *Hamilton*?

Week Eleven: Vaudeville

PRE-ACTIVITY DISCUSSION: What is vaudeville?

ACTIVITY: Read and watch George Abbott and Philip Dunning's *Broadway*.

POST-ACTIVITY DISCUSSION: Why was vaudeville popular and why did it stop being popular? Where are elements of vaudeville still visible in popular culture?

Week Twelve: "Realistic" Drama

PRE-ACTIVITY DISCUSSION: Should playwrights write dialogue that sounds exactly like how people speak?
ACTIVITY: Read and watch excerpts from *Glengarry Glen Ross*; (Individual/Partners) Write a "realistic" workplace dramatic scene. Share with class.
POST-ACTIVITY DISCUSSION: Should playwrights write dialogue that sounds exactly like how people speak?

ACTORS AND DIRECTORS

Course Overview: Actors and directors are the most visible collaborators in theatre productions. You will frequently hear discussion of actors "owning" roles in original or well-known productions, or that every actor *must* play Hamlet at some point to prove their artistic mettle. Actors and directors receive credit for orchestrating productions when they are successful or take blame when a production is a failure. What makes actors and directors so alluring? Why do people still like them even though we hear about their bad "diva" behavior? And how much influence do actors and directors have in developing a production? Come share your perspective on these topics and more as we learn about the power of the actor and director on stage.

Weekly Schedule

Week One: Putting on a Show; Theatre Artists and Collaborators

PRE-ACTIVITY DISCUSSION: What is involved in a theatre production? Who is hired and what do they do? What happens behind the scenes before and during productions? Who should get credit for the show?
ACTIVITY: Watch clips from *42nd Street*, *Chorus Line*, and *Slings & Arrows*.
POST-ACTIVITY DISCUSSION: What did you learn about the production process from these works? How realistic do you think these portrayals of theatre production are?

Week Two: Actors

PRE-ACTIVITY DISCUSSION: Who's your favorite actor? What makes them appealing? Why do male actors usually get top billing? Why do they get paid more?

ACTIVITY: (Individual/Partner/Small Groups) Play matching games:

1. Match the salary with the actor and the role.
2. Match actor with the role that made them famous.
3. Match all of the actors who have played the same role.
4. Identify the not so famous film actor (but superb theatre actor).

POST-ACTIVITY DISCUSSION: Who are some actors who've become defined by a single role? Which actor's portrayal of each character do you prefer?

Week Three: Actors Cont'd

PRE-ACTIVITY DISCUSSION: Who is your favorite actress? What plays have you seen that featured a female lead? What was the role? How was this character depicted? For example, were they smart, funny, or a damsel in distress?

ACTIVITY: Watch clips from *My Fair Lady*, *North by Northwest*, and *The Age of Adaline*.

POST-ACTIVITY DISCUSSION: What actresses have maintained a career over several decades? How have their careers changed while those of their early male costars have stayed the same? What plays have you seen that have more females than males in the cast?

Week Four: Actor Training

PRE-ACTIVITY DISCUSSION: What actor training methods have you heard of? Which actors are associated with these forms? Should all actors study acting?

ACTIVITY: Introduce Stanislavski and The Method; Practice a Chekhov acting exercise (Push/Pull, Expand/Contract); Watch documentary on Uta Hagen and Group Theatre.

POST-ACTIVITY DISCUSSION: How did the (mis)interpretation of the Stanislavski method influence American theatre? Which training method do you think is most effective?

Week Five: Sir Ian McKellen

PRE-ACTIVITY DISCUSSION: In what films have you seen Sir Ian McKellen? What makes him popular? What "techniques" do you see in his performances?

ACTIVITY: Watch clips from *Inside the Actors Studio* and *King Lear*.

POST-ACTIVITY DISCUSSION: How has your perspective changed about Ian McKellen? How does learning about the actor's perspective impact how you view their acting?

Week Six: Ethel Merman and Chita Rivera

PRE-ACTIVITY DISCUSSION: Ethel Merman and Chita Rivera had long careers spanning 50 years, from Broadway to film. Why were Merman and Rivera so popular?

ACTIVITY: Watch clips of Merman in the 1930s as an ingénue, at the height of her career in *Annie Get Your Gun* and *Gypsy*, and at the end of her career parodying herself in *Airplane!* at the end of her career; Watch clips of Rivera in *West Side Story*, *Anything Goes*, and *Kiss of the Spider Woman*.

POST-ACTIVITY DISCUSSION: What does it take to become a legend on Broadway? Why were Merman and Rivera so popular?

Week Seven: Directors

PRE-ACTIVITY DISCUSSION: What directors are you familiar with? What do directors do? How much influence do they have in a production? What happens when directors and actors disagree?

ACTIVITY: (Individual/Partners/Small Groups) Play trivia games:

1. Match the director with the show.
2. Match the director with their photo.

POST-ACTIVITY DISCUSSION: How did you do at the matching game? Who did you not recognize? What do you know about these directors? What was memorable about their works?

Week Eight: George C. Wolfe, Musicals, and More

PRE-ACTIVITY DISCUSSION: What is the benefit of writers directing their own work? Should playwrights direct their own work? Why or why not?

ACTIVITY: Watch clips from *Jelly's Last Jam, Bring in 'da Noise, Bring in 'da Funk, The Wild Party, Ma Rainey's Black Bottom*, and *Angels in America: Millennium Approaches*.

POST-ACTIVITY DISCUSSION: How do Wolfe's productions challenge conventions of narrative storytelling? How does Wolfe address narratives of history? What do you think it takes to win a Tony, Obie, or other major theatre award?

Week Nine: Peter Brook, Ariane Mnouchkine, and Cultural Appropriation

PRE-ACTIVITY DISCUSSION: Should art be separated from the artists' personal history? What is cultural appropriation? What is Orientalism? Can we borrow from other cultures without appropriating?

ACTIVITY: Read accounts about production of Peter Brook's *Mahabharata*; Watch clips from Théâtre du Soleil productions.

POST-ACTIVITY DISCUSSION: How do the theatrical reviews differ from the scholarly criticisms of *Mahabharata*? What examples of commercially successful, yet "bad" productions can you think of? How do Brook and Mnouchkine appropriate Asian culture?

Week Ten: Julie Taymor and Puppetry (and Cultural Appropriation)

PRE-ACTIVITY DISCUSSION: What do you think of when you hear *Spider-Man: The Musical*? Which versions of the *Lion King* have you seen? What is the most "un-Shakespearean" Shakespeare adaptation you have seen?

ACTIVITY: Watch clips from *Lion King*, *Oedipus Tyrannus*, *Titus Andronicus*, and (parodies of) *Spider-Man*.

POST-ACTIVITY DISCUSSION: Sometimes Taymor's directing results in the most financially successful production in musical theatre history, and other times her productions fail catastrophically. Why do you think this happens?

Week Eleven: Actor and Director Collaborators; Bob Fosse and Gwen Verdon

PRE-ACTIVITY DISCUSSION: How can dysfunctional relationships lead to exciting dramatic collaborations?

ACTIVITY: Watch clips from *Chicago*, *Damn Yankees*, *Sweet Charity*, and *All That Jazz*.

POST-ACTIVITY DISCUSSION: What happens when an actor and director become permanently associated with each other?

Week Twelve: Actor and Director Collaborators Cont'd; The Burton/Gielgud and O'Toole/Olivier *Hamlet*s

POST-ACTIVITY DISCUSSION: Why do you think Hamlet is the "ultimate" male acting role?

ACTIVITY: Watch multiple versions of the Ghost scene in *Hamlet*; (Small Groups) Cast a production of *Hamlet* and choose directors.

POST-ACTIVITY DISCUSSION: How is *Hamlet* radically different depending on the actor and director?

SOMETHING FOR EVERYONE: THEATRICAL GENRES

Course Overview: From tragedies to comedies, musicals and experimental forms, join us as we explore theatrical styles and genres throughout history that have made audiences laugh, cry, or wonder why they went to see the show. What makes a comedy funny? Why do audiences like revenge dramas? And why are jukebox musicals so successful? Learn the answers to these questions and more as we discuss your own theatrical experiences and why audiences keep coming back for more. We'll watch videos, read plays, practice acting exercises, and create our own theatre.

Weekly Schedule

Week One: Greek Tragedy

PRE-ACTIVITY DISCUSSION: What is your favorite Greek myth or character? Why?

ACTIVITY: Play trivia games matching contemporary stage, film, or television characters to Greek mythological figures and Gods; Watch documentary on Greek Tragedy and *Oedipus*.

POST-ACTIVITY DISCUSSION: How are the origins of western theatre related to tragedy? What was its function? Does tragedy have a function in our society today?

Week Two: Chinese Drama

PRE-ACTIVITY DISCUSSION: Can all plays be categorized as either comedy or tragedy? Why or why not?

ACTIVITY: Watch *Orphan of Chao*.

POST-ACTIVITY DISCUSSION: How is *Orphan of Chao* similar to and different from tragedy? What genre would you use to describe this play? What do you think is the appeal of this play? Why do you think this play remains popular and is produced around the world?

Week Three: Psychological Drama

PRE-ACTIVITY DISCUSSION: What plays have you seen that could be considered psychological dramas? Why do you think it's popular?

ACTIVITY: Watch *Gaslight*; (Individual/Partners/Small Groups) Write a plot for a psychological drama.

POST-ACTIVITY DISCUSSION: What examples from your own life are similar to *Gaslight*? How has the central premise of *Gaslight* become shorthand for talking about psychological abuse (gaslighting)? What are your reactions to the three main characters? Do you identify with any of the characters? Why or why not?

Week Four: Comedies; High Brow, Low Brow

PRE-ACTIVITY DISCUSSION: What type of humor do you like? What do you see in popular media today? What films, television, and stand-up comedians do you like? Which ones do you dislike? What actors do you find funny?

ACTIVITY: (Partners/Small Groups) Tell a funny story or joke; Read *For Whom the Southern Belle Tolls*; Nominate plays that should be parodied.

POST-ACTIVITY DISCUSSION: What was funny about the jokes and plays? How does analyzing *why* something is funny ruin the humor?

Week Five: Comedies; Comedy of Manners

PRE-ACTIVITY DISCUSSION: What are the components of comedy of manners? Who do the characters portray?

ACTIVITY: Watch or read *An Ideal Husband*; (Individual/Partners/Small Groups) Write a comedy of manners scene of going to the theatre where a character does everything. Think about where you should sit, when you should talk, what you do at intermission, and so on. Share with class.

POST-ACTIVITY DISCUSSION: How does *An Ideal Husband* satirize social conventions? How were the social conventions in your play different from others?

Week Six: Comedies; Political Humor

PRE-ACTIVITY DISCUSSION: What role does humor play in addressing political issues? Should theatre be political or used to address sociocultural issues?

ACTIVITY: Read scenes from *The Reincarnation of Rama*; (Small Groups) Create a political theatre sketch from current events. Share with class.

POST-ACTIVITY DISCUSSION: How is humor more effective than drama for discussing social issues?

Week Seven: Tragicomedies, Dark Comedies, and Schadenfreude

PRE-ACTIVITY DISCUSSION: What terrible things have you laughed at, but knew you shouldn't?

ACTIVITY: Read or watch *The Real Inspector Hound* and *Loot*.

POST-ACTIVITY DISCUSSION: Can murder and funerals be funny? What clichés does Tom Stoppard parody in his metatheatrical murder mystery comedy? How does the violent murder of Joe Orton overshadow his dark comedies?

Week Eight: Musicals; Early History of Musical Theatre

PRE-ACTIVITY DISCUSSION: What musicals/operas are you familiar with? Why do you think those musicals/operas continue to be popular or are no longer popular?

ACTIVITY: Play Name that Musical; Watch Part I of *Broadway: The American Musical*.

POST-ACTIVITY DISCUSSION: How did the genres of opera, operetta, cabaret melodrama, music hall, burlesque, revues, and vaudeville combine to form musical theatre in the late nineteenth/early twentieth century?

Week Nine: Musicals; Jukebox Musicals

PRE-ACTIVITY DISCUSSION: How are jukebox musicals a throwback to musicals of the 1920s and 1930s, where the plot exists as a bridge between songs (i.e., *All Shook Up*, *Across the Universe*, or *Beautiful: The Carole King Musical*) or, sometimes, have no plot at all (i.e., *Ain't Misbehavin* or *Smokey Joe's Cafe*)? How are these different from musicals where the songs further the plot?

ACTIVITY: Watch clips from a jukebox musical; (Small Groups) Create a jukebox musical. Choose five song and dance numbers that will be in the musicals and "sell" it to the class.

POST-ACTIVITY DISCUSSION: Which elements make a successful jukebox musical? Which one of your classmates' jukebox musicals would you pay money to see? Why?

Week Ten: Musicals; Broadway Stars and Starlets

PRE-ACTIVITY DISCUSSION: Who are your favorite actors? Who would you cast in a film adaptation of a given musical?

ACTIVITY: Watch CBS interview with Marni Nixon; Watch clips from *King and I*, *West Side Story*, *My Fair Lady*, and *The Greatest Showman*.

POST-ACTIVITY DISCUSSION: Should ghost singers be used in film adaptations of musicals? Why or why not?

Week Eleven: Experimental Theatre; Surrealism, Dada, Existentialism, *Butoh*

POST-ACTIVITY DISCUSSION: Surrealism and Dada were responses to the First World War, Existentialism and *butoh* were responses to the Second World War; what are other, more contemporary examples of art in response to war?

ACTIVITY: Read excerpts from *The Spurt of Blood*, *Waiting for Godot*, and *Funnyhouse of a Negro*; Do a *butoh* exercise: close one hand into a fist and slowly open your hand, concentrating on the hand movement.

POST-ACTIVITY DISCUSSION: How do the works function as social commentary (or as reflections of time and place)?

Week Twelve: Experimental Theatre; Theatre of the Absurd

PRE-ACTIVITY DISCUSSION: Do plays need plots?

ACTIVITY: Read *Philip Glass Buys a Loaf of Bread* and excerpt from *The Bald Soprano*; Write an absurdist scene with each student contributing a new line. Students may intentionally repeat lines or interpret the previous line as broadly as possible. Do four rounds. Read scene.

POST-ACTIVITY DISCUSSION: How do lines stay interesting even though it repeats? How do absurdist plays discuss themes or issues? Why do you think artists and audiences are attracted to absurdist theatre? What function does this form play in society?

THEATRE AS FILM

Course Overview: Film and theatre are two distinct yet related art forms. View some of the most famous adaptations of theatre on film, learn the history of these productions, and share your interpretations of these classic works. We will explore themes, character, plot, dramatic strategies, genre, and more. Throughout the course we will address the following questions: What makes adaptations of plays into film successful? What role do actors and directors play in the adaptation process? How do the film adaptations change the story of the play?

Note: Activities each week will be watching clips from the films listed in week headings.

Weekly Schedule

Week One: *The Importance of Being Earnest*

DISCUSSION: The 1952 film adaptation of *The Importance of Being Earnest* treats the story very much like a filmed stage play. The 2002 film version is more cinematic and includes special effects, fantasy sequences, multiple locations, and so on. What are the merits of both?

Week Two: *Chi-Raq*

DISCUSSION: What elements of Greek comedy do you see in this film? How has comedy changed? Does this story still work as a comedy with the new plot of gang violence in Chicago?

Week Three: *M. Butterfly*

DISCUSSION: How does the play address the problem of Orientalism? Song Liling observes that only a man can play the perfect woman. Do you agree or disagree? Why or why not? How does the real-life case of Shi Pei Pu and Bernard Boursicot differ from the fictionalized characters of Gallimard and Song Liling? Are the characters portrayed realistically? What does that mean?

Week Four: *A Streetcar Named Desire*

DISCUSSION: Does the change to the plot of *Streetcar* that was required by the Production Code (Stella leaves Stanley after he rapes her sister) make Stella

a more empowered character than in the play (when she goes back to him)? As written, Blanche Dubois is thirty-one years old. How have perceptions of aging changed? Why do people stay in abusive relationships?

Week Five: *Ran, Throne of Blood, Romeo+Juliet, Richard III*

DISCUSSION: Shakespeare plays are adaptations of prior works or biographies. What is more important in a Shakespeare adaptation: the language or the plot? How do the films interpret the themes of the source (in a radical adaptation) or use a design concept to tease out the play's themes (i.e., *Richard III* set in the Second World War, *Romeo+Juliet* set in the Miami-esque Verona Beach)?

Week Six: *Who's Afraid of Virginia Woolf?*

DISCUSSION: How does the play and film portray (or not portray) abortion, profanity, and codependent relationships? Does setting a film in a single location work in film? Are the scenes in the empty bar, or when the characters wander around outside, necessary? Which character is most sympathetic?

Week Seven: *Angels in America, History Boys, The Lady in the Van*

DISCUSSION: Who is the intended audience for film adaptations of these plays? If a play is adapted into a film is there a reason for theatre companies to continue to perform the play or is it overshadowed by the film version?

Week Eight: *Inherit the Wind, Twelve Angry Men, Born Yesterday*

DISCUSSION: Should all plays or musicals be adapted into film? Why or why not? If a play is being adapted into a film should it be adapted in a way that is cinematic? Should it preserve elements of what made the play a success on Broadway? How are stage play dialogues different from film dialogue? Do they need to be different? Do you enjoy watching films that "look" like plays?

Week Nine: *A Raisin in the Sun, Dutchman, Fences*

DISCUSSION: How does each playwright deal with the problem of racism in the USA? How has the situation changed since the 1960s? Which adaptation of *A Raisin the Sun* is more effective?

Week Ten: *Chicago, Cabaret, Jesus Christ Superstar*

DISCUSSION: What plays, musicals, or films have you seen that include a large cast of female characters? How has theatre changed since the original version of *Chicago* premiered in 1926? Why is it important to have female leads? Do nonrealistic musical numbers work in film?

Week Eleven: *God of Carnage*

DISCUSSION: What strategies did the film use to make four people sitting in a room fighting interesting? Has this situation happened to anyone? How did/would you handle a child injuring another child? Is this "problem" depicted realistically in the film? What do you think the playwright's message was? Roman Polanski directed the film. Should the "art" be separated from the artists?

Week Twelve: *Double Suicide*

DISCUSSION: What play and musical do you think should be adapted and why? Who would you cast? Who would direct the film? What would be the setting and time period? What style would you make it?

Additional Resources

Books

Gerould, Daniel, ed. *Theatre/Theory/Theatre: The Major Critical Texts from Aristotle and Zeami to Soyinka and Havel*. New York: Applause Theatre & Cinema Books, 2000.

Wilson, Edwin, and Alvin Goldfarb. *Theatre: The Lively Art*. New York: McGraw Hill Education, 1991.

Wilson, Edwin, and Alvin Goldfarb. *The Theatre Experience*, 9th ed. New York: McGraw Hill Education, 2015 (or any other edition).

In-Depth Reading

Brockett, Oscar, and Frank Hildy. *History of the Theatre*, 10th ed. New York: Pearson, 2008 (or any other edition).

Brown, John Russell, ed. *Oxford Illustrated History of the Theatre*. Oxford: Oxford University Press, 1995.

Nellhaus, Tobin, Bruce McConachie, Carol Fisher Sorgenfrei et al., eds. *Theatre Histories: An Introduction*, 3rd ed. Abingdon: Routledge, 2016 (or any other edition).

Websites

HowlRound Theatre Commons; Emerson College; http://howlround.com. Accessed June 30, 2022.

The Kennedy Center Digital Stage; The Kennedy Center; https://www.kennedy-center.org/digitalstage. Accessed June 30, 2022.

PBS Learning Media—Drama Art Toolkit; PBS, & WGBH Educational Foundation; https://ca.pbslearningmedia.org/collection/about-drama/. Accessed June 30, 2022.

The Theatre Times; The Theatre Times; http://thetheatretimes.com. Accessed June 30, 2022.

3

Theatre History, Theory, and Criticism

The theatre must give us everything that is in crime, love, war, or madness.
—Antonin Artaud, poet, playwright, and theatre director[1]

Theatre remains theatre even when it is instructive theatre, and in so far as it is good theatre it will amuse.
—Bertolt Brecht, playwright, author, theatre artist[2]

I don't understand how theatergoers can go to the theatre and not want to have more active and rigorous conversations with what they're seeing on the stage.
—Lynn Nottage, playwright and professor[3]

Some artists believe that theatre should challenge audiences into action after leaving the performance. Others see theatre as spectacles that are full of sex, violence, or elaborate costumes, and staging that are used to provoke the audience into an emotional response. Some advocate for a combination of all of the above. Throughout history, theatre has been defined and redefined by artists, some conforming to the trends of their generation and others working to defy convention. Theatre can be reflective of the time in which it is created, or it can attempt to be a dragonfly in amber, aiming to preserve performance traditions.

Theatre history, theory, and criticism expose students to intercultural dramatic canons and a variety of perspectives beyond Shakespeare, Arthur Miller, and the American Musical Songbook. They address humans reflecting, responding, and reimagining the world from, between, and in contradiction with their realities. From Aristophanes to The Second City, theatre involves everything from celebrity gossip to political protests. Theatre history, theory, and criticism are rich with content to explore the world in complex ways.

What Are Theatre History, Theory, and Criticism?

Theatre history involves discovering the productions, contexts in which theatre takes place, and people involved in the theatre-making process. It investigates the culture, politics, people, trends, and other influences that "inspired" theatre artists, such as patronage systems that are prevalent throughout different theatre histories around the world.

Theatre theory is the act of attempting to understand theatre from philosophical viewpoints. From ancient writings of Aristotle and Kālidāsa to the modern works of Una Chaudhuri and Elinor Fuchs, theatre theory describes the ephemeral events of theatre and their impact. Theatre theory includes performance and acting processes, dramatic structure, audience relationships, verisimilitude, and more.

Theatre criticism is the critique of theatrical performances, examining acting, design, and production in addition to the script. Drama criticism is textual critique that looks at plays as literature. Theatre critics used to be cultural icons and wielders of considerable make-or-break power, which connects theatre criticism to theatre history.

Students in these courses will draw from historical periods, artists, and theory to analyze theatre. They will compare and contrast theatrical styles, examine theatrical innovations, read critiques by critics, develop their own theories, and investigate how theatre contributes to the larger fields of art and culture.

Benefits for Students without a Background in Theatre

Students learn the "who," "what," "why," "where," and "how" of theatre. They gain new knowledge beyond famous actors and actresses, and learn about technical designers, directors, and other influencers. By examining what happens inside the theatre (backstage, onstage, and audience) and outside the theatre (theatre critics, laws and regulations, societal norms, and politics, etc.), new theatre history, theory, and criticism students get a 360-degree view of theatre.

Benefits for Students with a Background in Theatre

History, theory, and criticism will help students frame their appreciation of theatre within the context of other thinkers and cultural movements. They will examine how points of view are confirmed or challenged by others throughout history, expanding their existing knowledge of theatre beyond the western canon.

How Do I Put Together a Course?

Go to a Theatrical Museum Exhibit

Sometimes museums will hold special exhibits that involve theatre. The exhibits can broaden your existing knowledge of theatre and be a starting point to get you excited to explore new theatre histories. Some types of exhibits can include costumes, scene designs, and puppetry. Museums may also invite scholars, performers, and other experts to give talks, do demonstrations, or perform shows.

Go to an Old Bookstore or Antique Show

Find theatre memorabilia and learn about what productions were popular. You may come across theatre programs, clippings of reviews and notices, masks and costumes, posters, figurines, postcards, autographs, signed headshots or photos, publicity photographs, plays, actors' biographies, and acting/directing/designing/critic/audience memoirs. If you can, purchase these memorabilia and bring them to class. These artifacts help bring topics to life.

Ask a Theatre Company for Their Inspirations

Not every theatre has a dramaturg, but if they do, take advantage of it. Dramaturges are the theatre historians of the production and tend to have far more knowledge of theatre history and theory than anyone else at the theatre. Contact the dramaturg and ask for their sources.

If they do not have a dramaturg, ask the director about the artistic intentions behind the production. If the director says that they were commissioned and do not have any artistic intentions, ask the artistic and managing directors of the company for the reasons behind curating the season the way they did. Regardless of their answers you will have interesting stories relating to theatre history and theory.

Ask Friends What Theatre Shows They Have Seen

Many people will probably have seen at least one theatre show in their lifetime. Whether they are professional shows or amateur shows does not matter. Ask your friends what shows they have seen and you will get a variety of ideas on topics to discuss in your class.

Watch Films about Theatre

In addition to film adaptations of plays (see Chapter 2 for a list), there are also many narrative and documentary films about theatre you can include in your course to illustrate theatrical styles, histories, and genres for your students:

Narrative Films

All About Eve, directed by Joseph L. Mankiewicz, 1950
All That Jazz, directed by Bob Fosse, 1979
An Actor's Revenge, directed by Ichikawa Kon, 1963
Applause, directed by Rouben Mamoulian, 1929
Beaumarchais the Scoundrel, directed by Édouard Molinaro, 1996
Cradle Will Rock, directed by Tim Robbins, 1999
Farewell My Concubine, directed by Chen Kaige, 1993
In the Bleak Midwinter, directed by Kenneth Branagh, 1995
Lady of Burlesque, directed by William A. Wellman, 1943
Laugh, Clown, Laugh, directed by Herbert Brenon, 1928
Laura, directed by Otto Preminger, 1944
Les Enfants du Paradis, directed by Marcel Carné, 1945
Moulin Rouge!, directed by Baz Luhrmann, 2001 (Musical Adaptation: 2018)
Mrs. Henderson Presents, directed by Stephen Frears, 2005
Murder at the Vanities, directed by Mitchell Leisen, 1934
The Reckoning, directed by Paul McGuigan, 2003
Sharknado, directed by Anthony C. Ferrante, 2013
Singin' in the Rain, directed by Gene Kelly and Stanley Donen, 1952 (Musical Adaptation: 1983)
Sweet Smell of Success, directed by Alexander Mackendrick, 1957 (Musical Adaptation: 2002)
Tipping the Velvet, directed by Geoffrey Sax, 2002
Topsy-Turvey, directed by Mike Leigh, 1999
Waiting for Guffman, directed by Christopher Guest, 1996

Documentary Films

Angkor Awakens, directed by Robert H. Lieberman, 2016
Broadway: Beyond the Golden Age, directed by Rick McKay, 2018
Broadway: The Golden Age, by the Legends Who Were There, directed by Rick McKay, 2003
Fiddler: A Miracle of Miracles, directed by Max Lewkowicz, 2019

The Ghosts of Bread and Puppet, directed by Harry Hall, 2013
Giving Voice, directed by Fernando Villena and James D. Stern, 2020
The Heat Is On: The Making of Miss Saigon, directed by David Wright, 1989
OT: Our Town, directed by Scott Hamilton Kennedy, 2002
Original Cast Album: Company, directed by D. A. Pennebaker, 1970
Paradise Now: The Living Theatre in Amerika, directed by Sheldon Rochlin, 1970
Paris Is Burning, directed by Jennie Livingston, 1990
The Personals: Improvisations on Romance in the Golden Years, directed by Keiko Ibi, 1998
The Puppet Lady, directed by Kate Gondwe, 2016
Shakespeare Behind Bars, directed by Hank Rogerson, 2005
T'Ain't Nobody's Bizness: Queer Blues Divas of the 1920s, directed by Robert Philipson, 2013

There are many ways to use films to shape your course. While the content of the film can spark new ideas for your students, the format and framing of films you choose can also be used to encourage students to think critically about what they are watching.

- Select films that make a point of comparing the "good" and "bad" acting of characters as part of the plot. Have students take note of the differences in characters' acting styles to help them see nuances in performances. For many people, "bad" acting probably catches their attention more than "good" acting because they find it comic, entertaining, or disconcerting. There are merits in both. What is considered "good" acting also varies depending on genre. Have students watch acting from similar genres to compare styles. Sometimes bad acting is done intentionally and sometimes not. Examples of actors "acting": *Stage Beauty*, *Stage Door*, and *Waiting for Guffman*.
- Watch films made in different eras. Every generation has its own performance styles. To understand the changes in performance style, watch films from different periods and take note on how the actors change their physical and vocal performance (if not a silent film). Reflect on why these acting styles were popular. Examples: comparing the 1936, 1968, and 1996 versions of *Romeo and Juliet*, watching films from the 1930s featuring the stylized mid-Atlantic accent and depictions of smoking.
- Watch films about theatre and performance set in different time periods that present different genres and discuss the choices filmmakers made interpreting the era. By watching period films about theatre and performance that are set in distinct historical eras, you will discover that there may be many inaccuracies or poetic license (or even parody law) involved in the production. Because film

productions are well-documented, you will be able to research the processes of recreating historical performance styles and time periods. Examples: *An Actors Revenge* (kabuki), *Children of Paradise* (Boulevard du Crime), and *Farewell My Concubine* (Beijing opera).
- Choose documentaries from a variety of sources (artist, a theatre troupe, time period, specific production) that present contrasting perspectives on theatre and performance. Example: *Giving Voice* (monologues), *Paradise Now* (troupe), and *Original Cast Album: Company* (Broadway).
- Choose documentaries within the same category. Example: examining puppetry in *The Puppet Lady*, *The Ghosts of Bread and Puppet*, and *Angkor Awakens*.
- Have students select two or three things to focus on throughout a film. Examples: how actors are presented offstage vs. onstage, how actors change their physical and vocal performances, and hairstyles and costuming.
- Pick two or three films that you like best. Think about why you enjoyed the films and pick key points for your students to discuss around the elements that drew you to the films.

Dive into Research

Go to your local library and find out more on a subject that you appreciate about theatre. Become a superfan and find out everything you can about your favorite actor, performance, or time period. Once you get started, you will see that in addition to books and films, you may find articles, reviews, posters, letters, photos, and other ephemera. If you are lucky, you may discover in your research that there may be a collection (public or private) you can view. You may also learn that your town or city has some well-known theatre practitioners.

Go on the web and do research. If you come across an interesting individual or theatre concept in your research that does not have a Wikipedia entry, submit to have their entry created (or write it yourself). This can lead others, sometimes highly renowned experts, who have the knowledge and research to develop content for you. They will often share links, provide references for all of their information, and make connections to other theatre-related information. This can help you understand how these people or ideas relate to larger theatre movements. *Do not rely on Wikipedia as the only source for your teaching. Follow up on the references, read the revision history of articles, and refer to footnotes to fact check the information you wish to use.* Once you have your topic and your sources, try to answer these questions:

- Who are the major artists in a given time period and place? For example, who are the most famous performers, directors, writers, producers, stage designers, and so on?
- What time period and place did your theatre genre or movement take place? If it is no longer performed, when was it most popular?
- What was the historical context? What was happening politically? Culturally?

If focusing on a particular performance at a local theatre, find out the answers to these questions:

- Is your performance genre or play an adaptation of an earlier work?
- Has the play been readapted before?
- What were some of the inspirations for the play and/or production design?
- What are the major differences between the adaptations?
- Who were the authors of the other adaptations? Who was the original writer?
- Where and when did these adaptations take place?

Once you have the answers for the above, go further in-depth into the performance by addressing these questions:

- Read theatre reviews. What do critics say about the artists?
- Read biographies and other material, such as interviews and memoirs. What do the biographies and other resources say about the artists? Are they perceived differently by critics, people in authority, and tabloids? How so?
- What was the gender of the performers? What were the role of men or women in society at that time and how were they enforced?

Online Archives and Websites

If you are unable to visit archives, performances, or museums explore some these additional resources online (all accessible at the time of publication):

50 Playwrights Project	https://50playwrights.org/
African American Theatre: Manuscripts, Archives & Rare Books Division, New York Public Library	https://libguides.nypl.org/africanamericantheater/marb
Americans for the Arts Research Database	https://www.americansforthearts.org/

Asian American Theatre Revue	https://aatrevue.com/Newsblog/info-on-the-revue/directory/Billy Rose Theatre Division, New York Public Library; https://www.nypl.org/locations/divisions/billy-rose-theatre-division
The Black Archives Historic Lyric Theater	https://www.bahlt.org/
Black Theatre Commons	https://blacktheatrecommons.org/theatres/
Black Theatre Network	http://www.blacktheatrenetwork.org/
Broadway for Black Lives Matter	www.bwayforblm.com
Broadway World	www.broadwayworld.com
Canadian Latinx Theatre Artist Coalition	https://caltac.ca/
Chinese Shadow Puppetry: A Comprehensive Informational Website	https://www.chineseshadowpuppetry.com
Contemporary Playwrights of Color	https://sites.google.com/nyu.edu/contemporaryplaywrightsofcolor/
Curtain Call Resource Guide for Anti-Racism in Theatre	https://curtaincallbway.com/2020/09/08/resource-guide-for-anti-racism-in-theatre-broadway/
Dance Studies Association Resources for Moving Dance-Based Pedagogy Online	http://dancestudiesassociation.org/news/2020/resources-for-moving-dance-based-pedagogy-online?fbclid=IwAR1A28Gw0L86PMOZCsrVk7Ns09IbL767Wa7OIC5LyY6W8hq5GPq21-Z85A8
Google Arts & Culture	artsandculture.google.com
Latinx Theatre Commons	https://howlround.com/ltc
The LGBT Community Center National History Archive (search for theatre, theater, or drag)	https://gaycenter.org/archives/
The Met Collection	https://www.metmuseum.org/
Momentum Stage Resources and Databases	https://www.momentumstage.org/decolonize
MsMojo (search for musicals)	https://www.youtube.com/channel/UC3rLoj87ctEHCcS7BuvIzkQ

National Theatre Archive	https://www.nationaltheatre.org.uk/about-the-national-theatre/archive
Native American Women Playwright Archive	https://spec.lib.miamioh.edu/home/nawpa/
Project Gutenberg (search for plays)	https://www.gutenberg.org/
Royal Shakespeare Company Archive	https://www.rsc.org.uk/about-us/collections-and-archives
Shaw Festival Archives	https://www.shawfest.com/theatre/
The Stanford Encyclopedia of Philosophy Archive (search theorists names)	https://plato.stanford.edu/archives/spr2019/
A Student's Guide to Performance Studies	https://hwpi.harvard.edu/files/hwp/files/peformance_studies.pdf
Theatre Historical Society of America	https://historictheatres.org
Theatre on Film and Tape Archive, New York Public Library	https://www.nypl.org/about/divisions/theatre-film-and-tape-archive
The Theater Times	https://thetheatretimes.com/

Analyze a Performance Using Theory

While applying theory to a performance may seem daunting, it is fairly straightforward in practice. Theory assists with framing things in ways that help you appreciate different aspects of the production. To figure out what kind of theories you wish to examine in your class, think about:

- What themes are in the performance?
- Did anything stand out to you? What was strange or unique about the performance?
- What do you think the director or artists were trying to say in their choices?
- If you read the play before seeing it, how does the performance differ from the script of the play? What new elements were added? What was changed? What do you think the director or artists were trying to say in their choices?
- How does the performance present gender, ethnicity, race, class, and so on? What stood out to you? What do you think were the intentions behind these representations?

- How was the play cast? Were the actors the same age/gender/race as what was written in the script?
- What was the time period and setting of the show? How did the time and place frame the performance?
- How was the language of the play performed? Did it mirror everyday realistic speech? If not, what did it do?
- What was left unsaid? What do you think were the implied meanings and themes? What do you think were the obvious, clearly stated themes?
- How does viewing the performance from different perspectives such as gender, class, or race change your interpretation of the play?
- Was the show successful in its interpretation and performance of the play? Why or why not? Which elements worked well and which did not?

When you have answered some of these questions, look for theories related to the topics you found most interesting. For example, if the production uses non-traditional gender roles in its casting, look at Laurence Senelick's *The Changing Room* for background on traditions and interpretations of drag performance and Judith Butler's theories of performativity of gender.[4]

How Do I Select and Organize Topics?

Forget Chronology and Region

Do not worry about organizing your history or theory topics by a linear timeline or a specific region. It is not possible to cover every time period or country in the world in one course. Focus on the topics and themes rather than following a chronological order. Dispelling the myth of the "progress" of a linear timeline will bring more value to the theatres and ideas you discuss without unintentionally privileging any one type of theatre.

By Artist or Play

An entire course can be focused on productions of a single play or productions of the works of a single playwright over time. We recommend focusing on a single play for short-term such as four to six weeks maximum. Focusing a class on a single playwright is recommended if there are already superfans in your course:

EXAMPLE #1: *MACBETH*

Notable productions of *Macbeth* can be used as a springboard for discussing classic works in the international context, US history, and race. This is a fun play to begin the discussion of histories because of the mythology and superstition surrounding *Macbeth*. The name of *Macbeth* should never be said in a theatre because of a supposed curse on the play. The most common alternative names theatrefolk use for *Macbeth* is "The Scottish play," "The Bard's Play," "M," "Mackers," "Big Mac," and "MacB."

Because *Macbeth* is widely performed and known, *Macbeth* is also an excellent way to discuss different theatrical styles and historical time periods. One of the most famous US productions of *Macbeth* was directed by Orson Welles in 1937 at the Lafayette Theatre in Harlem, New York. This production was funded by the government and was part of the Federal Theatre Project's Negro Theatre Unit that was managed by the Works Progress Administration (WPA, 1935–39), which created jobs for artists during the Great Depression. Welles's *Macbeth*, better known as Voodoo *Macbeth*, included an all-Black cast. The production toured various cities throughout the USA and had integrated audiences. This play provides an avenue for discussing the Depression Era in general and theatre specifically, the impact of the government in the arts, race and segregation in the USA, and development of American theatre as we know it today.

When the name *Macbeth* is mentioned in the theatre, it is believed by some that terrible things will happen. Some unfortunate things that have happened during productions of *Macbeth* include:

- In 1606, during the first production of the play at Hampton Court the actor playing Lady Macbeth died.
- In the aforementioned WPA 1937 Orson Welles production, he employed houngan and mambo, and an audience member attempted to cut Welles at the Lafayette Theatre.
- In the 1937 performance at The Old Vic, a stage weight almost fell onto Laurence Olivier and parts of his (real) sword broke and flew into the audience.
- In the 1954 production at Fort St. Catherine, Charlton Heston's legs were burned from kerosene-soaked tights.
- In 1964, a fire burned down the D. Maria II National Theater in Lisbon, Portugal.
- Critics described the 1980 Old Vic production of *Macbeth* starring Peter O'Toole as "Macdeath" and "Macflop," reviewing O'Toole's performance

as campy, ridiculous, and over-the-top. This was *before* O'Toole staged a career comeback for being delightfully campy and over-the-top.
- In 1849, the most dramatic of these *Macbeth* productions caused the Astor Place Riots. Violence broke out in New York City over rival productions of *Macbeth* that left 31 people dead and 120 people injured.

Macbeth also provides a method of examining theatre in popular culture, as the curse has been featured in television programs including *Slings and Arrows*, *The Simpsons*, and *The West Wing*. It offers a wide variety of film adaptations for students to examine, including Kurosawa Akira's *Throne of Blood*, Jayaraj's *Veeram*, and William Morrissette's *Scotland, PA*, among several others. Having students experience the drastically different interpretations of the same plot helps underscore the significance of dramatic interpretation and production design.

Example #2: Tennessee Williams

Tennessee Williams was a prolific playwright who had many of his plays adapted into films. Like Aristotle using *Oedipus* as the example of a perfect play, contemporary theatre instructors often turn to the work of Tennessee Williams to illustrate dramatic concepts. Williams adaptations span the 1940s to the present day and it is likely many of your students will have seen some of his films throughout their lifetime. Some adaptations of Williams's plays include: *Suddenly, Last Summer, Night of the Iguana, Baby Doll, Sweet Bird of Youth, This Property Is Condemned, The Roman Spring of Mrs. Stone, The Fugitive Kind, Summer and Smoke, The Rose Tattoo, Cat on a Hot Tin Roof, Period of Adjustment, The Glass Menagerie,* and *A Streetcar Named Desire.*

Multiple versions of the same play can also be shown to compare them, or versions can be shown individually alongside reading the script. All of the films are long, so it is recommended to show clips or break up screenings into multiple classes. For example, students can read Scene Three from *A Streetcar Named Desire* and watch and contrast the iconic 1951 Marlon Brando and Vivian Leigh film as well as the 1984 filmed production with Treat Williams and Ann Margret, the 1995 version starring Alec Baldwin and Jessica Lange, and the 2014 stage production featuring Gillian Anderson and Ben Foster.

By Theatre Theorist, Theory Type, or Groups of Theory

Select from a range of theories throughout theatre history. You can organize the course by specific theorists, type of theory, or specific time period. Many theorists do not practice theatre and their theories can be used to apply to a variety of artists and genres throughout history. For example, Antonin Artaud's Theatre of Cruelty can be examined through the context of reality television, the plays of Sarah Kane, and World Wrestling Entertainment (WWE).

For theory categories, there are acting, playwriting, audience, broad theories that cover all aspects of a show, and performance studies. For example, Bertolt Brecht's Epic theatre is a broad theory that addresses acting, playwriting, and the audience. Epic theatre can be seen as an influence on several productions such as *Hair*, *Angels in America*, and most post-Second World War adaptations of Shakespeare. Performance studies provide ways of interpreting everyday performances in the "real world." Performance studies courses can be based around analyzing fandoms of *Star Trek*, Disney movies, American football, and World Cup football or looking at conspiracy theories and political campaign rhetoric as performance.

Groups of theories developed during a specific time period can also be interesting to see how different artists reacted to similar cultural movements. For example, between the 1950s and 1970s in the USA, the Living Theatre used spectacle and audience interaction, while the San Francisco Mime Troupe turned to *commedia dell'arte* and satire as a contemporary spin on a historic mode of providing cultural commentary.

By Cultural and Other Fields of Theory

There are many theories outside of theatre that can be useful in analyzing theatre. Theatre artists have drawn from political theory, postcolonial theory, rituals and religious theory, feminist theory, environmental theory, popular culture theory, and more to innovate and create new types of theatre. There are also many theatre movements that draw from other art practices, such as music, dance, literature, and art, and these are also helpful in creating a diverse program. For an overview on some popular cultural theories, we recommend *The Routledge Critical and Cultural Theory Reader* and *Cultural Theory and Popular Theatre: A Reader*.

Beyond cultural and creative theories, it may be fruitful to investigate theatre forms through theories that are even broader. While artists may not have directly attempted to put these theories in practice, it may be useful to apply non-creative theories to challenge students to stretch their perspective to see theatre in new ways. For example, game theory, chaos theory, or any other scientific theory.

By Popular Theatre Type

Popular theatre forms such as Broadway shows will likely grab your students' attention right away. Discussing historical context and theory will be easier to do when the students already have an appreciation for a particular show.

Other popular forms in the USA are family dramas like *August, Osage County*, murder mystery plays such as those written by Agatha Christie, and Neil Simon-style farces. Organizing a course by most produced plays by decade is another option. *Our Town* has been on the list of top ten most produced plays in the USA since it was written in the 1930s. A course could be designed around unpacking its enduring popularity.

Outside of the USA, students may have some knowledge about shadow puppets, *kabuki*, Indian dance drama, Beijing opera, mime, clowning, masks, and opera. Below are some of *our* favorite genres. It is by no means a comprehensive list, but includes types of theatre that have been popular with our students:

- *Puppet Theatre* is present in many cultures and includes a broad range of types, from rod puppetry to string puppetry. Punch and Judy are slapstick-style glove puppets popular in Britain and France. *Wayang kulit*, Indonesian shadow puppetry, involves one puppet master, or *dalang*, performing multiple roles. *Bunraku*, Japanese puppetry, involves three puppeteers working together to perform one puppet.
- *People's Theater* (twentieth century to present) is theatre written for or by people of the working class. People's theatre can include socialist drama, contemporary activist theatre, and community theatre groups. Topics of the plays are centered on issues of social justice such as oppressive landlords, terrible working conditions, unfair wages, and so on. Examples include San Francisco Mime Troupe, Bread and Puppet Theatre, Philippine Educational Theater Association, and the many groups that make up Honk!
- *Postcolonial Theatre* (1950s to present) addresses oppressive structures in relation to racism and the continued need for acknowledging the ongoing influence of the dominant powers on the lives of the oppressed. Examples include *Dutchman*, *Cloud 9*, *A Tempest*, *The Strong Breed*, *House of Sonya*, and *The Rez Sisters*.
- *Twentieth century isms and Performance Art* include, but are not limited to, expressionism, surrealism, Dadaism, existentialism, absurdism, and other movements that developed in response to cultural climates and their schools, communities, acolytes, and detractors. Famous figures include Bertolt Brecht, Eugene O'Neill, Antonin Artaud, Samuel Beckett, Eugene Ionesco, Jean Paul Sartre, Federico Garcia Lorca, Maria Irene Fornes, Holly Hughes, Karen Finley, Carolee Scheeman, Yoko Ono, and many more.

- Commedia dell'arte originated in Italy in the sixteenth century as improvisational comedy based around scenarios and stock characters. *Commedia* influenced art, opera, puppetry, and comedy. *Commedia*'s influence can be seen in works by Molière and Edna St. Vincent Millay, among others.
- *Musicals* are plays with a lot of music that aren't operas. Musicals typically incorporate singing and dancing, and most of a show is dedicated to singing dialogue, rather than speaking dialogue. Examples include works by Stephen Sondheim, George Gershwin, Andrew Lloyd Weber, and Sarah Bareilles. While music has been included as part of theatrical performances for millennia, musical theatre in its current form evolved from nineteenth-century operetta, revue, and other entertainments. While the official title of "first modern musical" is contested, two of the earliest shows to solidify the genre are Charles M. Barras and Thomas Baker's *The Black Crook*, which premiered in 1866 and Charles H. Hoyt's 1891 play *A Trip to Chinatown*. *Show Boat*, which premiered in 1927, also sometimes receives the title of "first modern musical," despite musicals being popular throughout the 1910s and 1920s.
- Kabuki is a stylized form of performance and is the "Broadway" equivalent of Japan. It incorporates dancing, special effects, trapdoors, acrobatics, costume changes, and other theatrics. It is also known for male actors playing female characters because women were banned from the stage in the mid-1600s. *Kabuki* flourished during 1603–1868.
- *Sanskrit Drama* (200 BCE–700 CE) is Indian drama. Playwrights include Kālidāsa, Śūdraka, and Bhāsa. The text *Natyasastra* by Bharata Muni describes the theory to Sanskrit drama. Interpretations of Sanskrit drama are performed in other theatre forms such as *kathakali*.
- Kathakali is an Indian dance drama that features male dancers, elaborate costumes, masks, and makeup. *Kathakali* formalized as a performance genre in the seventeenth century CE, but elements of *kathakali* trace back to 200 CE and performances are based on Sanskrit dramatic texts.
- *Ancient Greek Comedy and Tragedy* spans roughly 700 BCE to 300 BCE. Aristophanes, master of Athenian Old Comedy, wrote about interpersonal conflict in politics, war, literature, gender, and sex. Menander, representative of Athenian New Comedy, is considered the granddaddy of situation comedy. Aeschylus, Euripides, and Sophocles are the tragedians from whom we have surviving plays. Sophocles' *Oedipus Tyrannus* forms the rubric of comparison Aristotle used to describe dramatic success in *The Poetics* (*c.*335 BCE).
- Xiqu *or Chinese opera* emerged during the Song Dynasty (960–1279) and is a musical performance that incorporates stylized acting, acrobatics, dance, and falsetto singing. There are many regional forms and *jingju*, or Beijing opera, is one of the most widely known forms today.

- Nō is a Japanese theatre form that originated during the fourteenth century. *Nō* is known by some as "the art of walking" and is ritualistic and slow, with stylized speech and movement. It is the "drama" of traditional Japanese theatre that is often performed with *kyōgen*, a comedic play.
- *Realism, Naturalism, Henrik Ibsen, and August Strindberg* all date to the late nineteenth/early twentieth century. Realism presents everyday people in situations from everyday life, Naturalism is Realism's more extreme extension. Ibsen is regarded as a protofeminist and protoenvironmentalist for his plays *A Doll's House* and *An Enemy of the People*. Strindberg's plays, which include *The Father* and *Miss Julie*, examine gender, sexuality, and interpersonal relationships. Both playwrights' later plays, including *When We Dead Awaken* and *Dream Play*, contain surrealist and expressionist elements.
- *Anton Chekhov* was the author of fourteen plays and several short stories that reflect and comment on life in a time of impending radical sociocultural change before the Russian Revolution. His most famous plays include *Seagull*, *Uncle Vanya*, *Cherry Orchard*, and *Three Sisters*. Chekhov collaborated with Konstantin Stanislavski, creator of the "System," and the Moscow Art Theatre in the late nineteenth and early twentieth centuries. His nephew, Michael Chekhov, developed his own successful acting technique.

By Patronage Systems

Theatre historically has functioned under patronage systems, created by outsiders for (and with access to) people in power, which provides a unique vantage point for examining how power structures have an impact on and are responded to by artists. Three of the most famous examples are *kabuki* theatre transitioning from women to boys to men to play principal female characters under the orders of court leaders, Molière's comedies lampooning bourgeois social climbing written for the court of Louis XIV, and scenes in Shakespeare's *Macbeth* written to appeal to James I.

What Activities and Discussions Can I Do?

The activities included in this chapter assist students with information literacy and creativity. Students practice questioning perspectives and historical narratives while learning how to research, analyze, and apply their existing knowledge to engage with the course material. In discussions of potentially

controversial topics in theatre history and theory, all opinions are welcome and differing opinions may lead to critical self-reflection as students explore their thoughts from a variety of perspectives. The activities also help students connect and incorporate their knowledge into creative forms such as collaborating on their own dramatic works and manifestos, linking theatre history and theory to theatre practice.

All of the activities described in Chapter 2 are applicable to this chapter. Film activities may be particularly helpful for setting up historical contexts, viewing primary sources, and contrasting different interpretations of source material in theatre history.

Go on Field Trips

Take your students outside the classroom to experience theatre behind the scenes. There are several ways to learn about theatre beyond attending theatre performances. These include:

- *Site visits*: Arrange a tour of a theatre and other performance venues.
- *Archival research*: Have students pick a topic and go to the library to uncover more about their favorite subjects. This is a great skill to teach them so they can continue investigating when they are not in class.
- *Local Hall of Records and other archives*: Have students look at letters, maps, deeds, and contracts and the story that grows out of them.
- *Historical societies and museums*: Even when there is not a theatre exhibit, if they have a specific region or time period on display, it can help students immerse themselves in that area. If your town at any point had a train station, it most likely also had a theatre that was frequented by touring companies, authors, or public speakers. That means there likely exists some ephemera related to their passing through the town.

Research the Research

When conducting research, verifying the credibility of the source is the most important part. To evaluate a source, students should attempt to verify the credibility by determining the purpose relevance, context, and background of the source. There are two acrostics to help students vet sources. Have students practice using one or both of the below methods for assessing sources.

> The CRAAP Test, developed by librarians at California State University Chico, provides one framework for evaluating sources.[5] CRAAP stands for:
> 1. *Currency*: When was this information posted or published?
> 2. *Relevance*: Is the reading relevant to the matters at hand?
> 3. *Authority*: Who is the source? Can you trust information from this source?
> 4. *Accuracy*: Is the reading free from errors? Has the information in the source been vetted and by whom?
> 5. *Purpose*: Is the piece written to inform or to persuade? What are the author's intentions? Why was this particular piece included?
>
> The SIFT test, developed by Mike Caulfield as a more internet-savvy version of the CRAAP Test, takes the emphasis off of the vetting of sources by outside authorities and instead puts the onus of verifying validity on individuals.[6] The Four Moves of SIFT are:
> 1. *Stop.* Before you use something as a source, find out information about the source. Do you know the website or source of the information and the reputation of the claim and the website?
> 2. *Investigate the Source.* Research where the media is coming from. What is their expertise and agenda?
> 3. *Find better/trusted/reputable coverage.* Look for other reporting and analysis on the claim. What does consensus on the claim appear to be?
> 4. *Trace claims, quotes, and media coverage to the original source.* By tracing the claim, quote, or media back to its original context, you get a sense if the version you saw was accurately presented. If there are inconsistencies, what was inaccurate and what biases are present?

Run a Performance Workshop

Performance workshops can be useful no matter the group's experience level. If you do not have experience doing any of the forms, find a video. There are many free instructional videos on the internet and some that you may find at your local library. The videos can be recordings of others conducting workshops or actual instructional videos. Either can be helpful in exploring performance. Set the expectation that everyone is trying it to get a sense of what it is like for a performance and no one needs to do well. Failed experiences can lead to interesting discussions.

For additional ideas on performance-related topics see Chapter 5.

Create a Jukebox Musical

Have students watch excerpts from Taylor Mac's *A 24-Decade History of Popular Music*. Then have them work in small groups to generate their own list of songs to represent each decade, as well as characters and a plot, to create the structure for a historic jukebox musical. The same characters can appear in each time period or the scenes can be connected by theme. Students can even create a jukebox musical of musicals!

Do a Singalong

Below are some examples of musicals and some of their best-known songs from the 1930s to present. Be careful when selecting older musicals or songs because many of the conventions may be inappropriate for today. Be sure to interrogate the canon and address stereotypes and issues in the plays. While many musicals are popular, they are not reflective of all populations.

1930s

Anything Goes
- "Anything Goes"
- "You're the Top"
- "I Get a Kick Out of You"

1940s

Oklahoma!
- "Oh, What a Beautiful Mornin'"
- "I Cain't Say No"
- "Oklahoma"
- "Everything's Up to Date in Kansas City"

Pal Joey
- "Bewitched, Bothered, and Bewildered"
- "Zip!"
- "The Lady Is a Tramp"

1950s

Guys and Dolls
- "Luck Be a Lady"

- "If I Were a Bell"
- "A Bushel and a Peck"
- "Take Back Your Mink"

West Side Story
- "Gee, Officer Krupke"
- "America"
- "Tonight"
- "Maria"

1960s

Fiddler on the Roof
- "If I Were a Rich Man"
- "Tradition"
- "Matchmaker, Matchmaker"

The Fantasticks
- "Try to Remember"
- "Never Say No"
- "Soon It's Going to Rain"

Hair
- "Aquarius"
- "Let the Sunshine In"
- "Hair"

1970s

Grease
- "You're the One That I Want"
- "Summer Nights"
- "Beauty School Dropout"
- "Look at Me, I'm Sandra Dee"

A Chorus Line
- "One"
- "Dance 10, Looks 3"
- "What I Did for Love"

1980s

Phantom of the Opera
- "The Phantom of the Opera"
- "The Music of the Night"
- "All I Ask of You"

Cats
- "Memory"

Dreamgirls
- "And I Am Telling You I'm Not Going"
- "One Night Only"
- "I Am Changing"

1990s

Hedwig and the Angry Inch
- "Wig in a Box"
- "Origins of Love"
- "Sugar Daddy"

Rent
- "Seasons of Love"
- "Take Me or Leave Me"
- "La Vie Bohème"

Mamma Mia
- "Mamma Mia"
- "Dancing Queen"
- "Take a Chance on Me"

2000s

The Producers
- "Springtime for Hitler"
- "Keep It Gay"
- "I Wanna Be a Producer"

Wicked
- "Defying Gravity"
- "For Good"
- "Popular"

2010s

Hamilton
- "My Shot"
- "You'll Be Back"
- "The Schuyler Sisters"

Organize a Costume Party

Have students role-play as their favorite actor or character. Costumes can easily be created with a little imagination and a few everyday objects. If costumes are too difficult, students can simply play the character or actor. Give them time in class to choose a character and develop some physical and verbal cues to perform the character. Students guess who the characters are.

Play a Game

Games are an easy way to get students working together and thinking about their experiences with theatre. History is filled with fun facts and it is easier to learn them through game formats.

Time Machine

Design a performance with elements from different countries and time periods. Write down different countries and time periods, put them in two different bags, and have students pick one from each. This is best for small groups and more fun toward the end of the course when students are more familiar with different performance styles.

Trivia

Theatre history easily lends itself to trivia games. From unknown histories of famous actors to unfortunate accidents that happen in the theatre (on- or offstage), there are many interesting fun facts that you can incorporate to keep students on their toes.

Examples (answers in bold):

1. What is the animal that Mephistopheles first appears in Goethe's *Faust*?
 a) A fly
 b) A black poodle
 c) A cat
 d) A camel

2. Gibson Girl Evelyn Nesbit earned notoriety as "the Girl on the Red Velvet Swing" during the "crime of the century" trial of Harry K. Thaw for the 1906 murder of Stanford White. Bored with posing for artists, Nesbit found work as a showgirl in this production, later lampooned in *On the Town*. What was the name of the production?
 a) *The Merry Widow*
 b) *Dancing Queen*
 c) *Floradora*
 d) *A Trip to Chinatown*

3. What was the integrated drag revue emceed by Queer civil rights icon Stormé DeLarverie from 1955 to 1969?
 a) *The Jewel Box Revue*
 b) *Hot Chocolate*
 c) *The Lipstick Criminals*
 d) *United Colors of Burlesque*

4. Which theatre style has the longest average run time?
 a) *Kyōgen*
 b) Broadway musical
 c) *Wayang kulit*
 d) One-Act play

5. In 1903 this was the first full-length Broadway musical written and produced by Black artists. It starred Bert Williams, the comedian that W. C. Fields described as "the funniest man I ever saw and the saddest man I ever knew." What is the name of the musical?
 a) *Ziegfeld Follies*
 b) *In Dahomey*
 c) *Porgy and Bess*
 d) *Show Boat*

6. What is the first musical to gross over $1 billion?
 a) *Les Misérables*
 b) *The Phantom of the Opera*
 c) ***The Lion King***
 d) *Hamilton*

7. Which genre features *women* playing men?
 a) **Restoration theatre**
 b) *Kabuki*
 c) *Jingju*
 d) Elizabethan

8. Which puppet form utilizes three puppeteers per puppet?
 a) Shadow
 b) ***Bunraku***
 c) Finger
 d) Marionettes

9. Which film actors did *not* start their careers on the stage?
 a) Catherine Zeta Jones
 b) **Chow Yun-fat**
 c) Chiwetel Ejiofor
 d) Charlie Chaplin

10. How did the Greek playwright Aeschylus allegedly die?
 a) Poisoned by hemlock
 b) **Getting hit on the head by a tortoise**
 c) Attacked by hounds
 d) Reading lines from his play

Below are additional questions that can be made into multiple choice questions:

- What was created in response to deaths resulting from theatre fires, patented in the UK in 1892, and first available for sale in the USA in 1908? These devices have been adopted as part of International Building Code. ***Answer:*** crash bar or panic bar.
- What do you call a dramatic pose in *kabuki*? ***Answer:*** *mie*.
- Born in the Sudan in 1860, he lived in Paris and London before he was purchased by P. T. Barnum in 1882 and taken to the USA, dying after he was struck by a train in 1885. His name means "gigantic" in English

and he is the mascot of Tufts University. Who is he? ***Answer:*** Jumbo the elephant.
- Unfinished after Giacomo Puccini's death in 1924, this opera was completed by Franco Alfano in 1926. Set in China, it is a multilayered adaptation, based on Friedrich Schiller's adaptation of Carlo Gozzi's adaptation of one of the stories in Nizami's *Haft Peykar*. What is the name of the opera? ***Answer:*** Turandot.
- What animal is in the Buddhist story *Journey to the West*? ***Answer:*** monkey.
- Which famous director ended his career appearing in wine commercials and performing with The Muppets? ***Answer:*** Orson Welles.
- What is the first known play by an African American playwright? ***Answer:*** *King Shotaway* by James Brown (1823).
- What is the family-friendly variety entertainment popular in the late nineteenth and early twentieth century in North America? ***Answer:*** vaudeville.
- What is the more adult counterpoint to vaudeville, a satiric popular entertainment combining comedy sketches, showgirls, and strip tease? ***Answer:*** burlesque.
- The convention of black-clad ninjas is based on *kuroko*, the stagehands and/or puppeteers in which art forms? ***Answer:*** *bunraku*, *nō*, and *kabuki*.
- What is the stage illusion in which an offstage figure is reflected onto a pane of glass in between the performers and the audience? *Hint: it is still used in Disney's Haunted Mansion to give the illusion of ghosts sitting next to riders in the doom buggies.* ***Answer:*** Pepper's Ghost.
- What is the part called when a woman plays a male character, often in order to show off her legs in tight trousers? ***Answer:*** breeches role.
- What is the women's role called in *jingju*? ***Answer:*** *dan*.
- What is the name of the Marx Brothers comedy that pokes fun at Eugene O'Neill's *Strange Interlude*, with actors breaking the fourth wall and speaking their internal thoughts to the audience? ***Answer:*** *Animal Crackers*.
- What are static scenes in which the actors do not move? *Hint: Sometimes it is used as a method to get around obscenity laws by having nude performers remain stationary.* ***Answer:*** tableaux vivants.
- What was the performance venue known as the Hippodrome originally constructed for? ***Answer:*** horse/equestrian shows.
- What are funambulists? ***Answer:*** tightrope walkers (or high-wire performers).
- What is the wheeled platform in Ancient Greek theatre used for displaying bodies in tragedies or revealing ridiculous action in comedies? ***Answer:*** ekkyklema.
- How many hand gestures are there in *kathakali*? ***Answer:*** 600.
- His 1867 play *Under the Gaslight* was the first to contain the now clichéd plot device in which someone is tied to the railroad tracks in the path of an oncoming train only to be saved at the last second. Who is the playwright? ***Answer:*** Augustin Daly.

Who Am I?

Have students guess the identity of the famous person based on descriptions. Examples:

Ira Aldridge (1807–67)
- Shakespearean actor.
- Born in New York City in 1807.
- Performed as part of William Henry Brown's African Grove Theatre in the 1820s.
- Immigrated to Liverpool to perform in England and Europe.
- Died in Poland shortly after the US Civil War.

Josephine Baker (1906–75)
- Born in St. Louis.
- Became a celebrity in 1920s Paris.
- Had a pet cheetah.
- Adopted several children.
- Wore a banana skirt onstage.
- Was a spy for the Allies during the Second World War.
- Argued with Walter Winchell over segregation at the Stork Club during the 1950s.

Vivien Leigh (1913–67)
- Born in Darjeeling, India.
- Had a tumultuous marriage and relationship with Laurence Olivier.
- Acted in plays by Noel Coward, George Bernard Shaw, Shakespeare, Sophocles, and Thornton Wilder.
- Died of tuberculosis twenty years after contracting it in North Africa during the Second World War.
- Best known for two films, *Gone with the Wind* and *A Streetcar Named Desire*.

Mei Lanfang (1894–1961)
- Began training as a performer at age eight.
- Made his stage debut at eleven.
- Inspired Bertolt Brecht's "Alienation Effects in Chinese Acting".
- Famous for playing female lead roles.
- Director of the Chinese Beijing Opera Theater and Chinese Opera Research Institute.

Billy Porter (1969–)
- From Pittsburgh, Pennsylvania.
- Appeared as Teen Angel in the 1994 revival of *Grease* and Belize in the 2010 revival of *Angels in America*.
- Played Lola on Broadway in *Kinky Boots*.
- Starred in the television show *Pose* about 1980s/1990s ballroom culture.
- Recognized internationally for both his red carpet fashions at award shows and activism.

Chita Rivera (1933–)
- Originated the role of Anita in *West Side Story* on Broadway (in the film adaptation Anita was played by EGOT-winner Rita Moreno).
- Played Velma Kelly in the original 1975 cast of *Chicago*.
- 2009 recipient of the Presidential Medal of Freedom.

Paul Robeson (1898–1976)
- Played football for Rutgers University and in the NFL.
- Earned a law degree from Columbia University.
- Originated the role of Joe in *Show Boat* on Broadway.
- Changed the lyrics of "Old Man River" to remove racist language.
- Starred in Eugene O'Neill's *Emperor Jones* and *All God's Chillun Got Wings*.
- Blacklisted during the McCarthy era.

Lea Salonga (1971–)
- First Asian actor to win a Tony Award for *Miss Saigon* (1991).
- Voice of two Disney Princesses, Jasmine and Mulan.
- Played Mrs. Lovett in the 2019 revival of *Sweeney Todd*.

Song Kang-ho (1967–)
- Trained in improv theatre.
- Worked as a stage actor for ten years before becoming a film actor.
- Appeared as a priest who becomes a vampire in Park Chan-wook's *Thirst*.
- Played Kim Ki-taek in the Academy Award-winning film *Parasite*.

Spiderwoman Theater
- Founded by three women in 1976.
- Known for storyweaving.
- Performances include *Women in Violence*, *Winnetou's Snake Oil Show from Wigwam City* and *The Three Sisters from Here to There*.
- Collaborated with queer theatre group Split Britches.

Vanessa Williams (1963–)
- Forced to abdicate as Miss America when *Penthouse* published unauthorized nude photographs.
- Starred as the Witch in the 2002 revival of *Into the Woods*.
- Appeared on Broadway in *Kiss of the Spider Woman*, *Carmen Jones*, and *St. Louis Woman* and on television in *Ugly Betty* and *Show Boat*.

B. D. Wong (1960–)
- Originated the role of Song Liling in *M. Butterfly*.
- First Asian American actor to win a Tony Award (1988).
- Led protest against casting of Jonathan Pryce as the Engineer in *Miss Saigon*.

Name That Musical

Play commercials (which can be found on YouTube) that use songs from musicals and have students guess the musicals. This can be an individual or team effort. Examples:

- "Good Morning" in Tropicana commercial—from *Singin' in the Rain*.
- "Diamonds Are a Girl's Best Friend" in Giorgio Armani commercial—from *Gentlemen Prefer Blondes*.
- "Tonight" in Mountain Dew commercial—from *West Side Story*.
- "My Favorite Things" in Volvo commercial—from *The Sound of Music*.
- "Cool" and "Mambo" in Gap commercials—from *West Side Story*.
- "It's a Hard Knock Life" in HotJobs commercial—from *Annie*.
- "Anything You Can Do" in Tide commercial—from *Annie Get Your Gun*.
- "Whatever Lola Wants" in Pringles and Pepsi commercials—from *Damn Yankees*.

Engage in Friendly Discourse

Debates can be formal or informal. Informal debates can be as simple as creating two teams with opposing sides. Each team will have the opportunity to present their side of the case, ask questions or challenge the other team, and defend their position. A third team will be a panel of judges and they decide who wins the debate.

Role-play Debates

To add some extra fun to the class, have students role-play specific artists or people as they debate the topic. This will keep the debate light and entertaining, particularly if it is a serious subject. For example, the topic can be government funding in the arts. Students can portray wealthy patrons and famous artists and discuss whether they believe the arts should be funded by the government or not. The time periods or countries do not have to match up between the students. Students can imagine how people might view the same topic throughout cultures and histories.

Formal Debates

If you wish to have more structured debates, try one of the formats below. All of them can be adapted to create abbreviated versions:

- *Candidate*: This is a roundtable of candidates arguing their platform on a variety of topics that are moderated by a host.
- *Congressional*: This is a mock legislative debate where participants develop a bill to pass by the group. After a presentation and questions, everyone votes whether to pass the bill or not.
- *Lincoln-Douglas*: There are two debaters. One takes an affirmative position, the other a negative position. Each debater gets thirteen minutes of talking time and three minutes of time to cross-examine their opponent.
- *Team Policy*: There are two teams. One provides a plan to resolve a problem. Another opposes the plan.
- *Mock trial*: Students simulate a real trial and play the roles of lawyers and witnesses. Three attorneys and three witnesses perform at a time.

Discussions

Have students observe and engage with the community in which the class takes place. Whether your students live where there is a vibrant performance community or someplace where artistic opportunities are limited, there are avenues for lively discussion. Ask their thoughts on what they would like to see, create, try, change, or rebuild. There are several discussion questions in the sample syllabi but here are a few jumping-off points:

- What is the performance history of your community?
- What type of theatre should we bring back? What can we learn from it?

- What type of theatre are we ready for now?
- What type of theatre do you want to see in the future?

When discussing notable productions or plays, ask:

- How was this production/play reflective of its time?
- How did the production/play challenge the politics of its time?
- What innovations did the production/play contribute?
- How might audiences have reacted to the production/play during its time?
- How might this play be staged today? *Should* it still be staged?
- Who would you like to see direct or act in this play?

When discussing theories and criticism, ask:

- How did critics respond to the production/play when it was first produced or written? Has critical opinion changed over time?
- How do the critical or theoretical claims differ from your own ideas of theatre?
- What is useful about this theory or criticism?
- What would you change about this theory or criticism?
- What would you say to the theorist or critic?
- If a production flopped during its initial run and later became successful, why do you think that happened?

How Do I Run the Course?

How Do I Add Fun?

Take frequent breaks during serious discussions with activities such as singalongs and games. Get the energy up! Breaks can be as long as you need them to be. It can be a one-minute game of Zip, Zap, Zop, or a fifteen-minute game of trivia. Pay attention to your audience and keep the pulse of what your students need to regain focus.

Some students *love* fact-checking, especially when it comes to history. When there is a lot of information to discuss, have students participate by looking up information together. This can be done on your laptop with the entire class, individually, or in small groups. If a student asks a topical question to which you do not know the answer, students can look up sources in class using their phones. Do not be surprised if this leads to being fact-checked during class.

THEATRE HISTORY, THEORY, AND CRITICISM

Add light material in between difficult topics so that students have the mental energy to consider "serious" material. Alternatively, sandwich difficult topics and start on a high and end on a high.

How Do I Moderate Discussions?

Establish an agreement of respect among participants. Of all the courses you teach, theatre history, theory, and criticism are the most eclectic in terms of types of subject matter. Therefore, it is absolutely necessary to establish a high level of respect for different opinions. Have your students agree not to intentionally attack or offend one another and be aware that they may express an opinion with which others may not align. See Chapter 1, How to Manage Different Personalities, for more ideas.

Experience vs. Theory

Make clear expectations about the discussion before beginning. Acknowledge that students may have different points of view about the theories and that is okay. The purpose is to find new ways of understanding theatre through theoretical frameworks. No one needs to agree with a particular point of view in order to participate in discussions.

Theoretical discussions are challenging because they require students to think about a subject on a broader scale, sometimes without real-life examples to couch their understanding. Students who are new to discussing theory may have a difficult time distinguishing experience from theory. If their own experiences differ from what a theory espouses, students may not agree with the theory they are learning about or misinterpret the theory. For example, a student may think "simultaneous dramaturgy" is talking back to the actors and heckling, but what Augusto Boal means is getting the audience directly involved in the creation of the performance. Let students talk about their own experiences and do your best to connect them back to the theory for discussion.

Recognize What You Do Not Know

Acknowledge that knowledge is not universal. What is seen as "common knowledge" by one student may be brand new information to another. If someone misremembers or makes a mistake about dates, names, or facts in general, encourage your students to be supportive of their classmate and to share something that they learned recently that changed their view of something they have previously thought was "common knowledge." Remind them that no

one knows everything and that everyone is in the course because they want to learn something new.

Hidden Narratives

Sometimes narratives are hidden because people do not or did not have the agency to speak about them. Other times narratives are hidden out of fear of challenging the master narrative or of putting their mistakes on display. Remind students that they are not seeing the entirety of the lives of every artist and performer they encounter, only what is presented to the public. Often their mistakes are hidden (to varying degrees of success). Discuss who is accepted after making mistakes, who is not, and why.

Mistakes of the Historical Past

Interpretation of events changes as histories and identities of more people are included. What may have been acceptable, lauded, or standardized when a work was produced may be seen as insensitive, offensive, ill-conceived, or incorrect when viewed in the present day. Challenge your students to explore how historical works can or should be produced today. Should they still be celebrated as "great works of art"? Should some works be removed from the theatrical canon? What is the value of learning about these works today?

International Topics

Some of your students may be well-travelled and others may not. Students' perspectives on other countries or of regions within the USA may be shaped by popular media, personal experiences, and education. Encourage students to think about how their own experiences affect their understanding of other cultures and places.

Political and Historical Topics

When addressing political and historical subjects, assess student understanding about them as they likely have some prior knowledge. If discussing political parties and policies vs. politics in general, make sure your students understand the differences. While students may not agree on policies and politicians, broader politics may be useful in drawing students into discussions. For example: women's role in society.

Race and Gender

Race and gender may be topics in your classroom no matter the race and gender makeup of your course or the subject matter at hand. Be conscious of keeping the conversation on track when discussing vocabulary and redefining terms by having students link their ideas back to history or theory. For a more detailed list of strategies for addressing contentious topics, see Chapter 1, How to Create a Respectful Environment.

Switch Gears

Bring in a new topic for discussion. As mentioned in Chapter 1, always have a backup or two. You can even set up an agreement with your students that you will end discussions if it gets too offtrack or heated, or if anyone strongly dislikes a topic.

Table Topics

If there are additional topics that students wish to discuss, but the class is not ready to talk about them yet, table topics for future sessions. You may also table topics if discourse becomes too confrontational. You may also set this expectation at the beginning of class to help students feel safe.

What Do I Do on the First Day?

Start with something familiar that your students will be able to engage in discussion with immediately. Show clips from popular musicals or shows, historically or present, or discuss the latest popular show. For example, *Hamilton* is a popular show that many people have heard of even if they have not seen it. This can spark discussion about theatrical form, story, and how much one is willing to pay for a theatre ticket.

Another lively way to begin the class is to collect students' most memorable moments in theatre. Have each student share the show they attended and have them explain why it was memorable. This can be a positive or negative experience. This serves several purposes. First, it gets students involved in discussions immediately. Second, you can assess students' experiences in theatre. Third, you can use this information to frame class discussions. Make sure to write down the names of the shows and descriptions so you can bring them up in future conversations. These examples will be a great way to link students' experiences to theatre history and theory that you discuss in class. You can also end the class by referencing their theatre experiences.

How Do I End a Class?

Have students reflect on their most memorable theatre experiences. Ask them how they feel about them after learning more about theatre history and theory. Have them analyze shows they've seen using theatre terms and theory.

Create a map of all of the theatre that you have studied and create a slideshow with a collection of images from different theatre theories and histories. Ask students to reflect on how these theatre histories and theories intersect or not. As a class, try to come up with thesis statements about various theatre practices.

Ask students to share their biggest or favorite takeaways from the class. This can be content discussed, personal experiences, or interactions with others that they had in the class. Students come into the class with different value systems and will appreciate being able to share their values with others.

What Do I Include on the Syllabus?

Content Warning

There may be difficult topics that come up when talking about theatre history. Make a note when your course includes material that may be controversial or distressing. This can be as simple as stating "this film contains brief nudity" or "this play contains violence."

Sample Syllabi

Class activities are highlighted below and are included for instructor reference. Some instructions are for students and other instructions are for the instructor. Do not include them in the printed syllabus that students receive and instead list the discussion topics and any dates that involve guest speakers or special events. All activities are for entire class unless noted. Instructors may need to introduce topics to set up activities.

MUSICAL THEATRE HISTORY

Course Overview: Love musical theatre? Can you sing show tunes by heart? Musical theatre is the most commercially viable form of theatre in the USA. With its high-risk productions, musical theatre can also lose big. Why do audiences keep

coming back for more? What is it about song and dance that makes audiences willing to pay $100 or more for theatre tickets? We will answer these questions and more by examining some of Broadway's top selling musicals and learn about the most successful genres. We will play games, watch musicals, read reviews, and engage in many interactive activities that will broaden your knowledge and deepen your appreciation for musical theatre.

Weekly Schedule

Week One: Introduction

PRE-ACTIVITY DISCUSSION: What is your favorite musical? Why do you think musicals are the most popular form of live theatre in the USA? What film adaptations of musicals have you seen? What musical adaptations of films have you seen?

ACTIVITY: Play Name That Musical; (Small Groups) Play Musical Theatre Chronology; (Group) Watch rehearsal scenes from 1967 and 2005 versions of *The Producers*.

POST-ACTIVITY DISCUSSION: How is musical theatre important in shaping American culture?

Week Two: Popularity vs. Artistic Merit; Where Does Musical Theatre Fit in?

PRE-ACTIVITY DISCUSSION: Why do you think people like Jason Robert Brown?
ACTIVITY: Watch clips from *Last Five Years*, *Pal Joey*, and *Company*.
POST-ACTIVITY DISCUSSION: How do these three musicals explore interpersonal relationships? How does your opinion of the protagonists influence your opinion of the musical?

Week Three: Mother Wore Tights; Burlesque, Vaudeville, and Revues

PRE-ACTIVITY DISCUSSION: What do you think of when you hear the words "cabaret," "burlesque," and "vaudeville"? What celebrities do you associate with these forms?

ACTIVITY: Watch clips from *Cabaret*, *Chicago*, *Moulin Rouge!*, *Murder at the Vanities*, and *The Muppet Show*.

POST-ACTIVITY DISCUSSION: How do burlesque, vaudeville, and revues continue to influence popular culture? What aesthetics are carried through from the earlier musicals to the more recent ones?

Week Four: Framers, Founders, Movers, and Shakers

PRE-ACTIVITY DISCUSSION: How important is it that theatre depict historical events accurately?

ACTIVITY: Watch clips from *1776*, *Hamilton*, and *Assassins*.

POST-ACTIVITY DISCUSSION: How do musicals change the way we perceive history? How much creative license should artists have when recreating history?

Week Five: Drop Another Dime in the Jukebox Musical

PRE-ACTIVITY DISCUSSION: What makes a song catchy? Is music or story more important in a musical? Why?

ACTIVITY: Watch clips from *Mamma Mia*, *Tina*, and *Ain't Misbehavin'*; (Small Groups) Create a jukebox musical and devise a plot. Share with class.

POST-ACTIVITY DISCUSSION: Which of your classmates' jukebox musicals would you most like to see staged? Which has the most interesting plot?

Week Six: *Cats*, Now and Forever

PRE-ACTIVITY DISCUSSION: Why is *Cats* an international phenomenon?

ACTIVITY: Watch clips from *Cats* stage production and 2019 film.

POST-ACTIVITY DISCUSSION: What are the messages in the two films? How does the 2019 film impact the legacy of the stage production?

Week Seven: Names in Lights on the Great White Way

PRE-ACTIVITY DISCUSSION: Would you go see a show just to see a particular star? Why or why not? And which star would you see?

ACTIVITY: Watch different versions of *Hello Dolly*.

POST-ACTIVITY DISCUSSION: Who would you cast in *Hello Dolly*?

Week Eight: Politics in Song

PRE-ACTIVITY DISCUSSION: Can you think of a musical so controversial that the producers would shut it down? Musicals are considered "mainstream" entertainment; are there topics they should avoid?

ACTIVITY: Watch clips from *Cradle Will Rock*, *Parade*, and *Spring Awakening*.

POST-ACTIVITY DISCUSSION: How successful are musicals at sparking conversations about suicide, sex work, communism, lynching, and abortion? Does presenting these issues in musicals trivialize them?

Week Nine: Unofficial Trilogy; *Hair*, *A Chorus Line*, and *Rent*

PRE-ACTIVITY DISCUSSION: How do these three popular musicals form an unofficial trilogy about "outsiders"? What are some of their similarities? How did they all happen to come along at the right time to spark national conversations?

ACTIVITY: Watch clips from *Hair*, *A Chorus Line*, and *Rent*.

POST-ACTIVITY DISCUSSION: How do these musicals attempt to have audiences sympathize with the characters and their situations? How did the national popularity of these musicals change attitudes about people living with HIV, people who are LGBTQIA2S+, and Vietnam War protesters?

Week Ten: Cultural Appropriation

PRE-ACTIVITY DISCUSSION: What does cultural appropriation mean? Should artists be able to create shows about other cultures or races? Why or why not?

ACTIVITY: Watch clips from *Show Boat*, *West Side Story*, *Flower Drum Song*, and *The King and I*.

POST-ACTIVITY DISCUSSION: How has opinion of/reaction to blackface/brownface/yellowface changed in American history? Should these musicals still be performed today, but with a diverse cast?

Week Eleven: Hey Big Spender!; Big Budget Musicals

PRE-ACTIVITY DISCUSSION: How much would you pay to see a show? When you spend that amount, what are your expectations for the show? What constitutes a "good" show?

ACTIVITY: Watch clips from *Miss Saigon* and *Titanic*.

POST-ACTIVITY DISCUSSION: How do these musicals' attempts at spectacle and realism affect the audiences' experience? How would the audience get a different experience without the special effects? Do the set and props take away or add to the story? Why?

Week Twelve: Popularity Contest

PRE-ACTIVITY DISCUSSION: What was the most surprising thing you learned?

ACTIVITY: Watch Ms. Mojo's "Top 10 Best Broadway Musicals of All Time."

POST-ACTIVITY DISCUSSION: What are the top ten musicals of all time? Why?

EVERYONE'S A CRITIC

Course Overview: Have an opinion about theatre? Do you often find yourself disagreeing with public opinion about what is mainstream and popular in theatre? Theatre critics have long been sharing their opinions with society, yet why do their opinions matter more than yours? Come find out how what theatre criticism is, what dramatic criticism is, and how some theatre critics have become cultural icons. Questions we will consider are: How do theatre critics make or break shows? What responsibility do theatre critics have to theatre as an art form? And what role does the audience play in theatre criticism? We will read reviews and criticism, watch and analyze films, write our own criticisms, and engage in discussions. There will be opportunities to attend theatre performances outside of class. Take back the power and be your own tastemaker!

Weekly Schedule

Week One: Introduction

PRE-ACTIVITY DISCUSSION: What is the difference between criticism and reviewing? What is the role of the critic and what is the role of a reviewer?

ACTIVITY: (Small Groups) What are the top five most memorable productions you have seen over the course of your lifetime? What made them stand out? Remember: "memorable" doesn't necessarily mean "good."

POST-ACTIVITY DISCUSSION: What common elements did you discuss in your reviews of the plays? Why do you think those elements stood out?

Week Two: The Role of the Critic

PRE-ACTIVITY DISCUSSION: What is the responsibility of the critic? How have theatre critics and/or reviews influenced your interest in watching a show?

ACTIVITY: Read Rob Weinert-Kendt's "Can 3 Views Change Theatre Criticism?"; Watch scenes from the video of *One Man, Two Guvnors* at the National Theatre.

POST-ACTIVITY DISCUSSION: What impact do theatre critics make in society? How have theatre critics shaped theatre?

Week Three: The Audience as Critic; Fans and Superfans

PRE-ACTIVITY DISCUSSION: What is the significance of the existence and distribution of a film of the original Broadway cast? How does a musical having superfans have an impact on its perception by those outside of the fan base?

ACTIVITY: Watch clips from filmed production of *Hamilton*.

POST-ACTIVITY DISCUSSION: If you have seen *Hamilton* live, how did you think the production translated to film? How does a film of the original Broadway production influence touring and regional productions? Did watching the filmed production of *Hamilton* have an impact on your understanding of the popularity of the play?

Week Four: Theatre Critics in History; Aristotle

PRE-ACTIVITY DISCUSSION: Should Aristotle's *Poetics*, which was based solely on using *Oedipus Tyrannus* as an ideal model for all plays, be used to critique other drama?

ACTIVITY: (Individual) Pick a favorite play or movie. Critique other plays using your favorite as the rubric.

POST-ACTIVITY DISCUSSION: How is it limiting to use one person's subjective opinion as the measure of "good art"?

Week Five: Theatre Critics in History; *Le Cid* Controversy

PRE-ACTIVITY DISCUSSION: Who determines whether or not something is "good"?

ACTIVITY: Read a plot summary of *Le Cid*; Read overview of the Aristotelian Unities of time, space, and action; Introduce that the play was so controversial that Cardinal Richelieu got involved in the Quarrel of *Le Cid*. Read various critiques and counter-critiques of the play's right to exist.

POST-ACTIVITY DISCUSSION: Why was everyone so upset? What are other examples of plays and films that audiences loved but critics and cultural elites hated?

Week Six: Critics in History; Coleridge and Shaw

PRE-ACTIVITY DISCUSSION: Critics are rarely objective in their opinions. What agendas might a critic have in writing about a play? Do you think "to see him act is like reading Shakespeare by flashes of lightning" is a good review or a bad review? Would that description make you want to see the production?

ACTIVITY: Read quotable quotes from Samuel Taylor Coleridge (*Biographia Literaria*) and George Bernard Shaw reviews (*Shaw on Theatre*).

POST-ACTIVITY DISCUSSION: How do Coleridge and Shaw encapsulate the plays and performances? How does their writing provide a record of an ephemeral art form? How does writing theatre criticism help authors with their own writing?

Week Seven: Contemporary Theatre Critics; Ben Brantley

PRE-ACTIVITY DISCUSSION: What contemporary theatre critics do you know of today? If you do not know any, why do you think that is?

ACTIVITY: Read Ben Brantley's review of *Orphans* in the *New York Times*; Read Margaret Lyons's article, "Alec Baldwin Sure Does Hate Ben Brantley"; Read Alan Henry's article, "Ben Brantley Apologizes Over *New York Times* Review for *Head Over Heels*."

POST-ACTIVITY DISCUSSION: How much influence do theatre critics have? How has the role of the theatre critic changed?

Week Eight: Contemporary Theatre Critics

PRE-ACTIVITY DISCUSSION: Why do many women who are theatre critics sign their reviews with initials instead of their names? Have you ever felt compelled to hide your identity to be taken seriously?

ACTIVITY: Read Daniel Jones's "Blistered and Burned: The Absence of Female Critics"; Watch Spalding Gray discuss his *Our Town* reviews in *Monster in a Box*.

POST-ACTIVITY DISCUSSION: How is this a reflection of wider discrimination and the absence of women in the theatre in general?

Week Nine: Theatre Critic as Cultural Icon

PRE-ACTIVITY DISCUSSION: What theatre critics do you consider as cultural icons? What makes someone a cultural icon?

ACTIVITY: Watch clips from *Citizen Kane* and *The Man Who Came to Dinner*.

POST-ACTIVITY DISCUSSION: Why would someone aspire to be a theatre critic? How do you think Alexander Woollcott felt about being lampooned as Sheridan Whiteside?

THEATRE HISTORY, THEORY, AND CRITICISM

Week Ten: Theatre Critic as Cultural Icon Cont'd

PRE-ACTIVITY DISCUSSION: How are critics sinister figures?

ACTIVITY: Watch clips from *All About Eve*, *Laura*, and *Sweet Smell of Success*.

POST-ACTIVITY DISCUSSION: Are critics still cultural icons? Who has taken their place as tastemakers and cultural influencers? Who has similar power to promote and destroy?

Week Eleven: Production Review

PRE-ACTIVITY DISCUSSION: What were your expectations before going to see the show? How did the show's marketing influence your perception of the show?

ACTIVITY: Watch a local production before class; (Small Groups) Read review(s) of the production and discuss which parts you agreed and disagreed on. Describe how your experience was different than that of the review.

POST-ACTIVITY DISCUSSION: How has reading the review changed your perception of the show? What are the advantages of reading a review before seeing a show?

Week Twelve: Who Will Critique the Critics?

PRE-ACTIVITY DISCUSSION: What is an example of a show you enjoyed at first, but your opinion changed upon hearing a negative review? What is a show that you enjoy despite negative reviews?

ACTIVITY: Read Rob Weinert-Kendt's "Who will critique the critics?"; Write a review of last week's production; (Small Groups) Share your review with the group.

POST-ACTIVITY DISCUSSION: How do critics influence theatre? What role can we play as audiences in shaping theatre?

PUPPETS, MUSICALS, AND MORE!

Course Overview: Theatre has existed throughout the world for thousands of years, often occurring alongside and commenting on major historical events. Theatre history spans a wide variety of forms, from lavish musical extravaganzas to experimental shows featuring lone actors in tiny black box theatres. We will explore performances by watching videos; reading plays, articles, and reviews; discussing our own experiences with theatre; and creating our own stories.

Weekly Schedule

Week One: Introduction to Course and Musicals

PRE-ACTIVITY DISCUSSION: What is the most memorable theatrical production you have seen? Why?

ACTIVITY: Watch clips of the same scenes from the 1955 and 1999 versions of *Oklahoma!*.

POST-ACTIVITY DISCUSSION: What was different about these two films? What was memorable about them? Did the two films tell the same story? Why or why not? What is the importance of the actor, director, and stage designers? How does the historical period influence the adaptation of the musical?

Week Two: Musicals Cont'd

PRE-ACTIVITY DISCUSSION: Why is musical theatre popular in the USA? What other forms of musical theatre are you familiar with? Do you have to understand music to appreciate it?

ACTIVITY: Watch clips from *La Traviata*, *Peony Pavilion*, and the stage production of *Cats*.

POST-ACTIVITY DISCUSSION: What common elements do you see in all three productions? How important is story in musical theatre? Should music or story be prioritized in a musical? Why?

Week Three: Puppetry

PRE-ACTIVITY DISCUSSION: What type of puppetry have you seen? Should puppetry be for children only? Why do you think puppetry is an effective learning tool for children?

ACTIVITY: Watch clips from *Sesame Street* and *The Muppet Show*. Introduce origins of *Sesame Street* and *The Muppet Show* in British music hall and Punch & Judy shows, American burlesque, vaudeville, and children's education.

POST-ACTIVITY DISCUSSION: How are *Sesame Street* and *The Muppet Show* different from children's entertainment that came before? What exists in *Sesame Street* and *The Muppet Show* that are for audiences of all ages? What did you notice watching these "for children" shows that surprised you?

Week Four: Puppetry Cont'd

PRE-ACTIVITY DISCUSSION: Why do you think puppetry is not mainstream entertainment for adults in the USA, but is a popular form of entertainment for adults outside the USA?

ACTIVITY: Watch clips from *The Puppet Lady*, *Ghosts of Bread and Puppet*, *Sita Sings the Blues*, and *Angkor Awakens*.

POST-ACTIVITY DISCUSSION: Which puppetry form speaks to you? What are the advantages of each form? How would you describe each form?

Week Five: Puppetry Cont'd

PRE-ACTIVITY DISCUSSION: Do puppets need to be realistic in movement or image? How can non-realistic puppets be used for storytelling?

ACTIVITY: Watch clips from Lunatique Fantastique and *Little Shop of Horrors*; (Individual) Make puppets out of socks, paper bags, or ordinary objects; (Small Groups) Talk to others using your puppet.

POST-ACTIVITY DISCUSSION: How did puppets help you communicate with others? What new things did you learn about yourself while using the puppet?

Week Six: Greek Drama

PRE-ACTIVITY DISCUSSION: What myth would you want to see staged in theatre?

ACTIVITY: Introduce staging techniques, deus ex machina, and offstage deaths, and Aristotle's *Poetics*; Watch clips of *Oedipus Tyrannus* and *Sharknado*.

POST-ACTIVITY DISCUSSION: How does *Sharknado* successfully or not successfully follow the unities of time, space, and action? Do you agree or disagree with Aristotle's *Poetics*? Why or why not? What other influences of Greek drama do you see in society today?

Week Seven: Greek Comedy

PRE-ACTIVITY DISCUSSION: What are examples of things that are offensive in modern comedy? How might translators of Greek comedy change the plays to make them more "appropriate" for their contemporaries?

ACTIVITY: Read multiple versions of the same scene in a Greek comedy adapted by different translators. For example, the Agon from *Clouds*, the young man and the three crones in *Assemblywomen*, or Aeschylus and Euripides in *Frogs*; (Small Groups) Create a new translation of the scene

(that addresses contemporary social issues, to highlight the generation gap, etc.); (Small Groups) Create your own version of the same scene using the different translation and share revised scenes.

POST-ACTIVITY DISCUSSION: Instead of adapting myths and legends, Greek comedies were about "everyday people" and social situations. What archetypes from ancient comedy are still relevant now?

Week Eight: Political Plays

PRE-ACTIVITY DISCUSSION: Should art be produced for art's sake? Or can art have a political message? Why or why not?

ACTIVITY: Read excerpts from *Waiting for Lefty* and *The White-Haired Girl*.

POST-ACTIVITY DISCUSSION: What were the messages of the plays? How were the plays effective in delivering their messages? How can these plays be staged today? If they cannot be staged today, why not?

Week Nine: Political Plays Cont'd

PRE-ACTIVITY DISCUSSION: What urgent issues would you like to see on stage? What would you want people to think about when they are watching a show?

ACTIVITY: (Individual/Partners/Small Groups) Create a political play; (Individual/Partners/Small Groups) Adapt an existing play for political purposes by setting it in a different time period and cast the adaptation using famous actors.

POST-ACTIVITY DISCUSSION: Can a political play be effective if it is merely "preaching to the choir"? Why or why not? What role does theatre play in creating cultural change in society?

Week Ten: Experimental Theatre

PRE-ACTIVITY DISCUSSION: What experimental theatres have you seen? What did you like/dislike about them?

ACTIVITY: Read reviews of *Sleep No More*, *Queen of the Night*, *Gatz*, and *The Illuminati Ball*; Review websites of the shows; Read descriptions of the set.

POST-ACTIVITY DISCUSSION: What are the advantages of environmental theatre spaces? How can they be potentially risky?

Week Eleven: Experimental Theatre Cont'd

PRE-ACTIVITY DISCUSSION: What do you think of when you hear the term "performance art"?

ACTIVITY: Watch documentaries on Coco Fusco and Guillermo Gómez-Peña: *The Couple in the Cage: Two Undiscovered Amerindians Visit the West* and *The Case for Yoko Ono*.

POST-ACTIVITY DISCUSSION: How do experimental productions and performance art translate when you are not able to attend in person? Why do you think performance art is often political in some way?

Week Twelve: End of Class Celebration

PRE-ACTIVITY DISCUSSION: Revisit the most memorable production that you have seen. Why do you think it was the most memorable?

ACTIVITY: (Small Groups) Create your own production of *A Christmas Carol* and share production ideas with the class.

POST-ACTIVITY DISCUSSION: What did you find most interesting or surprising in the different theatre histories discussed in the course? What would you like to see?

THEORIZING THEATRE

Course Overview: Theatre theory is the act of attempting to understand theatre from philosophical viewpoints. From ancient works to present day, theatre theory describes the ephemeral events of theatre and their impact. This course includes the study of performance and acting processes, dramatic structure, audience relationships, verisimilitude, and more. We will engage in discussions, read excerpts from influential texts, watch highlights from performances, and create new theories of theatre. Come learn how to use your own experience and knowledge of theatre to be a part of the conversation of what makes theatre fun, intriguing, and memorable.

Weekly Schedule

Week One: Introduction

PRE-ACTIVITY DISCUSSION: What is your ideal theatre? What elements of theatre do you enjoy the most?

ACTIVITY: (Individual) Write your own theory of theatre. Describe how the staging, acting, scenery, and audience should work.

POST-ACTIVITY DISCUSSION: How does a theory contribute to the theatrical production process? How would your theory of theatre affect the way audiences experience theatre?

Week Two: Augusto Boal

PRE-ACTIVITY DISCUSSION: Do you enjoy being an active or passive spectator? Why?

ACTIVITY: Read excerpts from *Games for Actors and Non-Actors*; Watch clips from *Augusto Boal in Rio De Janeiro* or other interviews.

POST-ACTIVITY DISCUSSION: How can Boal's theories of theatre be used in theatre today? What elements of theatre of the oppressed do you see in other shows you have seen?

Week Three: Postcolonialism

PRE-ACTIVITY DISCUSSION: What is postcolonialism? How does postcolonialism describe the experience of the colonized? Should Native American works be considered postcolonial? Why or why not?

ACTIVITY: Play a trivia game about postcolonial plays; Read summary of *Dutchman*; Introduce Frantz Fanon's *Black Skin, White Masks*.

POST-ACTIVITY DISCUSSION: What commonalities do you see in these plays? How are these characters' identities and conditions tied to postcolonialism?

Week Four: Constantin Stanislavski and The Method

PRE-ACTIVITY DISCUSSION: What do you like about theatre with "realistic" acting? How is realistic acting different from other forms of acting? For example, physical acting? How does realistic acting affect the audience's reception of a performance?

ACTIVITY: Introduce The Method and the terms "objective" and "super objective"; Take *A Tempest* or another postcolonial play and analyze the characters' objectives and super objectives; (Small Groups) Give each other different objectives to reinterpret and perform the script.

POST-ACTIVITY DISCUSSION: How does The Method influence a way that a script is interpreted? How does it help your understanding of acting?

Week Five: Antonin Artaud and Theatre of Cruelty

PRE-ACTIVITY DISCUSSION: What do you expect out of an evening at the theatre? How do you expect to feel after you have attended a performance?

ACTIVITY: Introduce Artaud and Theatre of Cruelty; Read *The Spurt of Blood*; Look at production photos from past productions.

POST-ACTIVITY DISCUSSION: How did Artaud misinterpret Balinese and Cambodian performance forms? What role do you think neurodivergence played in Artaud's theories of performance and playwriting style?

Week Six: Aristotle's *Poetics*

PRE-ACTIVITY DISCUSSION: Would you use two-thousand-year-old lecture notes as the basis for an entire artistic genre? Why or why not?

ACTIVITY: Introduce Aristotle's *Poetics*; (Small Groups) Take the Aristotelian elements of plot, character, thought, diction, song, and spectacle and map them onto famous plays and movies. Share findings with class.

POST-ACTIVITY DISCUSSION: How do popular twentieth- and twenty-first-century films and plays measure up to Aristotle's standards and expectations?

Week Seven: Bertolt Brecht and Epic Drama

PRE-ACTIVITY DISCUSSION: What do you think of when you hear the name Bertolt Brecht? How about Kurt Weill? Or Lotte Lenya? Or Mack the Knife? How did Bertolt Brecht's theatre career change world history?

ACTIVITY: Introduce Epic Drama; (Small Groups) Create an epic drama about a historic event using parallel plots and multiple character groupings. Select popular songs for characters to sing to underscore scenes in the play.

POST-ACTIVITY DISCUSSION: How is Brechtian epic drama similar to Shakespeare?

Week Eight: Gender and Theatre

PRE-ACTIVITY DISCUSSION: In what ways is gender a performance? What are some typical gendered behaviors that have changed in your lifetime? How has gendered clothing changed in your lifetime? How have gender roles for professions changed in your lifetime?

ACTIVITY: Watch clips from *RuPaul's Drag Race* and *Dragula*; (Small Groups) Create an activity for drag performers to compete in. Share with class.

POST-ACTIVITY DISCUSSION: In what ways is gender a performance? What does drag say about performance of gender?

Week Nine: Identity and Theatre: Cathy Cohen, Jill Dolan, and LGBTQIA2S+

PRE-ACTIVITY DISCUSSION: When did you remember first seeing LGBTQIA2S+ characters in mainstream popular culture? Why do you think society became more accepting in the past 30 years?

ACTIVITY: Watch clips from documentary *T'Ain't Nobody's Bizness: Queer Blues Divas of the 1920s*; (Individual) Write down all the different identities you have in response to the following prompts:

1. The parts of my identity I am most aware of on a daily basis are _____.
2. The parts of my identity I wish I knew more about are _____.
3. The part of my identity I feel is most discriminated against is_____.
4. The part of my identity that is most difficult to discuss with other people is _____.

Share responses.

POST-ACTIVITY DISCUSSION: How do your different identities influence the way you perceive the world? How might intersectionality change the way theatre is created?

Week Ten: Ritual and Theatre

PRE-ACTIVITY DISCUSSION: What are examples of in-between stages, where something is in the process of becoming something else? What are examples of things that are always in the in-between?

ACTIVITY: Introduce Victor Turner's liminal and liminoid; (Individual) Pick common activities that have had rituals develop around them. Act them out for the class and/or teach/share them with your classmates.

POST-ACTIVITY DISCUSSION: Why and how have these rituals developed surrounding these activities? How do they help bring communities together? What experiences from your life have been liminal? What is something you identify as liminoid?

Week Eleven: The Essence of Theatre

PRE-ACTIVITY DISCUSSION: How does theatre transform the audience into another space?

ACTIVITY: Read excerpts on Zeami and Bharata in *Theatre/Theory/Theatre*; Watch clips of *nō* and *kathakali* performances.

POST-ACTIVITY DISCUSSION: How would you describe the essence of theatre? What is the purpose of theatre?

Week Twelve: New Theories of Theatre

PRE-ACTIVITY DISCUSSION: Which theories of theatre resonates the most with you?

ACTIVITY: (Individual) Write your own theory of theatre. Describe how the staging, acting, scenery, and audience should work. Share theory with class.

POST-ACTIVITY DISCUSSION: How will learning about theatre theory change the way you view theatre and performance?

ENCOUNTERING PERFORMANCE IN EVERYDAY LIFE

Course Overview: What is theatre and what is performance? How do the two relate to one another? The idea of theatre and performance has changed over time. Performance is now used to encompass both theatre and performance of activities that do not take place on a stage. Performance has taken on a broad meaning to include big cultural events such as the Olympics and political campaigns, to everyday events such as eating and working. The concept of Dramatism, introduced by Kenneth Burke, frames real-life events as performances. This course uses Dramatism as an introduction to performance and cultural studies and you will explore the significance of performances in your own life. We will engage in discussions, watch films, participate in debates, and create our own theories of everyday life.

Note: See Key Terms for full description of Dramatism.

Weekly Schedule

Week One: Introduction to Performance in Everyday Life and Dramatism Pentad

PRE-ACTIVITY DISCUSSION: What are events you have experienced that felt more like a play or movie than real life? What seemed unreal about the event?

ACTIVITY: Introduce Dramatism Pentad; (Partners) Share a recent example of a situation where perspectives changed as you learned about the situation from different perspectives. Interpret the event using the Pentad (Act, Scene, Agent, Agency, and Purpose). Present to the class.

POST-ACTIVITY DISCUSSION: How have public figures reacted to significant events in history? What has stuck out to you most about actions and speeches?

Week Two: Dating and Other Misadventures

PRE-ACTIVITY DISCUSSION: Why do some people consider dating a stressful activity? What advice would you give others? What advice would you give your younger self?

ACTIVITY: Read highlights from "Dating After 60 Is Hard" and "How Tinder Changed Dating for a Generation" from *The Atlantic Monthly*; (Partners) Describe your first date ritual process:

1. How do you get a date?
2. How do you prepare for a date?
3. How do you behave on a date?
4. What conversation topics are avoided?
5. How do you end a date?

POST-ACTIVITY DISCUSSION: How has online dating changed from "traditional" dating? What elements of dating remain the same? What is the reason it has remained the same?

Week Three: Food and Dining Out

PRE-ACTIVITY DISCUSSION: What foods do you associate with different regions in the USA? What foods do you associate with different rituals and social events? What foods did you not have growing up that have become commonplace? How have tastes changed? How is food marketed?

ACTIVITY: Read Benjamin Wachs's "LiPo Lounge Says 'Fuck You, Tourist': Asian Kitsch" from *SF Weekly*; (Individual/Partners/Small Groups) Examine menus and pictures from national and regionally famous restaurants. Examine historic cookbooks. Present findings to the class.

POST-ACTIVITY DISCUSSION: What can we infer from the restaurants and the people they're appealing to as customers? What do the included recipes in the cookbooks suggest about the context in which they were created? What are things that you will notice during dinner tonight?

Week Four: The Theatre of Customer Service

PRE-ACTIVITY DISCUSSION: What was the best customer service experience you have had? What was the worst?

ACTIVITY: Read highlights from Michael Morgan, Pamela Watson, and Nigel Hemmington's "Drama in the Dining Room: Theatrical Perspectives on the Foodservice Encounter"; (Small groups) Create a satiric customer training plan for employees. Present to class.

POST-ACTIVITY DISCUSSION: Should theatre be used for customer service training? Why or why not? How has the idea of work and customer service changed in your lifetime?

Week Five: Hard Bodies, Performing Patriotism, and Olympic Spectacles

PRE-ACTIVITY DISCUSSION: What is the first Olympics you remember watching? Who are memorable personalities you recall and why? How have different opening and closing ceremonies depicted the host country?

ACTIVITY: Watch Beijing Olympics (2008) opening ceremony; Read three newspaper reviews of the Beijing Olympics opening ceremony.

POST-ACTIVITY DISCUSSION: What is the importance of the Olympics, and specifically, the opening ceremony in promoting culture and/or nationalism?

Week Six: Gender, Snacking, and the Super Bowl

PRE-ACTIVITY DISCUSSION: Do you watch the Super Bowl? If you do not watch the Super Bowl, have you seen any Super Bowl commercials or half-time shows? Which ones were memorable and why? Why do you think Super Bowl audiences have been declining and are at an all-time low?

ACTIVITY: Watch Super Bowl half-time shows featuring Beyonce, JLo and Shakira, and Prince.

POST-ACTIVITY DISCUSSION: What do the half-time shows reveal to you about the historical context? What are the rituals of half-time shows? How do the half-time shows create community?

Week Seven: The Alumni Want Athletics

PRE-ACTIVITY DISCUSSION: What do you do when attending or watching a college sports game? Is there a difference between watching a game in person and on television?

ACTIVITY: Watch clips from *Rudy*, *The Blind Side*, *We Are Marshall*, *The Waterboy*, *Brian's Song*, *Jerry Maguire*, and *Drumline*; Watch half-time shows from Harvard, Stanford, University of California Berkeley, and University of Alabama.

POST-ACTIVITY DISCUSSION: How does emphasis on athletics show priorities in higher education? How are college sports used to engage alumni and thereby fund schools? How do the rituals promote collegiate culture? How do college sports promote inequalities in college life? What is the significance of the marching band in sports?

Week Eight: Selling Candidates; Political Campaigns

PRE-ACTIVITY DISCUSSION: How do you learn about a political candidate? What political candidate events have you attended?

ACTIVITY: Watch the Lyndon Johnson Daisy ad; Watch PAC-sponsored ads; Watch a political campaign event.

POST-ACTIVITY DISCUSSION: How do political candidates use campaigns to build support? Which tactics are most effective? Why? How much of a political candidate's popularity is determined by their campaigns?

Week Nine: Conspiracy Theories; Are They Out to Get You?

PRE-ACTIVITY DISCUSSION: What conspiracy theories do you know about? Who believes in it? How does information about this conspiracy theory get disseminated?

ACTIVITY: Listen to Episode 265 (Fake Science) of *This American Life*; Watch clips from *Ancient Aliens*, *Enemy of the State*, and *Conspiracy Theory*.

POST-ACTIVITY DISCUSSION: Why do conspiracy theories perpetuate? How do they develop in response to change and difficult situations?

Week Ten: Code-Switching and Code Mixing

PRE-ACTIVITY DISCUSSION: How often do you speak in a different "language"? When would you change your communication style? How do adults speak differently to children? And why do they do that?

ACTIVITY: Introduce the practice of code-switching; Watch clips from *Sorry to Bother You*.

POST-ACTIVITY DISCUSSION: What does code-switching require the speaker to do? Why do people code-switch? How does code-switching improve or hinder communication?

Week Eleven: Develop Your Own Theory of Performance in Everyday Life

PRE-ACTIVITY DISCUSSION: What have people found strange about you?

ACTIVITY: (Individual) List everyday events that you have found confusing, strange, or have been expected to behave in a different way than you normally do.

POST-ACTIVITY DISCUSSION: How does creating a theory help you better understand strange events?

Week Twelve: Roundtable Discussion of Theories of Performance

PRE-ACTIVITY DISCUSSION: What would you include in a performance manifesto?

ACTIVITY: (Individual) Create a performance theory. Share with class.

POST-ACTIVITY DISCUSSION: What area of performance theory needs more attention? How has performance theory changed your perspective?

THEATRE HISTORY: A HANDS-ON EXPERIENCE

Course Overview: Theatre history is all around us. Experience theatre history from a historian's perspective. Visit museums, archives, libraries, and theatres to discover the theatre history in your community. Learn how to conduct research using primary and secondary resources and share newfound knowledge with others.

Weekly Schedule

Week One: Introduction

PRE-ACTIVITY DISCUSSION: Why is history important to you? Why is history important to society?

ACTIVITY: (Individual/Partners/Small Groups) Browse collections available through Google Arts & Culture App; (Individual) Do an Art Selfie; (Individual/Partners/Small Groups) Find the list of theatre-related artifacts (provided by instructor) online.

POST-ACTIVITY DISCUSSION: What new things did you learn about internet research and resources? What was difficult about using your phone to do research? What was the quality of the results? What are the benefits of doing internet research?

Week Two: Field Trip to Museum

PRE-ACTIVITY DISCUSSION: How do museums tell a story? How can the "staging" of the rooms affect a visitor's experience?

ACTIVITY: View current exhibits; (Small Groups) If a museum based on local history, view exhibits about the region's history; (Individual/Partners) Complete a checklist of things to locate in the museum.

POST-ACTIVITY DISCUSSION: How did the curation of the museum's exhibits enhance your understanding of the region's artistic community and history? How is theatre presented through visual art?

Week Three: Field Trip to Hall of Records

PRE-ACTIVITY DISCUSSION: How are theatres related to growing and diversifying communities? How is the survival of theatres tied to local and regional economies?

ACTIVITY: View city almanacs and atlases from a variety of time periods. Examine the emergence and disappearance of neighborhood theatres and what replaced them. If there are land titles and deeds to properties, examine those as well.

POST-ACTIVITY DISCUSSION: What changes of the city influenced theatre?

Week Four: Field Trip to Theatre

PRE-ACTIVITY DISCUSSION: What is your favorite theatre? Why? What is the most unique theatre you have attended?

ACTIVITY: Take a tour of the house, stage, and backstage of a theatre.

POST-ACTIVITY DISCUSSION: How does the theatre stage, audience space, and technology affect the experience of watching a performance? After having seen all that goes on backstage to produce a show, how would you describe the culture of theatre?

Week Five: Field Trip to Library

PRE-ACTIVITY DISCUSSION: What items have you used at the library? What types of libraries have you visited and what resources did they have?

ACTIVITY: Archivists and reference libraries provide a guided viewing of collections of playbills, posters, letters, and journals describing performances; View archives and special collections; (Individual) Look for clippings or files on local venues or residents of note.

POST-ACTIVITY DISCUSSION: Is there still a place for physical libraries if there are resources available online? How can archival materials best be maintained so that people are able to access historical information?

Week Six: Field Trip to Theatre/Former Theatre

PRE-ACTIVITY DISCUSSION: What has changed in your neighborhood or city?

ACTIVITY: Visit a venue that used to be a theatre that has since been converted into something else. Look for elements from the structure's past life that still remain.

POST-ACTIVITY DISCUSSION: What are best practices for historic preservation? How can structures best be repurposed?

Week Seven: Field Trip to Library

PRE-ACTIVITY DISCUSSION: What materials do you hope to find? What do you think is lacking in theatre history?

ACTIVITY: (Small Groups) Pick a theatre topic and conduct research using library searching tools.

POST-ACTIVITY DISCUSSION: What challenges came up when you did your research? What strategies did you use to overcome them?

Week Eight: Field Trip to Theatre/Former Theatre

PRE-ACTIVITY DISCUSSION: What are some benefits of having a theatre in a town? How has theatre culture impacted local communities?

ACTIVITY: Visit a building that was originally a theatre, intermediately used as something other than a theatre, and then converted back into a theatre.

POST-ACTIVITY DISCUSSION: How have corporate-sponsored national tours and arts fundraising had an impact on historic preservation? How have attitudes shifted about preservation of historic landmarks?

Week Nine: Digital Collections and Online Archives

PRE-ACTIVITY DISCUSSION: How easy is it to access materials from national archives and special collections as an everyday person?

ACTIVITY: (Small Groups/Partners/Individual) Select a topic to research over the remaining class sessions using online digital collections (the Library of Congress, the Smithsonian, the Billy Rose Theatre Division, or the Victoria & Albert Theatre and Performance Collection).

POST-ACTIVITY DISCUSSION: How can digital collections provide an interactive experience?

Week Ten: Field Trip to Theatre/Former Theatre

PRE-ACTIVITY DISCUSSION: What alternative theatre spaces have you visited?

ACTIVITY: Visit a venue that was originally constructed as something other than a theatre and has since been converted into a theatre.

POST-ACTIVITY DISCUSSION: What elements of the original construction did you notice? Imagine yourself watching a show in this theatre. What would that experience feel like? What shows could this theatre stage using this space?

Week Eleven: Digital Collections and Online Archives

PRE-ACTIVITY DISCUSSION: What questions do you have about presenting your research?

ACTIVITY: Introduce presentation length, structure guidelines, and have students sign up for presentation order; (Small Groups/Partners/Individual) Gather final materials for presentation of topic.

POST-ACTIVITY DISCUSSION: Do you have any technical needs for their presentations? What else can I help you with?

Week Twelve: Presentations

ACTIVITY: (Small Groups/Partners/Individual) Present findings from research.

POST-ACTIVITY DISCUSSION: How has conducting first-hand research and visiting theatres, museums, and archives helped you understand theatre history? What materials were you not able to locate and on your "wish list"?

THEATRE FOR LIFELONG LEARNING

Course Overview: Interested in getting involved with and learning more about the Older Adult Theatre movement? There are many older adult theatre groups around the world and there is room for more. We will explore how older adults

are portrayed in theatre, how that perception is changing, and how educational programs, community projects, and production companies are making a positive impact in theatre for older adults. We will read plays, watch films, write monologues, play improv games, and engage in lively discussions. You will also have the opportunity to form your own theatre communities. Come listen, learn, and share.

Weekly Schedule

Week One: Introduction and Archetypes in Older Adult Theatre & Three D's (Death, Dying, and Dementia)

PRE-ACTIVITY DISCUSSION: What stereotypes of older adults are there in society? What makes stereotypes dangerous?

ACTIVITY: Introduce the Three D's; Read/Watch clips from *The Outgoing Tide*, *Sundowning*, *Marvin's Room*, and/or *The Lady in the Van*.

POST-ACTIVITY DISCUSSION: How do these works reinforce stereotypes? What could you change to make them better?

Week Two: *Ripcord*

PRE-ACTIVITY DISCUSSION: What would you like to see in a play featuring older adults?

ACTIVITY: Read Act I of *Ripcord*.

POST-ACTIVITY DISCUSSION: How does the play challenge stereotypical views of aging? How does it not?

Week Three: *Ripcord* Cont'd

PRE-ACTIVITY DISCUSSION: Which characters do you relate to and why?

ACTIVITY: Read Act II of *Ripcord*.

POST-ACTIVITY DISCUSSION: How do the characters' journeys change throughout the play? How do their experiences reflect reality?

Week Four: Intergenerational Theatre

PRE-ACTIVITY DISCUSSION: How can a children's theatre best partner with older adults?

ACTIVITY: Read the website of Oregon Children Theatre's Intergenerational Queer Theatre Project.

POST-ACTIVITY DISCUSSION: What positive influences do you see in working with a children's theatre group? What can we learn from working with different generations? How can older adults improve the lives of other generations?

Week Five: New York Deaf Theater

PRE-ACTIVITY DISCUSSION: Why is it important to consider accessibility and universal design when producing theatre?

ACTIVITY: Watch video performance of New York Deaf Theater.

POST-ACTIVITY DISCUSSION: How can theatre in general better serve the needs of all audience members and theatre practitioners?

Week Six: Vintage Improv

PRE-ACTIVITY DISCUSSION: What is your familiarity with improv? Have you seen a Vintage Improv Festival?

ACTIVITY: Introduce Miki Manning and the Vintage Improv movement; Play improv games. *See Performance Exercises in Chapter 5.*

POST-ACTIVITY DISCUSSION: How does improvisation help people live in the present?

Week Seven: Queer Elders Theatre

PRE-ACTIVITY DISCUSSION: How can theatre help build community for people who come out later in life? How can theatre provide a community?

ACTIVITY: Introduce programming and initiative for Queer Elders.

POST-ACTIVITY DISCUSSION: What ways have you built a community of your own? What challenges did you face and how did you overcome them? How can you help others build community?

Week Eight: Penelope Project

PRE-ACTIVITY DISCUSSION: How would you feel about collaborating with college students on a production? How do you think theatre can have a positive impact on quality of life?

ACTIVITY: (Small Groups) Read excerpts from *The Penelope Project*.

POST-ACTIVITY DISCUSSION: What are some of the challenges with working with college students? What ways can we build trust and respect with other generations? How can we work through creative differences among different generations?

Week Nine: Stagebridge Oakland

PRE-ACTIVITY DISCUSSION: What older adult courses have you taken? Which did you find most valuable? Which was most enjoyable? Why?

ACTIVITY: Review the website of Stagebridge Oakland programming.

POST-ACTIVITY DISCUSSION: How is the Stagebridge programming different from other institutions that you know of? What would your ideal program look like? What classes would it have?

Week Ten: Creating Your Own Theatre Community

PRE-ACTIVITY DISCUSSION: What would you like to share with the world about aging?

ACTIVITY: (Individual/Partners) Write a one-minute monologue about aging; Share play with partner.

POST-ACTIVITY DISCUSSION: What did you learn about others' perspectives of aging? What are the most pressing issues that older adults face today? How can theatre communities help overcome these challenges?

Week Eleven: Creating Your Own Theatre Community Cont'd

PRE-ACTIVITY DISCUSSION: How have older adult educational programs impacted your life? What would you like to see it do differently?

ACTIVITY: (Small Groups) Develop a plan to create a theatre community. Answer the following questions:

1. What courses would you offer?
2. What types of theatre would you produce?
3. What resources are available to you?
4. What programs can you run for free or with minimal costs?
5. What partnerships can you make?
6. Which idea would you implement first?

POST-ACTIVITY DISCUSSION: How did you determine what programming to offer? Why? What obstacles did you encounter when coming up with strategies for partnerships and funding?

Week Twelve: Creating Your Own Theatre Community Cont'd

ACTIVITY: (Small Groups) Finalize your theatre community plan. Share with class.

POST-ACTIVITY DISCUSSION: What are your biggest takeaways from the course? How has the course changed your perception of aging? How can we work together to create new communities?

Additional Resources

Key Terms and Key Figures

Aeschylus (c.456–525 BCE): Greek tragedian who wrote *Oresteia*, a play about the trials of the House of Atreus and the one surviving Greek cycle play. A fictionalized version of Aeschylus defeats Euripides in a battle of wits in Aristophanes's *Frogs*.

Edward Albee (1928–2016): absurdist American playwright best known for *Who's Afraid of Virginia Woolf?*, *Seascape*, *The Zoo Story*, *The Sandbox*, *Three Tall Women*, *A Delicate Balance*, and *The Goat, or Who Is Sylvia?*

Aristophanes (c.446–386 BCE): Greek old comedy writer best known for *Lysistrata*. His plays provide commentary on sex and gender roles (*Lysistrata*, *Assemblywomen*, and *Thesmophoriazusae*), war and poverty (*Knights*, *Wasps*, and *Plutus*), philosophy (*Clouds*), and playwriting (*Frogs*).

Aristotle (c.384–322 BCE): Greek philosopher and student of Plato who wrote *Poetics* which described the elements of an ideal play based on his analysis of Sophocles' *Oedipus Tyrannus*.

Art Selfie: Google application that uses facial recognition software to compare the subject of a photograph with the faces in paintings in museums around the world and bring up matches.

Antonin Artaud (1896–1948): French surrealist artist who developed the Theatre of Cruelty which emphasized creating visceral reactions in audiences. Artaud was also an actor, appearing in several films during the 1920s and 1930s, and created several paintings and drawings as part of his therapy for schizophrenia. His best-known play is the one-act *The Spurt of Blood*.

BIPOC: Black, indigenous, and people of color.

Augusto Boal (1931–2009): Brazilian theatre artist who created Theatre of the Oppressed. His works focused on improvisational exercises and eliminated the barrier between actor and audience, and is known for inviting audiences to participate directly in theatre-making.

Kate Borstein (1948–): gender theorist, playwright, and performance artist whose famous works include *My (New) Gender Workbook*, *Gender Outlaw*, and *Hidden: A Gender*.

Ben Brantley (1954– present): cochief theatre critic for the *New York Times*.

Bertolt Brecht (1898–1956): German playwright, actor, and theorist who created Epic Theatre which privileged action over realistic portrayals of life. Best-known plays include *The Caucasian Chalk Circle*, *Mother Courage and Her Children*, *The Threepenny Opera*, and *The Good Person of Szechuan*. His song "Mack the Knife," written in collaboration with

Kurt Weill, has been recorded by multiple artists, most famously Louis Armstrong, Ella Fitzgerald, and Bobby Darin.

Judith Butler (1956–): queer theorist and philosopher who developed concept of gender performativity. Author of *Gender Trouble* and *Bodies That Matter*.

John Cariani (1969–): author of *Almost, Maine*, a play about love and relationships in a small town, which became one of the most-produced plays in the USA in the early twenty-first century.

Code-mixing: mixing two languages or more to communicate.

Code-switching: to change your language (foreign or using different words within the same language) to communicate to different populations.

Samuel Taylor Coleridge (1772–1834): English critic, poet, and philosopher. His most famous work is the poem *The Rime of the Ancient Mariner*. In theatre, he is best known for coining the term "willing suspension of disbelief," in *Biographia Literaria*.

Cultural theory: the field of study that examines culture and creates theories to explain or describe culture.

Jill Dolan (1957–): Sexuality Studies author, researcher, and editor of the *Theatre & Sexuality* book series.

Dramatic criticism: the critique of the literature or plays of theatre.

Dramatism: a theory developed by rhetorician Kenneth Burke to interrogate and understand complex incidents, events, and interactions using a theatrical framework. Using the Dramatistic Pentad process, everyday events are examined by Act, Scene, Agent, Agency, and Purpose, which provides perspectives for examining motivations behind actions. The Pentad corresponds with Who (Agent), What (Act), When/Where (Scene), Why (Purpose), and How (Agency).

Euripides (c.480–406 BCE): the least "successful" of the Greek playwrights whose works survived, Euripides is best known for tragedies, *Medea*, *The Bacchae*, *The Trojan Women*, and *Iphigenia in Aulis*.

Frantz Fanon (1925–61): Martinican psychiatrist and philosopher who was instrumental in the creation of postcolonial theory. His book, *Black Skin, White Masks*, describes anti-Blackness and "the problems of identity created for the colonial subject by colonial racism; and on the consequent need to escape from these neuroses, which colonialism has produced."[7]

Federal Theatre Project (1935–39): a project funded by the Works Progress Administration to create jobs for artists throughout the USA during the great depression. The Federal Theatre Project was headed by Hallie Flanagan.

*****fourth wall:** see definition in Chapter 5: Performance.

Elinor Fuchs (1933–): performance theorist and author of *The Death of Character* and *Making an Exit*. Her writing on theatre and postmodernism combined cultural theory with dramatic criticism. She pivoted to write about aging, the self, and society.

Gender: cultural understandings and expectations of "male" and "female" behaviors as determined by a society. Gender identity is one's sense of their own gender.

Intersectionality: the interconnected categories of race, class, and gender as related to and impacted by access to resources, discrimination, and dominant power structures.

LGBTQIA2S+: an acronym for Lesbian, Gay, Bisexual, Transgender, Queer, Intersex, Asexual/Aromatic/Agender, Two-Spirit. Alternatively used are LGBTQIA+, LGBTQ2S+, and LGBTQ+. The + represents any identities not included in the acronym (i.e., genderqueer, genderfluid, and pansexual individuals).

Liminal: the in-between place or stage of something. For example, theatre is between reality and fiction.

Metatheatricality: when a theatrical production acknowledges that it is a theatrical production. The most common example of this is having one or more characters break the "fourth wall" and talk directly to the audience.

***The Method: see** definition in Chapter 5: Performance.

Arthur Miller (1915–2005): American playwright best known for *The Crucible, Death of a Salesman, All My Sons*, and *The View from the Bridge*. Miller adapted and directed *Death of a Salesman* for the Beijing People's Theatre in 1983. Miller was married to Marilyn Monroe and wrote the screenplay of her last completed film, *The Misfits*.

Mimesis: the imitation of the world in art and literature.

Bharata Muni (c.200/500 BCE): Indian theatre and music theorist who wrote *Natyasastra*. The book described the *rasa* or flavor of theatre.

Qui Nguyen: American playwright of *She Kills Monsters*, a fantasy comedy drama about death, family, queer identity, and tabletop gaming in the 1990s that has become popular for production at high schools and colleges.

Lynn Nottage (1964–): American playwright who is known for *Ruined* (2009) and *Sweat* (2017). Nottage bases her plays off of first-person interviews and field research. She is the first woman to win the Pulitzer Prize twice in the twenty-first century.

The Penelope Project: a multiyear interdisciplinary collaboration in the USA adapting *The Odyssey* between the University of Wisconsin's theatre department and Luther Manor's residential facility for older adults. It was established by TimeSlips Creative Storytelling founder Anne Basting.

Performance: a performance of any kind, such as a dance, drama, music, or performance art.

Performance studies: an interdisciplinary field of study that examines meanings and dynamics of performance in everyday life; ritual such as sports, religion, festivals, and so on; and more "traditional" performance contexts such as dance, theatre, television, and so on.

Performativity: performed behaviors and/or the idea that identity is framed and formed via performed behaviors.

Plautus (c.254–184 BCE): Roman comedian whose plays concern family misunderstandings, generational conflicts, sending up pompous stereotypes, mistaken identities, and romances. His most famous plays are *Menaechmi* and *Miles Gloriosus*. Influence of his plays can be seen in Machiavelli's *Mandragola*, Shakespeare's *The Comedy of Errors*, and Stephen Sondheim's *A Funny Thing Happened on the Way to the Forum*.

Postcolonial theory: theories that examine the oppression of peoples that were once living in colonial cultures.

Queer: not straight and/or not cisgender. Queer can be used to describe both sexual orientation and gender identity.

Laurence Senelick (1941–): Russianist and Queer Studies historian and Russian translator. Author of *The Changing Room*, an international history of drag performance and "Private Parts in Public Places" about sex work in New York City. He is also known for his translations of Anton Chekhov.

George Bernard Shaw (1856–1950): Irish playwright, critic, and novelist who is known for his socialist views. His most famous plays are *Major Barbara*, *Pygmalion*, *Saint Joan*, *The Doctor's Dilemma*, *Man and Superman*, and *Androcles and the Lion*.

Sophocles (*c.*496–406 BCE): Greek tragedian whose works include *Electra*, *Antigone*, *Oedipus at Colonus*, and, most famously, *Oedipus Tyrannus*, which Aristotle based *Poetics* on.

*****Constantin Stanislavski:** see Chapter 5: Performance.

Theatre: a performance of a play or story on stage (informal and formal), usually with actors.

Theatre criticism: the critique of theatre performance as a whole.

Tinder: a dating application used on cell phones to choose partners. Participants swipe right to potentially match with a partner. Swiping left is used to dislike or unmatch a person's photo.

Victor Turner (1920–83): British anthropologist and author of *From Ritual and Theatre: the Human Seriousness of Play* and *The Forest of Symbols*. Turner coined the terms "liminal" and "liminoid" to describe the impermanent and permanent in-between spaces in life, society, and ritual.

Verfremdungseffekt, also known as The Alienation Effect or A Effect or Distance Effect: the act of distancing the audience from the performance so that the audience does not get lost in the emotions of a play. This term was coined by Bertolt Brecht during the 1930s.

Verisimilitude: the realness, truthfulness, or accuracy of something.

Orson Welles (1915–85): American actor, producer, and director who shot to fame in his late teens/early twenties for his work with the Mercury Theatre and the Federal Theatre Project. He directed *The War of the Worlds*, *Voodoo Macbeth*, and *Cradle Will Rock* before going to Hollywood to direct *Citizen Kane*, *Touch of Evil*, and other films.

Thornton Wilder (1897–1975): American playwright who was born in the Midwest but raised by missionaries in Asia. Wilder wrote *Our Town*, which has been a top-produced play since it was first performed in the 1930s. He also wrote the surrealist/existentialist play *The Skin of Our Teeth* and *The Matchmaker*, which was adapted into the musical *Hello Dolly*.

Tennessee Williams (1911–83): American playwright from the American South best known for *The Glass Menagerie*, *A Streetcar Named Desire*, *Cat on a Hot Tin Roof*, and *The Night of the Iguana*. While his most famous plays were all made into movies, several of his other plays are better known from their film adaptations, including *Suddenly Last Summer*, *Baby Doll*, *The Rose Tattoo*, and *This Property Is Condemned*.

August Wilson (1945–2005): American playwright who cofounded the Black Horizon Theatre in Pittsburg. He is best known for his cycle of ten American plays that featured the Black experience in different decades. The most famous plays in the cycle are *Fences*, *The Piano Lesson*, *Joe Turner's Come and Gone*, and *Ma Rainey's Black Bottom*.

Zeami Motokiyo (1363–1443): Japanese playwright and theorist of *nō*. He wrote *Fūshi kaden* in which he used the "flower" to describe acting.

Plays

If a play has been adapted into a film or if filmed productions are available, dates are listed in parentheses.

1776, Sherman Edwards and Peter Stone, 1969 (Film Adaptation: 1972)
A 24-Decade History of Popular Music, Taylor Mac, 2011–16
Ain't Misbehavin', Murray Horwitz, Richard Maltby Jr, and Luther Henderson, 1978
Almost, Maine, John Cariani, 2004
Assassins, Stephen Sondheim and John Weidman, 1990
Assemblywomen, Aristophanes, *c*.391 BCE
Belle Reprieve, Lois Weaver, Peggy Shaw, Bette Bourne, and Paul Shaw, 1990
Cabaret, John Kander, Fred Ebb, and Joe Masteroff, 1966 (Film Adaptation: 1972)
Cambodian Rock Band, Lauren Yee, 2018
Cats, Andrew Lloyd Webber, based on T. S. Eliot's *Old Possum's Book of Practical Cats*, 1981 (Film Adaptation: 2019)
Chicago, John Kender, Fred Ebb, and Bob Fosse, 1975 (Film Adaptation: 2002)
A Chorus Line, Marvin Hamlisch, Edward Kleban, James Kirkwood, Jr, and Nicholas Dante, 1975 (Film Adaptation: 1985)
A Christmas Carol, based on the short story by Charles Dickens (over 50 adaptations of Dickens' "A Christmas Carol" have been created between the story's first public performance in 1853 and today)
Clairvoyance, Diana Oh, 2019
Company, Stephen Sondheim and George Furth, 1970 (Revised 2020)
Death of a Salesman, Arthur Miller, 1949 (Film Adaptations: 1951, 1985)
Dutchman, Amiri Baraka, 1964 (Film Adaptation: 1967)
For Whom the Southern Belle Tolls, Christopher Durang, 1994
Frogs, Aristophanes, *c*.405 BCE
Gladstone Variations, Convergence Theatre, 2007
The Glass Menagerie, Tennessee Williams, 1944 (Film Adaptations: 1950, 1966, 1973, 1987)
Hair: The American Tribal Love-Rock Musical, Gerome Ragni, James Rado, and Galt MacDermot, 1967 (Film Adaptation: 1979)
Hamilton, Lin-Manuel Miranda, 2015 (Film Adaptation: 2020)

Hello, Dolly!, Jerry Herman and Michael Stewart, 1964, based on Thornton Wilder's *The Merchant of Yonkers/The Matchmaker* (Film Adaptation: 1969)

Invisible Thread, Matt Gould, 2014

The King and I, Richard Rodgers and Oscar Hammerstein II, 1951 (Film Adaptation: 1956)

The Lady in the Van, Alan Bennett, 1999 (Film Adaptation: 2015)

The Lion King, Elton John, Tim Rice, Roger Allers, Irene Mecchi, Lebo M, Mark Mancina, Jay Rifkin, Julie Taymor, and Hans Zimmer, 1994 (Adapted from the 1994 Disney film *The Lion King*)

Ma Rainey's Black Bottom, August Wilson, 1982 (Film Adaptation: 2020)

Mamma Mia! Catherine Johnson, based on songs composed by Benny Andersson and Bjorn 1 Ulvaeus, 1999 (Film Adaptation: 2008)

Marvin's Room, Scott McPherson, 1990 (Film Adaptation: 1996)

Miss Saigon, Chaude-Michel Schonberg, Alain Boublil, and Richard Maltby, Jr, 1989

Native Gardens, Karen Zacarías, 2017

Oedipus Tyrannus, Sophocles, *c.*429 BCE (Film Adaptations: 1957; 1967; 1968; 2003)

Oklahoma! (Film Adaption: 1955; Broadway Revival Film: 1999)

Our Town, Thornton Wilder, 1938 (Film adaptation: 1940)

The Outgoing Tide, Bruce Graham, 2011

Pal Joey, John O'Hara, Richard Rodgers, and Lorenz Hart, 1940 (Film Adaptation: 1957)

Parade, Alfred Uhry and Jason Robert Brown, 1998

Passing Strange, Stew, 2006

A Raisin in the Sun, Lorraine Hansberry, 1959 (Film Adaptations: 1961, 1989, 2008)

Red Velvet, Lolita Chakrabarti, 2012

Rent, Jonathan Larson, 1996 (Film Adaptation: 2005)

Ripcord, David Lindsay-Abaire, 2015

She Kills Monsters, Qui Nguyen, 2011

Show Boat, Jerome Kern and Oscar Hammerstein II, 1927 (Film Adaptations: 1929, 1936, 1951, 1989)

Smart People, Lydia Diamond, 2014

Spring Awakening, Frank Wedekind, 1891 (Adapted into a Musical by Duncan Sheik and Steven Sater in 2006)

The Spurt of Blood, Antonin Artaud, 1925

A Streetcar Named Desire, Tennessee Williams, 1947 (Film Adaptation: 1951)

Sweat, Lynn Nottage, 2015

The Thanksgiving Play, Larissa FastHorse, 2018

This Is Who I Am, Amir Nizar Zuabi, 2020

Tina: The Tina Turner Musical, Katori Hall, Frank Ketelaar, Kees Prins, and Tina Turner, 2018

Titanic, Maury Yeston and Peter Stone, 1997

La Traviata, Music by Giuseppe Verdi and text by Francesco Maria Piave, 1853 (Film Adaptation: 1983)

An Urban Rail Conveyance Named Desire, Exquisite Corpse Theatre (a translation exercise from the early 2000s in which Streetcar was translated into Mandarin and then back into English), printed in *Bitch Goddess*, by Robert Rodi, CreateSpace/Amazon.com, 2002, 213–15.
Waiting for Lefty, Clifford Odets, 1935
West Side Story, Leonard Bernstein, Stephen Sondheim, and Arthur Laurents, 1957 (Film Adaptation: 1961; 2022)
The White-Haired Girl, Yan Jinxuan, He Jingzhi, and Ding Yi, 1945 (Film Adaptation: 1950)
Wig Out, Tarell Alvin McCraney, 2008

Books

Ball, David. *Backwards and Forwards: A Technical Manual for Reading Plays*. Carbondale: Southern Illinois University Press, 1983.
Banham, Martin, ed. *The Cambridge Guide to Theatre*. Cambridge: Cambridge University Press, 1995.
Banham, Martin, Errol Hill, and George Woodyard, eds. *The Cambridge Guide to African and Caribbean Theatre*. Cambridge: Cambridge University Press, 1994.
Brandon, James R., ed. *The Cambridge Guide to Asian Theatre*. Cambridge: Cambridge University Press, 1997.
Gerould, Daniel, ed. *Theatre/Theory/Theatre: The Major Critical Texts from Aristotle and Zeami to Soyinka and Havel*. New York: Applause Theatre & Cinema Books, 2000.
Wilmeth, Don B., ed. *The Cambridge Guide to World Theatre*. Cambridge: Cambridge University Press, 1993.

In-Depth Reading

Badmington, Neil, and Julia Thomas, ed. *The Routledge Critical and Cultural Theory Reader*. London: Routledge, 2008.
Boal, Augusto. *Theatre of the Oppressed*. New York: Theatre Communications Group, 1993.
Brockett, Oscar, and Frank Hildy. *A History of Theatre*, 10th ed. New York: Pearson, 2008.
Burke, Kenneth. *A Grammar of Motives and a Rhetoric of Motives*. Cleveland, OH: Meridian Books, 1962.
Case, Sue-Ellen. *Feminism and Theatre*. London: Routledge, 1998.
Chinoy, Helen Krich, and Toby Cole. *Directors on Directing: A Sourcebook of the Modern Theatre*. Brattleboro: Echo Point Books and Media, 2013.
Dukore, Bernard, ed. *Dramatic Theory and Criticism: Greeks to Grotowski*. New York: Holt, Rinehart and Winston, 1974.
Fisher-Lichte, Erika. *The Routledge Introduction to Theatre and Performance Studies*. London: Routledge, 2014.

Hauser, Frank, and Russell Reich. *Notes on Directing: 130 Lessons in Leadership from the Director's Chair*. New York: Performance Group, 2008.

Hoffman, Warren. *The Great White Way: Race and the Broadway Musical*, 2nd ed. New Brunswick: Rutgers University Press, 2020.

Lane, Stewart F. *Black Broadway: African Americans on the Great White Way*. Garden City, NY: Square One, 2015.

Schreiber, Brad. *Stop the Show!: A History of Insane Incidents and Absurd Accidents in the Theater*. New York: Thunder's Mouth Press, 2006.

Stempel, Larry. *Showtime: A History of the Broadway Musical Theater*. London: W. W. Norton, 2010.

Storey, John, ed. *Cultural Theory and Popular Theatre: A Reader*, 4th ed. Harlow: Pearson Longman, 2009.

Wolf, Stacy. *A Problem Like Maria: Gender and Sexuality in the American Musical*. Ann Arbor: University of Michigan Press, 2002.

4

Playwriting, Play Development, and Storytelling

Even when I'm writing plays I enjoy having company and mentally I think of that company as the company I'm writing for.
—Wole Soyinka[1]

I have never once in writing a play given a thought about what the scene's about or what I want to say to the audience. I have nothing to say to the audience. I don't give a damn about the audience. The audience isn't there when I'm writing a play.
—Maria Irene Fornés[2]

Every artist has their own method and playwrights are no exception. A playwright, like Wole Soyinka, may take strong consideration of who his audience is when telling his stories while others, like Maria Irene Fornés, do not "give a damn" about the audience. Both of these playwrights are successful and highly regarded by theatre artists and audiences around the world, despite their differing perspectives on approach.

There is no wrong reason to choose to tell your stories and there is certainly no wrong way to go about doing it. Playwriting may seem like an elusive art form. In reality, it is simple because there is no "right" way to share stories and it is up to each playwright to determine how they wish to do it. Playwriting, play development, and storytelling inspire students to discover and develop their own creative recipe by breaking down barriers and fostering a supportive atmosphere.

Playwriting, play development, and storytelling courses challenge students to be present, to focus, and to think imaginatively. This chapter includes ideas for writing exercises and improvisational activities that help beginning to advanced writers build confidence, reduce fear of the inner critic, and share their work with others. For students who wish to share their work with people outside

courses, this chapter also offers suggestions on how to develop performance programs for new writers that will be encouraging, fun, and engaging for audiences of all types.

What Are Playwriting, Play Development, and Storytelling?

Playwriting is creating plays by writing. Students learn how to write dialogue and tell a story using tools such as character objectives, obstacles, and action. Play development, sometimes also known as devised theatre, utilizes performance exercises such as acting, directing, and improvisation to build and adapt plays. Students can develop plays from very little dialogue or from simple scenarios and ideas, such as performing a ten-minute play in response to a general theme like "the hero's journey" or "revenge." Students discover what the play entails through rehearsals and discussion, rather than writing. Storytelling involves creating performances through oral narratives. Storytelling, simply put, is the art of telling and sharing stories through speech and voice. Storytelling typically involves one individual storyteller, but there can be multiple storytellers sharing a story. Presentation-wise, storytelling is easily adapted for a variety of collaborative and performance contexts, such as story slams and audio formats. The focus is on creating a singular cohesive narrative that often follows one perspective throughout the course of a story. Like play development, it may or may not include writing in its process.

Students in all three of these areas learn how to create stories that have characters and plots. They also work individually and collaboratively, and build awareness of themselves and others. They will learn how to give and receive constructive feedback. Playwriting students will improve their writing skills and play development and storytelling will sharpen their performance skills.

Benefits for Students without a Background in Developing New Works

Students will learn how to create a play from the ground up. They gain writing and performance experience by working individually and in groups. They hone their abilities to look at a story from a variety of perspectives and character objectives, how to structure a play, and how to take an inspiration and turn it into a play.

Benefits for Students with a Background in Developing New Works

Students with experience writing and devising theatre will be challenged to work cooperatively with others and share control of the narrative. By developing

performances through scene work, collaborative writing, and performance, students get to hear their plays out loud and see them workshopped with actors.

How Do I Put Together a Course?

Go See Theatre and Storytelling Performances

Find out what shows and storytelling events are in your town and attend them! Storytelling nights often take place outside of theatre; the most popular locations are coffee shops, pubs, bars, breweries, and on virtual venues like YouTube. There's no better way to get inspired, learn about the theatre, and keep informed about the latest trends than by going to see a show.

Read and Analyze Plays

Read plays that you have seen in production to get an idea how scripts can be transformed onto stage. Pay attention to characters, plot structure, language, themes, and so forth. Also read plays that you have not seen to familiarize yourself with genres, techniques, and styles. For example, read Henrik Ibsen's *The Wild Duck*, John Leguizamo's *Freak*, Michael R. Jackson's *A Strange Loop*, and Tristan Tzara's *The Gas Heart*. Analyze what elements make the play interesting to read, perform, or see onstage. Think about how characters relate to each other, or not, the pacing of each scene, transitions between scenes, how the play works together as a whole, and so on.

Watch Performances on Video

In addition to stage productions broadcasted on television such as the *American Masters* and *Live at Lincoln Center* programs on PBS, there are many storytelling videos and audio recordings online. For example, *Stories from the Stage* has several filmed storytelling performances available. *Third Wing* also offers online theatrical content.

Listen to Podcasts

Several podcasts offer storytelling and staged readings of new plays. *The Moth* and the *Parsnip Ship* have all of their archives online in an audio format. *Storycorps* stories are available on their website and through the Library of Congress website.

Watch (Filmed) Rehearsals

Find a rehearsal on film or, better yet, try to make some new theatre friends and see if you can sit in on a live rehearsal. Rehearsals are a great way to learn the ins-and-outs of theatre. Types of rehearsal include: read throughs, on-book rehearsals, off-book rehearsals, character work, blocking rehearsals, fight rehearsals, pickup rehearsals, technical rehearsals, cue to cues, and dress rehearsals. Attending initial read-throughs provides an opportunity to observe a company's first impressions of a play. If your students are able to attend a technical rehearsal, they will be able to see the dramatic transformation that quickly comes to a production through collaboration. Seeing a production before the final product will give insight on how plays are transformed from paper to stage, and how actors develop their characters.

Read and Keep the Programs

Theatre programs often contain interviews with the playwright or the playwright's notes on the play if they are living. If it is a premiere or a workshop production the program will also likely contain notes on the writing and play development process.

Read or Watch Interviews with Playwrights

Interviews can be found in print media or on video. From promotional videos to in-depth interviews by cultural programs, there are a variety of ways to find out what the playwriting process entails. You may discover an interesting method, story, fun fact, or piece of gossip from these interviews that can be used in your class. PBS *Open Studio* occasionally discusses play development.

Read Manifestos Written by Playwrights

You do not *have* to have your students read Bertolt Brecht's *On Theatre*, Antonin Artaud's *Theatre and Its Double*, Gotthold Ephraim Lessing's *Hamburg Dramaturgy*, or Aristotle's *Poetics* but you can. For playwrights from the western canon, see *Playwrights on Playwriting*. We recommend that you review some of these documents for reference and historical context, so that you can paraphrase the concepts and summarize the key points for your students.

Learning Georges Polti's *The Thirty-Six Dramatic Situations*, first published in English in 1916, can be useful for writing and interpretation exercises. Polti's book outlines 36 plots from which stories can be derived. He describes different scenarios, such as mistaken jealousy or crime pursued by vengeance, that occur frequently in popular plays.

Read about Non-Scripted Forms

There are many forms of theatre that are non-scripted and knowledge of these performances may help you create a more interesting course. For example, *commedia dell'arte* and Punch & Judy are improvisational traditions that use stock characters and scenarios to build stories.

Think about Which Aspects of Playwriting and Play Production Interest Your Students

If you are able, collect information about what the students want to learn. If you aren't able to, ask them on the first day of class. Find out if they want to write short plays like ten minutes or longer works like full-lengths and one-hour one-acts. Do they want to write collaboratively or write alone? Do they want to work on character development, dialogue, or plot? Are they interested primarily in autobiographical storytelling or do they want to work with fiction? Have they been waiting their entire life to write a play about their terrible boss, their long-lost love, or a great adventure during a tumultuous time?

Think about What Concepts You Want Students to Learn

After you have done some research on the above, develop a list of the most important aspects of playwriting, play development, or storytelling that you want students to learn. Think about:

- What concepts might be new to students?
- What are the essential elements for creating a performance?
- What new vocabulary can students use to communicate to each other in class?
- What would be helpful for a new writer to know about playwriting, play development, or storytelling?

How Do I Select and Organize Topics?

By Themes or Key Terms

Organizing a course by themes or key terms provides a guide for you and your students to build upon their skill level each week. It also provides students with a clear vision of what the course is about. Start by brainstorming ideas for key

terms. When you have come up with a long list, start grouping common terms or themes together. Then organize the groups together into weeks. Examples of terms:

Action: the movement of the story.
Actor beats: the unit of measure between character states.
Act: a section of a play that is typically determined by the natural breaks in the action of the story. Many plays have two to five acts. Short plays are also called one-act plays.
Argument: two characters having a disagreement about something. *This is often mistaken for action.*
Backstory: the history and/or background of the characters and their situation.
Character: the individuals in the story (can be people, animals, objects, or ideas).
Collaborative development or play development: a playwriting technique, also known as devised theatre, that includes workshopping the play with actors.
Conflict: a clash of characters' objectives. *This is also known as the "problem" and should not be confused with "argument."*
Dialogue: conversational speech spoken by two or more characters.
Line: the dialogue spoken by an actor or what the actor calls out if they forget their line.
Monologue: a one-person speech.
Motivation: the character's motivations and desires.
Objective: the character's goal within a scene.
Obstacle: something that hinders a character from obtaining their objective.
Off-book: actors' lines are memorized.
Offstage characters: characters referenced in the text that do not appear onstage.
On-book: actors using the script to read or reference in during a rehearsal or performance.
Pacing: the flow of the story.
Playwriting beats: pauses that are written into the script by the playwright.
Plot: the main events that make up the action of a story.
Problem: the characters' objectives clashing. *It can also be referred to as conflict.*
Scene: a short section of the play. A series of scenes can make up an act.
Setting: where the action of the play takes place.
Stage directions: instructions within the script about staging, pacing, action, etc.
Stakes: things that will be lost or destroyed if the objective is not obtained.
Story: the play's narrative or a series of events as they occur in chronological order.
Subtext: the unspoken meanings "between the lines."

Super objective: the character's goal within a play.
Theme: the main idea of the story.

By Playwright

You write in order to change the world, knowing perfectly well that you probably can't.
—James Baldwin, novelist and playwright[3]

Students may be fans of specific playwrights. If this is the case, it could be advantageous to organize your class around playwrights. This can keep them interested in the material and excited to come to class.

Have your students write their plays in the style of famous playwrights. Each playwright has a distinct style. Take a one-act play or a few pages from a full-length play and read plays out loud to hear the writing style of the playwright. Choose contrasting playwrights so that the distinctions are obvious. For example, have students read a David Mamet play, an Annie Baker play, a Moliere play, and a Bertolt Brecht play. Then have them identify the following:

- Genre(s).
- Characters' patterns of speech.
- Characters' vocabularies.
- Character types (if applicable).
- Plot and stakes (describe in one or two sentences).
- Action or what moves the story forward.

Once the above have been defined, have students pick one playwright and one element of the writer's style and create a short scene. For students desiring more of a challenge, they may incorporate several elements of a writer's style into a scene.

By Playwriting Technique

There are many devices that playwrights use. Some follow the traditional Aristotelian technique of building each scene to a higher point until it reaches climax such as the appearance of the ghost in Stephen Mallatratt's *The Woman in Black*. Others remove climax altogether, such as Samuel Beckett, where nothing happens in *Endgame*. William Shakespeare and Bertolt Brecht wrote plays that are episodic and/or have multiple parallel plots and subplots (*King Lear*, *Threepenny Opera*, *Twelfth Night*, *Mother Courage*).

By Genres and Forms

Genres, styles, and forms are related to playwriting technique, but they are broader concepts that explain what makes up the entirety of a play. For example, one-act plays are a form of play that run under an hour and can be of any genre. One-act comedies describe both the genre and form. You can design a course around writing thematic ten-minute plays or farces. Other options include crafting a course based around character development or having your students write episodic dramas or melodramas. Examples of genres and forms:

Adaptation: a play that bases its plot on an existing story, work, real-life event, or other reference.
Character-driven: a play where characters are more important than the action.
Domestic comedies or dramas: plays about family life.
Episodic drama: a play that has multiple short scenes, often in different locations and following multiple sets of characters.
Experiential: an interactive play that involves the audience being part of the play.
Experimental: a play that breaks conventions of realism, plot structures, and language.
Farce: ridiculous over-the-top comedies filled with innuendo, pratfalls, and occasionally bizarre scenarios.
Full-length: a play that runs over an hour.
Melodrama: action-driven plays with archetypal characters written to evoke strong emotional reactions in audience members.
Non-realistic: plays that do not take place in or use dialogue like real life.
One-act: a play that is one hour or under in run time.
Plot-driven: a play where the plot is central, more so than the characters.
Realistic: plays that take place in everyday settings and have dialogue that tries to sound like real life.
Ten-minute: a play that runs for ten minutes and is a fully realized story.

By Guest Playwright

Bringing in a "real" playwright will probably be the most exciting part of a class. You can usually find a willing playwright through local writers' networks and theatre companies or put out a call through a community arts network on social media. You may also be able to help the playwright by facilitating a staged reading of one of their works in progress.

One of the biggest benefits of having a guest playwright come to class is that they can help inspire your students to write and demystify the writing process.

Hearing playwrights talk about their initial experiences with writing, the number of works that do not ever make it onto stage, and how long it takes for them to complete drafts can help set students' own expectations of their own writing. Some playwrights spend years working on a single play and students will understand that what they write in their first draft will not be perfect. Interview questions you can ask the guest playwright are:

- How did you start writing?
- What drew you to playwriting specifically rather than other art forms?
- Who or what are your biggest influences?
- What happens when you are involved in the production of your own plays?
- What is your creative process?
- Do you think about the audience when writing? If so, who do you imagine as your audience?
- How long does it take for you to complete a play? What took the shortest amount of time? What took the longest?
- What plays are your favorites and why?
- Which production companies would you like to see produce one of your plays and why?
- If you could create a dream team of actors, who would it include and why?

By Partnership with Local Storytelling Organizations

If there are local storytelling organizations in your area, find out what performances they have and take your class to the events. If you do not know of any, start by asking local museums, libraries, pubs, cafes, and other performance venues that organize literary events and host open mics. Before attending events, give students key terms or ideas to observe in the performance. After the event, discuss and analyze the performance in class.

For organizations in your area that do not yet provide storytelling workshops targeted at intergenerational student populations or specifically for older adults, see if you can incorporate your course into their existing program. If there is a storytelling course for teenagers, see if you can invite them to participate in a workshop with your students.

What Activities and Discussions Can I Do?

Playwriting, play development, and storytelling activities help students develop self-reflection, communication, and reading comprehension skills. Activities that

involve providing and working with feedback help students learn to support each other through the writing and collaboration process. Some activities spark imagination and give students opportunities to take ideas from conceptualization to realization through the creation of scripts and scenarios. Others encourage students to respond to, explain, analyze, critique, and interpret everyday life experiences and historical events.

Read a Play

Provide students with a variety of plays to read. Begin with shorter plays and build up to reading longer plays. Depending on the interest and attention level of your students, you may want to exclusively use shorter plays. Longer plays may require several sessions to read through. It is best to use plays that can be finished in one course session so all students participate fully in course discussions; Students who miss a class or come sporadically may find it difficult to "catch up" in the middle or end of a play reading. Examples:

Ten-Minute Plays

Boy Meets Girl, Wendy Wasserstein, 1999
The Janitor, August Wilson, 1985
Los Vendidos, Luis Valdez, 1976
Philip Glass Buys a Loaf of Bread, David Ives, 1990
R.A.W. ('Cause I'm a Woman), Diana Son, 1996
Sure Thing, David Ives, 1988

One-Act Plays

Betting on the Dust Commander, Suzan Lori-Parks, 1987
The Long Voyage Home, Eugene O'Neill, 1917
Orphan of Chao, Ji Junxiang, 13th Century CE
Sound of a Voice, David Henry Hwang, 1983
Still Stands the House, Gwen Pharis Ringwood, 1938
Trifles, Susan Glaspell, 1916

Full-Length Plays

Ching Chong Chinaman, Lauren Yee, 2008
Cloud Nine, Caryl Churchill, 1979
Cost of Living, Martina Majok, 2016

Disgraced, Ayad Akhtar, 2012
Fires in the Mirror: Crown Heights, Brooklyn and Other Identities, Anna Deveare Smith, 1992
for colored girls who have considered suicide / when the rainbow is enuf, Ntozake Shange, 1976
Giving Up the Ghost, Cherrie Moraga, 1989
The Haunting of Lin-Manuel Miranda, Ishmael Reed, 2019
An Inspector Calls, J. B. Priestley, 1945
Oleanna, David Mamet, 1992
A Raisin in the Sun, Lorraine Hansberry, 1959
Sweat, Lynn Nottage, 2015
The Thanksgiving Play, Larissa FastHorse, 2015
Topdog/Underdog, Suzan-Lori Parks, 2001
Yerma, Federico García Lorca, 1934

Playwriting Exercises

The included activities break down the steps in playwriting and play development and get students actively writing and creating. Many of these activities have been successful with our students who came into a course with no prior experience with playwriting. They focus on technical skills and help students with their writing by actively engaging in the writing process. Each exercise has a specific goal and can be completed within a short period of time. They provide building blocks for writing as well as ways to get unstuck in the writing process.

When selecting writing activities, start with one idea at a time. Begin with writing monologues, describing settings, or writing dialogues. Do not combine everything right away. As students gain more practice, slowly integrate layers by adding more characters, combining settings with characters, and so on.

First-line prompts are the easiest way to get students writing immediately. Some students have difficulty either getting started or instinctually begin writing descriptive narrative fiction, rather than dialogue. Providing the first line helps remove those obstacles.

Many of the writing exercises can be modified for verbal storytelling or play development. For portions that require brainstorming, have students do that portion of the exercise in writing or verbally, and then do the scene writing portion verbally.

The exercise instructions in the chart are for students unless otherwise noted. Playwriting exercises can be used for any experience level. The chart includes beginner, intermediate, and advanced writing exercises and specifies the skills

students practice (collaboration, letting go, observation, etc.) as well as the activity type (group, individual, or partner).

Name	Description	Skill	Type	Level
Fill in the Blank	Instructor provides students with parts of sentences and have them fill out the rest. Examples: • I looked out the window and thought _____. • I've always wanted to _____. • I called up _____ and told them _____. • When I heard the news that___, I knew I had to _____. • I went to the _____ and __.	letting go	individual	beginner
Exquisite Corpse	Write one line of dialogue. Then pass it to the person on your right. Add a line to the dialogue you just received and fold the paper so that only the line you have just written shows. Continue this process until everyone has a chance to add to the scene or until time is up.	collaboration, letting go	large group	beginner
Realistic Dialogue	Eavesdrop on a conversation: Get into groups of four, then divide into partners. Two people observe the other pair having a conversation. Then rotate and another pair observes.	realism, observation, collaboration	small groups	beginner
Collaborative Scene #1	Choose a partner. Choose two characters and write four lines of dialogue. Then switch plays with partner and add four lines to partner's play. Continue switching back and forth four times until there are a total of sixteen lines for each play.	collaboration, letting go	partners	beginner
Collaborative Scene #2	Instructor writes a play together with each student, simultaneously. Instructor gives every other line of dialogue as students write their response.	imagination, collaboration, letting go	large group	beginner

Name	Description	Skill	Type	Level
	Example:			
	INSTRUCTOR: Excuse me.			
	Student writes a line.			
	INSTRUCTOR: Can you help me?			
	Student writes a line.			
	INSTRUCTOR: I'm trying to find my way to the supermarket.			
	Student writes a line.			
	INSTRUCTOR: I don't understand.			
	Student writes a line.			
	INSTRUCTOR: I still don't understand.			
	Student writes a line.			
	INSTRUCTOR: I'm confused.			
	Student writes a line.			
	INSTRUCTOR: Can you show me the way?			
	Student writes a line.			
	INSTRUCTOR: Thank you.			
Collaborative Scene #3	Choose a partner. Individually, write a character by describing the age, gender, profession, physical appearance, likes, and dislikes. Add a setting. Write one line of dialogue. Then pass play to partner. With partner's play, write a brief description of a new character, including a profession and a relationship with the existing character. Write a line of dialogue for the second character. Switch the plays and write dialogue for the other character. Switch a total of eight times until there are sixteen lines total.	imagination, collaboration, letting go, character development	partners	intermediate
Positives and Negatives	Write a scene that starts out on a positive or negative note. Then end the scene the opposite way.	scene structure, advancing the story	individual	intermediate
Raising the Stakes	Write a scene. Raise the stakes of the story and continue the scene. Keep raising the stakes as the scene continues.	scene structure, advancing the story, raising the stakes	individual	intermediate

Name	Description	Skill	Type	Level
Objectives #1	Create a character. Describe what the character wants in the scene and what the character wants in the story.	character development, objective	individual	beginner
Objectives #2	Create two characters. Give each character the same objective and write a scene where each character's objective becomes an obstacle for the other character.	objectives, obstacles	individual	intermediate
Objectives #3	Create two characters. Give each character a different objective and write a scene where each character's objective becomes an obstacle for the other character.	objectives, obstacles	individual	intermediate
Brainstorm	Brainstorm story ideas.	story development, collaboration	large groups/ small groups/ partners/ individual	beginner
Character Descriptions and Backstories	1. Choose three characters and write descriptions for each of them. Start with a physical description, then add words to describe their personality. Add as many details as possible. 2. Then, pick one of the characters and write a backstory. This can be written as a list or in full sentences. Think about: what the character likes to do on the weekends, who they admire, who they like to spend their time with, what makes them angry, what type of restaurant does they go to, etc. 3. Then write a scene starring the character from #2 above, and the other two characters from #1 above. Start the scene with this line of dialogue, "I've been looking for you."	character development, scene development, story development	individual	beginner

Name	Description	Skill	Type	Level
Monologues	1. Choose a character you like. Write a monologue where they are having a very bad day. 2. Choose a character you do not like. Write a monologue where they are having a good day. 3. Choose a person you do not understand well. Write a monologue about that person going on a date with your best friend.	character development, scene development, story development	individual	beginner
Character Photos	Instructor provides a diverse group of photographs of people. Students select a photograph and describe the person's personality traits.	character development, imagination	individual	beginner
Setting Photo Prompt	Instructor provides pictures of common locations for the students. Students select a picture, describe the environment, and write a scene about what just happened (or is about to happen) at the location.	imagination, setting	individual	beginner
Word Prompts	Instructor provides a list of positive and negative words. Students write a scene incorporating one positive and one negative word in a scene.	scene development	individual	advanced
Title Prompt	Instructor provides a list of titles. Students write a scene based on the title. Examples of titles are: • *Never Again.* • *Unseen.* • *Black Hair.* • *Tomorrow Comes Too Soon.* • *How to Make Friends When You're Eighty.* • *Two Aisles Over.* • *Adventures Are Never Fun.*	theme development	individual	advanced
Place	Choose a location, three characters, and an objective for each character. Write a scene.	scene development, setting, character development	individual	advanced

Name	Description	Skill	Type	Level
Theme	Pick a theme and write a one-minute scene.	scene development, story development	individual	intermediate
Character	Pick a character and write a one-minute monologue.	character development	individual	intermediate
Plot	Pick an event and write a one-minute scene.	scene development	individual	intermediate
Place	Pick a location and write a one-minute scene.	scene development	individual	intermediate
Image	Pick an image and write a one-minute scene.	scene development, story development	individual	intermediate
Abstract Idea	Pick an abstract idea and write a one-minute scene. Examples: • Love. • Responsibility. • Courage. • Dedication. • Culture. • Friendship. • Trouble. • Loyalty. • Justice. • Forgiveness. • Compassion. • Beauty. • Weakness. • Knowledge. • Truth. • Betrayal. • Jealousy.	scene development	individual	intermediate
History	Write a scene about something that happened in history. Pick three characters and put them in a setting.	character development, story development	individual	beginner

Name	Description	Skill	Type	Level
News Event	Choose a recent news event. Answer the following questions: • What was interesting about the event? • Who was there? • Where did it take place? • What happened? • What led to what happened? • How did it affect the people, place, or thing involved? • What were the stakes? • What were the obstacles? • How did the event end? Write a scene from the answers.	character development, story development	individual	beginner
People You Know	Choose a person you know. Describe what they look like, what they are motivated by, who they are friends with, how they behave at work, how they behave at home, what they eat for dinner, where you would find them during the weekend, etc.	character development, imagination	individual	beginner
Character You Do Not Like	Choose one character that you do not like. Describe this person in detail including physical features, pattern of speech, behavior, values, friends, etc.	character development, imagination, letting go	individual	intermediate
Song Inspiration	Instructor plays a song. Students choose two characters and write their backstories. Then write a scene starting which starts with the first line, "I have something important to tell you." Then students rewrite the scene again with two different characters.	character development, scene development	individual	advanced
First Line Prompts	Write a scene starting with one of the following lines: • "I can't believe my luck!" • "I'm in trouble!" • "This has never happened to me before."	scene development	individual	advanced

Name	Description	Skill	Type	Level
	• "I wish it were Monday."			
	• "That's not what they told me."			
	• "None of this makes sense!"			
	• "Stop what you're doing!"			
	• "Are you listening?"			
	• "I need a break."			
	• "You really shouldn't have."			
	• "I want answers."			
	• "I've been looking for you."			
	• "You were right."			
	• "I'm sorry."			
	• "What's wrong with you?"			
	• "I don't want to be here."			
Middle Line Prompts	Write a scene using one of the following lines in the middle of the story:	scene development	individual	advanced
	• "I wish I had done things differently."			
	• "It's not my fault you didn't listen!"			
	• "What am I going to do now?"			
	• "Don't give up."			
	• "This might sound crazy, but […]"			
	• "You're not listening to me!"			
	• "I couldn't help it."			
	• "That's why I didn't say anything."			
	• "You don't sound sorry."			
	• "Ow."			
	• "I don't believe you."			
Last Line Prompts	Write a scene ending with one of the following lines:	scene development	individual	intermediate
	• "Well, that didn't go as expected."			
	• "I have no regrets."			
	• "Well, that's that then."			
	• "Do you think we could try this again?"			

Name	Description	Skill	Type	Level
	• "Good bye."			
	• "Wait! Don't go."			
	• "Something tells me I'll be seeing him again."			
	• "Time for margaritas."			
	• "No."			
	• "I have nothing more to say to you."			
	• "Are you happy now?"			
	• "I'll see you in Hell!"			
	• "What a wonderful day for a wedding."			
Beginnings #1	Write a scene that starts at the beginning of a story.	scene development	individual	intermediate
Beginnings #2	Write a scene that starts in the middle of a story.	scene development	individual	intermediate

Storytelling Exercises

The storytelling exercises provide help with brainstorming. They focus on helping students generate ideas, develop enthusiasm for sharing their stories with others, and organize their thoughts. Unlike the writing exercises, the storytelling exercises are specifically geared to help students practice telling stories verbally from beginning to end, giving students facility turning events into narratives.

Storytelling exercises are a great way to include students who have difficulty writing. Storytelling activities help students develop their speech and presentation skills. While stories do not have to be written down before performance, some students may choose to so they can feel more organized and confident. Storytelling can be fully improvised or rehearsed. No matter which style you wish to emphasize with your students, having students practice with live storytelling is the key to success.

Before doing storytelling exercises, it is recommended to begin the course with vocal warmups. For vocal warmups, see the Performance Exercises in Chapter 5.

Name	Description	Skill	Type	Level
Historic Event	Pick a historic event that everyone has experienced. Share your experience of the events in your group, making note of how things changed as a result of the events in the story. Each person speaks for one to three minutes.	memory, imagination, collaboration	individual/ small groups	beginner

Name	Description	Skill	Type	Level
Good Memory	Pick a good memory. Tell a story for one to three minutes.	memory, imagination, collaboration	individual/ small groups	beginner
Strange Memory	Pick a strange memory. Tell a story for one to three minutes.	memory, imagination, collaboration	individual/ small groups	beginner
Something That Didn't Happen	Create an imagined story. Outline key points in the story. Tell the story in five minutes or less.	imagination, collaboration	individual/ small groups	intermediate
Theme #1	Pick a theme. Each person tells a one-minute story. Practice two to three times.	imagination, reaction time	individual	intermediate
Theme #2	Instructor provides a list of themes. Students vote on a theme or randomly pick a theme from the list. Students create a two- to five-minute story based on the theme.	imagination, reaction time	individual	intermediate
Multicharacters	Pick three to five characters. Tell a story with these characters interacting with dialogue.	character development, collaboration	individual/ small groups	intermediate
Folktale	Create a folktale. Folktale should include: • A moral (the moral does not have to be a "conventional" moral). • A quest or challenge. • A problem.	story development, collaboration	individual/ partners/ small groups	advanced
Ghost Story	Create a ghost story. Ghost story should include: • Backstory for the ghost. • What the ghost wants. • How the ghost interacts with the living. • A personality for the ghost. • Whether the ghost is hostile, friendly, flirtatious, etc.	story development, collaboration	individual/ partners/ small groups	advanced
A Story Three Different Ways	Tell a two-minute story as a comedy. Retell the same story as a tragedy. Retell the same story from the perspective of a different character.	genres, story development	individual	advanced
Retelling Others' Story	Tell a two-minute story. Your partner retells your story to class.	listening, collaboration	individual/ partners	beginner

Name	Description	Skill	Type	Level
Adaptations	Stories can be adapted from anything. Outline key points of the story. Tell an adapted story. For group adaptations, decide on a main storyline and take turns telling the same story. For inspiration, students can draw from: • Existing plays, musicals, operas, and performances. • Fiction. • Nonfiction. • Poetry. • Film. • Autobiography. • Biography. • History. • Current events or news, including newspapers. • Fairytale. • Music. • Dance. • Myths. • Art exhibits. • Museum exhibits. • Emails. • Letters. • Dating apps. • Text exchanges. • Journals. • Photographs. • Picture books. • Coffee table books. • Self-help books. • Cook books. • Advice and "Dear Abby" articles. • YouTube videos and Vlogs. • Online community forums. • Websites. • Everyday life experiences such as going to a famous restaurant, going to an amusement park, etc.	collaboration, story development	individual/ small group	advanced

Name	Description	Skill	Type	Level
Brainstorm	As a class, brainstorm five lists: characters, objectives, problems, locations, and first line/last line. Randomly draw one item from each list. In groups, create a story incorporating all elements.	character development, story development, collaboration	small groups	advanced
Plot Synopsis	Instructor provides a plot synopsis of a famous play. Students create a new play with the plot synopsis by doing the following: 1. Choose a time period. 2. Reframe the characters to reflect professions of people in the selected time period. 3. Rewrite the plot of the play.	story development, character develop, collaboration	groups	advanced
Famous Quotes	Instructor provides a list of quotations. Students vote on quotes or randomly pick a quote. Students create a two- to five-minute story on quote.	imagination	individual	intermediate
Tell Your Story	Write a monologue about an experience that happened to you. Think about: • The weirdest person you have ever met. • The weirdest situation you have ever been in. • A surprising (positive) experience. • A stranger you got to know and never saw again. • A stranger you got to know and became good friends with. • An experience with an animal. • The first time you traveled on a plane. • The first time you traveled abroad. • The funniest thing you heard a child say. • The funniest thing your child has said. • The funniest thing you said as a child. • Something that someone's said that has stuck with you. • Something you got away with. • Someone you will never forget. • Someone you wish you could forget.	Autobiographical storytelling, memory	individual	beginner

Play Development Exercises

Take any of the playwriting and storytelling ideas above and use them for developing plays in groups. Start each class with improvisational games and acting exercises before moving into work improvising scenes and creating characters. See the chart of Performance Exercises in Chapter 5 for details on improvisation and acting exercises.

Watch or Listen to Storytelling Performances

Watch videos from storytelling performances, such as *Stories from the Stage* and performances by Anna Deveare Smith, Sarah Porkalob, and Ian McShane. Standup comedy has great examples of creative and dynamic storytelling inspiration and you can incorporate works of Richard Pryor, Bob Newhart, Margaret Cho, Chris Rock, and others into your course design. Radio is an excellent course of storytelling based on lived experiences. Listen or watch the oral history storytelling online on *This American Life* and Studs Terkel's *Working* (available on *Studs Terkel Radio Archive*).

Play a Game

There are many different types of games that you can play with students in your playwriting, play development, or storytelling course. The games below are focused on topics related to playwrights, plots, famous lines, and characters.

Trivia

Trivia is an easy way to introduce new information or assess students' existing knowledge anytime during a course. See Chapter 2 on strategies of how to create and organize trivia games. Examples below (answers in bold):

1. The Greek word *hamartia* is often translated as "tragic flaw." What is its alternate meaning, which comes from archery?
 a) **Mistake or missing the mark**
 b) An unfortunate turn of events
 c) An inevitable disaster
 d) A character flaw

2. Which playwright has *not* won a Pulitzer Prize?
 a) Katori Hall

b) Suzan-Lori Parks
c) Paula Vogel
d) Lauren Gunderson

3. What was the name of the opera written by Austrian composer Mozart, based on a French play by Beaumarchais about Spanish people, with an Italian libretto written by Da Ponte? *Hint: It features Cherubino, one of the most famous breeches roles (in which a woman plays a male character) in western theatre and a duet from this opera is played as an act of protest by a character in* The Shawshank Redemption.
 a) *Carmen*
 b) *The Marriage of Figaro*
 c) *Aida*
 d) *Nixon in China*

4. What is the name of the Shakespearean tragedy that opens with citizens preparing to take up arms against wealthy people who are hoarding grain? *Hint: This play is also parodied in the song "Brush Up Your Shakespeare" from the Cole Porter musical* Kiss Me, Kate. *What is the name of the play?*
 a) *Les Misérables*
 b) *Titus Andronicus*
 c) *The Merry Wives of Windsor*
 d) *Coriolanus*

5. Playwrights George S. Kaufman, Marc Connelly, and Robert E. Sherwood were charter members of this group. It also included Irving Berlin, Dorothy Parker, Tallulah Bankhead, Alexander Woollcott, and others. What was the name of the group?
 a) The He-Man Woman Haters Club
 b) The Algonquin Round Table
 c) The Wild Bunch
 d) The Garrick Club

Who Am I?

Have students guess the identity of the famous person based on descriptions. Unless you are using playwrights you have already studied in class, make sure to provide two lists for students to match the names with the descriptions.

Examples:

Aphra Behn (1640–89)
- Travel writer and novelist.
- An unsuccessful spy and an alleged lover of Charles II.
- Best known for writing *The Rover* and *The Banish'd Cavaliers*.

Georg Büchner (1813–37)
- A political activist and medical student.
- Wrote *Lenz*, a novella, *Leonce and Lena*, a satire on nobility and *Danton's Death*, a drama about the French Revolution.
- *Woyzeck*, his most famous (and unfinished) play, is about a soldier and was later adapted as an opera.
- Died at age 23 of typhus.

Alexandre Dumas, fils (1824–95)
- Son of a famous novelist and grandson of a biracial French general.
- Most famous work, *La Dame aux Camelias/Camille* is a semiautobiographical novel and stage play about his relationship with the courtesan Marie Duplessis.
- *La Dame aux Camelias* was adapted by Giuseppe Verdi as *La Traviata* and several films.

Christopher Durang (1949–)
- While also the author of several original works, best known for parodies of other authors, including Sam Shepard, Tennessee Williams, and David Mamet.
- Got his start as a playwright while a student at Harvard.

Jean Genet (1910–86)
- Released from prison after Pablo Picasso and Jean-Paul Sartre petitioned the French president.
- A supporter of Angela Davis.
- Most famous plays are *The Balcony* and *The Maids*.

Susan Glaspell (1876–1948)
- Cofounder of the Provincetown Players, the first company to produce the plays of Eugene O'Neill.
- Midwest Bureau director of the Federal Theatre Project.
- Won Pulitzer Prize for her 1930 play *Alison's House*.
- Best-known play is *Trifles*, written in 1916.

Tomson Highway (1951–)
- Originally produced and published *The Rez Sisters* and *Dry Lips Oughta Move to Kapuskasing* in English during the 1980s.
- Published the plays again in Cree in 2010.

August von Kotzebue (1761–1819)
- A consul in Russia.
- Wrote over two hundred works.
- Murdered by a German university student in 1819.

Christopher "Kit" Marlowe (1564–93)
- Translator, poet, and playwright.
- Died under mysterious circumstances in Elizabethan England.
- Lived with fellow playwright Thomas Kyd.
- Wrote the line "Is this the face that launched a thousand ships?"

Chikamatsu Monzaemon (1653–1725)
- Father was a doctor and a *ronin* (masterless samurai).
- Wrote plays for *bunraku* and *kabuki*.
- Best known for writing love suicide plays, including *The Love Suicides at Amijima* and *The Love Suicides at Sonezaki*.
- Also wrote historical romances and plays about social structures and societal conventions.

Marsha Norman (1947–)
- Author of *'Night, Mother* and *Getting Out*.
- Librettist for the Broadway musicals *The Color Purple*, *The Secret Garden*, and *The Bridges of Madison County*.

Clifford Odets (1906–63)
- Title character in *Barton Fink* is based on this playwright.
- A founding member of the Group Theatre.
- Wrote *Golden Boy* and *Waiting for Lefty*.

Eugene O'Neill (1888–1953)
- His father toured in an adaptation of Alexandre Dumas, pere's *The Count of Monte Cristo* for forty years.
- *Long Day's Journey into Night* is based on his family.
- Won a posthumous Pulitzer Prize (his fourth) in 1957 for that play.

Ntozake Shange (1948–2018)
- Playwright, poet, and novelist.
- Most famous work is the 1976 choreopoem, *for colored girls who have considered suicide / when the rainbow is enuf*.
- *for colored girls* was adapted into a 2010 film by Tyler Perry.

Sam Shepard (1943–2017)
- Lovers include Joni Mitchell, Patti Smith, and Jessica Lange.
- Plays include *Curse of the Starving Class*, *Buried Child*, and *True West*.

Wole Soyinka (1934–)
- Political activist, playwright, novelist, and essayist.
- Famous works include *Death and the King's Horseman*, *The Road*, and *The Lion and the Jewel*.
- Twenty-second dramatist to win Nobel Prize for Literature.
- First Black author to win Nobel Prize for Literature.

Paula Vogel (1951–)
- Won a Pulitzer Prize for *How I Learned to Drive*.
- Defended her doctoral dissertation at Cornell in 2016, forty years after she started her Ph.D. program.

Lauren Yee (c.1985–)
- Named a "Storyteller to Watch" by *Variety* in 2021.
- Collaborated with the band Dengue Fever to write the 2018 "play with music" *Cambodian Rock Band*.

Match the famous line to the play, playwright, or character

Print out the quotes and names and cut them into strips so that each quote or name is on its own sheet. Give each group a set and have them decide which line goes with which name. Examples:

- "Hell is other people."—*No Exit*, Garcin, Jean-Paul Sartre.
- "Blow out your candles, Laura—and so goodbye […]"—*The Glass Menagerie*, Tom, Tennessee Williams.
- "You see things; and you say 'Why?' but I dream things that never were; and I say 'why not?'"—*Back to Methuselah*, The Serpent, George Bernard Shaw.
- "Figure it out. Work a lifetime to pay off a house. You finally own it, and there's nobody to live in it."—*Death of a Salesman*, Willy Loman, Arthur Miller.

- "Second to the right and then straight on till morning."—*Peter Pan*, Peter Pan, J. M. Barrie.
- "The truth is rarely pure and never simple."—*The Importance of Being Earnest*, Algernon, Oscar Wilde.
- "I have come to the conclusion that one useless man is called a disgrace, that two are called a law firm, and that three or more become a congress."—*1776*, John Adams, Sherman Edwards and Peter Stone.
- "Once upon a time freedom used to be life—now it's money."—*A Raisin in the Sun*, Mama, Lorraine Hansberry.
- "I have always depended on the kindness of strangers."—*A Streetcar Named Desire*, Blanche Dubois, Tennessee Williams.
- "Life is but a walking shadow, a poor player that struts and frets his hour upon the stage and then is heard no more. It is a tale told by an idiot, full of sound and fury signifying nothing."—*Macbeth*, Macbeth, William Shakespeare.
- "It takes a great deal of courage to stand alone even if you believe in something very strongly."—*Twelve Angry Men*, Nine, Reginald Rose.

Match the Image of Playwright to Name

Create a slide presentation with pictures of playwrights and multiple choices for the correct playwright. Working in groups or partners, each decides on the best answer.

Match the Plot to the Play

Provide a list of famous plays and plots. Print them out and cut them into strips of paper so that each name and description is on its own paper. Have students work in groups to figure out the answers. Examples:

Macbeth
Man wins a battle, rescuing the king's son, and is promoted. On his wife's suggestion, he kills the king and several other people, which leads to the couple's death.

Medea
Woman kills her own children to take revenge against her husband who leaves her for a "conventional" woman.

Private Lives
Two couples stay in adjacent suites on their honeymoons. One member of each couple used to be married to a member of the other couple. Hijinks ensue.

Pygmalion/My Fair Lady
A retired military officer and a professor make a wager about whether the professor will be able to pass off a cockney flower girl as a member of high society.

A Doll's House
A woman borrows money from a man to help her family. When her husband finds out, he is horrified. She decides she can no longer be a wife and mother and leaves the family.

Three Sisters
A group of women say they want to go to Moscow. They never go to Moscow.

Waiting for Godot
Two people wait for somebody to show up. The person never shows up.

Mismatched Main Characters

Using plays that you have read or discussed in class, have students swap characters from two plays and retell the story. Have students think about:

- How would the character behave in the story?
- How would the character relate to the other characters?
- What new obstacles would the character create for the other characters?
- How would the story end?

Plot in a Bag

Have students write down three things on separate pieces of paper. It can be people, abstract concepts, themes, locations, or anything they want. Collect the ideas in a bag. In small groups, they draw five things from the bag and create a plot for a story.

Discussions

A lot of discussions emerge organically when students begin writing or reading a play together. To get students talking, begin with questions that allow students to share their experiences. Once students have established a writing routine in class and are comfortable reading plays out loud, spend more class time discussing playwriting technique and their writing.

Questions about the Creative Process

- What is your creative process?
- How does creativity work?
- How is creative thinking different from other ways of thinking? Is it?
- What stories or plays would you be interested in adapting? Why?
- What is a play that you enjoyed watching or reading? Why?
- What is the worst play that you have ever seen? How would you rewrite it differently to make it work?
- What is the most important part of a story to you? Character? Plot? Message? Something else?

Questions about Dialogue and Stage Directions

- How is writing dialogue different from other types of writing?
- What makes dialogue realistic or believable?
- Should dialogue be realistic? Why or why not?
- What makes a great beginning? What are some examples you can think of?
- What makes a great ending? What are some examples you can think of?
- How much does a script change from the page to the stage?
- How much does an actor's performance impact the interpretation of a play?
- What benefits are there to having a play read out loud when writing?
- Should stage directions be added into a script? Why or why not?
- As an actor or director, how might you interpret stage directions?
- What can stage directions tell us about a story?

Questions about Collaboration

- What famous writing duos do you know about? What makes their work interesting?
- If you could collaborate with one playwright, who would it be? And why?
- If you could collaborate with one actor, who would it be? And why?
- What are the benefits of working collaboratively?
- What are the challenges of working collaboratively?
- How might you benefit from working collaboratively?
- What experience do you have collaborating with others creatively?
- What have you learned from your experience working with others?

How Do I Run the Course?

The information included below is specific to this chapter. For additional ideas, see Chapter 5 for performance-related topics that may be used for reader's theatre and play development.

How Do I Get Students Writing?

Start with a group improvisational activity to get students warmed up and thinking creatively. Group activities are important to establish a supportive environment for the class. It also gives students who are not accustomed to doing creative work ideas from others to work from.

For the first writing activity, choose something that is easy. In other words, use an activity that has very clear instructions and is short enough that any student can do in a few minutes.

How Do I Get Students Performing?

Start out by having students read plays or scenes aloud. Provide printed copies of your scenes, usually in eighteen-point font, and have your students sit in a circle. Make sure to have an equal number of characters in the scene as there are students, less one. Start by having one student read the stage directions and have students take on reading responsibilities for each new character until everyone around the circle has a character. That way students aren't hesitant to speak or vying for specific characters and everyone participates in the reading.

To workshop plays, divide the class into breakout groups of three to five. Have each group perform for the other group before performing in front of the entire class.

How Do I Make Writing and Performing Fun?

Stress the importance of laughter and living in the moment. Reiterating what we've said in previous chapters—there are no wrong answers!

- Facilitate activities that are easy enough so everyone can be successful. When something is too difficult, students can get frustrated and shut down.
- When beginning a class, have the students do a silly activity whether it is writing, acting, or improvising. The playfulness of the activity will help get them comfortable and less intimidated by the class.

- Ask students what stories they want to see that do not exist/that they wish there were more of and then encourage them to create those stories.

How Do I Help Students Become Comfortable with "Mistakes"?

Have students read unsuccessful plays by famous playwrights, such as Chekhov's first untitled play, to show students how even the "experts" make mistakes. Sometimes a flop can become a cult classic and develop a huge following, for example, *Chess* or *The Rocky Horror Show*. Other times plays can come in and out of fashion. For example, Shakespeare's *Titus Andronicus* was popular during his lifetime, but was not well-appreciated again until the mid-twentieth century.

Have students read and perform each other's work anonymously. Things that a student may think are "mistakes" or elements of their play they are unsure about may resonate with audiences and performers. Often when students hear their work being performed there are happy accidents. For example, an actor reading a line "wrong" may give the play a completely new interpretation the playwright may never have thought of on their own.

Once your students have been writing together for a while, have students intentionally write a "bad" short play and then write a "good" short play. Read all of the plays out loud without knowing which ones were intended to be "good" or "bad." Students may discover that they enjoy reading (and writing) "bad" plays more. After reading the plays discuss what makes a play "bad" or "good."

How Do I Manage Student Feedback?

Feedback is about how the audience feels and experiences the play. There are no right or wrong experiences and they are subjective. The purpose of feedback for playwriting, storytelling, or play development is to help writers or performers reflect on their work and discover new ways to improve it. Writers and performers themselves come up with solutions to problems and learn how to think critically about their own work. The best feedback will engage with the artists in a productive way that puts them in a place of curiosity. Feedback given in the form of questions is often effective in doing this.

Before having students give feedback, set the ground rules on how to give feedback. Establishing ground rules and expectations assists students with focusing their feedback as well as maintaining a supportive environment. If expectations are not set at the beginning, students may also end up giving suggestions instead of feedback.

THEATRE FOR LIFELONG LEARNING

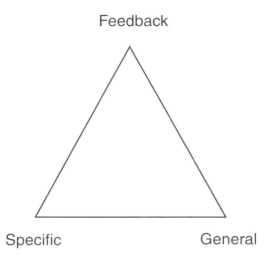

FIGURE 4.1: Feedback.

There are different types of feedback that can be useful for students. See Figure 4.1. General feedback summarizes overarching experiences that an audience member has. For example, "I felt exhilarated after watching the play!" General feedback can help writers or performers understand if the main theme or experience they were trying to create for audiences were effective. Specific feedback addresses details about a play. For example, "I found the character of Sandy very irritating. She reminded me of an annoying coworker who volunteered me for extra work!" Specific feedback can help artists pay closer attention to details within their work. It can help writers and performers see what small changes they can make to get their message across. Depending on the artists' personality, specific feedback may also be easier to consume and work with than general feedback because they are directed at smaller parts of the play.

Feedback is often confused with suggestion. Suggestion is about what the audience wants the writer or performer to change to meet the audience member's particular viewpoint. This does not take into account what the writer or performer's intentions were and suggestions may derail an artist's message. Suggestions are audiences interjecting their own ideas into an artist's creation. This may or may not be welcome to artists and is especially difficult to hear for new artists. Here are some common feedback and suggestion phrases:

Feedback	Suggestion
I liked/did not like …	Why don't you …
I am interested in knowing more about …	You should focus on …
I did not understand …	Why didn't you …
How did you …	It would be better if …
Why did you choose …	If you change …
My main takeaways were …	It should be …
What did you intend …	You should …

When Should Students Give Feedback?

Students should practice giving feedback multiple times throughout the writing or performance process, in order for students to be able to successfully revise their works and/or choose the works for final performance. Feedback is essential for helping students grow as writers and performers.

How Do I Help Students Become Comfortable with Feedback?

To promote constructive criticism and a supportive course environment, start by having students share their work with a partner. If they do not want to share their work with another student, offer to read their work as the instructor and give them positive feedback and encouragement. This helps students build confidence if you, the instructor, think they are doing good work.

If students still do not want to share their work, do not force them. The key thing is to have them coming back to class each week. When a routine is set and more students share their work, hesitant students may be more inclined to share.

After partners have shared their work with each other, ask volunteers to share their work with the entire class. This helps build confidence for all students. Another method is for you to write a very "bad" scene and read your scene out loud. This will help the students feel more comfortable sharing their work *or they may think you are a bad writer!*

What Do I Do If a Student Doesn't Want to Participate?

At the beginning of class, set the expectation that all students are encouraged to participate, but they do not have to do anything they do not want to do. If students want to disengage from an activity, they have the right to step out of the classroom or stay and observe. This usually helps students

feel that they have a choice and voice in the class and are not being forced to participate.

Secondly, set up the expectation that the work is creative and there is no right or wrong way to do it. The most important thing is that they are doing it. If you want to show students an example of this, collect the early works of famous writers or artists that were poorly received initially. Some notable examples include the disastrous first production of Anton Chekhov's *Seagull* in Saint Petersburg, and John Cariani's *Almost, Maine*, which flopped on Broadway but went on to become one of the most-produced plays in the USA. This will help dispel the myth that some people have innate talent and others do not.

What Do I Do on the First Day?

To introduce the class and assess the knowledge of your students, find out what they like about theatre and writing by starting a discussion. Refer to questions in the Discussions section. These are easy questions that anyone can answer and will have an opinion about.

Beginning the course with a game or a simple exercise is another way to get students engaged in the course immediately. Play something that has minimal rules. You want to make sure that *all* students can follow along with the activity. Be aware that if it is too difficult at the beginning, it may turn students off from trying other activities.

Set the expectation that first drafts will not be final drafts. Emphasize that theatre is a practice, not a perfect. Writing takes time and sometimes what we think may work in writing does not translate to performance. Encourage students to be patient with the writing, revising, and rewriting process.

How Do I End a Class?

End your class with a performance, reading, or a final roundtable discussion. Students should be encouraged to continue writing, developing, and sharing their stories after the class ends. If there is interest, help students establish a regular play or storytelling slam.

If you film their performances, create a montage of "best of" moments to celebrate everyone's successes. Students may enjoy looking back at their accomplishments. You will discover your students and yourself realizing that there were things that happened, but everyone forgot about. It is a great way to acknowledge everyone's accomplishments and hard work throughout the course.

How Do I Help Students Put on a Performance?

There are many ways to produce a show with your students. You can be minimalistic and do staged readings or go with a full production using costumes, sets, lights, and so on. The performance choice you select will depend on a few factors. Questions to consider:

- How much time do you have to rehearse?
- Will students rehearse on their own time or only use class time?
- How many students want to perform in front of an audience outside your course?
- Where will your performance take place?
- How many people does the space accommodate? How many audience members? How many performers?
- What is the availability of your performance space? What day and time will it take place?
- When do you need to set a date for the performance?
- How will you market the performance?
- How many people do you expect will come to the performance?
- What resources do you have for microphones, costumes, lighting, props, set, sound, and music, and so on?
- Can you get any additional financial support?
- What additional labor support can you get?

Staged Readings

Staged readings are great for classes of any size and can be done virtually or in person. They require less preparation for students. In a staged reading, performers can be on-book and do not need to memorize their dialogue. Actors can be seated throughout the reading. Staging and movement are kept to a minimum.

To help students put on a staged reading, provide each actor a copy of the script. Have students highlight their lines so they know what to read. Then read the play together.

After an initial reading, work on developing clear diction and volume so that performers' voices can be heard clearly. It is important that audiences can hear every word clearly or they may miss a part of the story.

Then work on developing and refining character personalities through voice. Have the students think about how their characters' voices sound, what the lines mean to their characters, and how they would say the lines. This will require some time to analyze the characters and the play as a whole.

When students have a better understanding of what their character wants, how they behave, and where the characters fit in the world of the play, they will be able to add details to the performance that make the reading engaging for the audience.

Workshop Production

A workshop production has minimal scenery, props, lighting, and costume, and the actors can be on-book if necessary. You may have a simple "lights up, lights down" lighting plot and a set consisting of a table and chairs and actors can dress in all black or in street clothes.

You will need to find and secure a venue to host the production. Some libraries, museums, cafes, or schools have spaces that are configured to host events. Assist students with recruiting additional actors if needed. Plan the rehearsal schedule and make sure students are able to rehearse at least once in the performance venue.

Full Production

Full productions are the most labor intensive and may involve collaboration with a theatre. They require all performers to have their lines memorized and know their blocking. Costumes, lighting, props, and scenery may or may not be used. If you decide to put on a full production, it will limit the number of plays you can produce since students will need more preparation time to practice performing and running technology for a full production.

Additional Tips

- *Recording class performances*: If students are willing to, film performances throughout the course. You can use this on the last day to show highlights from the class. If you do not have film capabilities, pictures work as well.
- *Plotters vs. Pantsers*: Some students will like to plan out their entire story before writing, while others enjoy flying by the seat of their pants and seeing where the characters/situations they develop take them. Improvisational games are a great way to help plotters be okay with writing without a plan.
- *"Creative" expectations*: Students may create or say something offensive to others. At the beginning of the class, set up the expectation that everyone will

respect one another and have the intention of not purposefully being offensive. If something offensive happens, try to address it right away. If that is not possible without embarrassing the student(s), pull them aside when you have a break.
- *"It really happened to me!"*: Some students may *only* want to stick to the personal memories vs. creating new work. Challenge them to use their imagination more often. Suggest that they start by writing stories "ripped from today's headlines."
- *Aha moments*: Give students space to have "aha moments" in class and follow tangents. Even experienced students may have moments of revelations, especially when they are working with others.
- *Difficult experiences*: Give students space to process difficult experiences (whether personal discoveries or challenges in activities). Making "mistakes" or not being perfect may be difficult for some students.
- *Theatre as therapy*: Some students may treat your class as therapy, especially if they are creating theatre pieces using their own histories. Allow them to do this occasionally, but keep the class on track and focus on the present. Even though not all students will vocalize this, theatre does have many positive therapeutic elements even when it is not specifically "theatre therapy."
- *"I can't remember"* or *"I don't want to remember!"*: Personal experiences and memories may be difficult for some to reexperience. Give students the option of making up a story or using someone else's if they do not want to use their own experience.
- *"I'm a star!"*: Some students might be more interested in performing, acting, or being funny and entertaining, rather than learning storytelling or playwriting techniques. Encourage them to collaborate with classmates to share the wealth of their talent.
- *"They're not doing my story right."*: When students perform others' works, they will likely not perform the stories the way the creators envisioned them. Remind the class that performances of plays *always* appear different in production no matter who the playwright is. Also, others' interpretation of the script or story helps bring new perspectives for the creator. Feedback is productive for writing and theatre is a collaborative form where success comes from relinquishing control.
- *"Everyone's a critic!"*: To avoid receiving too much negative or positive feedback that is not productive to the process, remind students to be specific, provide guiding discussion questions, and encourage everyone to participate.

What Do I Include on the Syllabus?

Feedback

Providing and receiving feedback on creative work can be a challenge. To help students become comfortable and respectful with the idea of feedback, make sure to cover it on the syllabus. For example:

Feedback Guidelines
- Share what you liked about your classmates' work. Be as specific as possible.
- Phrase your feedback as questions. Let your classmates figure out what they wish to change and how they want to do that.
- Offer suggestions only when your classmates ask for them.

Expectations

Expectations for writing or storytelling exercises are useful to include because many new writers will expect that the first draft will be the final draft. Students may not be aware that most writers (including successful ones) write several drafts and spend hours (or years) revising a work. Emphasize that they have only spent a few minutes on a writing exercise. It is not realistic to expect anyone to write an award-winning ten-minute play in twenty minutes. It could happen. But it is unlikely. Much of the time in class will be used for initial brainstorming and getting ideas out and into the world. Example:

Expectations
- First drafts are not final drafts!
- Let your ideas grow and try not to second guess yourself.
- Stories adapt and change over time.
- We are not striving for perfection (or even the good). We are striving to create.
- Writing is an exercise. Practice may not make perfect, but it does make it easier.
- You are here to write. Write. Tell stories.

Sample Syllabi

Class activities are highlighted below. Do not include them in the printed syllabus that students receive. All activities are for the entire class unless noted. Activity

instructions are for students unless noted. Instructors may need to introduce topics to set up activities.

THE ART OF PLAYWRITING

I like theatre because it's so unprofitable.

—Annie Baker[4]

Course Overview: While you may not get rich writing plays, you can still have fun writing them. You can create characters that you always wanted to be, put them in any situation you would like, and see how things play out in action and dialogue. In this course, we will investigate how playwrights develop characters, plot, and structure. We will read plays, view media, engage in discussions, and do short in-class writing assignments. The activities we do will encourage active listening, critical thinking, and creativity. You will also have the opportunity to lead a discussion with a partner or small group.

Weekly Schedule

Week One: Ten-Minute Plays

PRE-ACTIVITY DISCUSSION: What ten-minute plays have you seen? What makes them fun to watch?

ACTIVITY: Read *Sure Thing* by David Ives; Watch Kennedy Center interview with David Ives.

POST-ACTIVITY DISCUSSION: What makes this play interesting? What was unexpected about the play? What genre is this play and why?

Week Two: Writing Your First Play

PRE-ACTIVITY DISCUSSION: What would you like most about writing? What stories do you enjoy telling?

ACTIVITY: Group Storytelling (*see Performance Exercises in Chapter 5 for description*); (Partners) Tell a story to your partner. Then write the first four lines of dialogue of the story in play form. After writing four lines, switch plays with partner and add four lines to the play. Keep switching until each writer has written four sets of dialogue per play (for a total of sixteen lines in each play). Read entire plays out loud with partner; Two to three students share play with class.

POST-ACTIVITY DISCUSSION: What was difficult about this activity? What did you learn about your story from having half of it written by your partner? How might this process help with writer's block?

Week Three: Where Do I Begin?

PRE-ACTIVITY DISCUSSION: Where can we "find inspiration"? Where do we start?

ACTIVITY: (Individual) Pick a person (real or fictional) that already exists. Write a monologue from that person's point of view with the character going on a blind date; Two to three students share monologues with class.

POST-ACTIVITY DISCUSSION: Did the characters behave in ways that were believable based on what we know about them? What did you learn about your character? What did you learn about others' characters?

Week Four: Ten-Minute Comedies

PRE-ACTIVITY DISCUSSION: What makes a ten-minute play? Can any play be a ten-minute play? Why or why not?

ACTIVITY: Read *Boy Meets Girl*.

POST-ACTIVITY DISCUSSION: Should stories always begin at the beginning? How do your perceptions of the characters change? What makes this story interesting?

Week Five: Writing Beginnings

PRE-ACTIVITY DISCUSSION: Should plays start at the beginning or in the middle of the action? What are the advantages of each?

ACTIVITY: Read the first two pages of Sophocles' *Oedipus Tyrannus*; (Individual) Write a scene that starts from the beginning. Write a second scene that starts from the middle of the action.

POST-ACTIVITY DISCUSSION: Should stories always begin at the beginning? What major events has the protagonist experienced before the start of the play? What makes this story interesting?

Week Six: Dramas; The Well-Made Play

PRE-ACTIVITY DISCUSSION: What are the benefits of following a formula when writing? What is your definition of a well-made play?

ACTIVITY: Read scenes from Act I of *A Raisin in the Sun*.

POST-ACTIVITY DISCUSSION: Describe the action of the story. What kept you wanting to hear more of the story? What does Walter Lee want? Why does he want to go into business with Willy and Bobo and what does his family think about this plan?

Week Seven: Writing Positives and Negatives

PRE-ACTIVITY DISCUSSION: How do positives and negatives affect the outcome of your stories?

ACTIVITY: (Individual/Partners) Write a scene starting with a positive and ending with a negative; Write a scene starting with a negative and ending in a positive; Two to three students share scenes with class.

POST-ACTIVITY DISCUSSION: How did each scene start and end? What works about using that strategy? What did the exercise challenge you to do?

Week Eight: Experimental Theatre

PRE-ACTIVITY DISCUSSION: What are some experimental plays you have seen? What makes them work? Or why didn't they work for you?

ACTIVITY: Read *Philip Glass Buys a Loaf of Bread*.

POST-ACTIVITY DISCUSSION: What makes this play fun? How does the author play with language? What is the story about?

Week Nine: Experimental Theatre Cont'd

PRE-ACTIVITY DISCUSSION: What topics or stories might work well for experimental theatre? Can all plays be experimental? Why or why not?

ACTIVITY: (Individual/Partners) Choose a theme and write about it in a nonlinear structure.

POST-ACTIVITY DISCUSSION: How did exploring a theme without a standard structure affect the way you perceived the story? How does story work in nonlinear storytelling? What advantages does nonlinear storytelling offer?

Week Ten: Writing Endings

PRE-ACTIVITY DISCUSSION: What are the most memorable endings you have seen or read?

ACTIVITY: (Individual) Take a scene from last week; write a positive ending to the scene; Write a negative ending; (Small Groups) Read scenes out loud.

POST-ACTIVITY DISCUSSION: Why are endings so important?

Week Eleven: Revising

PRE-ACTIVITY DISCUSSION: What are your characters' objectives? What is the main message of your play?

ACTIVITY: (Small Groups) Check character dialogue and revise according to the following:

1. Is the language true to the characters?
2. Do the characters have distinctive personalities and dialogue?
3. If you have a plot, how does it build?
4. How does the story flow?
5. Does the story draw your attention?

POST-ACTIVITY DISCUSSION: Which elements did you focus on and why? What was the biggest challenge?

Week Twelve: Staged Reading

ACTIVITY: Read plays.

POST-ACTIVITY DISCUSSION: What did you like about each play? What was the most interesting aspect of each play? What did you enjoy most about the writing process? What did you learn about yourself during the playwriting process?

CREATIVE COLLABORATION AND PLAY DEVELOPMENT

Course Overview: Come find out what happens with the magic of collaboration. Play development or devised theatre is the process of workshopping to better tell a story. Development happens through performing and improvising scenes, participating in discussions, experimenting with alternate means of expressing ideas, staged readings, incorporating feedback into revisions, and sharing work with an audience. We will host a staged reading and practice developing scripts for devised theatre, improvisation into text, and adaptations.

Weekly Schedule

Week One: Introduction to Play Development (Devised Theatre)

PRE-ACTIVITY DISCUSSION: What experience do you have with playwriting, performance, or collaboration? What is difficult about collaborating? What makes a collaboration fun?

ACTIVITIES: Introduce the works of *commedia dell'arte*, Punch & Judy, street theatre, Anne Bogart, Jerzy Grotowski, Tadashi Suzuki, Jacques Lecoq, PunchDrunk, Caryl Churchill, and the San Francisco Mime Troupe.

POST-ACTIVITY DISCUSSION: What exactly is devised theatre? As we begin the process, what are your biggest questions about the play development process?

Week Two: Improvisation into Scripted Drama and Telling Story through Action

PRE-ACTIVITY DISCUSSION: What are the elements of a story?

ACTIVITY: Brainstorm five lists: Characters, Objectives, Problems, Locations, and First Line/Last Line; (Small Groups) Randomly draw a location, a problem, three characters, a first line and a last line, and an objective for each character. Start the clock with five minutes. The actors must incorporate all of the story elements into their five-minute scene. After five minutes, rotate the elements.

POST-ACTIVITY DISCUSSION: Which elements of each version of the story would you keep if you were combining them into one play? Which elements carried over between all versions of the story?

Week Three: Collaborative Creation of a Ten-Minute Play

PRE-ACTIVITY DISCUSSION: What are ten-minute plays and how are they different from scenes?

ACTIVITY: Read three ten-minute plays; (Small Groups) Create a ten-minute play idea. Share with class.

POST-ACTIVITY DISCUSSION: How did you determine the story? What choices did you make based on the ten-minute play structure? What would you have done if the play was longer? Which play idea did you like the most? Why?

Week Four: Adapting Canonical Texts

PRE-ACTIVITY DISCUSSION: What adaptations or parodies of famous plays and stories have you seen? How do the adaptations change the story? Are they more relatable? Do they reflect different points of view?

ACTIVITY: (Small Groups) Instructor provides groups with a plot synopsis from a famous play. (See exercises for other variations.) Each group must:

1. Choose a time period.
2. Reframe the characters to reflect personality traits or professions of people in the selected time period.
3. Rewrite the plot of the play.
4. Share play with class.

POST-ACTIVITY DISCUSSION: Which of these adaptations would you most likely see in performance and why? How did these adaptations change the way you thought about the story of the famous play?

Week Five: Devising "Issues Plays" or Adapting Canonical Texts into Issues Plays

PRE-ACTIVITY DISCUSSION: What are social issues you care about? What does society at large think about this issue? What are ways to tell stories related to this issue in a compelling way? How can a play be revised and updated to talk about contemporary social issues?

ACTIVITY: (Small Groups) Adapt a play to address an issue or develop a contemporary story into a short play. Share with class.

POST-ACTIVITY DISCUSSION: What elements of the plays stood out to you? How did the plays make the issue interesting? How do the play adaptations change the message or understanding of the story? Which play did you enjoy the most? Why? What would you do differently next time?

Week Six: Devising Monologues

PRE-ACTIVITY DISCUSSION: What are some famous quotations you know?

ACTIVITY: Instructor provides a list of famous quotations on different themes such as aging, patriotism, love, etc. Students vote on theme. Instructor reads quotes from chosen theme. (Individual) Choose a quotation and write a monologue on that quote. Monologue does not have to contain the quotation but it can; (Partners/Small Groups) Share plays; (Individual) Select favorite lines; (Individual) Revise play; (Partners/Small Groups) Share plays.

POST-ACTIVITY DISCUSSION: Of all of the plays created over the course of the semester, which would you most likely spend additional time developing?

Week Seven: Revisiting Past Projects

PRE-ACTIVITY DISCUSSION: What are three things you hope to get out of workshopping your play? What are three things you want your classmates to concentrate on while reading your play?

ACTIVITY: (Individual/Partners/Small Groups) Generate a list of questions for others to answer. For example, "What should I change about the relationship between Character X and Character Y?" or "What would make the ending less abrupt?"; Read plays out loud; Respond to questions; Divide class into two workshopping breakout groups.

POST-ACTIVITY DISCUSSION: How did the questions help you see your plays in a new way?

Week Eight: Workshopping: Group One

ACTIVITY: Group One selects a play to workshop; Group One selects readers from Group Two; Group Two does a table reading; Group One revises play.

POST-ACTIVITY DISCUSSION: What did you hear differently in the reading? What would you like to change with the play?

Week Nine: Workshopping Group Two

ACTIVITY: Group Two selects a play to workshop. Group Two selects readers from Group One. Group One does a table reading. Group Two revises play.

POST-ACTIVITY DISCUSSION: What did you hear differently in the reading? What would you like to change with the play?

Week Ten: Preparing to Share New Works with an Audience

PRE-ACTIVITY DISCUSSION: Which works do you want to share with an audience? What questions would you most like answered by audiences? What are your biggest concerns about sharing your work with an audience?

ACTIVITY: Class selects what to include in the staged reading, the casting, and the run order of the staged reading; Practice reading through the works aloud; (Small Groups) Make any prereading revisions. (Individual) What do you want to get out of the staged reading? What aspects of the play do you want readers to emphasize?

Week Eleven: Staged Reading for an Audience

ACTIVITY: Hold a virtual or in-person staged reading of material created by the class for friends, family, and community members. Provide feedback and comment cards for audience members or invite them to stay for a post-reading discussion.

POST-ACTIVITY DISCUSSION: Facilitate a discussion about the staged reading: How was your experience reading your character(s)? What insights did you gain from the reading? What are the themes of each play? What connections, similarities, and differences do you notice across all of the plays?

Week Twelve: Final Reflections

DISCUSSION: How was it to see your play performed with an audience? What new things did you see happen? What new perspectives have you gained from participating in the performances? Which plays would you like to continue developing? What ideas do you have for future plays?

STORYTELLING

Course Overview: Interested in learning how to tell compelling ghost stories, folktales, and adventures from your own life? Come give it a try and explore how to create stage presence and connect with an audience. You will have the opportunity to develop your own stories, work with partners and small groups, and do a three- to five-minute performance at the end of the course. Come to listen, learn, and share!

Weekly Schedule

Week One: Something Good: Introduction to Recalling and Using Experiences for Storytelling

PRE-ACTIVITY DISCUSSION: How does storytelling enhance memory? How does storytelling change the ways we remember the past?

ACTIVITY: (Small Groups) Pick a historic event you all experienced. Share your experiences of the events with your group, making note of how things changed as a result of the events in the story. Each person speaks for one to three minutes.

POST-ACTIVITY DISCUSSION: How widely did the recollections of the same event vary among your group? What surprised you about hearing the different stories? How did it change your perception of history?

Week Two: Something Good/Something Strange; Getting Specific with Details, and Building Obstacles

PRE-ACTIVITY DISCUSSION: Are there any things that happened that your family "won't let you forget"? Do you have a "remember the time that [...]" story?

ACTIVITY: (Small Groups) Pick a good memory and tell a story for one to three minutes; Pick a strange memory and tell a story for one to three minutes.

POST-ACTIVITY DISCUSSION: What changed in your retelling of the story? What new elements did you add to make it relatable for the audience? How did it feel telling a good and strange story? What was it like to hear others' stories?

Week Three: Imagination and Speculation; Something That Didn't Happen, but Could Have

PRE-ACTIVITY DISCUSSION: What is a time you made a choice and the choice changed *everything*? What might have happened if you made the other choice?

ACTIVITY: (Individual) Prepare the bullet points of your imagined story. (Partners/Small Groups) Tell a story in five minutes or less.

POST-ACTIVITY DISCUSSION: Which option would you have gone with if you were presented with one of your classmate's options?

Week Four: First-Person Narrative; Giving and Taking Feedback

PRE-ACTIVITY DISCUSSION: What are some themes around which people have interesting stories?

ACTIVITY: (Small Groups) Pick a theme. Each person tells a one-minute story. Practice two to three times.

POST-ACTIVITY DISCUSSION: What specific elements did you like about each performance? Why? What was unclear about the stories? What did you want to know more about in the stories?

Week Five: First-Person Narrative; Five-Minute Stories with a Theme

PRE-ACTIVITY DISCUSSION: What are some themes around which people have interesting stories?

ACTIVITY: (Small Groups) Pick a theme. Each person tells a five-minute story.

POST-ACTIVITY DISCUSSION: What was helpful with the feedback? What kind of feedback would you like more of?

Week Six: Character Games and Scenarios

PRE-ACTIVITY DISCUSSION: How do you create characters? What makes them interesting to watch?

ACTIVITY: (Small Groups) Pick a theme. Tell a one-minute story. Retell the one-minute story with a puppet as a second character.

POST-ACTIVITY DISCUSSION: Were you able to tell what the different character was? Why or why not?

Week Seven: Multicharacter Storytelling

PRE-ACTIVITY DISCUSSION: How do you indicate that someone other than the narrator is speaking? What goes into creating multiple character voices?

ACTIVITY: (Small Groups) Tell a three- to five-minute story with three or more characters who interact with dialogue.

POST-ACTIVITY DISCUSSION: Could you distinguish between the different characters in others' stories? What worked and did not work?

Week Eight: Adapting a Folktale or Ghost Story

PRE-ACTIVITY DISCUSSION: What makes a great folktale or ghost story? What elements are most intriguing? Why?

ACTIVITY: (Small Groups) Tell a folktale or ghost story in five minutes. Including the following:

Ghost Story
1. Backstory for the ghost.
2. What the ghost wants.
3. How the ghost interacts with the living.
4. A personality for the ghost.
5. Whether the ghost is hostile, friendly, flirtatious, etc.

Folktale
1. A moral (the moral does not have to be a "conventional" moral).
2. A quest or challenge.
3. A problem.

POST-ACTIVITY DISCUSSION: Who told different versions of the same story? Which plot elements were the same and which differed? Which do you remember most vividly from childhood?

Week Nine: Telling the Same Story Three Different Ways; Comedy, Tragedy, and Flipped Narrators

PRE-ACTIVITY DISCUSSION: Which genres are you familiar with? What are the main elements of each genre?

ACTIVITY: (Small Groups) Tell a two-minute story as a comedy; Tell the same story as a tragedy; Tell the same story with the narrator changed to a different character.

POST-ACTIVITY DISCUSSION: How did telling the same story three different ways give you new perspectives about your story? How is using genre helpful in storytelling?

Week Ten: Retelling Someone Else's Story

PRE-ACTIVITY DISCUSSION: What do you think is going to be the most difficult aspect of listening to someone else tell your story? How are you going to react if they "get it wrong"? Why is it important to ask open-ended questions?

ACTIVITY: (Partners) Tell a two-minute story. Partner retells two-minute story to class.

POST-ACTIVITY DISCUSSION: Which elements of your story do you think were most memorable for your partner? Which elements of your partner's story were most memorable to you?

Week Eleven: Telling Adapted Stories

PRE-ACTIVITY DISCUSSION: Why are stories told and retold over time? Why do people like listening to stories they are already familiar with? Where can we find stories to adapt?

ACTIVITY: (Small Groups) Tell an adapted story as a group. Decide on the main storyline and take turns telling the story; Share stories with the class.

POST-ACTIVITY DISCUSSION: Which stories do you want to share as part of the final performance? How should they be grouped? Are there any that you think are difficult acts to follow that you want to place either at the end or before a break?

Week Twelve: Public Performance of Stories

PRE-ACTIVITY DISCUSSION: What is the run order for the performance? Can everyone hear the person on stage? Can everyone see the person on stage?

ACTIVITY: (Individual) Tell a five-minute story; Audience votes on favorite stories in categories such as best character, best villain, best plot, best beginning, best ending, etc.

POST-ACTIVITY DISCUSSION: How was the experience of sharing your stories? What surprised you about responses to the stories?

CREATING PERFORMANCE

Playwriting, Play Development, and Storytelling

Course Overview: Do you consider yourself a writer? Do you consider yourself a performer? If you answered "Yes" or "No" to either, you already have what it takes for creating performance! Creating performance is for everyone even if you don't consider yourself a writer or performer. In this course, we will blur the boundaries between writing and performance, and explore playwriting, play development, and storytelling. Don't know what these are? Come find out by trying each one by learning to tell compelling stories in condensed amounts of time. Each week you will practice your writing and performance skills as well as improve your facility with narrative and collaboration. While each form has a different approach, they are all related and this class will help you build foundational skills to perform each art form. We'll end with a sharing session where you will read your plays and tell stories.

Weekly Schedule

Week One: One-Minute Stories

PRE-ACTIVITY DISCUSSION: What are playwriting, play development, and storytelling? Which form do you have experience working in? Which form do you have the most interest in? What do you hope to accomplish with the course? Are there specific skills you would like to develop?

ACTIVITY: (Individual) Write a one-minute play; Share plays with class; (Individual) Tell a one-minute story.

POST-ACTIVITY DISCUSSION: How does it feel to complete your first play and tell your first story? Which form are you more drawn to? Why? What advantages are there of each form?

Week Two: Personal Stories and Storytelling

PRE-ACTIVITY DISCUSSION: What great or strange experiences have you had that would make an interesting story? What makes a great story? What function does storytelling play in society? Who do we tell stories to and why?

ACTIVITY: (Partners) Pick a theme. Tell a one-minute story related to the theme based on a past experience.

POST-ACTIVITY DISCUSSION: What did you learn about the other person's personality by the content, language, and performance?

Week Three: Personal Stories and Playwriting

PRE-ACTIVITY DISCUSSION: Why do we draw from our own experiences for writing? What playwrights use their life experiences for writing?

ACTIVITY: (Individual) Define the who, where, what, and time of your personal story. Define the obstacles and resolution of your story. Write a one-minute play based on your life or someone else's; (Partners) Read play; Two to three students share with class.

POST-ACTIVITY DISCUSSION: What made the characters or story come alive? How did it feel to create a story by identifying the structural elements first?

Week Four: Personal Stories and Play Development

PRE-ACTIVITY DISCUSSION: Why is it important to workshop and collaborate with others to create plays?

ACTIVITY: Play Zip Zap Zop. *See Performance Exercises in Chapter 5 for full details*; (Small Groups) Give plays to others to perform. Rehearse one-minute plays from previous week; Perform plays for class.

POST-ACTIVITY DISCUSSION: What new insights do you see in your play from the performance?

Week Five: Adaptations and Storytelling

PRE-ACTIVITY DISCUSSION: What is your favorite poem, story, film, theatre, etc.? What part do you enjoy the most?

ACTIVITY: (Individual/Group) Take the most memorable moments of your favorite story and retell the story in two minutes.

POST-ACTIVITY DISCUSSION: What were the messages of the stories you heard? How did your retelling change the original story? How did you decide what details to include? What could you do next time?

Week Six: Adaptations and Playwriting

PRE-ACTIVITY DISCUSSION: What new spin can you add to a play adaptation? What advantages does turning a film/novel/poem into a play have? What changes would need to be considered to make a story stageable?

ACTIVITY: (Partners) Pick a maximum of three main characters of your story. Write a play adaptation. Read play to partner; Two to three students share play with class.

POST-ACTIVITY DISCUSSION: How was the adaptation different from the original? What new elements or characters did you explore in the adaptation? What did you notice in others' approach to creating a play adaptation?

Week Seven: Adaptations and Play Development

PRE-ACTIVITY DISCUSSION: What fairytales do you know? Which fairytales were popular in your childhood? What made them popular?

ACTIVITY: (Small Groups) Perform a fairytale.

POST-ACTIVITY DISCUSSION: What new elements did you see from the performance? How well did the story flow? How were the characters portrayed?

Week Eight: Collaborative Storytelling

PRE-ACTIVITY DISCUSSION: How does storytelling enhance memory? How does storytelling change the ways we remember the past?

ACTIVITY: (Small Groups) Pick a historic event you all experienced. Share your experiences of the events with your group for fifteen minutes, making note of how things changed as a result of the event. Each person speaks for one to three minutes.

POST-ACTIVITY DISCUSSION: How widely did the recollections of the same event vary among your group?

Week Nine: Collaborative Playwriting

PRE-ACTIVITY DISCUSSION: What is the hardest part of writing with a partner or group? Why are there so few partnerships in writing?

ACTIVITY: (Partners) Choose two characters. Write four lines of dialogue. Exchange with a partner. Write four lines of dialogue to their play. Switch back and forth until each play has sixteen lines. Then read plays out loud; Two to three students share plays with class.

POST-ACTIVITY DISCUSSION: What did you learn about yourself? What did you learn about your partner? How did it feel having no control over half the dialogue and taking over someone else's play?

Week Ten: Collaborative Play Development

PRE-ACTIVITY DISCUSSION: What do you want to see from a performance of your play?

ACTIVITY: (Small Groups) Give plays written the previous week to other groups to perform.

POST-ACTIVITY DISCUSSION: What new insights did you gain about your play in watching the performance? What new insights did you get performing someone else's play?

Week Eleven: Workshop for Performance

PRE-ACTIVITY DISCUSSION: Which form are you most drawn to? Why?

ACTIVITY: (Individual/Partners/Small Groups) Pick stories and plays to include in performance. Rehearse performance.

POST-ACTIVITY DISCUSSION: What is the message of the story? How do you want audiences to feel?

Week Twelve: Performance

ACTIVITY: Performances.

POST-ACTIVITY DISCUSSION: What was your favorite part of the class? What are you most proud of?

Additional Resources

Books

Cole, Toby, ed. *Playwrights on Playwriting: From Ibsen to Ionesco*. New York: Cooper Square Press, 2001.

Polti, Georges. *The Thirty-Six Dramatic Situations*. Translated by Lucile Ray. Franklin, OH: James Knapp Reeve, 1922.

Play Anthologies

Adell, Sandra, ed. *Contemporary Plays by African American Women: Ten Complete Works*. Champaign: University of Illinois Press, 2015.

Alvarez, Natalie, ed. *Fronteras Vivientes: Eight Latina/o Canadian Plays*. Toronto: Playwrights Canada Press, 2013.

Barlow, Judith E., ed. *Plays by American Women, 1900–1930*. New York: Applause Books, 1985.

Boffone, Trevor, Teresa Marrero, and Chantal Rodriguez, eds. *Encuentro: Latinx Performance for the New American Theater*. Evanston, IL: Northwestern University Press, 2019.

Chávez, Denise and Linda Feyder, eds. *Shattering the Myth: Plays by Hispanic Women*. Houston: Arte Publico Press, 1992.

D'Aponte, Mimi, ed. *Seventh Generation: An Anthology of Native American Plays*. New York: Theatre Communications Group, 1998.

Darby, Jaye T. and Stephanie Fitzgerald. *Keepers of the Morning Star: An Anthology of Native Women's Theater*. Los Angeles: UCLA American Indian Studies Center, 2003.

King, Moynan. *Queer/Play: An Anthology of Queer Women's Performance and Plays*. Toronto: Playwrights Canada Press, 2019.

King, Jr., Woodie, ed. *The National Black Drama Anthology: Eleven Plays from America's Leading African-American Theaters*. New York: Applause Books, 2000.

Hatch, James V., and Ted Shine. *Black Theatre USA: Plays by African Americans, the Early Period 1847–1938*. New York: Free Press, 1996.

Hatch, James V., and Ted Shine. *Black Theatre USA: Plays by African Americans, the Recent Period 1935–Today*. New York: Free Press, 1996.

Hodges, Ben, ed. *Forbidden Acts: Pioneering Gay & Lesbian Plays of the 20th Century*. New York: Applause Books, 2003.

Huerta, Jorge, ed. *Necessary Theater: Six Plays about the Chicano Experience*. Houston: Arte Publico Press, 1989.

Lee, Josephine, Donald Eitel, and Rick Shiomi, eds. *Asian American Plays for a New Generation*. Philadelphia, PA: Temple University Press, 2011.

Mojica, Monique, ed. *Staging Coyote's Dream: An Anthology of First Nations Drama in English*. Toronto: Playwrights Canada Press, 2003.

Mojica, Monique and Ric Knowles, eds. *Staging Coyote's Dream: Volume II*. Toronto: Playwrights Canada Press, 2009.

Nelson, Brian, ed. *Asian American Drama: 9 Plays from the Multiethnic Landscape*. New York: Applause, 1997.

Perkins, Kathy, and Roberta Uno, eds. *Contemporary Plays by Women of Color: An Anthology*. London: Routledge, 1996.

Sandoval-Sánchez, Alberto and Nancy Saporta Sternbach, eds. *Puro Teatro: A Latina Anthology.* Tucson: University of Arizona Press, 2000.

Svich, Caridad, and María Teresa Marrero, eds. *Out of the Fringe: Contemporary Latina/o Theater and Performance.* New York: Theatre Communications Group, 2000.

Uno, Roberta, ed. *Contemporary Plays by Women of Color: An Anthology*, 2nd ed. London: Routledge, 2017.

Uno, Roberta, ed. *Unbroken Thread: An Anthology of Plays by Asian American Women.* Amherst: University of Massachusetts Press, 1993.

Yew, Chay, ed. *Version 3.0: Contemporary Asian American Plays.* New York: Theatre Communications Group, 2011.

In-Depth Reading (International Play Anthologies)

Banham, Martin. *Contemporary African Plays.* London: Methuen Drama, an imprint of Bloomsbury Publishing, 1999.

Gainor, J. Ellen, Stanton B. Garner, Jr., and Martin Puchner, eds. *The Norton Anthology of Drama, Volume I.* New York: W. W. Norton, 2017.

Gainor, J. Ellen, Stanton B. Garner, Jr., and Martin Puchner, eds. *The Norton Anthology of Drama, Volume II.* New York: W. W. Norton, 2017.

Gilbert, Helen, ed. *Postcolonial Plays: An Anthology.* Abington: Routledge, 2007.

Perkins, Kathy A. *Black South African Women: An Anthology.* London: Taylor & Francis, 2005.

Solga, Kim, and Roberta Barker, eds. *New Canadian Realisms: Eight Plays.* Toronto: Playwrights Canada Press, 2012.

Taylor, Diana, and Sarah J. Townsend, eds. *Stages of Conflict: A Critical Anthology of Latin American Theater and Performance.* Ann Arbor: University of Michigan Press, 2008.

Walker, Craig S., and Jennifer Wise, eds. *The Broadview Anthology of Drama, Volume I.* Peterborough: Broadview Press, 2003.

Walker, Craig S., and Jennifer Wise, eds. *The Broadview Anthology of Drama, Volume II.* Peterborough: Broadview Press, 2003.

Wetmore, Kevin J., and Siyuan Liu, eds. *The Methuen Drama Anthology of Modern Asian Plays.* London: Methuen Drama, an imprint of Bloomsbury Publishing, 2014.

Plays Online

New Play Exchange; New Play Exchange: https://newplayexchange.org/. Accessed June 30, 2022.

Project Gutenberg; Project Gutenberg: https://www.gutenberg.org/. Accessed June 30, 2022.

5

Performance

During callbacks [for Into the Woods*] we would tell people, "Please come in and sing for the role of Little Red Riding Hood," and they would say, "No, I should audition for the grandmother." And we explained, "No, all of the roles are for you. You can play any part."*

—Rose Ginsberg, Lenox Hill House[1]

One of the most exciting aspects of performing is that you get to be different people. In theatre, you can play a moustache twirling villain, a funny best friend, or even Little Red Riding Hood. There are no parameters for who can play which roles and the only requirements are enthusiasm, commitment, and a willingness to work with other people. From scene stealing musical numbers to playing the winking raisonneur, every role is important and there is a place for everyone. It takes a community of performers to build the world of the story on stage, and there is nothing quite like it when it all comes together.

Performance, acting, improvisation, and production courses are the most popular ways to engage with students. As a performing art, theatre performance courses encourage students to explore their individuality, creativity, and resourcefulness by working with others to perform. There are roles for actors and non-actors to be directly involved in performance. Performance courses are opportunities for students to develop their personal and people skills while contributing to the creation of theatre communities.

What Is Performance?

Performance invites students to explore their acting abilities in a fun collaborative setting. Performance students will be challenged to address their fears and explore new talents to create scenes with others. This chapter focuses on performances that take place on a stage, namely acting, theatre improvisation, and reader's theatre.

Students practice performing with and without scripts. Through performance students build upon their individual skills to take part in a communal activity. They learn to perform, analyze scripts, and develop stories. Through games and exercises students hone their intuition and spontaneity, and practice being present. They explore characters, physicalize actions, and communicate through speech and body language. Students also practice acting and reacting, creating scenes, and connecting and engaging with audiences.

Benefits of Performance

Performance is good for everyone! Students have an interactive experience and learn more about themselves and how they work with others. The stage is more welcoming if there is support. Through performance students build empathy, develop their imaginations, and create together.

Performance is especially beneficial for cognitive function because it helps with memory and helps people live in the moment. There are performance exercises geared specifically for memory, increasing reaction time, concentration, pattern recognition, and spatial relationships. These are all important aspects of keeping minds healthy, alert, and active.

Acting also has the added benefit of social interaction. Many performance exercises are centered on group interaction and ensemble building. The success of exercises is reliant on how well students can communicate with others, how well they understand others' needs, how well they understand their own needs, and how well they can work with others to create a fun experience.

Students do not need to memorize scripts to experience the memory benefits of acting and performing. Staged readings can help with ensemble building, listening, and collaboration. With regular practice, reading scripts and rehearsing scenes can improve memory function.

Finally, and most importantly, students are focused on being in the present through the process of performing. While older adults may draw on memories for acting, performance is focused on the experience of the now. Live performance offers a guaranteed method to practice living in the moment and going with the unexpected.

Benefits for Students without a Background in Performance

Students gain first-hand experience performing theatre. They develop a better appreciation for theatre when they have a chance to try new skills in a safe environment. Performance classes are for everyone, even "ordinary" people.

Benefits for Students with a Background in Performance

I always wanted to be an actor, but I fell in love ... I took care of a lot of people in my life and getting involved in this—being cast as Cinderella—makes me feel like a little kid. I said, "You know what? It's my turn." That's the whole thing. It's my turn now.
—Rebecca Marks, Actor[2]

Many students return to acting and performance as older adults after spending years working in other fields. They may be in your class to revisit past aspirations that were put on hold. These students will have the opportunity to renew their performance interests and practice their talents in a group setting, and with an audience.

How Do I Put Together a Course?

In addition to the strategies in Theatre Appreciation, it is important for performance instructors to take time for self-discovery. Performance is a very personal art form and requires high self-awareness and a strong ability to connect with others. This is no easy task and this job is even more difficult for instructors of performance. The challenge for many performers is to overcome their self-judgement and get out of their own heads. Due to the intimate nature of performance, instructors may find it useful to determine their own performance styles, *address their fears*, and engage in constant self-reflection. The suggestions below are a few ways that new instructors can work through the self-discovery process in preparation for a performance class.

Take an Acting, Improvisation, or Movement Class

If you have never studied acting or participated in theatre production, we strongly recommend that you gain some preliminary experience before teaching older adults. If you have never taken an introductory acting course, sign up for a one-day acting or movement workshop and see how it has an impact on your mind and body. Pay close attention to how the course was organized to encourage or discourage participation. You may also be able talk to students or instructors at the end of the course to get an understanding of their experiences.

Watch Recordings of Acting, Improvisation, or Movement Classes

There are many instructors who have recorded their courses. Search on YouTube or go onto company websites and social media. You will find wide variations of

how instructors teach performance. For example, Spolin Games Online is a website with many videos of performers playing Viola Spolin's improv games and the approach on the site is more technical compared to other improv resources.[3] It may also be helpful to read Spolin's *Theater Games for the Lone Actor* and try some of the exercises in the book before or after watching acting videos.

Get Involved with Local Theatres and Gain Production Experience

Local theatre groups can be cliquish but they also frequently need production support. If you have never auditioned for a production and are willing to take a risk, go through the audition process. Prepare for the audition by memorizing one-minute dramatic and comedic monologues. Practice cold reading by reading plays, stories, news articles, and so on aloud. If a script of the play you are auditioning for is available at your library, borrow a copy and practice reading lines from the play. You may also get yourself a headshot and write a theatrical resume. If you want to be involved without performing, work for the crew so you can watch rehearsals and observe the performance process.

Join a Community Theatre Group

There are many opportunities to do readings and practice performance with local meetups and community groups. They may have weekly meetings where you can see others perform plays and participate as a reader.

Practice Theatre Games with Friends

Theatre games are essential for first-time teachers. Playing games is a great way for instructors to discover their own creativity and style. Some exercises can be played as party games with people you know because they require no experience. By playing theatre games, instructors learn some of the key principles of performance.

Try Some of the Individual Exercises in the Games and Activities Section

- Do an "incognito Tuesday" in which you go through a full day playing a character.
- Perform Private Moment exercises in which you think mindfully about your actions and the motivations behind them. *See full description in Performance Exercises*.
- Create characters and fill in the "Objectives" worksheets.

- Practice improvisation activities in everyday life. *See examples in the Performance Exercises.*
- Do creative activities that activate your mind and get you thinking about characters and stories. For example, write character monologues, tell a story to a friend, create stories about people in stock photographs, paint a picture, or draw stick figures.
- Write down what you see, hear, smell, and feel in an environment, with or without people. Observe these spaces in real life and imagine your own places in your mind. Keep these observations in a journal.

How Do I Select and Organize Topics?

By Self-Discovery

Theatre performance is a very personal, yet collective effort. Decide what type of performance teacher you want to be. Think about:

- What about your personality draws people to you?
- What are your limitations?
- Who do you admire and why?
- What kind of acting instructor would you like to be?
- Who is your ideal student? How will you teach when your class is not made up of students who are your imagined ideal?
- What do you want students to get from your class?
- What would you like to challenge yourself and students to do?

By Accessibility

Focus on leading exercises that do not rely heavily on students memorizing lines or reading texts. There are many reasons for this. Some students may have difficulty holding scripts, reading scripts, or memorizing scripts. Breaking free of text allows more students to participate fully. Helping students develop communication skills non-verbally or through improvising is more effective for creating naturalistic or realistic performance skills. Many acting classes do not give students scripts to memorize until they are much more experienced. For example, a twelve-week acting class may end with a performance of a five-minute monologue or short scene with minimal dialogue. Movement exercises should also be carefully selected and adapted to account for range of motion. The most challenging aspect of this course will be to accommodate a mix of accessibility.

By Acting Style

You can design a course focused on skills from a specific performance method so students can identify the methodologies of each practice. In popular culture, acting is often conflated as either broad "Shakespearean" declarative acting or frenetic "method" acting where actors cry on cue. By exploring different performance styles, students will learn some of the nuances of acting and be able to create performances that are more interesting for both the audience and performer.

Acting for the Camera

Cameras can zoom in and zoom out and video can be edited to show action from different angles, often making it unnecessary for actors to physicalize their characters in a big way. Acting for the camera often involves performing realistically and paying attention to the small details. For example, a hand fidgeting with a pencil, a soft sigh, or eyes moving around as a character is replays a bad decision they made. Exercises focus on acting for long, medium, close-up shots, how to work with multiple cameras, and blocking techniques for film.

Commedia dell'Arte

This 16th century Italian style focuses on movement and behavior of stock characters. Commedia has four broad stock character groups: *zanni* (servants), *vecchi* (old men), *innamorati* (lovers), and *capitani* (captains). Traditionally, many characters are masked, however, modern day performers do not always use masks. Characters are used to improvise scenes using set scenarios and *lazzi* (comedic gags or jokes).

Improvisation

Improvisation is about creating performances without any preconceived notion of what the scene or story will be ahead of time. Stories can be developed based on audience prompts or completely devised by the actors themselves. Improvisation training involves games and exercises that help performers develop stories, characters, and work as an ensemble.

Melodrama

Melodrama gives students an opportunity to do fun "bad" acting. Similar to *commedia* and farce, characterizations are based in broad archetypes such as the fearless hero, damsel in distress, and moustache-twirling villain.

Melodrama uses physical vocabulary including exaggerated movements such as fainting, facial expressions, hand gestures, and walking, often accompanied by dramatic music to underscore action. Considered by modern sensibilities as overacting, melodrama is about using acting so that the person in the last row of the audience can understand what is happening. Some examples you can watch are *Dudley Do-Right*, *Now, Voyager*, and *The Wind*. For a comprehensive guide of gestures that can be adapted for melodramatic acting, see Albert M. Bacon's *A Manual of Gesture*, Henry Siddons' *Practical Illustrations of Rhetorical Gestures and Action*, Quintilian's *Institutio Oratorio*, John Bulwer's *Chirologia*, and François Delsarte's *System of Oratory*. These books have examples of moves from oratory that represent different emotions to create scenes.

Movement: Dance, Mime, Clowning, and Physical Comedy

Movement-based performance methods convey stories, emotions, and interactions through physical means. Stories are acted out and told entirely through movement and use little to no dialogue in scenes. They can be funny, pie-in-the-face comedy, tragic portrayals of sadness, or a combination of the two (i.e., the sad clown who is not in on the joke). Exercises for this form will focus on physical movement including walking, gestures, breathing, and stretching warm-ups, partner and dancing, creating imagery, revealing the characters' journey all through movement, how to interact with audiences and communicate with fellow students without words, practicing with mask work, developing gags, jokes, and bits, and choreographing short movement combinations to music. Students also learn how to communicate by using costumes, props, and makeup.

Musical Theatre

Musical theatre involves singing, dancing, and acting in a performance. The primary focus is on acting through singing. Dance numbers and non-singing dialogue can also be used, but are peripheral in relation to the singing. Musical theatre acting exercises include vocal warm-ups, singing, blocking, dancing, and acting.

Puppetry

Puppetry uses puppets to perform a story. Puppets can be any form including hand, finger, rod, shadow, string, sock, and more. Puppets do not have to be professionally made and any object can be used as a puppet. Students will learn how to make their own puppets using ordinary objects, how to move their puppet as an individual artist or with others, and how to speak with puppets.

Schools of Acting

A course can spend the entire term focusing on practicing one style of actor training or contain three or four multi-week units each covering a different style. A combination course might contain a Stanislavski section on character development questions and sense and memory recall, a Suzuki section emphasizing physical activity and grounding the body in space, a Meisner section on observation, intentional listening, and practicing ping pong, and a Chekhov section on levels and archetypal gestures.

By Themes, Key Terms, or Key Figures

A course based around themes and key terms is focused on building vocabulary and facility with a broad range of performance elements. Key terms may include:

Acting: the process of performance.
Actor: the person who portrays characters on stage.
Stella Adler (1901–92): actor, Group Theatre co-founder, and founder of the Stella Adler Studio of Acting. She taught several Hollywood stars, including Marlon Brando and Robert De Niro. She is also credited with introducing the "Method" to American actors.
Amphitheatre: an outdoor performance venue with fan-shaped raked seating, often built into a hillside.
Arena/in-the-round: a performance space that is in the center, with the audience seated around the set and actors (similar to boxing and wrestling audience configurations).
Audience: the people who watch the performance.
Back of house: the parts of the theatre that the audience does not see.
Backstage: the area directly behind/off the stage.
Black box/studio: a smaller, multi-use performance venue with a variety of possible audience and staging configurations. It is frequently painted black.
Augusto Boal (1931–2009): activist and founder of the Theatre of the Oppressed. He developed legislative theatre while serving in the local government in Rio de Janeiro.
Box office: the space and department that handles ticketing and reservations.
Cast: the actors of a production.
Chekhov Method: an acting technique developed by Mikhail Chekhov in which actors interact with each other onstage through metaphorically pushing or pulling and expanding and contracting.
Mikhail "Michael" Chekhov (1891–1955): actor, director, and theatre instructor. A student of Stanislavski and nephew of Anton Chekhov.

Cold reading: actors reading a script aloud that they have not rehearsed and/or have never read before.
Collaboration: working together cohesively towards a common goal.
Comp: a free ticket.
Costume designer: the person who develops the creative vision for the costumes.
Crew: the technical staff who make the show work behind the scenes, including the lights, sound, stage, props, costumes, and stage management.
Cue to cue: a technical rehearsal in which the full dialogue is not used. Actors move from cue line to cue line to rehearse technical elements such as entrances and exits, lighting changes, sound effects, or scenery changes.
Director: the person who develops the creative vision for a show, supervises actors during the rehearsal process on blocking and delivery of lines, and collaborates with technicians to realize the production.
Downstage: the front area of the stage.
Dress rehearsal: the final rehearsal before a show opens that does its best to duplicate the conditions of a live performance by going through the full production without stopping.
Ensemble: a group that performs together.
Environmental performance: a performance where the audience experiences the play from within the set.
Find your light: to find the area onstage where you are lit. This can be done by feeling the heat of the stage lights on your face or looking directly ahead and seeing the light source.
Fly captain: the person who coordinates movement of scenery through a fly system where scenery is flown in and out of the space using ropes and pulleys.
Fourth wall: the invisible wall that separates the performers from the audience.
Front of house: the area from the door of the theatre to the stage and the people working in this space including box office, bar staff, and ushers.
Given circumstance: the environment and situation in which a play takes place.
Uta Hagan (1919–2004): American theatre actor known for her "object Exercises."
Hamming/mugging/chewing scenery: overacting, frequently with the intention of getting a reaction from the audience.
House: the area where the audience sits, *or* the theatre, *or* the audience in general.
Immersive: bringing the audience into the world of the play and directly involving them in the play's action.
Improvisation: a performance without planning ahead.
Lighting designer: the person who develops the creative vision for the lighting.
Master electrician: the person responsible for programming the board and running circuits to realize the lighting design.

Sanford Meisner (1905–97): actor who created the Meisner Technique. He was a child musician before becoming an actor and acting teacher. Some of his students include Bob Fosse, Christopher Lloyd, and Michelle Pfeiffer.

Meisner Technique: an "external" acting method developed by Sanford Meisner in which actors respond to their fellow actors and their environment.

Melodramatic acting: exaggerated physicalized acting that is dramatic, often involves "woe is me" hand on forehead type gestures.

The Method: an actor training method popularized in the 1930s–1950s, based on interpretations of the Stanislavski System and focused on emotional memory recall techniques.

Open air: productions staged outside.

Performance: the show.

Physical acting: communicating with the body.

Prop: an item carried by actors onstage that is not scenery, such as a cup or a weapon.

Promenade: an outdoor street performance.

Proscenium: the fourth wall of a traditional theatre. The orchestra and audience are on one side of the proscenium, the set and performers on the other.

Read-through: the initial reading of the play with the cast, director, and stage Manager.

Rigger: the person who hangs things in a theatre such as lights, scenery, speakers, and so on.

Scenic designer: the person who develops the creative vision for the scenery.

Site-specific: a performance based around a specific venue, for example staging a production of *Hamlet* at Castle Elsinore in Denmark.

Sound designer: the person who develops the creative vision for the sound.

Viola Spolin (1906–94): American theatre improvisation educator and creator of theatre games.

Spotlight: a moveable light used to draw audience attention to (a) specific performer(s).

Stage business: actions actors perform to create the environment of the play.

Staged reading: a performance where actors use scripts during the show.

Stagehand: a person who moves scenery and props during a production.

Stage left: the actors' left and the audiences' right.

Stage makeup: cosmetics designed to define facial features under stage lighting.

Stage manager: the person who manages the rehearsal, calls the show, and is the main point of contact for all parties involved with the production.

Stage presence: a performer's ability to catch the audience's attention without doing anything.

Stage right: the actors' right and the audiences' left.

Staging: how a play is presented.

Constantin Stanislavki (1863–1938): Russian actor and director who developed the Stanislavski System. He collaborated with Anton Chekhov and co-founded the Moscow Art Theatre.
Stanislavski System: an acting technique in which actors learn to empathize with their characters with the aim of portraying them realistically. The system is often conflated with "method acting" and the Actors Studio.
Lee Strasberg (1981–82): co-founder of the Group Theatre and co-founder of the Actors Studio with Cheryl Crawford, Robert Lewis, and Elia Kazan. He was credited with introducing the "Method" to American actors.
Strike: to take down all the technical equipment, set, and props at the end of a run.
Suzuki Method: an acting method based in physical activity; often associated with repeatedly stomping feet to connect the body in space.
Suzuki Tadashi (1939–): Japanese avant-garde director and acting instructor who created of the Suzuki Method of actor training. He also collaborated with Anne Bogart, the creator of Viewpoints training.
Technical director: the person who coordinates sound, lighting, rigging, set design and construction, and all other technical aspects of a show through the show's opening.
Tech rehearsal: a rehearsal in which design and production staff test the technical elements of a production in the performance venue with actors.
Thrust: a stage that thrusts out into the audience.
Theatre manager: the person responsible for the administrative parts of theatre production.
Trigger/content warning: a written or announced notification of controversial, distressing, or hazardous material in a production such as gunshots, strobe lights, violence, or nudity.
Triple threat: the ability (or not) to act, dance, and sing.
Theatre game: an exercise that develops actors' abilities.
Upstage: the area of the stage farthest from the audience.

By Performance Principles

Performance principles can be useful in building performance skills so students have a specific task to focus on each week. Some of these concepts are easier to practice than others and with consistent focus, students develop a transferable performance vocabulary that is applicable in many styles of acting.

Act, Don't React

Reaction is a response in which your performance is based entirely on following somebody else's choice. Action is your own automatic response to the given circumstances.

Be Present

Focus on the here and now and pay attention to what is going on. Do not think about anything but the activity at hand.

Collaboration

Work with others to achieve a goal. Exchange ideas and create something new together.

Give and Take

Take turns sharing the space. Give others the opportunity to take the spotlight and then take the spotlight back, so that no one person dominates a scene or activity. Everyone gets to shine! This is also known as "share the space."

Hands

Practice physicality by paying attention to what you do with your hands when communicating different emotions and objectives. Try Meisner's Repetition with Activity exercise so that your hands are occupied while acting. Observe how you use your hands in everyday conversations.

Intuition

Not everything is logical. Go with what your gut tells you and let your intuition lead you. Do not worry about the "why?"

Levels

Levels are both the levels of the actors onstage, which should be varied to create visual interest—one person standing, one sitting, one up on a table, another sprawled on the floor—or expressed emotional intensity and vocal dynamics. Levels are also related to character status. For example, who is in charge of this scene? How are power dynamics distributed between the characters? Most scenes have hierarchies and characters may be able to change their level or character status within a play or scene.

Listen

Listen verbally, physically, and with intention to learn what others are trying to communicate consciously or unconsciously.

Make Your Partner Look Good

Rather than focusing on what you can do to make yourself look good, focus on making your partner look good. Pay attention to their needs and figure out what you can do in an activity that will help your partner "succeed."

Moment to Moment

Focus on the current moment and do not think ahead.

Offer

Start a scene, action, or idea so that someone else can build upon it.

Physicality

Ask yourself how your character moves and develop their tics and traits.

Say "Yes" and/or Say "Yes, and …"

This is both literal and metaphoric. Say "Yes," verbally. Then practice saying "Yes" by continuing the action. Every time you change a story or stop the activity, it is saying "No." "Yes, and" builds upon yes by further developing the action. Another interpretation of "Yes" is "Always reply, never deny, and never ask why."

Show, Don't Tell

Show, don't tell is also known as indicating. Theatre is about showing the audience what the story is about rather than telling them. For example: an actor shows the audience that they are in a park by sitting on the wet grass. An actor tells the audience that they are in the park when they say, "I'm in a park."

Spontaneity

Go with whatever thoughts first come to mind. Do not plan ahead.

Teamwork and Ensemble-Building

Everyone has their own part. Figure out what your role is within the group and do your part well so that everyone can succeed together.

What Activities and Discussions Can I Do?

Activities in this chapter encourage students to practice self-reflection, communication, and interpersonal connection. Activities included on the chart of Performance Exercises note the skills they help students develop, such as spatial awareness, ensemble-building, physicality, and listening. The emphasis of these activities is not becoming a star but on learning how to help each other in performance settings in practical ways, including skills students may transfer to life outside of performance contexts.

Journaling

Have students write down their thoughts and feelings in a journal. Journals are generally not read by the instructor and are for the students. Journals help students track their progress and review their experiences. Journals are often used by performers to process their struggles, moments of clarity, and other ideas, that helps them become aware of their behavior, actions, and performance personality.

Journals can also include reflective monologues in response to different character or story-based prompts. This helps students see the world from different perspectives and practice empathy. Reflective monologues help build imagination skills when students are not in class.

If students do not think in terms of narrative paragraphs, they can write their thoughts as lists, mind maps, or bulleted journal entries. Images are also a great way for non-narrative writers. Have students draw pictures of their feelings, ideas, and experiences. They can add to the same image each day or create new ones. Encourage them to use color and different writing implements to develop their images. The most important thing for journaling is to have a space to reflect on and organize their ideas.

Performance Exercises

There are many performance exercises that can be used for any experience level. The exercises are divided into warm-ups, games, and scene and character work

for beginning, intermediate, and advanced levels. Each activity specifies the skills students practice, as well as the activity type (group, individual, or partner), and if available, the artist who "introduced" the exercise for theatre.

Most of the exercises do not require the use of props and can be performed anywhere. In activities that do use props, they are minimal and we have included suggestions on how to incorporate everyday items that are available to anyone.

These exercises were selected because they require minimal instructions, help students focus on basic performances skills, and provide enough challenge that they can maintain interest. Once students have mastered an exercise, they can continue building on those skills by doing advanced variations of the same activity. The variations can also be used to review skills and help students make connections between different activities.

BEGINNING WARM-UPS

Title	Description	Skill	Type	Source
Zip Zap Zop	One at a time, students pass a zip, zap, or zop to another person. The order of words must remain the same. When someone zips, zaps, or zops them, they must pass a zip, zap, or zop to a different person. *Variations:* *1. Replace the words with theatre terms.* *2. Replace words with sounds.* *3. Replace words with motions.*	pattern recognition, concentration, listening, reaction, rhythm	group	Rohd
Street Fight	Each student pretends they are fighting with each other using fake punches, imaginary items, kicks, and so on. *Variations:* *1. Students engage in a boxing match.* *2. Students pick an imaginary sword and engage in a sword fight.*	body awareness, imagination, physicalization, reaction, spatial awareness	group	Spolin
Dodgeball	In two teams, everyone plays dodgeball. *Variations: Play soccer, basketball, or any other group sport.*	body awareness, imagination, physicalization, reaction	group	Spolin

PERFORMANCE

Title	Description	Skill	Type	Source
Tug of War	Students line up in two teams and play an imaginary game of tug of war.	body awareness, physicalization, reaction	group	Spolin
Vocal Symphony	Each student repeats a sound or word. They work together to create a harmonious sound. *Variation: A leader directs the students to start, stop, raise volume, or lower volume.*	ensemble building, listening, rhythm, speech, voice	group	
Rhythm Walk	Instructor claps their hands or uses a drum to beat a rhythm, increasing and decreasing the speed as the students walk to the beat. *Variations:* *1. Maintain a rhythm without a specific leader.* *2. Walk to music.* *3. Walk to movie soundtracks.* *4. If walking is unavailable, use any body part.*	pattern recognition, body awareness, listening, physicalization, rhythm	group	
Mirror	Two students stand across from each other. One is the leader and the other follows as the leader makes motions starting with their hands. *Variations:* *1. One student leads the entire group.* *2. No one leads the group and everyone tries to mirror each other.* *3. Mirror sounds.* *4. Mirror words.*	body awareness, concentration, ensemble building, listening, physicalization	partners	Spolin
Tongue Twisters	Students repeat tongue twisters. Classic examples include: • "If a dog chews shoes whose shoes does he choose?" • "Eleven benevolent elephants" • "She sells sea shells by the seashore." • "Red leather, yellow leather."	concentration, speech, voice	group	

Title	Description	Skill	Type	Source
	• "How much wood would a woodchuck chuck if a woodchuck could chuck wood?"			
	• "Guns and drums and drums and guns."			
	• "Unique New York."			
	• "Toy boat."			
	Variations (advanced Tongue Twisters):			
	• *"A tutor who tooted the flute tried to teach two young tooters to toot. Said the two to the tutor, 'Is it harder to toot, or to tutor two tooters to toot?'"*			
	• *"Truly rural."*			
	• *"The sixth sick sheik's sixth sheep's sick."*			
	• *"She sees cheese."*			
	• *"I slit a sheet, a sheet I slit, and on a slitted sheet I sit."*			
	• *Students can also try, "Pad kid poured curd pulled cod," which has been described as the "world's trickiest tongue twister" developed by MIT researchers in 2013.*[4]			
Volume Conductor	Students make a high-pitched sound when instructor raises their arm up high and low sounds when instructor lowers their arm. Students take turns being the conductor.	ensemble building, listening, rhythm, voice, levels	group	
Singalong	Students sing a song together. *Variations:* *1. Students sing one at a time.* *2. Students sing in competing groups, one at a time, or both at the same time*	ensemble building, listening, rhythm, speech, voice	group	
Scales	Students sing scales.	voice	group	
Vocal Warm-ups	Students do scales with vowels, lip trills, vocal sirens, loud and soft sounds, and low and high sounds. *See YouTube Videos in Additional Resources for examples.*	pattern recognition, listening, rhythm, speech, tone, voice	group	

PERFORMANCE

Title	Description	Skill	Type	Source
Names with Greeting	A student randomly calls out another student's name and gives them a greeting. For example, "Hello Susan," or "What's up Susan?" The student who has been called picks another student to greet. This is done while attempting to keep a rhythm.	pattern recognition, concentration, ensemble building, listening, reaction	group	Spolin
Balancing Circle	Students stand on opposite sides of a chair. They try to stay exactly opposite their partner as they move around the chair. Each student takes turn leading. After some practice, there is no leader.	body awareness, ensemble building, reaction, spatial awareness	partners	Boal
Dance Warm-ups	Students do ballet positions, basic stage dance moves, Bob Fosse style choreography, Motown style dancing, and so on. *See YouTube Videos in Additional Resources for examples.*	body awareness, physicalization, rhythm, spatial awareness	individual	
Lip Syncing	Students lip synch to a musical number while expressing the emotions or story in the song through gesture.	physicalization, spontaneity	individual/ group/ partners	Drag Performances

INTERMEDIATE WARM-UPS

Title	Description	Skill	Type	Source
Big Space, Little Space	Students observe and interact with a big space. Then do the same for a small space.	body awareness, imagination, physicalization, spatial awareness	individual	Spolin
Singing Rhythms	Group creates a rhythm with three or four hand motions (i.e., various claps, slaps, and snaps) to a rhythm with a pattern of hand motions while singing a song. Songs should be familiar and simple such as "Greensleeves," or "Alphabet Song," that have 4/4 time. *Variation: Use feet to stomp out rhythm.*	ensemble building, rhythm, voice	group	

Title	Description	Skill	Type	Source
Machines	Students become a machine together. One student starts and others add to the machine when they figure out what it is.	ensemble building, imagination, physicalization, visual awareness	groups	Boal
Acting Action Words	Students say everything that they are doing while they are doing it.	body awareness, physicalization, spontaneity	individual	Meisner/ Strasberg
Using Objects	Students choose an imaginary object. They show the object by using it. Audience guesses what the object is. *Variation: Students can take a real object and redefine the object by using it in a new way.*	imagination, physicalization, spontaneity	individual/ group	Spolin
Becoming Objects	Students become an imaginary object as a group. Audience guesses what the object is.	body awareness, ensemble building, imagination, physicalization	group	Spolin
Background Noise	Student are given a location or decide on a location. They create sounds of the location. Audience guesses what the location is.	ensemble building, imagination, voice	group	Spolin
Inflections	Read a poem with different tones and variations.	tone, voice	individual	
Pass a Facial Expression	One at a time, students randomly pass a facial expression to another person. The person receiving the facial expression repeats the facial expression back to the originator of the facial expression. Then they pick a new facial expression to make and a different person to pass it to. *Variations:* *1. Pass a gesture.* *2. Pass a sound.* *3. Pass a word.*	pattern recognition, body awareness, concentration, ensemble building, observation, physicalization	group	Spolin
Guided Meditation	Students close their eyes. Instructor gives students directions on what part of their body to feel or bring awareness to, what parts of their body to relax to release stress, and scenarios to imagine.	body awareness, imagination	individual	

PERFORMANCE

Title	Description	Skill	Type	Source
Peruvian Ball Exchange	Each student chooses a ball, a motion for handling the ball, and a sound that the ball makes. They mill about the room, show each other their ball, and exchange balls with each other. At the end, each student shows the ball that they have and students see if they can recognize their ball.	ensemble building, imagination, observation, physicalization, visual awareness	individual/ group	Boal
Singing Circle	One student steps into the circle and starts singing. They continue singing until someone else steps in. *Variations:* *1. Students slowly fade in and fade out when jumping in or exiting.* *2. Two students sing at a time (with the same or different song).*	ensemble building, spontaneity, voice	individual/ group	Halpern et al.

ADVANCED WARM-UPS

Title	Description	Skill	Type	Source
What's in the box?	Students open a box or door and react to the imaginary object or person. *Variations:* *1. Instructor can identify what is in the box and students imagine the rest of the details.* *2. Read an imaginary letter.* *3. Read an actual letter written by a classmate.*	imagination, physicalization, spontaneity, storytelling	individual	Spolin
Rhythm Stomp	Students stomp their feet one at a time, keeping in rhythm. *Variation: Clap one at a time in rhythm.*	concentration, ensemble building, listening, physicalization, reaction, rhythm	group	Grotowski, Bogart, Suzuki, and others
Where Listening	Students choose a location or instructor gives them a location. Students show the location by how they listen to it. Audience guesses where the location is.	concentration, intuition, imagination, physicalization, reaction, spatial awareness	group	Spolin

Title	Description	Skill	Type	Source
Gibberish Conversation	Students have a conversation in gibberish. *Variations:* *1. Students write a problem on a piece of paper. Student pairs draw one of the problems to discuss.* *2. Students ask each other questions and must respond in gibberish.*	ensemble building, listening, observation, reaction, speech, spontaneity, voice	partners	Spolin

BEGINNING GAMES

Title	Description	Skill	Type	Source
Name with Gesture	One at a time, students say their name while making a gesture. Group then repeats the name and gesture together.	ensemble building, listening, physicalization	individual/ group	Boal
Murder Game	Students close their eyes. Instructor picks a murderer by tapping them on the shoulder. Students open their eyes and walk around. The murderer kills other students by winking at them. When a student is murdered, they die a few seconds after they receive the wink. The group must figure out who is the murderer before everyone dies.	concentration, ensemble building, observation	group	camp game
Bodyguard and Assassin	Each student chooses someone to be their bodyguard and another person to be their assassin. They do not reveal to each other who they have chosen. They walk around the room and try to keep themselves behind their bodyguards and away from their assassins.	concentration, ensemble building, intuition, reaction, spatial awareness	group	Boal
Appearances	Audience closes their eyes (or turn around). One student changes three things about their appearance. Audience guesses what has changed about the student's appearance.	body awareness, concentration, observation, visual awareness	individual/ group	Spolin

INTERMEDIATE GAMES

Title	Description	Skill	Type	Source
Freeze Pass	One student walks around while everyone else is frozen. They pick the next person who gets to move by tapping them, giving them a look, or using other means of communication.	body awareness, concentration, ensemble building	group	Spolin
Freeze Stop	Students walk around until one person freezes. When someone notices the frozen person, they freeze as well. When everyone is frozen, students resume walking again.	observation, reaction, spatial awareness, visual awareness	group	Spolin
Where Walk	Students walk around the room as instructor calls out different locations. Students act out where they are.	imagination, reaction, spatial awareness, spontaneity	individual/ group	Spolin
Group Storytelling	Going around in a circle, students tell a story one word at a time. *Variations:* *1. Tell a story one sentence at a time.* *2. Instructor becomes a conductor and picks who gets to speak.* *3. Any student can jump into the story by raising their hand. If more than one raises their hand, the speaker chooses who gets to continue the story. Student must continue speaking until someone else takes over.*	ensemble building, listening, spontaneity, scene development, storytelling, action building	group	Spolin
Ping Pong	One student makes an observation about the other student. The other student repeats the observation back to the first student, and the repetitions of this phrase continue until something happens to change the repeated phrase. *Variation: Point of view;* One student makes an observation about the other student. The other student repeats the observation back to the first student from their point of	concentration, listening, observation	partners	Meisner

Title	Description	Skill	Type	Source
	view (i.e., "You're tapping your foot" becomes "I'm tapping my foot"). The repetitions of this phrase continue until something happens to change the repeated phrase.			
Mystery Leader	Sitting in a circle, students close their eyes as instructor picks a leader. The students open their eyes and try to figure out who the leader is by observation.	concentration, observation, physicalization	group	Boal

ADVANCED GAMES

Title	Description	Skill	Type	Source
Freeze Game	One student begins a scene. Another student yells "freeze" to stop the action, comes onstage, and changes the scene. After there are two actors onstage, at any point other students can yell "freeze," tag out one of the actors onstage, change the scene, and take their place in the action.	ensemble building, listening, spontaneity, scene development, storytelling	group	Spolin
Character Exchange	Students create a character by showing how the character speaks and walks. They mill about the room, interact with each other, and exchange their characters. Repeat for a set number of rounds.	character development, imagination, observation, physicalization	individual/ group	Boal
Repetition with Activity	One student picks a complicated activity to perform and begins performing the activity. The other student makes an observation about the activity being performed. The student performing the activity repeats the observation back from their point of view. They continue repetitions until something spontaneously changes the scene.	observation, physicalization, reaction, ensemble building, scene development	partners	Meisner

PERFORMANCE

BEGINNING SCENE & CHARACTER WORK

Title	Description	Skill	Type	Source
Free Form Scene	Students (any number) start a scene. Others can join in at any time. Students can stay in the scene as long as they wish. Scene is organic and does not have any rules.	listening, observation, storytelling, spontaneity	group	
Read Monologue	Students read a monologue out loud.	speech, tone, voice, character development	individual	
Intentional Listening	Each student picks a location (or a podcast or news broadcast), spends five minutes intentionally listening, and then describes what they hear (either by writing it down or telling a partner). *Variation: Pick and indoor and outdoor space.*	body awareness, concentration, listening, observation	individual, partners	Meisner
Clown Imitations	Students mirror another student when they have their back turned away. Every time the other student turns around, the first student stops mirroring.	physicalization, reaction, spontaneity, storytelling	individual	
Sitting on a Chair	Students try to sit on a chair, but are unable to. *Variation: Use other objects such as pencil, jacket, scarf, shoes, hat, and so on.*	physicalization, spontaneity, storytelling	individual	
Personal Problems	Student tries to use their hand, but it refuses to cooperate. They try picking up an object, shaking hands, giving high fives, pointing, writing, and so on. *Variation: Use other parts of their body, such as feet, head, fingers, waist, elbows, shoulder, and so on.*	physicalization, spontaneity, scene development, storytelling	individual	

INTERMEDIATE SCENE & CHARACTER WORK

Title	Description	Skill	Type	Source
Five On, Five Off	Freeze variation; scene begins with one student, second student calls "freeze" and restarts scene; scene grows until there are five actors, then each actor finds a logical reason to leave until all actors leave the stage. *Variation: Use different numbers or rotate with partners.*	ensemble building, listening, observation, reaction, scene development, action building	group	Spolin
Character Quirks	Each student gets a puppet, a character profession and a quirk to act out. The others try to guess who they are and their personality quirk. *Variation: Perform without puppets.*	ensemble building, observation, voice, character development	group	
Freeze Scene	Students walk around the room and instructor calls on a student to freeze on the spot and strike a pose. The other students build a static scene around that student.	ensemble building, imagination, scene development, visual awareness	group	Spolin
Character Walk	Students walk around the room as instructor calls out different characters for students to perform.	speech, tone, voice, character development, physicalization	individual/ group	Spolin
Character Greetings	Students walk around the room as instructor calls out different characters for students to greet. For example, "Greet each other like they are your long-lost twin."	character development, imagination, reaction, spontaneity	individual/ group	Spolin
System Character Question 1: Who Am I?	After selecting a script, each student describes their character by generating a list of questions and answering the questions. Potential questions include: • What is their personality? • What are their interests? • What is their profession? • Who are their friends and family? • How do they dress?	body awareness, character development, ensemble building, imagination	individual/ group	

Title	Description	Skill	Type	Source
	• What are their habits? • What are their dreams, fixations, and goals? *Example: Blanche Dubois is a thirty-year-old former schoolteacher staying with her younger sister Stella and Stella's husband Stanley. She lost the family home and buried all family members, with the exception of Stella. She thrives on male flattery. She drinks but conceals how much she drinks.*			Stanislavski
System Character Question 2: Where Am I?	Students describe where they are: • What does it look like? • What do they see? • What is outside of the scene that appears onstage? *Example: The porch, outer room, bedroom, and bathroom of Stella and Stanley's apartment on Elysian Fields in New Orleans. The building is owned by Eunice and Steve Hubbell, who live upstairs.*	imagination, listening, multitasking, observation, physicalization, spatial awareness	individual/ group	Stanislavski
System Character Question 3: When Is It?	Students describe the time of day, day of week, time of the year, and year in context. What has just happened in history or is about to happen in history that impacts the characters? *Example: It is early evening in early summer, after the Second World War. Blanche has just lost her job and lost the family house. Stella is pregnant. It is very hot.*	imagination, observation, physicalization, spatial awareness	individual/ group	Stanislavski
System Character Question 4: What Do I Want?	Students describe their characters' objectives in terms of wants and needs. *Example: Blanche wants to be loved, admired, and adored.*	character development, imagination, storytelling	individual/ group	Stanislavski

Title	Description	Skill	Type	Source
System Character Question 5: Why Do I Want It?	Students list the reasons and motivations behind their objectives. *Example: Blanche wants to have the life she believes she was entitled to have.*	character development, imagination, storytelling	individual/ group	Stanislavski
System Character Question 6: How Will I Get It?	Students list the strategies and methods they will employ to get what they want. *Example: Blanche will try to get what she wants through maintaining an idealized external version of herself and by marrying Stanley's friend Mitch.*	character development, imagination, storytelling	individual/ group	Stanislavski
System Character Question 7: What Do I Need to Overcome?	Students list what stands in the way of what they want and describe how this impacts their physicality and relationships with the other characters. *Example: Stella's husband Stanley stands in Blanche's way, digging into her past and reputation.*	character development, imagination, scene development, storytelling	individual/ group	Stanislavski
Inner Monologue	After completing the System Character Questions, students perform a scene, adding their inner monologue to the dialogue, and speaking their characters' thoughts aloud. *Example: "Is this the face that launched a thousand ships? Tastes have certainly changed."*	character development, imagination, multitasking, scene development, storytelling	partners/ group	Stanislavski
Stomp	Students lift their right foot, putting their weight on their left leg, and then stomps their right foot into the floor, transferring their weight to their right leg. They then repeat this motion and transfer of balance by stomping with their left leg. Repeat several times at various speeds.	pattern recognition, body awareness, concentration, ensemble building, intuition,	group	Suzuki

Title	Description	Skill	Type	Source
	The aim is to be able to shift balance on the feet and connect to the floor without moving the upper body. *Variation: The Stomp is the first of the basic Suzuki center of gravity trainings. The second motion involves moving the center of gravity forward by stomping feet in front of each other and shifting the center of gravity forward. The third motion involves standing with feet in a V, raising toes up and pressing heels into the floor. The fourth motion involves spinning.*	physicalization, reaction, rhythm, spatial awareness		
Commedia Characters	Instructor gives examples of the character's physicalization and personality. Students walk around performing the character and interacting with each other. Characters include: • Pantalone: miserly, old and hunched over or old, and walks with a cane. • Capitano: the braggart soldier, talks big, but is cowardly, walks like he owns the room. • Dottore: the doctor or the intellectual, speaks "eloquently," uses big words even if it doesn't make sense to anyone (including himself), often has his head tilted upwards as if he is day dreaming, and walks with his chest open and arms up as if balancing different ideas on each of his hands. • Arlecchino: the servant, fast and quick-witted, and body is perpetually ready to take action. • Brighella: the trickster of the servants, intelligent and a smooth talker, relaxed demeanor, and moves around with fluid motions like a fox.			

Title	Description	Skill	Type	Source
	• Innamorati: the lovers, young, beautiful, and innocent, romantic view of the world, and walks as if they are on air all the time. *Variation: Instructor or student creates stock characters based on sitcom characters.*	character development, imagination, physicalization, scene development, storytelling, action building, tone, voice	individual	
Incongruities	Students encounter everyday objects and personalities that are not behaving as they should and try to play along with the misbehaving objects and personalities. The objects can be mimed or another student can move the object. *Example: A student's newspaper keeps trying to fly away, their hat runs away on an attached string, and their best friend has turned into a vampire and nobody else notices.*	physicalization, imagination, spontaneity, scene development, storytelling	Individual	
Celebrity Puppets	Students create puppets out of paper bags or socks, choose a celebrity to impersonate with their puppet, and talk to each other.	character development, speech, tone, voice	individual/ group	
Read a Label	Students take an object and read the directions, ingredients, and so on out loud. *Variations:* *1. Read a newspaper.* *2. Read with meaning.* *3. Read for elocution exercises.* *4. Read for intensities.*	character development, speech, tone, voice, spontaneity, storytelling,	individual/ group	
Opposites	Students use an "opposite" tone of voice to say a phrase ("I love you!" "I'm so happy!" "You're the worst!" and so on). Have other students state whether they believe the words or the tone. *Variation: Pick a scene and perform the characters in the opposite way they are supposed to be.*	character development, speech, tone, voice	individual/ group	

Title	Description	Skill	Type	Source
Categories	The group is given a theme. Answering one at a time, they must come up with as many unique responses by performing a scene to the theme as they can in five minutes. *Variation: Scenes are nonverbal.*	ensemble building, scene development, storytelling	group	traditional parlor game
Archetypal Gestures	Each student starts at a neutral stance and chooses their own interpretation of the following archetypal gestures: push, tear, drag, smash, pull, throw, gather, penetrate, expand, drag, reach, contract. Instructor calls out archetypal gestures and an intensity level between one and ten. Students react based on the gestures and intensity levels called out by instructor. Start with silent gestures, add lines of dialogue in groups, then scenes in partners or monologues.	pattern recognition, listening, multitasking, observation, physicalization, reaction	individual/ partners/ group	Chekhov
The Magic If	Stanislavski's Magic If posits "What would I do if I were in these circumstances?" Students act out a scene as they imagine how they would behave if the scene was real life. *Example: What would I do if I had to live in a two-room apartment with my sibling and their partner?*	body awareness, character development, ensemble building, scene development, storytelling, action building	partners/ group	Stanislavksi
Melodrama Characters	Student chooses a melodrama archetype: • Kind/Wise Old Uncle or Mother Figure: usually runs afoul of the villain or is trying to protect the protagonists, provides sage advice and observations. • Damsel in Distress: protagonist, usually pursued by the Hero and the Villain, frequently needs rescuing.	character development, physicalization, scene development, storytelling, action building	group/ partners	

Title	Description	Skill	Type	Source
	• Handsome Hero: protagonist, sometimes more handsome than capable, sometimes saves the day and sometimes needs saving by the other characters.			
	• Hero's Loyal Sidekick/Servant: comic relief, often smarter than the Hero, a trickster figure, sometimes allied with the Villain's henchperson or the Uncle.			
	• Moustache Twirling Villain: usually has a monologue explaining why they're a villain and a monologue explaining their plans.			
	• Villain's Henchperson: often has a change of heart and allies themselves with the protagonists, often used as comic relief, sometimes befriends the Hero's sidekick.			
	• Femme Fatale/Vamp/Flirty Maid/Sultry Lady: the "bad girl," contrasts with the damsel in distress, often pursued by the other characters, flirtatious behavior can be manipulative or playful.			
	Students improvise a scene with the characters.			
	Variation: Add dialogue. Play the following scene with each archetype rotating through Character A and Character B and playing off of each other in different combinations:			
	A: Who's there?			
	B: It's me.			
	A: What do you want?			
	B: You know.			
	A: No, I don't.			
	B: Yes, you do.			

Title	Description	Skill	Type	Source
	A: *No.* B: *Figure it out.* A: *Oh.* B: *Yes.* A: *Really?* B: *Uh huh.* A: *You're sure?* B: *Yes.*			
Wig, Makeup, Costume, and Props	Students play a character based on a wig, costume, prop or makeup design. *For example, a pompadour can inspire an elitist-mannered dandy or sad clown makeup can inspire a downtrodden grief-stricken character.*	character development, physicalization, scene development, storytelling	individual/ partners/ group	
Performing Gender	Students play a character of a gender with which they do not identify. *Variation: Students take an existing role, and perform the character with a different age/background and so on.*	character development, physicalization, scene development, storytelling	individual/ partners/ group	

ADVANCED SCENE AND CHARACTER WORK

Title	Description	Skill	Type	Source
Private Moment	Student performs an action or series of actions for their character when their character thinks they are not being observed by other characters. *Variation: Characters know they are being watched.*	physicalization, scene development, action building	individual	Stanislavksi
Setting the Scene	Instructor provides a scene with vague or little dialogue for students to figure out. Students decide what their characters' objectives and motivation are and what the scene is about.	ensemble building, scene development, storytelling	partners	
Monologue	Students perform a monologue using existing texts or creating their own original work.	character development, storytelling	individual	

Title	Description	Skill	Type	Source
Musical Monologue	Each student selects a famous song from musical theatre and performs it as a monologue, developing objectives and actions for the character singing based on the song's context within the musical.	character development, rhythm, speech, storytelling, tone, voice	individual	
Acting the Song	Each student selects a famous song and creates different versions of the song/lines to explore different ways of producing meaning and action.	character development, rhythm, speech, storytelling, tone, voice	individual	
Fairytale Genres	Students perform a fairytale while the other group shouts out genres for them to perform the scene in (i.e., gangster *Snow White* or slapstick comedy *Bluebeard*). *Variations:* 1. *Audience calls out intensities.* 2. *Audience calls out emotions.* 3. *Audience calls out a combination of intensities and emotions.*	character development, ensemble building, reaction, scene development, storytelling	group	Spolin
Improvised Lyrics	Students take an existing song and improvise their own lyrics for the scene. *Variation: This can also be used as a warm up if students improvise words to a simple song without performing a scene. For example, "Happy Birthday," "Row, Row Your Boat," "Twinkle Twinkle Little Star," and so on.*	spontaneity, storytelling, voice	individual/ group	
Snapshots	Each group creates their own story in still frames with four focal points (beginning, middle, raise the stakes, and ending). *Variations:* 1. *Scenes are performed with movement.* 2. *Scenes are performed with movements and sounds.*	body awareness, ensemble building, physicalization, scene development, storytelling, action building	group	Spolin

PERFORMANCE

Title	Description	Skill	Type	Source
Abridgement	Students condense a famous play down to its main characters and action points. They act out the play in five minutes or less. *Examples:* Christmas Carol, Romeo and Juliet, Fences, *and* A Streetcar Named Desire.	character development, ensemble building, imagination, storytelling	group	
Characters and Locations	Audience calls out a setting and two characters. Students act out the characters meeting in the chosen location. *Variation: Add additional characters.*	character development, imagination, reaction, spontaneity,	partners/group	The Compass Players
Character Secrets	Students create a character who reveals a secret unintentionally. *Variation: Reveal secret intentionally.*	character development, imagination	individual	Spolin
Beats	Students read a monologue and mark where the beats are on the page.	character development, scene development,	individual	Stanislavski
Sing a Newspaper Article	Students sing a short newspaper article.	speech, tone, voice storytelling	partners/groups	Boal
Overacting	Students overact a monologue or scene.	physicalization, levels, speech, tone, voice, spontaneity	partners/groups	
Rhythm Scene	Students perform scene in rhythm to a song or metronome.	ensemble building, rhythm, scene development,	group	
Stage Whispers	Students perform a scene using only stage whispers.	physicalization, levels, speech, tone, voice	group	
Sense Memory Recall	Students recall memories related to each of the following senses as instructor calls out the sense and the example: • Smell: grilling, wet leaves, soap, citrus. • Sound: a concert they attended, the number one song the year they graduated high school, fireworks, waves at the beach.	body awareness, concentration, intuition, observation, physicalization, reaction	individual/group	Stanislavksi

251

Title	Description	Skill	Type	Source
	• Sight: the night sky, your favorite restaurant, a famous landmark you have visited. • Taste: coffee, water, tea, hot chocolate, lemonade. • Touch: burning your tongue, petting a cat or dog, washing your hands.			
Emotional Memory Recall	Students sit quietly and recall a chosen memory. As they think about the memory, they recall the emotions they experienced at the time and the emotions they experience reflecting on the memory.	body awareness, intuition, observation, reaction	individual	Stanislavksi
Commedia Scenes	Students perform a scene based on the following: • "Romeo and Juliet": Innamorati see each other and fall in love at first sight only to realize that their families are enemies and that she must marry a miser. They get Arlecchino help them devise a plan to be together. • Capitano arrives to town boasting of his exploits. Brighella pretends to be a soldier, challenges him to a duel, and Capitano runs away. • Arlecchino is a servant with two masters. He tries to serve both of them without knowing and must run back and forth. • Arlecchino and Brighella are trying to steal food from the kitchen. Brighella tricks Arlecchino into helping him and Arlecchino is left with nothing. *Variations:* *1. Students perform their own scenarios based on commedia characters.* *2. Students perform their own scenarios based on sitcom characters.*	character development, spontaneity, scene development, storytelling	group	

Title	Description	Skill	Type	Source
Melodrama Scenes	Students improvise scenes based on the following melodrama scenarios: • Railroad track: the stereotypical version of this scene is for the Handsome Hero to rescue the Damsel in Distress who's been tied to the tracks by the Villain. However, in the original version of the scene the roles are reversed. Play the scene rotating who saves whom. • Landlord Collecting Rent: play the scene with the following dialogue: LANDLORD: You must pay the rent. DAMSEL IN DISTRESS: I can't pay the rent. HERO: I'll pay the rent. DAMSEL IN DISTRESS: My hero.	character development, ensemble building, scene development, storytelling	group	

Triumph Prostration Opposition

FIGURE 5.1: You Must Pay the Rent.

• Lighting the Lighthouse: the Handsome Hero is on a ship caught in a storm and the Kindly Uncle, Damsel, and Sidekick must fight through the storm and past the Villain and their Henchman to light the lighthouse.

• Interrupted Wedding: two characters are getting married and other characters interrupt the wedding. This can be a "save the day" moment or doom and disaster.

Title	Description	Skill	Type	Source

FIGURE 5.2: An Interrupted Wedding.

- Waterfall: two characters are on a raft heading toward a waterfall while two other characters watch or try to rescue them. Rotate characters so that the scene plays out in different ways.

FIGURE 5.3: Melodramatic Gestures.

Title	Description	Skill	Type	Source
Group Puppet	Students create a group puppet with random objects. Each student moves one part of the body such as head, arms, or feet.	character development, speech, tone, voice	individual/ group	
Intensities	Students perform a role as others yell out numbers from one to ten. The actors must increase or decrease their intensity level.	reaction, levels, speech, tone, voice	individual/ group	Chekhov

PERFORMANCE

Title	Description	Skill	Type	Source
Push/Pull/ Expand/ Contract	Students perform a scene together, either improvised or using scripts. Students decide, or instructor assigns, whether they will try to metaphorically Push their scene partner away from them or Pull their scene partner toward them, and whether they will Expand, playing the scene with high energy, or Contract, by underplaying the scene. Rotate who is Pushing, Pulling, Expanding, and Contracting.	scene development, levels	partners	Meisner
Performance Art	Students pick a simple statement they wish to communicate with an audience. Then decide on a way to communicate the message indirectly and how they wish to interact with the audience. *Example:* *Statement: "Performance art makes people uncomfortable."* *Communication method: playing a song on the ukulele and jumping out the window.* *Interaction with audience: getting audience to perform vocal warmups with the performer, playing music, opening the blackout curtains and letting light into the theatre.*	body awareness, reaction, physicalization, scene development, spontaneity, voice	individual/ partners/ group	

Notes:
- Many theatre games and exercises are folkloric, coming from various theatre traditions and children's games around the world.
- Where possible, we included names in the "source" column to identify which modern-day artist first documented this exercise in their works. Full names of persons are: Anne Bogart, Augusto Boal, Mikhail Chekhov, Jerzy Grotowski, Charna Halpern, Sanford Meisner, Michael Rohd, Viola Spolin, Constantin Stanislavki, Lee Strasberg, and Suzuki Tadashi.
- Items under "skill" highlight some key skills students practice in these exercises. It is not meant to be an exhaustive list and there are numerous other skills students learn. For example, any group exercise will help students with ensemble building.

Guidelines for Performance Exercises

- *Seating*: many of the exercises above can be done seated, with chairs arranged in a circle so that everyone can see each other.
- *Walking*: For exercises that require walking or using the full body, change the exercise to use only the upper body. For example, focus on facial expressions, hand or arm gestures, and head motions. Let students choose which types of movements are comfortable for them.
- *Writing*: If working with partners, the student who is more comfortable writing can be the scribe for the pair. When working in small groups, there can be a designated record keeper who takes notes for each group. Alternatively, writing exercises can be changed to verbal exercises. The most important thing is for students to get their ideas out.
- *Seeing*: Help students by removing obstacles. Make sure there is adequate lighting in the classroom. Turn on overhead lights and/or open the blinds for exercises. If watching a video, turn off the lights. Use large print fonts. During performances, teach students blocking right away so that their backs are not turned to the audience when they are performing. During exercises, make sure they remember to use eye contact with each other. This will help them focus on helping others see what they are doing. If students cannot see well, describe the action and atmosphere when setting up scenes. For example, "They are in a cave behind a waterfall and sunlight is shining through the water." Finally, make sure to always speak your responses to questions versus just nodding yes or no so that everyone can understand you. When giving instructions, always give instructions verbally and be as descriptive as possible.
- *Hearing*: Large group activities can be difficult for students to hear. When doing exercises that require hearing, choose activities that do not involve many speakers talking at once. For example, Zip, Zap, Zop. During these exercises, have students use visual cues such as hand gestures and eye contact so that they practice multiple methods of communication. If a student cannot hear well, they may be able to better participate by reading visual cues. For exercises that do require multiple speakers or group discussions, separate the class into small groups. If possible, place each group far away from each other so that they can hear each other. Turn on closed captions on videos. If students need to read lips to understand what people are saying, make sure there is adequate light. Use microphones if available.

- *Memory*: repeat instructions and provide summaries at the beginning and end of each class.
- *Ask*: If you do not know what students need, ask them. Most will be willing to help you modify an activity so that they can participate. It is always better to ask than assume that you can figure it out on your own. You do not want to make incorrect assessments of students' needs.

Worksheets

Create worksheets for students to fill out. Worksheets can help bring abstract ideas into reality. Performance worksheets also assist students in organizing their thoughts, thinking analytically, and demystifying the acting process.

Objectives

Define the character's objective by answering the following questions:

1. Who am I?
2. What are my dominant personality traits?
3. What are mistakes I've made?
4. Who are my friends, family, and enemies?
5. What do I want?
6. How am I going to get what I want?
7. What obstacles stand in the way of getting what I want?

Character Descriptions

Describe the physical features of a character. For example:

- How tall are they?
- What color is their hair?
- Are their fingernails manicured?
- What kind of clothes do they wear to work? At home? On the weekend?

- How do they walk? Fast? Slow? Dragging their feet? Skipping?
- How do they talk? Fast? Slow? Loud? Soft? Tone of voice?
- What hand gestures do they use?
- How do they stand?
- How do they sit?
- Are they considered beautiful?
- Do they consider themselves beautiful?

Describe the personality of the character. For example:

- What do they like to eat for breakfast? Lunch? Dinner?
- How do they treat the wait staff at a restaurant?
- Where would they go to eat?
- What grocery store would they shop at?
- What do they like to drink?
- Do they cook?
- Who do they call when they are having a bad day?
- Are they close to their family?
- Do they have many friends? Who are they?
- Where would they travel to for a holiday?
- What do they like to do for fun?
- What is their pet peeve?
- Who do they admire?
- What was their childhood like?
- What do they do when they're frustrated? Angry? Afraid?

Beats

Prepare a script for performance by dividing it into beats defining changes in dynamics, emotion, and objective strategies.

1. Read the script and note the objectives, themes, and conflicts.
2. Read the script again and mark the beats where there are changes.
3. Assign each beat an action word that describes what the character does. Examples: The character is deflecting by changing the subject; The character is persuading another character to help them; The character is manipulating another character to help them. *Note: Happy, sad, angry, afraid are emotions, not actions. Act the action, not the emotion.*

Monologue Example

PENELOPE: I've never been attracted to women before. Maybe I'm a late bloomer? I've heard that some women change when menopause happens, but I'm not there yet. But really, who cares?

Well, my parents do, but I think they're happy that I'm not whining about George at our weekly dinners anymore and I'm not downing bottles of their four-hundred-dollar cabernets every time I'm there.

I never thought that they'd be okay with me being a lesbian or fluid, or whatever the latest politically correct term is. My parents are church-going people and said, "It's unnatural. God didn't make man and woman to be like that."

They'd get into arguments with my kids who would try to explain to them that times have changed, that it's okay to be with someone of the same gender. Sometimes, I'd try to help the kids out and turn it back on my parents. I'd ask, "So tell me how is it natural for women to get pregnant with in vitro fertilization? Isn't God saying that they shouldn't have children?" That would usually get them to change the subject.

Imagine my surprise when they didn't blink an eye when I told them that George and I were divorcing. And *I* was with a *woman* and her name was Susan. I thought for sure that I'd get an interrogation of some kind, but all they said was, "Is that so?"

It's been marvelous ever since. The kids and I just got back from Oregon with my parents last week. Now they're talking about taking us to France in the summer and China in the winter. I had no idea that they despised George as much as I did. They're even paying for Susan to join us.

Scene Example

STUDENT: Hey, you.
TEACHER: Are you talking to me?
STUDENT: Yeah.
TEACHER: Do you talk to all the professors this way?

STUDENT: Look. You gotta change my B- to a B.
TEACHER: Who are you? I don't remember you in any of my classes.
STUDENT: I worked really hard in the class and I think I deserve a B.
TEACHER: What's your name?
STUDENT: Taylor.
TEACHER: Taylor what?
STUDENT: Taylor Richards.

(TEACHER *looks through files and takes out two exams and a paper.*)

TEACHER: I was generous giving you the B-. Also, the handwriting on these exams doesn't match.
STUDENT: But I need a B. My parents say I need to get all B's.
TEACHER: Can you explain yourself?
STUDENT: I need a B or they won't give me my allowance.
TEACHER: No, I mean the exams. Did you have someone take the exams for you?
STUDENT: I can't believe you just accused me of cheating! Oh my God! I really need the money.
TEACHER: How much do your parents pay for?
STUDENT: They said if I got all B's they'd get me a new car. And a thousand dollars for each B. And I need that.
TEACHER: So you won't be homeless if you have a B-.
STUDENT: Of course not. My parents aren't that mean. Or that cheap.
TEACHER: Well, then. I guess you're stuck with a B- then.
STUDENT: But I need that money. I have a business to run. Grow lights are expensive!
TEACHER: *(laughing)* I see.
STUDENT: So what do you say?
TEACHER: No.
STUDENT: What? Why not?
TEACHER: Because you barely earned a B-. You're lucky I'm not reporting you to Judicial Affairs.
STUDENT: What does it matter to you if I get a B or B-? Come on.
TEACHER: You are welcome to appeal your grade with the registrar, but they'll only hear your case if you can prove mathematical inaccuracies in the course grading. And then they'd see the exams, which are in different handwriting, and they'd see that the

	mathematical error actually gives you a higher grade than you received. So. There you go. What do you want me to do?
STUDENT:	Ugh. Never mind. This sucks.
	(STUDENT *exits*.)

Location Observations

Pick an *indoor* place to observe for five minutes. Take notes on what you notice. Examples:

- What do you see?
- What is on the walls?
- Are there windows?
- What is the light like in the room? Sunlight or artificial?
- How tall is the ceiling?
- How big is the room?
- What do you smell?
- What objects are in the room?
- What is the temperature?
- Are there other people or animals in the space? How many?
- What do they look like?
- What are they doing?
- What sounds do you hear?
- What is the general atmosphere of the space?

Pick an *outdoor* place to observe for five minutes. Take notes on what you notice. Examples:

- What time of day is it?
- What color is the sky?
- Is the sun or moon out? Where is it positioned?
- Are you hot or cold?
- Is there a breeze?
- What does it smell like?
- What sounds do you hear?
- What do you see?

- What does the ground feel like?
- What objects are in this space?
- Are there other people or animals in the space?

Discussions

Self-Reflections

Ask students about their experience with an activity. Examples:

- What did you feel doing the activity?
- What was challenging for you? Why?
- What did you enjoy the most? Why?
- What was frustrating? Why?
- Were you able to focus? Why?

Observations

Ask students what stands out to them most when observing classmates' work. Examples:

- What did you notice that changed between the first and second time you saw your classmates perform their scene?
- What stood out the most between Actor A's portrayal of Character Y and Actor B's portrayal of Character Y?
- What was different about their stage chemistry and/or the energy of the scene?
- Where did your group/the other group fall apart? What caused them or you to lose focus?
- How did your group perform differently than the other group?
- How did you perceive the activity differently than others?
- How did you work with your group when there was a problem? How did others work with each other when there was a problem?

Reactions

Ask students for their immediate reactions. Examples:

- What is the first emotion that that you felt?
- What was the purpose of the exercise?
- How did the exercise help you?

- What do you think is going to happen next based on the way the last scene played out?
- What can you take from this experience to apply in your personal life, at work, with your family, or elsewhere?
- What are some benefits of performance for you?
- What are your biggest challenges with performance?
- What are your biggest fears with performance?
- What do you like most about performing?
- How do you define "good" acting? What are some examples?
- How do you define "bad" acting? What are some examples?
- What did you like about the actor(s) in this film? What didn't you like?
- What is "chemistry"? Can you create it?
- What connects actors to audiences?
- What acting styles do you prefer?
- Which actors do you like and why?

Play a Trivia Game

Create trivia involving actors, performance techniques, terms, or anything else related to acting. Examples (answers in bold):

1. *Chicago* features a rotating celebrity performer for the role of Roxie Hart. Who has *not* played Roxie Hart?
 a) Melanie Griffith
 b) Liza Minnelli
 c) Christie Brinkley
 d) Madonna

2. Which actor did *not* study with Stella Adler?
 a) Marlon Brando
 b) Mark Ruffalo
 c) Jane Fonda
 d) Salma Hayek

3. Which actor said, "Give me a bottle of vodka and a floor plan"?
 a) Kristin Chenowith
 b) Angela Lansbury
 c) Patti LuPone
 d) Elaine Stritch

4. With whom did Henry Fonda go on a date when he was appearing in summer stock?
 a) Thelma Todd
 b) Virginia Mayo
 c) Bette Davis
 d) Elizabeth Taylor

5. Who did George Gershwin tell to never go see a singing teacher?
 a) Ethel Merman
 b) Judy Garland
 c) Alice Faye
 d) Lupe Velez

6. Who said "Doing *Gypsy* was like doing therapy"?
 a) Ethel Merman
 b) Rosalind Russell
 c) Bette Midler
 d) Bernadette Peters

7. Which actor slept in a coffin?
 a) Sarah Bernhardt
 b) Ellen Terry
 c) Eleanora Duse
 d) Alla Nazimova

8. When Marilyn Miller was playing Woolworth heiress Barbara Hutton in *As Thousands Cheer* on Broadway, Hutton's cousin Jimmy Donahue sneaked onto the stage with Miller. This incident was adapted in what musical? Supplemental trivia: Ben Lyon, who had worked with Marilyn Miller, suggested "Marilyn" as a stage name to Norma Jean Baker.
 a) *Easter Parade*
 b) *Til the Clouds Roll By*
 c) *On the Avenue*
 d) *High Society*

9. How long did Sarah Dowling research cats to create her cat school for the cast of *Cats*?
 a) 1 month
 b) 5 months

c) 1 year
 d) 2 years

10. Which stage couple despised each other?
 a) Alfred Lunt and Lynn Fontanne
 b) Jessica Tandy and Hume Cronyn
 c) Libby Holman and Clifton Webb
 d) Ashley Judd and Jason Patric

Take Headshots and Character Photos

Throughout the course, have students take headshots and character photos of each other. Have students practice taking photos of each with different expressions (i.e. smiling, serious, or neutral) against a plain background, either wearing black or gray clothing or dressed as their characters. For headshots, instruct students to frame their photos either as head and shoulders or from the waist up. Taking pictures during exercises can teach students about blocking and help them see visually what they are presenting on stage and what the audience sees. Any type of photograph will help students become aware of how they use their bodies. At the end of the course students can compare the photos taken at different stages during the course to observe how they use their bodies.

With the permission of your students, headshots and production photos may be used for publicity purposes to advertise a production. They can be included in lobby displays, programs, online advertising, or posters. Headshots and production photos make shows feel more professional for your students and audience. They are also a nice memento for students to take away from the course.

Performance

While not everyone may want to perform for an audience, students are usually part of a performance course because they want to perform. Performances can be as formal or informal as you like. Your audience can be made up of fellow students, friends and family, potential students, or the public. Even if there are performances throughout the course it is nice to have an organized showcase at the end of the course to give them the experience of putting on a show for an audience. You and students may opt for staging an evening of short scenes, ten-minute plays, vignettes, a lip synch, a talent show, puppetry, performance art, a full-length play, a cabaret, or a staged reading.

FIGURE 5.4: Performance.

If you are planning to stage a show with audience members who are not part of the course population, we recommend the following performance process to help your students develop their production for the public. The performance process involves a cycle of rehearsal, performance, and feedback. The number of times you and your students go through the cycle depends on the amount of time you have to prepare for opening the show.

In addition to the above, there are many steps to consider when putting on a production. Review the following steps with your students before you undertake a production so that they know what is expected and can make an informed decision regarding how much of a commitment they want to make. This may be a multi-course process, with students developing ideas for a production in one course and staging the production in a following course:

1. Pick what you are going to perform.
2. Hold auditions/assign roles.
3. Do a read-through.
4. Run rehearsals and develop blocking.
5. Advertise the show.
6. Take notes and give feedback.
7. Do a technical rehearsal.
8. Do a dress rehearsal.
9. Take notes and give feedback.
10. Perform a preview.

11. Open the show.
12. Hold a post-show discussion.

Depending on your timeline steps 6–10 may be skipped. If you will be doing steps 6–10, see How to Manage Feedback and Feedback in Chapter 4.

The first time you put on a performance with your students will require a lot of work. As you and your students gain experience the process will become more enjoyable. One of the benefits of putting on performances is that there are lots of ways that students can be involved in the production process in addition to acting. Sound, costume, and scenic design, advertising and marketing, directing, stage management, and many other opportunities enhance actors' understanding of how a production comes together and how to work with theatre tech, improves ensemble-building, and may help students become better performers.

How Do I Run the Course?

How Do I Create a Safe Environment for Students to Explore, Create, and Participate?

Get students active, engaged, and participating. Remember that you are not there to inflate your own ego. Students may be intimidated if you fail to explain exercises clearly and expect them to perform "perfectly." Students may miss class or forget material from previous weeks. That means they may be "new" each time they come to class. As we've mentioned before, if an exercise falls flat, change tactics and do your best to simplify activities. Remember to:

- Keep your tone casual and conversational.
- Treat all students like people with feelings, experience, and opinions. This will put everyone at ease and help decrease anxiety about high expectations for performance.
- Include a *lot* of interactive games and activities.
- Give students time to discuss their feelings about activities. This helps them realize the value of their own experience.

Establish a class rule to "share the space" and encourage them throughout the course to do so. Work this into discussions as well as performance. Encourage students who do not speak up in discussions to participate.

Give students the option of sitting out of an exercise if they do not wish to participate. Having a choice in their participation decreases performance anxiety. Students often want to participate once the activity has started and they see others having fun. Students will also realize how easy the exercises are and feel less intimidated.

Check in with students frequently to see what they want to do. Expectations will change throughout the course as both students and instructor learn more about everyone's personalities, strengths, weaknesses, and enthusiasm.

How Do I Work with Students with Different Accessibility Needs?[5]

Below are general practices that can help your students navigate the course more easily. It is not meant to be a comprehensive list of modifications and you should always be willing to adapt to meet the needs of your students. Always:

- *Make sure students have access to accessible versions of text.* If they are reading something, provide large font prints or audio recordings as needed.
- *Speak slowly and clearly.* Look at students when you are speaking.
- *Allow students to sit if they need to.*
- *Be aware of volume.* While some students need help hearing, some have very good hearing. Always to do a volume check, especially on electronics. If you are using a bell or other object to refocus the class in between exercises, use something that is pleasant sounding.
- *Check your space.* Make sure there is room for people to sit and move around comfortably. If you have students who use wheelchairs or walkers, offer them extra space so they can easily enter or exit without disrupting others or drawing attention to themselves. Also make sure the room is configured in such a way that accessibility doesn't isolate anyone from group activities.
- *Mix groups up during each activity.* This will ensure that students with different accessibilities do not automatically get lumped in together. Some students may not have very much experience working with different accessibility needs. Mixing groups up for each activity will give them the opportunity to practice working with people with different perspectives.
- *Check the lighting.* Check with your students if they need lighting accomodations to navigate the classroom. Lights that are too bright or dim can make it difficult to see. If a dimmer is not available, try opening the blinds and using natural light instead of overhead lights.

> ## *Accessibility Notes for Performances*
>
> - Play scripts
> - If using scripts for your class, copies should be in large print font and include clear page numbers in a larger font than the text.
> - If possible, print single-sided. Flipping pages to read the back side can be challenging.
> - Make sure the scripts are either easy-to-hold or you have music stands with lights.
> - If students need help keeping track of where they are reading on a page, have them use their finger or a pen to follow along.
> - Microphones
> - If possible, mic end of semester performances. Because of increased awareness of accessibility accommodations, many venues provide audio equipment.
> - Lighting
> - Spotlights and other lights that are too focused or bright may be a hindrance to a performer. It can be difficult to see and performers may be disoriented if they cannot see the audience.
> - If you have a "real" stage and lights but minimal time or design experience, use a stage wash.
> - If you are using regular lights, set up lights to the right and left of your actors to create cross-lighting, which makes it easier to see than with overhead or front light.

How Do We Make Performance Fun for Everyone?

Divas may appear to always be having fun but other students may suffer from stage fright. Establish the classroom as a community where students can be free to be ridiculous, laugh at their own mistakes, and experiment. Stress the importance of being a supportive audience. Allow the option of removing the onus of an end-of-semester public performance if the students emphatically do not want to perform for an outside audience, though encourage them to share their work in the course.

As a performance instructor, your level of enthusiasm will be felt by students and it is very important that you are having fun and showing everyone that you are enjoying the activities. The more enthusiastic you are, the more enthusiastic they will be.

Finally, allow yourself to make mistakes, acknowledge them, and laugh together with your students. This will help students feel at ease that mistakes happen. As we noted before, theatre is a practice, not a perfect.

How Do I Manage *Extremely* Difficult Personalities?

One of the reasons why students enroll in acting courses is because they want to be on stage and the center of attention. They want to be seen, heard, and appreciated by *everyone*. Part of the challenge of teaching performance courses is helping students let go of their egos and work together to create a positive experience for all.

The most important thing for students to learn is that great theatre only happens by collective effort. If an individual tries to make the activity more "interesting" or "funny," the group will be unsuccessful. No one actor is more important than the other, and performers who try to steal the show only make themselves and the rest of the performers look bad. The result is an uncomfortable experience for the audience. The goal of performance is to connect with the audience, and this only happens when all actors are connecting.

To deter individuals from pulling focus and build a cohesive ensemble, spend the majority of the class on group activities like Follow the Leader. Follow the Leader requires the leader to choose movements that are simple enough that everyone can mimic. If the leader does not do this, followers become frustrated and the game falls apart. This will help students get used to working with each other and relying on their classmates to further their learning.

Show and tell them what great teamwork looks like and celebrate collaborative successes regularly. Have students name examples of collaborative successes and summarize their teamwork at the end of classes.

When students are trying to upstage their classmates, stop the performance and ask the class if that student is helping their partner realize the objective of the exercise. Then have them adjust their behavior until they are refocused on teamwork again.

How Do I Select Monologues, Scenes, and Plays for Students to Perform?

Check out monologue and scene anthologies from your library. Many of these books will contain scenes from famous plays. If you are only interested in a specific period, there are scene books published by years or time period. You can find many books under classic, modern, contemporary, new, best of all time, or best scenes for actors.

When you find monologues that interest you but are not familiar with the source play, find a copy of the play and read it in its entirety. Research the context of the plays you are considering for your courses. Look up contemporary reviews and statements by the playwrights so that you can provide additional background information for your students.

To help students figure out what they want to do, give them a few choices to select from. Although some students may already have plays in mind, most will likely not. Try to offer at least two options of monologues and scenes for each student or group. Example: a comic scene and a dramatic scene or a contemporary scene and a classical scene. For more plays and anthologies, see Additional Resources as well as previous chapters. Here are a few scenes and monologues we have found work well with actors with a variety of experience levels.

Monologues

Play	Playwright	Year first produced	Scene/Act and Character
*21A	Kevin Kling	1986	Ron Huber, Gladys, Not Dave, and other characters (excerpt)
The Adding Machine	Elmer Rice	1923	Act I: Mrs. Zero
* The Bacchae	Euripides	405 BCE	Tiresias; Second Messenger (excerpt)
Fires in the Mirror: Crown Heights, Brooklyn, and Other Identities	Anna Deveare Smith	1992	Any monologue
Burn This	Lanford Wilson	1987	Act I: Anna; Act II: Larry
Death of a Salesman	Arthur Miller	1949	Act I: Linda (excerpt); Act II: Willy (excerpt)
A Doll's House	Henrik Ibsen	1879	Act III: Nora (excerpt)
Educating Rita	Willy Russell	1980	Act I, Scene 6: Rita
Pygmalion	George Bernard Shaw	1912	Act I: Alfie Doolittle; Act 1: Henry Higgins; Act 3: Eliza Doolittle

Play	Playwright	Year first produced	Scene/Act and Character
Stop Kiss	Diana Son	1998	(multiple monologues throughout the play)
The Vagina Monologues	Eve Ensler	1996	Any monologue
Shakespearean Sonnets and Soliloquies	William Shakespeare	1585–1613[6]	Any sonnet or soliloquy

Two Characters

Play	Playwright	Year first produced	Scene/Act and Character
The Aliens	Annie Baker	2010	Jasper and KJ
*Lone Star	James McLure	1979	Roy and Ray
Proof	David Auburn	2000	Act I: Catherine and Robert (excerpt)
Closer	Patrick Marber	1997	Dan and Larry; Alice and Anna; Alice and Larry (or any permutation of the characters)
Fences	August Wilson	1985	Act I: Troy Maxson and Cory Maxson; Troy Maxson and Jim Bono (excerpt)
Picnic	William Inge	1953	Act I: Madge Owens and Millie Owens; Any other pairing of characters (excerpt)
A Doll's House	Henrik Ibsen	1879	Act III: Nora and Helmer (excerpt)
Far Away	Caryl Churchill	2000	Scene 1: Joan and Harper; Scene 2: Joan and Todd
The Glass Menagerie	Tennessee Williams	1944	Scene 2: Laura and Amanda
The Odd Couple	Neil Simon	1965	Felix and Oscar (any except)

Play	Playwright	Year first produced	Scene/Act and Character
Oleanna	David Mamet	1992	Act I: John and Carol (excerpt)
The Seagull	Anton Chekhov	1895	Act III: Trigorin and Nina (excerpt)
Seascape	Edward Albee	1974	Act I: Nancy and Charlie (excerpt)
The Sound of a Voice	David Henry Hwang	1983	Man and Woman (any scene with both characters)
A Streetcar Named Desire	Tennessee Williams	1947	Scene 1: Stella and Blanche; Scene 1: Blanche and Stanley
**Sure Thing*	David Ives	1988	Bill and Betty
Top Girls	Caryl Churchill	1982	Act II: Marlene and Joyce (excerpts)
Ubu Roi	Alfred Jarry	1896	Act I, Scene 1, Père Ubu, Mère Ubu (or any other scene with two characters)
Waiting for Godot	Samuel Beckett	1953	Act I: Vladimir and Estragon (excerpt)

Three or More Characters

Play	Playwright	Year first produced	Scene/Act and Character
Anna Christie	Eugene O'Neill	1921	Act III: Anna, Chris, and Mat (excerpt)
Far Away	Caryl Churchill	2000	Scene 3: Joan, Harper, and Todd
**God of Carnage*	Yasmina Reza	2008	Veronique, Michel, Annette, and Alain (excerpt)
The Glass Menagerie	Tennessee Williams	1944	Scene 5: Laura, Amanda, Tom, and Jim
Heartbreak House	George Bernard Shaw	1919	Act III: ensemble (excerpt)

Play	Playwright	Year first produced	Scene/Act and Character
The SS Glencairn Plays	Eugene O'Neill	1914–18	(4 one-acts) full ensemble with options for multi-character and two-character scenes as well as monologues (excerpt)
The Seagull	Anton Chekhov	1895	Act II: ensemble (excerpt)
Seascape	Edward Albee	1974	Act II: Nancy, Charlie, Leslie, and Sarah (excerpt)
Three Tall Women	Edward Albee	1990	Act II: A, B, and C (excerpt)

Notes
- For any plays listed with "excerpt" you will need to read the scene and decide what parts to use.
- Some plays may be dated and have terms that can be eliminated or revised if deemed offensive today. For example, racist terminology.
- *Indicates plays that do not have act or scene numbers.

What if Students Do Not Want to Make "Progress"?

It is fine if students are more interested in having fun than learning what *you* want them to learn. Even if students tell you that they are taking your class as a serious study, they may change their mind or have a different idea from you of what serious study means. Let go of your expectations of what you think students should do and how they should be performing. Instead, let the students guide your teaching. If you force your personal teaching agenda onto students who have a different learning goal than what you are offering, you may find yourself with a cancelled class. Modify according to student interests.

What Do I Do on the First Day?

Establish classroom etiquette. This needs to be introduced, discussed, and accepted by everyone in the course. Performance is perhaps the most vulnerable theatre class and it will be difficult for many students to do, especially in a group setting. Performance requires students address their insecurities and flaws, and to look inward.

Have students share their goals and expectations for the course. Ask them: What brought them to study performance? What is their background in performance?

Are they returning to performing after a long hiatus? Have they been performing their entire lives or is this a wholly new experience? Who is an actor whose work they admire?

Select an activity that students can do individually as well as part of a group. For example, breathing exercises can be used to bring awareness to the self and others. Private Moment or Hidden Quality exercises are a good way to combine individual work with collective interaction.

Select a game or exercise that is simple, but very difficult to do without failing, and involves each individual to perform well in a group setting. The purpose of this is to show them that no one is perfect, that they all have something to work on, and they will benefit from communicating with each other.

How Do I End a Class?

Performance

Students will likely enjoy doing a performance to close the course. It is a great way to celebrate what they have practiced throughout the course. Let your students decide if they would prefer the performance be open to friends and family or for each other without an audience.

Theatre Games

Bring back the theatre games. End where you began. For example, in one acting class students only wanted to play Freeze for the final two class periods and enjoyed murdering each other in increasingly bizarre ways.

Character Party

Have a party where each student plays a character. They must remain the same character throughout the party. If you are ambitious, make this a mystery party and have them pick roles or have their classmates guess who they are playing based on question responses and clues.

Journal Share

Have students share one or two journal entries with the class. Welcome any format for sharing; students may share drawings, words, sounds, sing a song, or any other method they choose.

What Do I Include on the Syllabus?

Setting up expectations and guidelines for classroom interaction is very important for creating an environment where all students can participate. Students will have different ideas of what a performance, acting, or improvisation class should be. They may have preconceived notions based on what they see on television and film, what they've experienced in other performance classes they have taken, and productions that they have been in. Inconsistencies and awkward situations may arise if you do not set the ground rules. We recommend including the following sections:

Everyone Is an Actor

- We are all starting at the beginning.
- Everyone will have their own journey.
- Everyone has unique processes.
- We all have different strengths.
- If you are doing the exercises, you are an actor; No one is expected to be a "great actor."
- Be supportive and aware of others.

Guidelines for Working with Others

- Say, "Yes."
- Say, "Yes, and …"
- Work together.
- Make your partner look good.
- Remember that we are among friends.
- Keep it simple.

Tips for Success

- Participate as much as you can.
- Be present and stay focused.
- Be open to new situations and challenges.
- Be okay with mistakes that you and your collaborators make.
- Let yourself be uncomfortable.
- Accept and adapt.

Sample Syllabi

Class activities are highlighted below. Do not include them in the printed syllabus that students receive. All activities are for entire class unless noted. For full activity descriptions, refer to Performance Exercises. Instructors may need to introduce topics to set up activities.

THEATRE IMPROVISATION FOR EVERYONE

Course Overview: Theatre Improvisation is not just for professionals! It can be used in everyday life to help you focus, improve memory function, decrease fear and anxiety, build confidence, and think on your feet. If you are looking for a fun way to exercise your brain, this is the class for you! Through discussions and group activities, you will share your perspectives with others, develop deep concentration and observation skills, and explore your imagination.

Weekly Schedule

Week One: Introduction

> PRE-ACTIVITY DISCUSSION: How familiar are you with improv? What do you think of when you hear the word improv?
>
> ACTIVITY: Zip Zap Zop; Name and Gesture; Pass a Gesture; Bodyguard and Assassin.
>
> POST-ACTIVITY DISCUSSION: What are three things you hope to get out of this course?

Week Two: Concentration Games

> PRE-ACTIVITY DISCUSSION: What are icebreaker activities you have had to do at work or school? Why do you think people are subjected to icebreaker activities?
>
> ACTIVITY: Name and Gesture; (Partners) Mirror; Group Mirror; Murder Game.
>
> POST-ACTIVITY DISCUSSION: How do pattern games help with memory and group cohesion?

Week Three: Concentration Games

PRE-ACTIVITY DISCUSSION: If you had five minutes to change your appearance and blend into a crowd, what would you change?

ACTIVITY: Name and Gesture; (Small Groups) Mirror Sound and Mirror Speech; Appearances; Categories; Watch clip of Nathan Lane walking like John Wayne in *The Birdcage*.

POST-ACTIVITY DISCUSSION: How do you communicate with minimal words? Is it more important to mimic the action exactly or to mimic the attitude and purpose behind the gesture?

Week Four: Group Games

PRE-ACTIVITY DISCUSSION: Are you going to forever associate your classmates' names with their gestures?

ACTIVITY: Name and Gesture; Follow the Leader; Categories; Dodgeball; Mystery Leader.

POST-ACTIVITY DISCUSSION: What made it difficult to follow the leader? Why do people blank out in the moment?

Week Five: Group Games, Listening, Give and Take

PRE-ACTIVITY DISCUSSION: How does context make it difficult to remember things you know you know?

ACTIVITY: Name and Gesture; Follow the Leader; Singing Circle; Freeze Pass.

POST-ACTIVITY DISCUSSION: As you continue to work together as an ensemble, do you think you are starting to anticipate gestures and movements in games?

Week Six: Physical Games, Listening, and Defining Place

PRE-ACTIVITY DISCUSSION: How do you listen to your surroundings and the people around you in different contexts? What are examples of fish out of water situations? How do people act differently in different contexts? How do people communicate without words?

ACTIVITY: Sound Ball; Where Walk; Where Listening; (Partners/Small Groups) Gibberish Conversation.

POST-ACTIVITY DISCUSSION: How do locations help build a scene? How do locations create characters? Which activity was the easiest in terms of understanding and communicating?

Week Seven: Physical Games, Objects, and Sounds

PRE-ACTIVITY DISCUSSION: When you walk into a space, what elements do you notice first?

ACTIVITY: Tug of War; Sword Fight; (Small Groups) Using Objects; (Small Groups) Becoming Objects; (Small Groups) Background Noise.

POST-ACTIVITY DISCUSSION: How can interactions with space create scenes? How do sounds and listening help you imagine the space?

Week Eight: Characters

PRE-ACTIVITY DISCUSSION: How do you create a character using gestures? What can you tell about a character before they speak? What can you tell about a character based on how they introduce themselves to other characters?

ACTIVITY: Character Walk; (Small Groups or Partners) Character Quirks with or without puppets; Character Greetings.

POST-ACTIVITY DISCUSSION: How were the puppets in *Mister Rogers*, *The Muppet Show*, and *Sesame Street* extensions of their creators? Who are other examples of actors and troupes who play a persona based in physicality?

Week Nine: Characters Cont'd

PRE-ACTIVITY DISCUSSION: Who are your favorite characters? Why? What makes these characters memorable?

ACTIVITY: (Small Groups) Characters and Where Walk combined; Free Form Scene; (Partners) Two characters scenes; (Partners or Small Groups) Character Secrets.

POST-ACTIVITY DISCUSSION: What do secrets reveal about characters? How did interacting with other characters help you develop your own character? What did you learn about your characters that was unexpected?

Week Ten: Building Scenes; Objectives, Obstacles, and Stakes

PRE-ACTIVITY DISCUSSION: How can you create a coherent scene without having discussed the scene with your team? How are improv performers able to create scenes based off of audience suggestions or stories?

ACTIVITY: Zip Zap Zop; (Small Groups) Free Form Scene; (Small Groups) Three-character scenes: one character wants something, the other tries to stop them, and a third comes in and raises the stakes.

POST-ACTIVITY DISCUSSION: How does defining the objectives, obstacles, and stakes help create a story? Why is the characters' objective important?

Week Eleven: Building Scenes; Beginning, Middle, and End

PRE-ACTIVITY DISCUSSION: What are some famous opening lines, closing lines, and cliffhanger lines that you remember?

ACTIVITY: Group Mirror; Free Form Scene; Scene using beginning, middle, and end; (Small Groups) Snapshots; (Small Groups) Moving scenes based on Snapshots.

POST-ACTIVITY DISCUSSION: What are the benefits of using the beginning, middle, and end framework? How does this differ from the objectives, story, and stakes approach?

Week Twelve: Fairytale Scenes

ACTIVITY: Name and Gesture; Group Mirror; (Small Groups) Fairytale Genres.

POST-ACTIVITY DISCUSSION: If someone asks you about this course or asks you "what is improv?" what will you say to them? What was the most memorable thing you learned in the course?

READER'S THEATRE

Course Overview: Have you ever wanted to perform in a play but don't like memorizing lines? Memorization is not the most important part of performance. In Reader's Theatre we will focus on ensemble-building, script analysis, voice, and characters. This course involves two performances of short plays for an audience, theatre games, and lots of fun.

Weekly Schedule

Week One: Introduction and Vocal Exercises

PRE-ACTIVITY DISCUSSION: What makes it difficult for someone to hear you?

ACTIVITY: Tongue Twisters; Zip Zap Zop; Volume Conductor; (Individual) Read a newspaper article out loud; (Partners) Read a scene.

POST-ACTIVITY DISCUSSION: How have these exercises helped you become aware of how to use your voice? How do theatre games help with ensemble-building?

Week Two: Vocal Exercises and Games

PRE-ACTIVITY DISCUSSION: What are your vocal strengths? What can you improve?

ACTIVITY: Tongue Twisters; Zip Zap Zop, Volume Conductor; (Partners) Read a Newspaper Article; (Partners) Sing a Newspaper Article; Overacting Monologue; (Partners) Read a Scene; Name Game in rhythm.

POST-ACTIVITY DISCUSSION: What are your vocal strengths? What can you improve?

Week Three: Character Games

PRE-ACTIVITY DISCUSSION: What makes a character interesting? Who are your favorite characters in plays/film? Why?

ACTIVITY: Tongue Twisters; Zip Zap Zop; Character Walk; (Small Groups or Partners) Character Quirks with Puppets; Inflections; Watch clip of Michelle Williams in *Fosse/Verdon*.

POST-ACTIVITY DISCUSSION: How can you make distinct characters?

Week Four: One-Minute Plays

PRE-ACTIVITY DISCUSSION: What can we do to help the audience see? What can we do to help the audience hear?

ACTIVITY: Vocal Warm-ups; (Individual) Choose and perform a one-minute play.

POST-ACTIVITY DISCUSSION: What did you enjoy about your performance? What did you enjoy about others' performances? What do you want to bring to the second performance?

Week Five: Gestures and Facials Expressions

PRE-ACTIVITY DISCUSSION: What do you find difficult about talking on the phone and reading written communication? How are they easier and harder than communicating face to face?

ACTIVITY: Pass a Facial Expression; Pass a Gesture; Intensities; (Small Groups) Exaggerated Scenes.

POST-ACTIVITY DISCUSSION: When has your face ever betrayed your intentions?

Week Six: Volume and Pacing

PRE-ACTIVITY DISCUSSION: If you cannot hear the words, what can you infer about a conversation from tone of voice and volume?

ACTIVITY: Rhythm Walk; Zip Zap Zop in rhythm; Rhythm Scene; (Small Groups) Stage Whispers.

POST-ACTIVITY DISCUSSION: What are your vocal strengths? What can you improve on?

Week Seven: Intensities

PRE-ACTIVITY DISCUSSION: What makes a scene compelling to watch?

ACTIVITY: (Small Groups) Each group chooses a one-page scene to perform. Every actor chooses an action to perform (for example: to celebrate, to question, to mock) and a number from one to ten at the level of intensity with which they are starting the scene. Read the scenes through three times with different intensity levels.

POST-ACTIVITY DISCUSSION: How did the scene change each time? What surprised you?

Week Eight: Swapping Characters

PRE-ACTIVITY DISCUSSION: Which actors do you think were mis-cast in their roles?

ACTIVITY: (Small Groups) Review and select ten-minute plays. Read through each play three times, with actors swapping characters each time. Determine who will play which role.

POST-ACTIVITY DISCUSSION: How did your group make their casting decisions?

Week Nine: Rehearsals; Volume and Pacing

PRE-ACTIVITY DISCUSSION: What is the importance of pacing in a scene?

ACTIVITY: (Small Groups) Rehearse scenes focusing on volume and pacing.

POST-ACTIVITY DISCUSSION: How does pacing add to the story?

Week Ten: Rehearsal; Character and Story

PRE-ACTIVITY DISCUSSION: Who are the characters, what do they want, how do they sound, and what role do they play in the story?

ACTIVITY: (Small Groups) Rehearse scenes.

POST-ACTIVITY DISCUSSION: Are the characters telling the story? If no, what can you add to their personalities, motivations, objectives, and performance?

Week Eleven: Ten-Minute Play Performance

ACTIVITY: Vocal Warm-Ups; Sound Check; (Small Groups) Perform ten-minute plays.

POST-ACTIVITY DISCUSSION: What did you enjoy about your performance? What did you enjoy about others' performance?

Week Twelve: End of Semester Reflections

ACTIVITY: Review performance: How did actors' voice, tone, facial expressions, and gestures show the characters? How did these performances tell the story?

POST-ACTIVITY DISCUSSION: How can you use these reader's theatre techniques in your own life?

ACTING FOR EVERYONE

Course Overview: Anyone can act! Acting is a skill that everyone can develop by playing games, doing exercises, and practicing with others. In this interactive course, you will learn the fundamentals of acting including the rules of the stage, how to read and analyze a script, and how to perform with others.

Weekly Schedule

Week One: Introduction and Theatre Games

PRE-ACTIVITY DISCUSSION: What is acting? What is theatre?
ACTIVITY: Zip Zap Zop; Names with Gesture; Group Mirror; Volume Conductor.
POST-ACTIVITY DISCUSSION: Why do you think playing theatre games is such an important aspect of studying acting?

Week Two: Physical Awareness and Self-Awareness

PRE-ACTIVITY DISCUSSION: What makes a performance successful?
ACTIVITY: Follow the Leader; Names with Gesture; Group Mirror; Guided Meditation.

POST-ACTIVITY DISCUSSION: What are rituals you engage in regularly? Why do you perform these activities the way that you do? What do you think about while performing these actions? What can you discern about a character based on their behavior patterns?

Week Three: Physical Awareness, Self-Awareness, and Group Awareness

PRE-ACTIVITY DISCUSSION: Why is it important to work together in theatre?

ACTIVITY: (Partners) Mirror with Sounds and Speech; (Partners) Balancing Circle; Follow the Leader.

POST-ACTIVITY DISCUSSION: How can we work together to better accomplish a task? How can we work together to better tell a story?

Week Four: Group Awareness

PRE-ACTIVITY DISCUSSION: What have you learned about your ability to work with groups so far? What can you improve?

ACTIVITY: Group Mirror; Becoming Objects; (Small Groups) Pick characters and show how they are related to each other without speech.

POST-ACTIVITY DISCUSSION: If you think your collaborators aren't doing things "right" how do you communicate to get everyone back in alignment? Which character or creation that emerged in today's activities most surprised you? Which aspects of the improvisations would you like to see in an expanded version?

Week Five: Nonverbal Scenes

PRE-ACTIVITY DISCUSSION: What makes a scene entertaining? What do actors need to show to the audience?

ACTIVITY: (Individual) What's in the Box?; (Small Groups) (Individual) Acting Action Words; Private Moment; Free Form Scene.

POST-ACTIVITY DISCUSSION: What was in the box? Who or what were you waiting for? Is it more difficult to act the action or to indicate the intention?

Week Six: Script Analysis, Objectives, and Beats

PRE-ACTIVITY DISCUSSION: When actors receive a script, what should they do next? How do actors determine how to perform a scene?

ACTIVITY: (Small Groups) Read a monologue from *Adding Machine*, *Radio Golf*, or *Death of Salesman*. Dissect monologue into beats.

POST-ACTIVITY DISCUSSION: How is dividing a monologue into beats similar to classical acting techniques of hitting emotional points in the script? How does an actor analyzing the objectives help the audience's understanding of the play?

Week Seven: Group Scenes and Give and Take

PRE-ACTIVITY DISCUSSION: Why is it important to share the space?

ACTIVITY: (Small Groups) Non-verbal Five On, Five Off; Freeze Variations.

POST-ACTIVITY DISCUSSION: Did anyone dominate the group scenes or did you function as an ensemble? Who are some of the best ensemble casts you have seen? What makes them effective?

Week Eight: Group Scenes

PRE-ACTIVITY DISCUSSION: How does the script tell the actor what to do? What can you learn about your character and relationship to other characters through their dialogue?

ACTIVITY: (Small Groups) Read scenes from *Pygmalion* and *Heartbreak House*. Dissect the scene into beats.

POST-ACTIVITY DISCUSSION: What are different ways you could divide the scenes in these plays? How does this change your interpretation of the characters and their objectives? How can changing the emphasis in a scene change whether the audience sympathizes with a character? Why is it important to understand how a scene fits into the broader context of the script?

Week Nine: Partner Scenes

PRE-ACTIVITY DISCUSSION: What motivates people? What do characters want and what stands in their way? What is at stake?

ACTIVITY: (Partners) Read scenes from one of the plays below and dissect the scene into beats:

- *The Aliens*, Jasper and KJ (excerpt).
- *Proof*, Act I: Catherine and Robert (excerpt).
- *A Doll's House*, Act III: Nora and Helmer (excerpt).

POST-ACTIVITY DISCUSSION: Why do you think these plays are both considered "classics" and "boring"? What is frustrating about the characters in these plays? What do these plays say about interpersonal relationships?

Week Ten: Rehearse Partner Scenes

PRE-ACTIVITY DISCUSSION: What is showing versus telling? What can your characters do to show, rather than tell the story?

ACTIVITY: (Partners) Rehearse scenes from the previous week. Add additional scenes as necessary.

POST-ACTIVITY DISCUSSION: What are alternate ways you can rehearse your scene next week?

Week Eleven: Rehearse Partner Scenes

PRE-ACTIVITY DISCUSSION: How are your characters connecting? How are they not connecting?

ACTIVITY: (Partners) Rehearse scenes from the previous week in at least two different ways.

POST-ACTIVITY DISCUSSION: Which interpretation of your scene and characters will you use in the performance? Why?

Week Twelve: Performance

ACTIVITY: (Small Groups) Perform scenes.

POST-ACTIVITY DISCUSSION: What did you learn about the script by performing it? What did you learn from watching others' performances? How has the course changed your thoughts about acting?

"SERIOUS" ACTING: ACTING METHODS AND GAMES

Course Description: Acting is exercise for mind and body! Interested in realistic or nonrealistic acting? Want to learn about different types of acting before committing to a single style for a whole course? Explore a variety of physical forms and methods of storytelling from clowning to puppetry to musical theatre. We will practice different forms, play games, develop characters, and perform short scenes together.

Weekly Schedule

Week One: Introduction and Theatre Games

PRE-ACTIVITY DISCUSSION: What is acting? What forms of acting are you familiar with? What names do you think of when you hear the word "acting"?

ACTIVITY: Bodyguard and Assassin; Murder Game; Name and Gesture.

POST-ACTIVITY DISCUSSION: What did you learn from these activities? Why might these theatre games be helpful for acting?

Week Two: Theatre Games

PRE-ACTIVITY DISCUSSION: What is chemistry? How do actors work together? What happens when you see a really good performer and a really bad performer in a show together?

ACTIVITY: Follow the Leader; Follow the Leader with Music; Mirror; Pass the Facial Expression.

POST-ACTIVITY DISCUSSION: What made it easier or more difficult to follow the leader?

Week Three: Puppetry

PRE-ACTIVITY DISCUSSION: What forms of puppetry are you familiar with? Which kind of puppetry are you most interested in? Why? Why do you think puppetry is popular?

ACTIVITY: Watch clips from *The Puppet Lady*; (Individual and Partners) Create sock puppets and perform with them.

POST-ACTIVITY DISCUSSION: How is puppet acting different from other forms of acting? How did puppetry help you perform?

Week Four: Puppetry Cont'd

PRE-ACTIVITY DISCUSSION: What skills do you need to develop as a puppeteer? What makes puppets fun to watch?

ACTIVITY: Vocal Warm-ups; (Individual) Everyday Puppets; (Small Groups) Everyday Puppets scenes.

POST-ACTIVITY DISCUSSION: What was difficult about using everyday objects as puppets? What did you do differently when you were part of a group puppet? How did different people give the same object different personalities by giving the object different voices?

Week Five: Clowning

PRE-ACTIVITY DISCUSSION: Why are people afraid of clowns? Why do others think clowns are funny?

ACTIVITY: Watch clips from *Laugh, Clown, Laugh*; (Individual) What's in the Box?; (Individual) Sitting on a Chair; (Individual) Personal Problems.

POST-ACTIVITY DISCUSSION: Are you still afraid of clowns? If you are a clown, are you afraid of yourself?

Week Six: Dance

PRE-ACTIVITY DISCUSSION: Do you like to dance? Do you consider yourself a good dancer? What makes a "good" dancer?

ACTIVITY: Rhythm Walk; Machines; Stomp; Pass the Gesture; (Partners/Small Groups) Create a story with dance. Perform to class.

POST-ACTIVITY DISCUSSION: How can movement be used to tell a story and convey emotions? For those of you who are not dancers, how was working with movement?

Week Seven: *Commedia dell'arte*

PRE-ACTIVITY DISCUSSION: What do you know about *commedia*? What do you know about sitcoms? What common character types are in your favorite sitcom?

ACTIVITY: Character Walk; *Commedia* Characters; (Small Group) *Commedia* Scenes.

POST-ACTIVITY DISCUSSION: What modern characters are modern-day examples of the *commedia* characters?

Week Eight: Melodrama

PRE-ACTIVITY DISCUSSION: How do you create a character using gestures? What can you tell about a character based on how they introduce themselves to other characters?

ACTIVITY: Melodrama Characters; (Small Groups) Melodrama Scenes.

POST-ACTIVITY DISCUSSION: Why do you think melodrama was popular for nearly a century? Why do you think it is considered bad acting today? Why have the tropes of melodrama stuck around? Why is it popular in cartoons?

Week Nine: Stanislavski

PRE-ACTIVITY DISCUSSION: What do you know about method acting? What does it mean to you?

ACTIVITY: (Individual/Partner) Beats; (Individual) Character Descriptions; Private Moment.

POST-ACTIVITY DISCUSSION: How did you feel doing these exercises? How were they different from the other exercises that we have done so far?

Week Ten: Meisner

PRE-ACTIVITY DISCUSSION: How can you make your reactions onstage more "believable"? Who do you think are good "realistic" actors?

ACTIVITY: Ping Pong and POV Ping Pong; Repetition with Activity; (Individual) Observations.

POST-ACTIVITY DISCUSSION: Do you still like realistic acting? Why do you think people prefer realistic acting over non-realistic?

Week Eleven: Musical Theatre

PRE-ACTIVITY DISCUSSION: What are your favorite musicals?

ACTIVITY: Singing Circle; Vocal Warm-Ups; Tongue Twisters; (Individual/Small Groups) Musical Monologue or Scenes.

POST-ACTIVITY DISCUSSION: How do songs function to further the story in a musical?

Week Twelve: Performance Art

PRE-ACTIVITY DISCUSSION: What is something you are passionate about and want to share with others? If you had a public platform and could say one thing, what would you say? If you could directly interact with an audience member, what would that look like? How would you like audiences to interact with you?

ACTIVITY: (Small Groups) Performance Art.

POST-ACTIVITY DISCUSSION: If someone asks you about this course or asks you "what is acting?" what will you say to them?

THEATRE PRODUCTION WORKSHOP

Course Overview: What does it take to put on a show? Who is involved and what do they do? In this course students learn how to put on a show by doing it firsthand. Students will select, cast, rehearse and perform two evenings of short plays and scenes. Performances will be reader's theatre and actors are not expected to have their lines fully memorized.

Weekly Schedule

Week One: Overview of Production Roles and Staging

PRE-ACTIVITY DISCUSSION: What roles do you have experience within theatre production? What roles do you want to explore?

ACTIVITY: Assess the stage and audience space; How many people can be in the audience? If there is no official stage, where should the stage be? What configurations are possible with the room? How many actors can fit in different configurations?

POST-ACTIVITY DISCUSSION: Which configurations are most suitable for the space? Which configurations do you want to try?

Week Two: Play Selection and Staging Strategies

PRE-ACTIVITY DISCUSSION: Who are your favorite playwrights and why? What role have you always wanted to play or see staged? Who wants to perform, run tech, or do both?

ACTIVITY: (Small groups) Choose scenes from the following plays to produce:
- *Anna Christie*, Act III: Anna, Chris, and Mat (excerpt).
- *Far Away*, Scene 3: Joan, Harper, and Todd.
- *God of Carnage*, Veronique, Michel, Annette, and Alain (excerpt).

POST-ACTIVITY DISCUSSION: Which plays can be staged using the available space, time, and budget? How many actors are required? What are the strengths and weaknesses of the play as a potential play for this class?

Week Three: Cast Plays

PRE-ACTIVITY DISCUSSION: How do you envision each of the characters in your head? What technical requirements do you have for your production?

ACTIVITY: (Small Groups) Read scene. Cast the play and tech crew.

POST-ACTIVITY DISCUSSION: Who is doing what? How did you come to that decision?

Week Four: Rehearsal; Characters

PRE-ACTIVITY DISCUSSION: How do you want to tell the story as a group? What do you want the audience to get from the production? What is the main message of the show?

ACTIVITY: (Small Groups) Rehearse scenes; Actors perform; Tech crew manages the rehearsal and decides on what props, set, lighting, and sound are needed; If there is no director, tech assists in blocking.

POST-ACTIVITY DISCUSSION: What went well and what did not? What improvements can you make? How can you better communicate?

Week Five: Rehearsal; Pacing

PRE-ACTIVITY DISCUSSION: What is the pacing of the scene? What are the clues?

ACTIVITY: (Small Groups) Rehearse scenes; Actors perform; Tech crew manages the rehearsal; If there is no director, tech assists in blocking.

POST-ACTIVITY DISCUSSION: What went well and what did not? What improvements can you make? How can you communicate better?

Week Six: Performance

ACTIVITY: Group Mirror; (Small Groups) Performance.

POST-ACTIVITY DISCUSSION: What did you enjoy about your performance? What did you enjoy about others' performance? What would you like to do differently next time?

Week Seven: Performance Reviews and Play Selections

PRE-ACTIVITY DISCUSSION: What was surprising to you about the productions? What did you learn from watching others perform? How did the tech and acting go? What story did each performance tell?

ACTIVITY: (Small Groups) Choose a ten-minute play to produce.

POST-ACTIVITY DISCUSSION: What are your goals for the next play? How will you reach these goals?

Week Eight: Cast Plays and Rehearsal

PRE-ACTIVITY DISCUSSION: Which tech role or acting roles do you want to perform?

ACTIVITY: (Small groups) Cast acting and tech roles; Tech crew manages rehearsal as actors perform scenes; Tech crew decides on what props, set, lighting, and sound are needed. If there is no director, tech assists in blocking.

POST-ACTIVITY DISCUSSION: What went well and what did not? What improvements can you make? How can you communicate better?

Week Nine: Rehearsal; Pacing

PRE-ACTIVITY DISCUSSION: How do you want to tell your story? What acting and technical choices can you make to tell this story?

ACTIVITY: (Small Groups) Tech crew manages rehearsal as actors perform scenes; Tech crew decides on what props, set, lighting, and sound are needed. If there is no director, tech assists in blocking.

POST-ACTIVITY DISCUSSION: What went well and what did not? What improvements can you make? How can you communicate better?

Week Ten: Rehearsal; Story

PRE-ACTIVITY DISCUSSION: What story do you want to tell with your scene? What messages or themes do want the audience to take away from the production?

ACTIVITY: (Small Groups) Tech crew manages rehearsal as actors perform scenes; Tech crew decides on what props, set, lighting, and sound are needed. If there is no director, tech assists in blocking.

POST-ACTIVITY DISCUSSION: How do you show the audience the story and messages?

Week Eleven: Performance

ACTIVITY: Counting; (Small Groups) Performance.

POST-ACTIVITY DISCUSSION: What did you enjoy about your performance? What did you enjoy about others' performance? What would you like to do differently next time?

Week Twelve: Roundtable Discussion

ACTIVITY: Review Performance: How did the tech and acting go? What story did each performance tell? How successful were the shows in telling their story?

POST-ACTIVITY DISCUSSION: What is a role you would like to take on in the future? How has the production process changed your understanding of theatre and collaborative work?

PERFORMANCE

Additional Resources

Television Shows

American Masters on PBS, 1986–present, https://www.pbs.org/show/american-masters/.
Inside the Actor's Studio on BravoTV, 1994–2018, 2019–present, https://www.bravotv.com/inside-the-actors-studio.
Variety Studio: Actors on Actors on PBS, 2014–present, https://www.pbs.org/show/variety-studio/.

Websites

Improv Encyclopedia, Updated January 7, 2018. http://improvencyclopedia.org/games/index.html.
MonologueArchive.com, Updated January 1, 2020. http://monologuearchive.com.
National August Wilson Monologue Competition, Updated December 1, 2020. http://augustwilsonmonologue.com
"Spolin Games Online." Spolin Games Online. Updated 2018. https://spolingamesonline.org/.

Books

Adler, Stella. *The Technique of Acting*. New York: Bantam Books, 1990.
Allen, David. *Stanislavski for Beginners*. Danbury: For Beginners LLC, 2015.
Boal, Augusto. *Games for Actors and Non-Actors*, 2nd ed. Translated by Adrian Jackson. London: Routledge, 2002.
Haarbauer, Martha. *Seasoned Theatre*. Portsmouth: Heinemann, 2000.
Halpern, Charna, Del Close, and Kim "Howard" Johnson. *Truth in Comedy: The Manual of Improvisation*. Englewood: Meriwether, 1994.
Johnstone, Keith. *Impro: Improvisation and the Theatre*. London: Methuen, 1989.
Johnstone, Keith. *Impro for Storytellers*. New York: Routledge, 1999.
Spolin, Viola. *Improvisation for the Theater: A Handbook of Teaching and Directing Techniques*. Evanston, IL: Northwestern University Press, 1993 (or any other edition).
Spolin, Viola, and Paul Sills. *Theater Games for the Lone Actor*. Evanston, IL: Northwestern University Press, 2001.
Suzuki, Tadashi. *Culture is the Body: The Theatre Writings of Tadashi Suzuki*. Translated by Kameron Steele. New York: Theatre Communications Group, 2015.

YouTube Videos

"4 Basic Moves for Actors Who Hate Dance Calls," Posted February 9, 2016. https://www.youtube.com/watch?v=mpp8EpTrmuk

"An Actor's Warm-Up," Posted February 27, 2017. https:// www.youtube.com/watch?v= CFXqyl4C1J4

"Celine Dion Shows Larry Her Vocal Warm-Ups," Posted September 18, 2018. https:// www.youtube.com/watch?v= AIqUX2QbLGw

EricArceneaux (YouTube channel with many videos), Posted November 2006-Present. https://www.youtube.com/c/ericarceneaux

"How to Do the 5 Basic Positions – Ballet Dance," Posted October 28, 2011. https://www.youtube. com/watch?v=b3bawTEPLtA

"How to Perform Step-BallChange Dance Move," Posted October 13, 2013. https://www.youtube.com/watch?v=erFqCWxtwTo&t=2s

"Learn 6 Signature Fosse Moves to Celebrate 23 Years of Chicago on Broadway," Posted November 22, 2019. https://www.youtube.com/watch?v=_1KWH99c-lM

"The Temptations Cha Cha (Instructional)," Posted July 24, 2008. https://www. youtube.com/watch?v= FjD26sNhqIk&feature=youtube

"Vocal Warm-Up #1: Breathing," Posted May 6,2011. https://www.youtube.com/ watch?v=Tc-_hoG4nec&t=13s

In-Depth Reading

Astell-Burt, Caroline. *I Am the Story: A Manual for Special Puppetry Projects*. London: Souvenir Press, 2002.

Bacon, Albert M. *A Manual of Gesture*. Chicago: S. C. Griggs, 1873.

Callery, Dymphna. *Through the Body: A Practical Guide to Physical Theatre*. London: Routledge, 2002.

Cornish, Roger. *Senior Adult Theatre: The American Theatre Association Handbook*. University Park: Penn State University Press, 1982, revised 1990.

Delgado, Ramon. *Acting with Both Sides of Your Brain*. New York: Holt, Rinehart & Winston, 1986.

Grotowski, Jerzy. *Towards a Poor Theatre*. Edited by Eugenio Barba. London: Routledge, 2002.

Meisner, Sanford. *Sanford Meisner on Acting*. New York: Vintage, 1987.

Rushe, Sinead. *Michael Chekhov's Acting Technique: A Practitioner's Guide*. London: Methuen Drama, an imprint of Bloomsbury Publishing, 2019.

Thurman, Anne, and Carol Ann Piggins. *Drama Activities with Older Adults: A Handbook for Learners*. Philadelphia, PA: Haworth Press, 1982.

Play Anthologies

Lane, Eric, ed. *Telling Tales: New One-Act Plays*. New York: Penguin Books, 1993.

Lane, Eric, and Nina Shengold, ed. *Leading Women: Plays for Actresses II*. New York: Vintage Books, 2008.

Lane, Eric, and Nina Shengold, ed. *Plays for Actresses*. New York: Vintage Books, 1997.

Lane, Eric, and Nina Shengold, ed. *Take Ten: New 10-Minute Plays*. New York: Vintage Books, 1997.

Schulman, Michael, and Eva Mekler, eds. *Great Scenes and Monologues for Actors*. New York: St. Martin's Press, 1998.

Schulman, Michael, and Eva Mekler, eds. *Play the Scene: The Ultimate Collection of Contemporary and Classic Scenes and Monologues*. New York: St. Martin's Press, 2004.

Conclusion: Theatre for All

No matter where or when a performance takes place, whether by trade guilds entertaining crowds on a village square, telling ghost stories around a fire, or a Broadway kick line in spangled pants, theatre has been a way for people to come together. By teaching an older adult theatre course, you and your students are contributing to this vibrant human tradition. Everyone participating in theatre becomes part of a community. From instructors to students, to theatre professionals and theatre companies, theatre courses for older adults create the space for people to engage, challenge existing perceptions, and come together to build new communities that are vibrant, supportive, and genuine.

The *Theatre for Lifelong Learning* initiative and ethos exists at the intersection of collaboration, creativity, storytelling, and community. See Figure C.1. We developed each of the chapters and outlined course topics not only to increase activity and engagement between older adults and instructors but to create experiences that draw on theatre's most important and transferable life skills. Collaboration is present not only in improvisational games and performances but also in writing exercises and students providing insight and input vis-à-vis course content. Creativity can be found in analyzing histories, creating adaptations of existing stories, and applying new ideas to discussions and activities. Storytelling touches part of every course, and elements of storytelling can be found in performance exercises, debates, discussions, trivia games, and field trips.

Theatre for older adults has been growing steadily since the 1970s, with the journal *AgingWell* reporting a 1012 per cent jump in the number of theatre programs for older adults between 1999 and 2016 alone.[1] Programming and initiatives focused on older adults' interests will increase substantially as the population of people over 65 is expected to grow from 14 to 25 per cent of the total population within the next 40 years.[2] With a rising older adult population comes

CONCLUSION

FIGURE C.1: Theatre.

the need for a wider variety of activities that address the different interests of diverse populations.

There are many types of theatre programs throughout the USA including older adult theatre companies, intergenerational theatre projects, and nonprofit organizations dedicated to providing theatre courses for older adults.[3] They partner with communities at senior centers, assisted living facilities, and nursing homes to teach theatre to older adults and offer them performance opportunities.

Older adult theatre programs play a significant role in creating new communities by working directly with subscriber bases in engaging ways. This is a win–win for both older adults and theatre companies. Theatre courses promote a stronger connection for existing subscribers and new connections for those who have interest in theatre but may not have had access. Even if they have the financial means, not all older adults are able to attend theatre shows. Bringing the theatre to older adult populations can be beneficial for both companies and the communities they serve.

Intergenerational Theatre

Another trend of theatre programs involving older adults is intergenerational theatre. Theatre companies are embracing intergenerational theatre as a way to integrate their existing programming with more diversity. One example of community-building activist intergenerational theatre is the Oregon Children's Theatre's Intergenerational Queer Theatre Project. Theatre participants are teenagers and adults who work together to create devised theatre pieces related to LGBTQIA+ experiences and histories.

Having older adults work with people of varying ages is beneficial in helping them engage with others while continuing to participate in society. Older adults are integrated, rather than isolated. In a national survey conducted in 2017 by Generations United and the Eisner Foundation, a majority of older adults stated that they would be happiest in intergenerational groups.[4]

In intergenerational theatre, all generations benefit from the experience of creating theatre. In the same survey, it was reported that most people of all age groups rarely interact with anyone outside of their general age range. Milken Institute Center for the Future of Aging posits in the title of the 2016 article that intergenerational programs are "Not Just Nice, But Necessary" for transformative positive community-building.[5] Community-building must incorporate all populations and recognizing intersectionality is key to ensuring these vibrant, sustainable communities thrive. As UK-based performance artist Selina Thompson observes, "Being in contact with our elders can force us to confront how our movements have failed, where people have been disappointed, or why someone who was the 'hot sexy art person of the day' has left the arts and is isolated or in poverty."[6] Other generations learn from older adults' experiences and their inclusion in intergenerational programs fosters exchange of ideas and challenges stereotypes and perspectives in all directions. In short, all generations benefit from the arts engagement.

Autobiographical and Documentary Theatre

Another approach is autobiographical documentary theatre that draws from older adults' stories and real-life events. On Stage Seniors, founded in 2007 at the McCarter Theatre Center in Princeton, New Jersey, and self-defined as the "Public Face of Positive Aging," produces devised documentary theatre pieces. While some of the work they create addresses issues surrounding the three D's and elder abuse (or having your teeth pickpocketed on the subway), On Stage Seniors tend to take a comic tone confronting problems.[7]

CloseToHomeProductions, a video production company run by Sue Pergot, has a Senior Theater Troupe of Lifelong in Ithaca, NY, which creates and produces choral theatre shows from actors' stories, described as Living History Theatre. The Senior Theater Troupe of Lifelong performs bare bones productions in a variety of venues for a wide range of audience sizes, from small groups to crowds of several hundred.[8]

Founded in 1989, the Theater Education program of the Queens Theatre Senior Ensemble Theatre visits retirement communities and long-term care facilities. The Senior Ensemble Theatre enlists professional directors and musicians to work with older adults on developing monologues and performance pieces.[9]

Groups like Stage Seniors, Senior Theater Troupe of Lifelong, and Queens Theatre Senior Ensemble are important because they provide a creative outlet for older adults to be heard and share their lived experiences. They are celebrations of their lives and give the ability to use memories to create new memories, rather than living in the past.[10] While this may seem obvious or clichéd, living in the present is a difficult practice for many older adults. The reasons for this are society's perceptions that older adults have already lived the best years of their lives, and the ingrained cultural practice of encouraging older adults into nostalgia and rumination.[11] These theatres take the nostalgic memories and everyday lived experiences, and turn them into new memories through comedy, performance, and human connection.

Theatre and Dementia

Mentioned in the introduction and Chapter 3, TimeSlips Creative Storytelling's mission is meaningful and creative engagement for older adults with symptoms of dementia. Founded in 1998 by MacArthur Fellow Anne Basting, TimeSlips trains and certifies facilitators to run versions of their creativity workshops and programs in fifteen countries. TimeSlips partners with university students and retirement community residents to develop and perform multidisciplinary arts projects based on literary works and personal histories. One of their initiatives is chronicled in *The Penelope Project*.

TimeSlips' work uses theatre to address long-term health issues for older adults, including those with dementia. Their work provides transformative experiences for its participants. TimeSlips also trains much needed theatre practitioners who can help older adults in terms of health, well-being, and quality of life.

Musical Theatre

The Young@Heart Chorus, an ensemble for singers over 70 founded in Northampton, Massachusetts, in 1982 by Bob Cilman, was the subject of an award-winning 2008 documentary film. Best known for their renditions of pop, punk, and rock songs, Young@Heart also collaborated with No Theater, the resident company of the A.P.E. Gallery in Northampton, on original theatre productions *Road to Heaven*, *Road to Nowhere*, and *The End of the Road*.[12] Young@Heart plays an ambassadorial role spreading joy, redefining aging, and forming friendships.

In 2019 Musical Theatre International (MTI) began publishing the "Broadway Senior" series, abridged versions of famous musicals adapted for performers at senior centers and retirement communities. Broadway Senior is a spin-off of MTI's "Broadway Junior" musicals (*Aladdin Junior*, etc.). MTI states that the purpose of the project "isn't about increasing revenue. It's about improving lives."[13] Older adults love auditioning for their musicals knowing they can play any role in the cast. MTI also provides apps to transpose the keys of the songs so that singers with a variety of ranges and abilities can perform the music.

Musical theatre programs are successful with older adults because they engage with the part of their affective memory that triggers positive feelings. Many people love musicals and they make people happy. Many older adults grew up in times when musicals were a bigger part of mainstream popular entertainment. Songs from musicals were often played on the radio and older adults were familiar with them even without knowing the shows that originated them. Musical theatre is perhaps the easiest way to engage non-theatre older adults into theatre.

Theatre Repertories

Finally, the Oakland-based nonprofit organization, Stagebridge, has been offering a wide range of theatre classes since 1978. Their comprehensive curriculum offers classes from acting and playback theatre, to tap dance and stand-up comedy. Stagebridge has introductory to advanced courses as part of their Performing Arts Institute. In addition to courses, they have a program called Storybridge, where "trained storytellers, many of them current or former Stagebridge students, use storytelling to help at-risk local students increase literacy—and confidence."[14] A third program is Seniors Reaching Out, which includes "entertainment and workshops for frail, isolated, or home-bound older adults."[15] Finally, Stagebridge's Grandparent's Tales program encourages children "to hear and re-tell the rich stories of older adults in their lives."[16]

Stagebridge is an important theatre program for many reasons. They are one of the few comprehensive theatre programs for older adults. Stagebridge has been around for over forty years and has had the opportunity to seriously train generations of older adult theatre artists to create their own work, contribute to the community, and teach others.

While Stagebridge and the other organizations mentioned above are playing a big role in providing theatre courses for older adults there is still room to broaden programming. With our addition of courses about theatre appreciation and theatre history, we hope to inspire new avenues of theatre education and practice. Older adults have more opportunities to get involved in theatre (and society) beyond memory work, performing, and serving as audience members. *Theatre for Lifelong Learning* provides theatre experiences that focus on the now, learning about all parts of theatre, and expanding the ways in which older adults can be involved in theatre communities.

What Other Opportunities Are Out There?

Older adult theatre courses are scalable and can be taught in a variety of settings to people with a variety of backgrounds and experience levels, all at minimal cost for the benefits provided. Once instructors are comfortable teaching a course, they can take their classes to different venues that offer courses for older adults or create new partnerships with organizations that do not have any older adult educational programming. Older adults can pick up this book and design their own in-house, peer-facilitated programs or partner with seasoned instructors to coteach in-person or remotely. Independent programs for older adults may find it fruitful to approach theatre companies and theatre companies should welcome new initiatives.

Older adults keep theatre alive. As the largest subscriber base of many theatres in the USA, older adults have historically been, and continue to be, the strongest supporters of theatre. Yet why does theatre frequently exclude older adults from theatre practice? Should theatre companies and theatre programs keep older adults only as theatre consumers of theatre? The answer is, "No." Theatre companies and theatre programs are not intentionally trying to exclude older adults from theatre practice, but it is nevertheless a common phenomenon. This likely happens for cultural reasons rather than any specific business or administrative policy. Theatre companies are especially suitable for offering older adult theatre programs because theatre courses can help increase their ticket sales.

Theatre companies expend copious resources on marketing, often with a focus on gaining new theatregoers while regarding older adults as a steady and reliable

revenue stream (until death). Although constantly targeting new customers is a common tactic for theatre companies, it is not necessarily the most profitable. *Harvard Business Review* states that acquiring a new customer often costs companies as much as 25 percent more than retaining current customers.[17] By creating services for older adults, theatre companies can show their subscriber base that they see them as an important part of the community, all while reducing their marketing costs.

Why We Wrote This Book

By creating communities with older adults, we continue to challenge our own perceptions of theatre and education, and become more flexible, adaptable, and inclusive. We have both "seriously" studied theatre in academia, which took the joy out of theatre, and working with older adults has helped us rediscover the fun. Our own experiences in theatre have informed our perspectives on theatre education as a whole and specifically theatre education for older adults. Theatre has had an impact on our lives and has intersected in ways that we could never have predicted.

Rae's story: Among my earliest memories is stringing floral curtains on the backyard clothesline to practice making dramatic entrances as Indiana Jones and Captain James T. Kirk. I made my theatrical debut at the age of 4 as a Christmas carol-singing cow. I took tap, ballet, modern, piano lessons, sang in show choir, went to theatre camp, played Agamemnon and Petruchio, built puppets to teach art history, and started teaching community-based intergenerational theatre when I was a teenager. I eventually retired from acting for the technical and playwriting side of things. Theatre is how I connected to my family history. Theatre is also the through-line that has saved my life on more than one occasion. I love the collaboration, the moving parts, and creating ephemeral things that stir feelings and provoke experiences. I started teaching in an older adults program a few months after my last grandparent died when I was sent to the offices of the Tufts University Osher Lifelong Learning Institute to clean out their storage closet. The director asked me what I did in my spare time and I said that I taught theatre. She said, "We need somebody to teach theatre classes." The rest is history.

Linda's story: My experience in theatre has always been at the periphery. I did not have theatre friends growing up, was not part of a theatre family, and did not take any dance, singing, or acting lessons as a young child. There was very little theatre in my life, even as a spectator. The first show I saw was a middle school production of *Oliver!* when I was 9. The second was *Fool Moon* at American Conservatory Theater when I was 15. I did not really know what theatre, amateur or

professional, was. I tried theatre for the first time when I was in high school as a way to overcome my fear of public speaking. My drama teacher Mr. Drain told me about a theatre workshop with the San Francisco Mime Troupe (SFMT). I had never seen any SFMT shows before and did not know who they were, but applied because they did not require an audition and their workshop was free. From the SFMT, I learned that theatre could be political, that anyone could create theatre, and that collaboration was magical. As I continued exploring theatre, I worked "regular" jobs and theatre remained at the margins as something I did during my spare time. I discovered an older adults program at my local community college by chance and was immediately drawn to being a part of this community because all of their classes were free.

Our experiences with theatre are wildly different and yet, we both find value in working with older adults in theatre. Being involved in older adult theatre has enhanced our own lives and continues to challenge us to discover new ways of learning, to both look inward and outward as ways of reflection, and to continue connecting with others who are completely different than ourselves.

Developing curriculum and collaborating with older adults translate into greater flexibility in all areas of our lives. Working with older adults has helped us increase our facility with universal design, adapt on the fly, navigate controversial topics, and practice diplomacy. It also encourages us to find joy and purpose in everyday interactions and experiences, and to better appreciate the mistakes, misunderstandings, miscommunications (the Burlesque Performance students were disappointed when they discovered we were not going to take off our clothes), and enjoy life's surprises. We've been adapting our curricula for online and remote course formats, which has proved an exciting adventure of trial and error, despite our initial hesitance regarding online education, and concern about its ability to provide the community necessary for successful theatre courses.

Our experiences of teaching and participating in theatre for older adults are different from our other experiences in theatre for two main reasons. Firstly, students in our courses learn how to let go of their ego. They engage in conversations and activities that promote a conscious intention to be part of a community. Self-interests are deprioritized and the course places the group above the individual. This is obvious when comparing our older adult theatre courses to our experiences working on stage productions or theatre classes. In many aspects of theatre there is ego, which may not always influence the success of a production or class but affects the experience of participants. It is generally not fun to have a clash of personalities because it often creates a lot of (unnecessary) stress. Older adult theatre has shown us that theatre can be less competitive and combative, and more of a "happy" family instead of a "dysfunctional" family. Secondly, the common

goal in our older adult theatre courses is not to work toward a final production but to create a sense of community and well-being. When courses do involve a final performance of some kind, the aim is to share work with each other, friends, and family. Finally, fun is prioritized above all else. If we are not having fun, we are not accomplishing what we need to learn in class.

Teaching older adult theatre has enabled us to support people in their creative journeys while making theatre inclusive and accessible for all. At moments throughout our life we have both felt like outsiders, even within theatre's world of outsiders. We do not know where our next job will be and we do not know which students will show up each week. What we do know is that teaching older adult theatre has helped us to be included while promoting inclusivity. We work with students to build connections, keep each other motivated, and create a sense of stability in an unstable environment. We hope that *Theatre for Lifelong Learning* will encourage you to continue your journey with theatre by working with older adults.

Notes

Preface: Why Older Adult Theatre?

1. Michael Paterniti, "The Secrets of the 80-Year-Old Chinese Runway Model," *GQ*, March 28, 2017, accessed June 17, 2021, https://www.gq.com/story/wang-deshun-fashion-week.
2. Ibid.
3. Ibid.
4. Jon Haworth, "Female Bodybuilder, 82, Beats Home Intruder So Badly He Had to Be Taken to the Hospital," *ABC News*, November 25, 2019, accessed June 17, 2021, https://abcnews.go.com/US/female-bodybuilder-82-beats-home-intruder-badly-hospital/story?id=67289683.
5. The phrase is used by Bradshaw to describe the title character in the film *Lucky*; Peter Bradshaw, "Lucky Review—Harry Dean Stanton Ages Disgracefully," *The Guardian*, September 12, 2018, accessed June 17, 2021, https://www.theguardian.com/film/2018/sep/12/lucky-review-harry-dean-stanton-david-lynch.
6. World Health Organization, "Dementia," accessed September 21, 2020, https://www.who.int/news-room/fact-sheets/detail/dementia; Dementia is the seventh leading cause of death World Health Organization; "The Top Ten Causes of Death," accessed May 29, 2021, https://www.who.int/news-room/fact-sheets/detail/the-top-10-causes-of-death.
7. Donovan T. Maust et al., "Perception of Dementia Risk and Preventive Actions among US Adults Aged 50 to 64 Years," *JAMA Neurology* 77, no. 2 (2020): 259–62.
8. In Harris Interactive for MetLife Foundation, "What America Thinks: MetLife Foundation Alzheimer's Survey," *MetLife*, accessed March 28, 2020, https://www.metlife.com/content/dam/microsites/about/corporate-profile/alzheimers-2011.pdf.
9. "Longest TV Career by an Entertainer (Female)," *Guinness Book of World Records*, accessed January 10, 2021, https://www.guinnessworldrecords.com/world-records/107740-longest-tv-career-by-an-entertainer-female; The longest TV career by a *male* entertainer is four years shorter than White's, see "Longest TV Career by an Entertainer (Male)," *Guinness Book of World Records*, accessed January 10, 2021, https://www.guinnessworldrecords.com/world-records/102899-longest-tv-career-by-an-entertainer-male.
10. *Lucky*, directed by John Carroll Lynch (2017, Superlative Films and Divide/Conquer).

11. Paterniti, "The Secrets of the 80-Year-Old Chinese Runway Model."

Introduction

1. Viola Spolin, *Improvisation for the Theater: A Handbook of Teaching and Directing Techniques*, 3rd ed. (Evanston, IL: Northwestern University Press, 1999), 3.
2. If you are interested in reading how theatre has a positive physiological and psychological impact on older adults, we recommend the following: "The Cultural Value of Older People's Experiences of Theatre-Making: A Review" is a review study that includes lists of documents from various perspectives including older adult theatre participants, audiences, and facilitators; *Applied Theatre: Creative Ageing* includes essays by facilitators and program directors working in older adult theatre; and *Creative Care: A Revolutionary Approach to Dementia and Elder Care* provides perspectives from Anne Basting's 25 years working with TimeSlips and how they use storytelling therapeutically with older adults; Miriam Bernard and Michelle Rickett, "The Cultural Value of Older People's Experiences of Theatre-making: A Review," *Gerontologist* 57, no. 2 (2016): 1–26; Michelle Rickett and Miriam Bernard, *Ageing, Drama and Creativity: A Critical Review*. The Cultural Value Project, 2014 (two versions of the National Institute on Aging's research on arts and aging); Sheila McCormick, *Applied Theatre: Creative Ageing* (York: Methuen Drama, an imprint of Bloomsbury, 2017); Ann Basting, *Creative Care: A Revolutionary Approach to Dementia and Elder Care* (San Francisco, CA: HarperOne, 2020).
3. "Learning New Skills Keeps an Aging Mind Sharp," Association for Psychological Science, October 21, 2013, https://www.psychologicalscience.org/news/releases/learning-new-skills-keeps-an-aging-mind-sharp.html.
4. Ipsit Vahia quoted in Matthew Solan, "Back to School: Learning a New Skill Can Slow Cognitive Aging," Harvard Health Blog, Harvard University, April 27, 2016, https://www.health.harvard.edu/blog/learning-new-skill-can-slow-cognitive-aging-201604279502.
5. Anne Fabiny quoted in Daniel Pendick, "Mental Strain Helps Maintain a Healthy Brain," Harvard Health Blog, Harvard University, October 29, 2015, https://www.health.harvard.edu/blog/mental-strain-helps-maintain-a-healthy-brain-201211055495.
6. Amanda Macmillan, "Why Friends May Be More Important Than Family," *Time* online, June 7, 2017, https://time.com/4809325/friends-friendship-health-family/#:~:text=Friends%20are%20increasingly%20important%20to%20health%20and%20happiness,because%20we%20enjoy%20spending%20time%20with%20them%20more.
7. Rosemary Blieszner, Aaron M. Ogletree, and Rebecca G. Adams, "Friendship in Later Life: A Research Agenda," *Innovation in Aging* 3, no. 1 (January 2019), https://academic.oup.com/innovateage/article/3/1/igz005/5423647.
8. Blieszner, Ogletree, and Adams, "Friendship in Later Life."
9. Marvin Formosa, "Geragogy," in *Lifelong Learning in Later Life: A Handbook on Older Adult Learning* (Rotterdam: Sense, 2011), 105.

10. Other terms developed for older adult education are educational gerontology, critical educational gerontology, education for older adults, integral permanent education, gerontological education, gerogogy, and gerontagogy. See Dominique Kern, "Research on Epistemological Models of Older Adult Education: The Need of a Contradictory Discussion," *Educational Gerontology* 44, nos. 5–6 (2018): 346, https://www.tandfonline.com/doi/full/10.1080/03601277.2018.1475123?scroll=top&needAccess=true.
11. Kern, "Research on Epistemological Models of Older Adult Education," 347; Hany Hachem, "Is There a Need for a Fourth Statement? An Examination of the Critical and Humanist Statements of Educational Gerontology Principles," *International Journal of Lifelong Education*, August 3, 2020, https://www.tandfonline.com/doi/full/10.1080/02601370.2020.1801869; Formosa, "Geragogy," 106–14.
12. Kern, "Research on Epistemological Models of Older Adult Education," 350–51; Hachem, "Is There a Need for a Fourth Statement?"
13. For a partial list of lifelong learning institutes, see "Lifelong Learning Institute Directory," National Resource Center for Osher Institutes at Northwestern University, Northwestern University, June 2018, http://nrc.sps.northwestern.edu/wp-content/uploads/2017/12/A-Directory-of-Lifelong-Learning-Institutes.pdf.
14. "Our Experiential Opportunities Change Lives," Road Scholar, accessed December 30, 2020, https://www.roadscholar.org/about/.
15. "Welcome to the OLLI at Tufts University," Osher Lifelong Learning Institute, Tufts University, accessed December 30, 2020, https://universitycollege.tufts.edu/lifelong-learning/osherlli.
16. "OLLI Home," California State University Long Beach Osher Lifelong Learning Institute, California State University Long Beach, accessed December 30, 2020, https://www.csulb.edu/college-of-health-human-services/osher-lifelong-learning-institute-home.
17. "Welcome to the Learning in Retirement Association (LIRA) Website," Learning in Retirement Association, University of Massachusetts Lowell, accessed December 30, 2020, https://www.uml.edu/community/lira/.
18. In one course, I had students born in eight different decades with disparate educational, accessibility, race, gender, language, and class backgrounds!
19. Kevin Gannon, "The Case for Inclusive Teaching," *Chronicle of Higher Education*, February 27, 2018, https://www.chronicle.com/article/the-case-for-inclusive-teaching/.
20. "Inclusive Teaching Strategies," Yale Poorvu Center for Teaching and Learning, Yale University, accessed December 30, 2020, https://poorvucenter.yale.edu/InclusiveTeachingStrategies.
21. Sally Bailey, *Barrier-Free Theatre: Including Everyone in Theatre Arts—in Schools, Recreation, and Arts Programs—Regardless of (Dis)Ability* (Enumclaw: Idyll Arbor, 2010).
22. "Playworlds," The Laboratory of Comparative Human Cognition, University of California, San Diego, accessed December 30, 2020, http://lchc.ucsd.edu/playworlds.

23. "Curriculum—The Arts at KPS," Kalgoorlie Primary School, accessed December 30, 2020, http://www.kalgoorlieps.wa.edu.au/curriculum.php?id=32.
24. "Towards a Pedagogy of Play," Project Zero, President and Fellows of Harvard College, Harvard Graduate School of Education, July 2016, https://pz.harvard.edu/sites/default/files/Towards%20a%20Pedagogy%20of%20Play.pdf.
25. Richard Schechner, "Chapter 4: Play," in *Performance Studies: An Introduction*, 3rd ed. (London: Routledge, 2013), 89–122.

1. Collaborating with Older Adults

1. An earlier version of this chapter was published in *Theatre Topics* 29, no. 1 (March 2019): 71–78.
2. Linda Lau and Rae Mansfield, "Theatre for Lifelong Learning Artist Interview: Irina Yakubovskaya," *Theatre for Lifelong Learning*, February 22, 2021, https://theatreforlifelonglearning.org/?p=331.
3. Alison Kafer, "Un/safe Disclosures Scenes of Disability and Trauma," *Journal of Literary and Cultural Disabilities Studies* 10, no. 1 (2016): 1–20.
4. For a full description, see Jeff Pierce, "'Coming Out' Stars", *LGBTQ+ Student Center*, University of Southern California, https://lgbtrc.usc.edu/files/2015/05/Coming-Out-Stars.pdf.
5. Ibram X. Kendi, *How to Be an Antiracist* (New York: Random House, 2019); Robin DiAngelo, *White Fragility: Why It's So Hard for White People to Talk about Racism* (Boston, MA: Beacon Press, 2018); Ijeoma Oluo, *So You Want to Talk about Race* (New York: Seal Press, 2018).; Also see "Our Mission," BU Center for Antiracist Research, Boston University, accessed January 3, 2021, https://www.bu.edu/antiracism-center/ and Robin DiAngelo, "Resources," *Robin DiAngelo*, PhD, Robin DiAngelo LLC, accessed January 3, 2021, https://www.robindiangelo.com/resources/.
6. Adapted from Linda Lau and Rae Mansfield, "10 Tips for Transforming Your Theatre Course Online," *Theatre for Lifelong Learning*, accessed May 31, 2021, https://wtheatreforlifelonglearning.org/?page_id=77 and Lau and Mansfield, "6 Tips to Engage Your Students in a Zoom Classroom," *Theatre for Lifelong Learning*, accessed May 31, 2021, https://theatreforlifelonglearning.org/?page_id=72.
7. Adapted from Linda Lau and Rae Mansfield, "10 Tips to Help Your Students Learn Online," *Theatre for Lifelong Learning*, accessed May 31, 2021, https://theatreforlifelonglearning.org/?page_id=79.

2. Theatre Appreciation

1. Suzie Mackenzie, "You have to laugh," *The Guardian*, November 19, 2004, https://www.theguardian.com/stage/2004/nov/20/theatre.

2. Vassar College, "The experimental Theatre of Vassar College," *Vassar Encyclopedia*, accessed June 4, 2020, http://vcencyclopedia.vassar.edu/curriculum/The%20Experimental%20Theatre%20of%20Vassar%20College.html.
3. Spolin, *Improvisation for the Theater*, 381.
4. Ibid., 217.

3. Theatre History, Theory, and Criticism

1. Antonin Artaud, *The Theatre and Its Double*, trans. Mary Caroline Richards (New York: Grove Press, 1958), 85.
2. Bertolt Brecht, "Theatre for Pleasure or Theatre for Instruction," *Brecht on Theatre: The Development of an Aesthetic*, trans. and ed. John Willett (New York: Hill and Wang, 1966), 73.
3. Victoria Myers, "An Interview with Lynn Nottage," *The Interval*, October 14, 2015, https://www.theintervalny.com/interviews/2015/10/an-interview-with-lynn-nottage/.
4. There are many theoretical readers available that include excerpts and explanations of theorists' writings.
5. "The CRAAP Test," Meriam Library, California State University Chico, accessed March 9, 2020, https://library.csuchico.edu/help/source-or-information-good.
6. Mike Caulfied, "SIFT (The Four Moves)," HapGood, June 19, 2019, https://hapgood.us/2019/06/19/sift-the-four-moves/.
7. Kwame Anthony Appiah, foreword to *Black Skin, White Masks*, by Franz Fanon, trans. Richard Philcox (New York: Grove Press, 2008), ix.

4. Playwriting, Play Development, and Storytelling

1. University of California Television (UCTV), "Conversations with History: Wole Soyinka," YouTube Video, 53:12, May 1, 2008, https://www.youtube.com/watch?v=wosbdri9dRc.
2. Michelle Memran, "Moment to Moment: with Maria Irene Fornes," *Brooklyn Rail: Critical Perspectives on Arts, Politics, and Culture*, accessed Jun 4, 2020, https://brooklynrail.org/2002/10/theater/moment-to-moment-with-maria-irene-fornes.
3. John Romano, "James Baldwin Writing and Talking," *New York Times*, September 23, 1979, https://www.nytimes.com/1979/09/23/archives/james-baldwin-writing-and-talking-baldwin-baldwin-authors-query.html.
4. Mark Lawson, "Annie Baker: 'I Like Theatre because It's so Unprofitable!'," *The Guardian*, October 24, 2019, https://www.theguardian.com/stage/2019/oct/24/playwright-annie-baker-the-antipodes-national-theatre.

5. Performance

1. Rose Ginsberg quoted by Adam Hetrick, "MTI's Broadway Senior Creates Musical Theatre for a New Generation of Performers—The Senior Citizen Generation," *Playbill*, July 12, 2019, https://www.playbill.com/article/mtis-broadway-senior-creates-musical-theatre-for-a-new-generation-of-performersthe-senior-citizen-generation.
2. Rebecca Marks quoted by Adam Hetrick, "MTI's Broadway Senior Creates Musical Theatre for a New Generation of Performers."
3. "Spolin Games Online Resources," Spolin Games Online, copyright 2018, spolingamesonline.org.
4. Jessica Durando, "World's Toughest Tongue Twister? Try It 10 Times Fast," *USA Today*, December 11, 2013, https://www.usatoday.com/story/news/nation-now/2013/12/11/mit-tongue-twister/3985789/.
5. For more information, see Sally Bailey, "Getting Off to a Good Start: Basic Adaptations for the Drama Classroom" and "Checklist for Building Accessibility," *Barrier-Free Theatre*, 145–78, 471–76.
6. Sonnets are recommended over soliloquies if students have a hard time making a performance their own. It is likely that students have seen performances of soliloquies and are less likely to have preconceived notions of how to perform sonnets. Sonnets are also recommended if you want students to develop their own characters from scratch.

Conclusion: Theatre for All

1. Barbara Worthington and Arn Bernstein, "Curtain Call—Senior Theater's Dramatic Growth," *AgingWell*, accessed March 29, 2020, https://www.todaysgeriatricmedicine.com/news/story2.shtml.
2. Office of Disease Prevention and Health Promotion, "Older Adults," accessed March 29, 2020, https://www.healthypeople.gov/2020/topics-objectives/topic/older-adults.
3. "Senior Citizen Programs," Inside Broadway, accessed March 29, 2020, https://www.insidebroadway.org/our-programs/senior-citizen-programs.html; "About," Philly Senior Stage, accessed March 29, 2020, http://www.phillyseniorstage.com/landing/; "Senior Repertory Theatre," Seacoast Rep, accessed March 29, 2020, https://seacoastrep.org/programs/senior-repertory-theatre/.
4. "All in Together: Creating Places Where Young and Old Thrive," Generations United and the Eisner Foundation, accessed March 29, 2020, https://www.gu.org/resources/all-in-together-creating-places-where-young-and-old-thrive/.
5. Trent Stamp, "Intergenerational Programs: Not Just Nice, But Necessary," *Next Avenue*, September 26, 2019, https://www.forbes.com/sites/nextavenue/2016/09/26/intergenerational-programs-not-just-nice-but-necessary/#78071dc0109a.

NOTES

6. Selina Thompson, "Radical Disruptions: How Intergenerational Exchange Builds Community," *HowlRound Theatre Commons*, September 22, 2019, https://howlround.com/radical-disruptions.
7. "About," Onstage Seniors, accessed March 29, 2020, http://www.onstageseniors.org/; "Intergenerational Queer Theatre Project," Oregon Children's Theatre, accessed March 29, 2020, https://www.octc.org/intergenerational-project.
8. "Senior Theater Troupe of Lifelong," CloseToHomeProductions, accessed March 29, 2020, http://closetohomeproductions.com/senior-theater-troupe/.
9. "SET—Senior Theatre Ensemble," Queens Theatre, accessed March 29, 2020, http://queenstheatre.org/set-senior-ensemble-theatre.
10. Eliza Bent, "How Senior Theatre Is Forging Ahead, *American Theatre*, April 2, 2014, https://www.americantheatre.org/2014/04/02/how-senior-theatre-is-forging-ahead/.
11. Some cultural examples include the common expression "youth is wasted on the young" and films that are framed around older adults looking back at the best moments of their lives when they were younger such as *Titanic*, *The Notebook*, *Big Fish*, *Divine Secrets of the Ya-Ya Sisterhood*, *Fried Green Tomatoes*, and *A League of Their Own*.
12. "Our Story," Young@Heart Chorus, accessed January 19, 2021, https://youngatheartchorus.com/our-story.
13. Nancy Coleman, "Into Their 60s and 'Into the Woods'," *New York Times*, July 6, 2019, https://www.nytimes.com/2019/07/05/theater/into-the-woods-senior.html; Adam Hetrick, "MTI's Broadway Senior Creates Musical Theatre for a New Generation of Performer: The Senior Citizen," *Playbill*, July 12, 2019, https://www.playbill.com/article/mtis-broadway-senior-creates-musical-theatre-for-a-new-generation-of-performersthe-senior-citizen-generation.
14. "Programs," Stagebridge, accessed March 29, 2020, https://www.stagebridge.org/programs-1.
15. Ibid.
16. Ibid.
17. Amy Gallo, "The Value of Keeping the Right Customers," *Harvard Business Review*, October 19, 2014, https://hbr.org/2014/10/the-value-of-keeping-the-right-customers.

Bibliography

Artaud, Antonin. *The Theatre and Its Double*. Translated by Mary Caroline Richards. New York: Grove Press, 1958.

Bacon, Albert M. *A Manual of Gesture*. Chicago: S. C. Griggs, 1873.

Badmington, Neil, and Julia Thomas, ed. *The Routledge Critical and Cultural Theory Reader*. London: Routledge, 2008.

Bailey, Sally. *Barrier-Free Theatre: Including Everyone in Theatre Arts—in Schools, Recreation, and Arts Programs—Regardless of (Dis)Ability*. Enumclaw: Idyll Arbor, 2010.

Ball, David, and Michael Langham. *Backwards and Forwards: A Technical Manual for Reading Plays*. Carbondale: Southern Illinois University Press, 1982.

Basting, Anne. *Creative Care: A Revolutionary Approach to Dementia and Elder Care*. San Francisco, CA: HarperOne, 2020.

Basting, Anne. *Forget Memory: Creating Better Lives for People with Dementia*. Baltimore, MD: Johns Hopkins University Press, 2009.

Basting, Anne. *The Stages of Age: Performing Age in Contemporary American Culture*. Ann Arbor: University of Michigan Press, 1998.

Basting, Anne, Maureen Towey, and Elle Rose, eds. *The Penelope Project: An Arts-Based Odyssey to Change Elder Care*. Iowa City: University of Iowa Press, 2016.

Bent, Eliza. "How Senior Theatre Is Forging Ahead." *American Theatre*. April 2, 2014. Accessed June 17, 2021. https://www.americantheatre.org/2014/04/02/how-senior-theatre-is-forging-ahead/.

Bernard, Miriam, and Michelle Rickett. *Ageing, Drama and Creativity: A Critical Review*. Swindon: Cultural Value Project, 2014.

Bernard, Miriam, and Michelle Rickett. "The Cultural Value of Older People's Experiences of Theatre-making: A Review." *Gerontologist* 57, no. 2 (2017): 1–26.

Boal, Augusto. *Games for Actors and Non-Actors*, 2nd ed. Translated by Adrian Jackson. London: Routledge, 2002.

Boyer, Johanna. *Creativity Matters: The Arts and Aging Toolkit*. New York: National Guild of Community Schools, 2007.

Bradbury, Helen, Nick Frost, Sue Kilminster, Miriam Zukas, eds. *Beyond Reflective Practice: New Approaches to Professional Lifelong Learning*. London: Routledge, 2010.

Bradshaw, Peter. "Lucky Review—Harry Dean Stanton Ages disgracefully." *The Guardian* online. September 12, 2018. Accessed June 17, 2021, https://www.theguardian.com/film/2018/sep/12/lucky-review-harry-dean-stanton-david-lynch.

Brantley, Ben. "A Hostage Who Turns into a Dad." *New York Times*. April 18, 2013. https://www.nytimes.com/2013/04/19/theater/reviews/orphans-with-alec-baldwin-at-the-schoenfeld-theater.html.

Brecht, Bertolt. *Brecht on Theatre: The Development of an Aesthetic*. Translated and edited by John Willett. New York: Hill and Wang, 1966.

Caulfied, Mike. "SIFT (The Four Moves)." June 19, 2019. Accessed June 17, 2021. https://hapgood.us/2019/06/19/sift-the-four-moves/.

CBS Sunday Morning. "Marni Nixon: Singing Voice of the Stars." July 27, 2016. Video, 8:59. Accessed June 17, 2021. https://www.youtube.com/watch?v=8gHWroo5F84.

Chan Tony. "Beijing Opera 京劇 A Monkey King 孫悟空." March 14, 2008. Video, 5:44. Accessed June 17, 2021. https://www.youtube.com/watch?v=-VOCDFIW4xg.

Coleman, Nancy. "Into Their 60s and 'Into the Woods'." *New York Times*. July 6, 2019. Accessed June 17, 2021. https://www.nytimes.com/2019/07/05/theater/into-the-woods-senior.html.

Cornish, Roger, and C. Robert Kase. *Senior Adult Theatre: The American Theatre Association Handbook*. University Park: Pennsylvania State University Press, 1981, revised 1990.

Coughlin, Joseph F. *The Longevity Economy*. New York: Public Affairs, 2017.

Coyle, Jake. "A Cover Band for the Ages." *Decatur Daily*. June 22, 2007. http://legacy.decaturdaily.com/decaturdaily/livingtoday/070622/young.shtml.

Cruce, Ty M., and Nicholas W. Hillman. "Preparing for the Silver Tsunami: The Demand for Higher Education among Older Adults." *Research in Higher Education* 53, no. 6 (2012): 593–613.

"Curriculum—The Arts at KPS." Kalgoorlie Primary School. Accessed December 30, 2020. http://www.kalgoorlieps.wa.edu.au/curriculum.php?id=32.

DiAngelo, Robin. "Resources." Robin DiAngelo, PhD. Robin DiAngelo LLC. Accessed January 3, 2021. https://www.robindiangelo.com/resources/.

DiAngelo, Robin. *White Fragility: Why It's So Hard for White People to Talk about Racism*. Boston: Beacon Press, 2018.

Donorfio, Laura K. M., and Brian G. Chapman. "Engaging the Older Learner on Growing Old—Positively!" *LLI Review* 4 (Fall 2009): 9–21.

Dukore, Bernard, ed. *Dramatic Theory and Criticism: Greeks to Grotowski*. New York: Holt, Rinehart and Winston, 1974.

Durando, Jessica. "World's Toughest Tongue Twister? Try It 10 Times Fast." *USA Today*. December 11, 2013. https://www.usatoday.com/story/news/nation-now/2013/12/11/mit-tongue-twister/3985789/.

"Episode 265: Fake Science." Produced by WBEZ. *This American Life*. May 21, 2004. https://www.thisamericanlife.org/265/transcript.

Fanon, Frantz. *Black Skin, White Masks*. Translated by Richard Philcox. New York: Grove Press, 2008.

Farquhar, Lynn. "Wisdom in a Learning in Retirement Institute." *Educational Gerontology* 36, no. 8 (2010): 641–53.

Fetters, Ashley. "How Tinder Changed Dating for a Generation." *Atlantic Monthly*. December 21, 2018. Accessed March 24, 2020. https://www.theatlantic.com/family/archive/2018/12/tinder-changed-dating/578698/.

Field, John, Jim Gallacher, and Robert Ingram, eds. *Researching Transitions in Lifelong Learning*. London: Routledge, 2009.

Fisher-Lichte, Erika. *The Routledge Introduction to Theatre and Performance Studies*. London: Routledge, 2014.

Formosa, Marvin. *Lifelong Learning in Later Life: A Handbook on Older Adult Learning*. Rotterdam: Sense, 2011.

Freedman, Marc. "The Next Act: College for the Second Half of Life." *Change: The Magazine of Higher Learning* 45, no. 6 (2013): 40–42.

"Fresh Air Remembers Pulitzer Prize-Winning Playwright Edward Albee." NPR Fresh Air. npr. September 20, 2016. https://www.npr.org/2016/09/20/494725169/fresh-air-remembers-pulitzer-prize-winning-playwright-edward-albee.

Gallo, Amy. "The Value of Keeping the Right Customers." *Harvard Business Review*. October 19, 2014. https://hbr.org/2014/10/the-value-of-keeping-the-right-customers.

Gannon, Kevin. "The Case for Inclusive Teaching." *The Chronical of Higher Education*. February 27, 2018. https://www.chronicle.com/article/the-case-for-inclusive-teaching/.

Generations United and the Eisner Foundation. "All in Together: Creating Places Where Young and Old Thrive." Accessed March 29, 2020. https://www.gu.org/resources/all-in-together-creating-places-where-young-and-old-thrive/.

Gerould, Daniel, ed. *Theatre/Theory/Theatre: The Major Critical Texts from Aristotle and Zeami to Soyinka and Havel*. New York: Applause Theatre & Cinema Books, 2000.

Gillette, J. Michael, and Rich Dionne, *Theatrical Design and Production: An Introduction to Scene Design and Construction, Lighting, Sound, Costume, and Makeup*, 8th ed. New York: McGraw Hill, 2020.

GoldThread. "What It Takes to Be a Chinese Opera Singer." May 23, 2019. Video, 5:56. https://www.youtube.com/watch?v=-g7OtHIfwmg.

Gorard, Stephen, and Neil Selwyn. "Towards a Le@rning Society? The Impact of Technology on Patterns of Participation in Lifelong Learning." *British Journal of Sociology of Education* 26, no. 1 (2005): 71–89.

Goulding, Anna. "Older People Learning through Contemporary Visual Art—Engagement and Barriers." *International Journal of Art & Design Education* 32, no. 1 (2013): 18–32.

Grotowski, Jerzy. *Towards a Poor Theatre*. Edited by Eugenio Barba. London: Routledge, 2002.

Haarbauer, Martha. *Seasoned Theatre: A Guide to Creating and Maintaining a Senior Adult Theatre*. Portsmouth: Heinemann, 2000.

Hachem, Hany. "Is There a Need for a Fourth Statement? An Examination of the Critical and Humanist Statements of Educational Gerontology Principles." *International Journal of Lifelong Education*. August 3, 2020. https://www.tandfonline.com/doi/full/10.1080/02601370.2020.1801869.

Halpern, Charna, Del Close, and Kim "Howard" Johnson. *Truth in Comedy: The Manual of Improvisation*. Englewood: Meriwether, 1994.

Harris Interactive for MetLife Foundation. "What America Thinks: MetLife Foundation Alzheimer's Survey." *MetLife*. Accessed March 28, 2020. https://www.metlife.com/content/dam/microsites/about/corporate-profile/alzheimers-2011.pdf.

Hartman-Stein, Paula E., and Aseneth La Rue, eds. *Enhancing Cognitive Fitness in Adults: A Guide to the Use and Development of Community-Based Programs*. New York: Spring, 2011.

Haworth, Jon. "Female Bodybuilder, 82, Beats Home Intruder so Badly He Had to Be Taken to the Hospital." *ABC News*. November 25, 2019. https://abcnews.go.com/US/female-bodybuilder-82-beats-home-intruder-badly-hospital/story?id=67289683.

Henry, Alan. "Ben Brantley Apologizes over *New York Times* Review for *Head Over Heels*." *Broadway World*. July 21, 2018. https://www.broadwayworld.com/article/Ben-Brantley-Apologizes-Over-New-York-Times-Review-For-HEAD-OVER-HEELS-20180727.

Hetrick, Adam. "MTI's Broadway Senior Creates Musical Theatre for a New Generation of Performers—The Senior Citizen Generation." *Playbill*. July 12, 2019. https://www.playbill.com/article/mtis-broadway-senior-creates-musical-theatre-for-a-new-generation-of-performersthe-senior-citizen-generation.

Hill, Faith. "Dating after 60 Is Hard." January 8, 2020. *Atlantic Monthly*. Accessed March 24, 2020. https://www.theatlantic.com/family/archive/2020/01/dating-after-middle-age-older/604588/.

Hodge, Francis, and Michael McLean. *Play Directing: Analysis, Communication, and Style*, 6th ed. New York: Routledge, 2010.

Hoffman, Warren. *The Great White Way: Race and the Broadway Musical*, 2nd ed. New Brunswick, NJ: Rutgers University Press, 2020.

"Inclusive Teaching Strategies." Yale Poorvu Center for Teaching and Learning. Yale University. Accessed December 30, 2020. https://poorvucenter.yale.edu/InclusiveTeachingStrategies.

"Intergenerational Queer Theatre Project." Oregon Children's Theatre. Accessed March 29, 2020. https://www.octc.org/intergenerational-project.

Istance, David. "Learning in Retirement and Old Age: An Agenda for the 21st Century." *European Journal of Education* 50, no. 2 (2015): 225–238.

Jones, Daniel. "Blistered and Burned: The Absence of Female Critics." *HowlRound Theatre Commons*. July 13, 2013. https://howlround.com/blistered-and-burned.

Kendi, Ibram X. "Antiracism Center." Ibram X Kendi. Boston University. Accessed December 30, 2020. https://www.ibramxkendi.com/antiracism-center-2.

Kendi, Ibram X. *How to Be an Antiracist*. New York: Random House, 2019.

Kennedy Center Education Digital Learning. "Theatre Conversations: David Ives." July 13, 2018. Video, 31:26. https://www.youtube.com/watch?v=m2FpNNKiHpI.

Kern, Dominique. "Research on Epistemological Models of Older Adult Education: The Need of a Contradictory Discussion." *Educational Gerontology*. 44, nos. 5–6. (2018): 338–53. https://www.tandfonline.com/doi/full/10.1080/03601277.2018.1475123?scroll=top&needAccess=true.

Kidahashi, Miwako, and Ronald J. Manheimer. "Getting Ready for the Working-in-Retirement Generation: How Should LLIs Respond?" *LLI Review* 4 (Fall 2009): 1–8.

Kramarae, Cheris. "An Older Feminist Actively Learning About Death." *Women & Language* 38, no. 2 (2015): 111–113.

Lau, Linda, and Rae Mansfield. "Theatre for Lifelong Learning Artist Interview: Irina Yakubovskaya." *Theatre for Lifelong Learning*. February 22, 2021. https://theatreforlifelonglearning.org/?p=331.

Lau, Linda, and Rae Mansfield. "Tips & Worksheets." *Theatre for Lifelong Learning*. Accessed May 31, 2021. https://theatreforlifelonglearning.org/?p=331.

Lau, Linda, and Rae Mansfield. "Waves of Opportunity: Best Practices for Working with Older Adults in Theatre." *Theatre Topics* 29, no. 1 (March 2019): 71–78.

Lawrence-Lightfoot, Sara. *The Third Chapter: Passion, Risk and Adventure in the 25 Years after 50*. New York: Farrar, Straus, and Giroux, 2009.

Lawson, Mark. "Annie Baker: 'I Like Theatre because It's So Unprofitable!'" *The Guardian*. October 24, 2019. https://www.theguardian.com/stage/2019/oct/24/playwright-annie-baker-the-antipodes-national-theatre.

"Learning New Skills Keeps an Aging Mind Sharp." Association for Psychological Science. October 21, 2013. https://www.psychologicalscience.org/news/releases/learning-new-skills-keeps-an-aging-mind-sharp.html.

Lee, Ya-Hui. "From Learners to Volunteers: A Qualitative Study of Retirees' Transformative Learning in Taiwan." *Educational Gerontology* 42, no. 12 (2016): 809–17.

Lev-Aladgem, Shulamith. *Theatre in Co-Communities: Articulating Power*. London: Palgrave Macmillan, 2010.

"Lifelong Learning Institute Directory." National Resource Center for Osher Institutes at Northwestern University. Northwestern University. June 2018. http://nrc.sps.northwestern.edu/wp-content/uploads/2017/12/A-Directory-of-Lifelong-Learning-Institutes.pdf.

"Longest TV Career by an Entertainer (Female)." *Guinness Book of World Records*. Accessed January 10, 2021. https://www.guinnessworldrecords.com/world-records/107740-longest-tv-career-by-an-entertainer-female.

"Longest TV Career by an Entertainer (Male)." *Guinness Book of World Records*. Accessed January 10, 2021. https://www.guinnessworldrecords.com/world-records/102899-longest-tv-career-by-an-entertainer-male.

Lyons, Margaret. "Alec Baldwin Sure Does Hate Ben Brantley." *Vulture*. May 7, 2013. https://www.vulture.com/2013/05/alec-baldwin-ben-brantley-fight.html.

Mackenzie, Suzie. "You Have to Laugh." *The Guardian*. November 19, 2004. https://www.theguardian.com/stage/2004/nov/20/theatre.

Macmillan, Amanda. "Why Friends May Be More Important Than Family." *Time* online. June 7, 2017. https://time.com/4809325/friends-friendship-health-family/#:~:text=Friends%20are%20increasingly%20important%20to%20health%20and%20happiness,because%20we%20enjoy%20spending%20time%20with%20them%20more.

Mangan, Michael. *Staging Ageing: Theatre, Performance, and the Narrative of Decline*. Bristol: Intellect, 2014.

Maust, Donovan T., Erica Solway, Kenneth M. Langa, Jeffrey T. Kullgren, Matthias Kirch, Dianne C. Singer, and Preeti Malani. "Perception of Dementia Risk and Preventive Actions among US Adults Aged 50 to 64 Years." *JAMA Neurology* 77, no. 2 (2020): 259–62.

McConachie, Bruce, Tobin Nellhaus, Carol Fisher Sorgenfrei, and Tamara Underiner, eds. *Theatre Histories: An Introduction*, 3rd ed. Abingdon: Routledge, 2016.

McCormick, Sheila. *Applied Theatre: Creative Ageing*. York: Methuen Drama, an imprint of Bloomsbury Publishing, 2017.

Meisner, Sanford. *Sanford Meisner on Acting*. New York: Vintage, 1987.

Memran, Michelle. "Moment to Moment: with Maria Irene Fornes." *The Brooklyn Rail: Critical Perspectives on Arts, Politics, and Culture*. Accessed June 4, 2020. https://brooklynrail.org/2002/10/theater/moment-to-moment-with-maria-irene-fornes.

Meriam Library, California State University Chico. "The CRAAP Test." Accessed March 9, 2020. https://library.csuchico.edu/help/source-or-information-good.

Merrill, Henry S. "So Are You Retired or What?: Notes from a Lifelong Journey in Search of Possible Selves." *Adult Learning* 23, no. 3 (2012): 153–55.

Morgan, Michael, Pamela Watson, and Nigel Hemmington. "Drama in the Dining Room: Theatrical Perspectives on the Foodservice Encounter." *Journal of Food Service*. March 19, 2008. https://onlinelibrary.wiley.com/doi/full/10.1111/j.1745-4506.2008.00090.x.

MsMojo. YouTube Channel. https://www.youtube.com/channel/UC3rLoj87ctEHCcS7BuvIzkQ.

Myers, Dennis R. Catherine Sykes, and Scott Myers. "Effective Learner-Centered Strategies for Teaching Adults: Using Visual Media to Engage the Adult Learner." *Gerontology & Geriatrics Education* 29, no. 3 (2008): 234–38.

Myers, Victoria. "Interview with Lynn Nottage." *The Interval*. October 14, 2015. https://www.theintervalny.com/interviews/2015/10/an-interview-with-lynn-nottage/.

Narushima, Miya, Jian Liu, and Naomi Diestelkamp. "Lifelong Learning in Active Ageing Discourse: Its Conserving Effect on Wellbeing, Health and Vulnerability." *Ageing & Society* 38 (2018): 651–75.

Office of Disease Prevention and Health Promotion. *Healthy People 2020: Older Adults*. Accessed March 29, 2020. https://www.healthypeople.gov/2020/topics-objectives/topic/older-adults.

"OLLI Home." California State University Long Beach, Osher Lifelong Learning Institute. California State University Long Beach. Accessed December 30, 2020. https://www.csulb.edu/college-of-health-human-services/osher-lifelong-learning-institute-home.

Oluo, Ijeoma. *So You Want to Talk about Race*. New York: Seal Press, 2018. Onstage Seniors. Accessed March 29, 2020. http://www.onstageseniors.org/.

"Our Experiential Opportunities Change Lives." Road Scholar. Accessed December 30, 2020. https://roadscholar.org.

"Our Mission." BU Center for Antiracist Research. Boston University. Accessed January 3, 2021. https://www.bu.edu/antiracism-center/.

"Our Story." Young@Heart Chorus. Accessed January 19, 2021. https://youngatheartchorus.com/our-story.

Paterniti, Michael. "The Secrets of the 80-Year-Old Chinese Runway Model." *GQ*. March 28, 2017. https://www.gq.com/story/wang-deshun-fashion-week.

Pendick, Daniel. "Mental Strain Helps Maintain a Healthy Brain." Harvard Health Blog. Harvard University. October 29, 2015. https://www.health.harvard.edu/blog/mental-strain-helps-maintain-a-healthy-brain-201211055495.

Pierce, Jeff. "Coming Out" Stars. *LGTQ+ Student Center*. University of Southern California. https://lgbtrc.usc.edu/files/2015/05/Coming-Out-Stars.pdf.

"Playworlds." *The Laboratory of Comparative Human Cognition*. Co-Laboratory of Comparative Human Cognition, University of California, San Diego. Accessed December 30, 2020. http://lchc.ucsd.edu/playworlds.

Robeson Jr., Paul. Interview by Terry Gross. *Fresh Air*. NPR. April 26, 2001. https://www.npr.org/templates/story/story.php?storyId=1122085.

Rohd, Michael. *Theatre for Community Conflict and Dialogue: The Hope is Vital Training Manual*. Portsmouth: Heinemann, 1998.

Romano, John. "James Baldwin Writing and Talking." *New York Times*. September 23, 1979. https://www.nytimes.com/1979/09/23/archives/james-baldwin-writing-and-talking-baldwin-baldwin-authors-query.html.

Rushe, Sinead. *Michael Chekhov's Acting Technique: A Practitioner's Guide*. London: Methuen Drama, an imprint of Bloomsbury Publishing, 2019.

Russell, Helen. "Time and Meaning in Later-Life Learning." *Australian Journal of Adult Learning* 51, no. 3 (2011): 547–65.

Schechner, Richard. *Performance Studies: An Introduction*, 3rd ed. London: Routledge, 2013.

Schweitzer, Pam. *Reminiscence Theatre: Making Theatre from Memories*. London: Jessica Kingsley, 2006.

Senelick, Laurence. *The Changing Room: Sex, Drag, and Theatre*. London: Routledge, 2000.

"Senior Citizen Programs." Inside Broadway. Accessed March 29, 2020. https://www.insideb roadway.org/our-programs/senior-citizen-programs.html.

"Senior Repertory Theatre." Seacoast Rep. Accessed March 29, 2020. https://seacoastrep.org/programs/senior-repertory-theatre/.

"Senior Theater Troupe of Lifelong." CloseToHomeProductions. Accessed March 29, 2020. http://closetohomeproductions.com/senior-theater-troupe/.

"SET—Senior Theatre Ensemble." Queens Theatre. Accessed March 29, 2020. http://queens theatre.org/set-senior-ensemble-theatre.

Solan, Matthew. "Back to School: Learning a New Skill Can Low Cognitive Aging." Harvard Health Blog. Harvard University. April 27, 2016. https://www.health.harvard.edu/blog/learning-new-skill-can-slow-cognitive-aging-201604279502.

"Spolin Games Online." Spolin Games Online. Updated 2018. spolingamesonline.org.

Spolin, Viola. *Improvisation for the Theater: A Handbook of Teaching and Directing Techniques*, 3rd ed. Evanston, IL: Northwestern University Press, 1999.

Stagebridge. Accessed March 29, 2020. https://www.stagebridge.org.

Stamp, Trent. "Intergenerational Programs: Not Just Nice, But Necessary." *Next Avenue*. September 26, 2019. https://www.forbes.com/sites/nextavenue/2016/09/26/intergenerational-programs-not-just-nice-but-necessary/#78071dc0109a.

Storey, John, ed. *Cultural Theory and Popular Theatre: A Reader*, 4th ed. Harlow: Pearson Longman, 2009.

Stucky, Nathan, and Cynthia Wimmer, eds. *Teaching Performance Studies*. Carbondale: Southern Illinois University Press, 2002.

Thomas, W. H. *What Are Old People For? How Elders Will Save the World*. Acton: VanderWyk & Burnham, 2004.

Thompson, Selina. "Radical Disruptions: How Intergenerational Exchange Builds Community." *HowlRound Theatre Commons*. September 22, 2019. https://howlround.com/radi cal-disruptions.

Thurman, Anne H., and Carol Ann Piggins. *Drama Activities with Older Adults: A Handbook for Leaders*. New York: Haworth Press, 1982.

"Towards a Pedagogy of Play." Project Zero. President and Fellows of Harvard College, Harvard Graduate School of Education. July 2016. https://pz.harvard.edu/sites/default/files/Towards%20a%20Pedagogy%20of%20Play.pdf.

UNESCO. "Three Genres of Traditional Dance in Bali." Video, 10:00. December 2, 2015. https://www.youtube.com/watch?v=h0hnblBc1YM.

United States Census Bureau. *Facts for Features: Older Americans Month*. April 10, 2017. https://www.census.gov/population/projections/data/national/2014/summarytables.html.

University of California Television (UCTV). "Conversations with History: Wole Soyinka." YouTube Video, 53:12. May 1, 2008. https://www.youtube.com/watch?v=wosbdri9dRc.

US Department of Education, National Center for Education Statistics. *National Household Education Surveys Program of 2005, Adult Education Survey.* 2005. Accessed August 3, 2018. https://nces.ed.gov/nhes/dataproducts.asp#2005dp.

Vassar College. "The Experimental Theatre of Vassar College." Vassar Encyclopedia. Vassar College. Accessed June 4, 2020. http://vcencyclopedia.vassar.edu/curriculum/The%20Experimental%20Theatre%20of%20Vassar%20College.html.

Video Gubbins. "Nippon—The Tradition of Performing Arts in Japan: The Heart of Kabuki, Noh and Bunraku." December 19, 2016. Video, 38:44. https://www.youtube.com/watch?v=3Pd47utJkt8.

Wachs, Benjamin. "LiPo Lounge Says 'Fuck You, Tourist': Asian Kitsch." *SF Weekly.* April 1, 2015. https://www.sfweekly.com/dining/lipo-lounge-says-fuck-you-tourist-asian-kitsch/.

Warner, John. "Getting Beyond the CRAAP Test: A Conversation with Mike Caulfield." *Inside Higher Ed.* August 14, 2019. https://www.insidehighered.com/blogs/just-visiting/getting-beyond-craap-test-conversation-mike-caulfield.

Weinert-Kendt, Rob. "Can 3 Views Change Theatre Criticism?" *American Theatre.* June 3, 2018. https://www.americantheatre.org/2019/06/03/can-3views-change-theatre-criticism/.

Weinert-Kendt, Rob. "Who Will Critique the Critics?" *American Theatre.* June 4, 2018. www.americantheatre.org/2018/06/04/who-will-critique-the-critics/.

"Welcome to the Learning in Retirement Association (LIRA) Website." Learning in Retirement Association. University of Massachusetts Lowell. Accessed December 30, 2020. https://www.uml.edu/community/lira/.

"Welcome to the OLLI at Tufts University." Osher Lifelong Learning Institute. Tufts University. Accessed December 30, 2020. https://universitycollege.tufts.edu/lifelong-learning/osherlli.

Wilder, Thornton. *Our Town: A Play in Three Acts.* New York: Harper & Row, 1957.

Wilson, August. "The Ground on Which I Stand." *American Theatre.* June 20, 2016. https://www.americantheatre.org/2016/06/20/the-ground-on-which-i-stand/.

Worthington, Barbara, and Arn Bernstein. "Curtain Call—Senior Theater's Dramatic Growth." *AgingWell.* Accessed March 29, 2020. https://www.todaysgeriatricmedicine.com/news/story2.shtml.

Milton Keynes UK
Ingram Content Group UK Ltd.
UKHW051817080124
435668UK00034B/457